PROJECTING DESIRE

CRITICAL CULTURAL COMMUNICATION

General Editors: Jonathan Gray, Aswin Punathambekar, Adrienne Shaw
Founding Editors: Sarah Banet-Weiser and Kent A. Ono

Dangerous Curves: Latina Bodies in the Media
Isabel Molina-Guzmán

The Net Effect: Romanticism, Capitalism, and the Internet
Thomas Streeter

Our Biometric Future: Facial Recognition Technology and the Culture of Surveillance
Kelly A. Gates

Critical Rhetorics of Race
Edited by Michael G. Lacy and Kent A. Ono

Circuits of Visibility: Gender and Transnational Media Cultures
Edited by Radha S. Hegde

Commodity Activism: Cultural Resistance in Neoliberal Times
Edited by Roopali Mukherjee and Sarah Banet-Weiser

Arabs and Muslims in the Media: Race and Representation after 9/11
Evelyn Alsultany

Visualizing Atrocity: Arendt, Evil, and the Optics of Thoughtlessness
Valerie Hartouni

Authentic™: The Politics of Ambivalence in a Brand Culture
Sarah Banet-Weiser

The Makeover: Reality Television and Reflexive Audiences
Katherine Sender

Love and Money: Queers, Class, and Cultural Production
Lisa Henderson

Cached: Decoding the Internet in Global Popular Culture
Stephanie Ricker Schulte

Black Television Travels: African American Media around the Globe
Timothy Havens

Citizenship Excess: Latino/as, Media, and the Nation
Hector Amaya

Feeling Mediated: A History of Media Technology and Emotion in America
Brenton J. Malin

The Post-Racial Mystique: Media and Race in the Twenty-First Century
Catherine R. Squires

Making Media Work: Cultures of Management in the Entertainment Industries
Edited by Derek Johnson, Derek Kompare, and Avi Santo

Sounds of Belonging: U.S. Spanish-language Radio and Public Advocacy
Dolores Inés Casillas

Technomobility in China: Young Migrant Women and Mobile Phones
Cara Wallis

Orienting Hollywood: A Century of Film Culture between Los Angeles and Bombay
Nitin Govil

Asian American Media Activism: Fighting for Cultural Citizenship
Lori Kido Lopez

Struggling For Ordinary: Media and Transgender Belonging in Everyday Life
Andre Cavalcante

Homegrown: Identity and Difference in the American War on Terror
Piotr M. Szpunar

Dot-Com Design: The Rise of a Usable, Social, Commercial Web
Megan Sapnar Ankerson

Postracial Resistance: Black Women, Media, and the Uses of Strategic Ambiguity
Ralina L. Joseph

Netflix Nations: The Geography of Digital Distribution
Ramon Lobato

Celebrity: A History of Fame
Susan J. Douglas and Andrea McDonnell

Fake Geek Girls: Fandom, Gender, and the Convergence Culture Industry
Suzanne Scott

Locked Out: Regional Restrictions in Digital Entertainment Culture
Evan Elkins

Beyond Hashtags: Racial Politics and Black Digital Networks
Sarah Florini

The Digital City: Media and the Social Production of Place
Germaine R. Halegoua

Distributed Blackness: African American Cybercultures
André Brock, Jr.

Wife, Inc.: The Business of Marriage in the Twenty-First Century
Suzanne Leonard

Race and Media: Critical Approaches
Edited by Lori Kido Lopez

Border Optics: Surveillance Cultures on the US-Mexico Border
Camilla Fojas

Dislike-Minded: Media, Audiences, and the Dynamics of Taste
Jonathan Gray

Digital Media Distribution: Portals, Platforms, Pipelines
Edited by Paul McDonald, Courtney Brannon Donoghue and Timothy Havens

Digital Black Feminism
Catherine Knight Steele

The Identity Trade: Selling Privacy and Reputation Online
Nora A. Draper

Latino TV: A History
Mary Beltrán

The Digital Border: Migration, Technology, Power
Lilie Chouliaraki and Myria Georgiou

Digital Unsettling: Decoloniality and Dispossession in the Age of Social Media
Sahana Udupa and Ethiraj Gabriel Dattatreyan

Streaming Video: Storytelling Across Borders
Amanda D. Lotz and Ramon Lobato

Chinese Creator Economies: Labor and Bilateral Creative Workers
Jian Lin

Fandom Is Ugly: Affective Attachments and Networked Harassment in Participatory Culture
Mel Stanfill

Projecting Desire: Media Architectures and Moviegoing in Urban India
Tupur Chatterjee

Projecting Desire

*Media Architectures and
Moviegoing in Urban India*

Tupur Chatterjee

NEW YORK UNIVERSITY PRESS
New York

NEW YORK UNIVERSITY PRESS
New York
www.nyupress.org

© 2025 by New York University
All rights reserved

References to Internet websites (URLs) were accurate at the time of writing. Neither the author nor New York University Press is responsible for URLs that may have expired or changed since the manuscript was prepared.

Library of Congress Cataloging-in-Publication Data
Names: Chatterjee, Tupur, author.
Title: Projecting desire : media architectures and moviegoing in urban India / Tupur Chatterjee.
Description: New York : New York University Press, [2024] |
Series: Critical cultural communication |
Includes bibliographical references and index.
Identifiers: LCCN 2024002623 (print) | LCCN 2024002624 (ebook) |
ISBN 9781479829620 (hardback) | ISBN 9781479829644 (paperback) |
ISBN 9781479829699 (ebook other) | ISBN 9781479829705 (ebook)
Subjects: LCSH: Multiplex theaters—India. | Motion picture industry—India. | Architecture and women—India. | Architecture and globalization—India.
Classification: LCC NA6846.I4 C49 2024 (print) | LCC NA6846.I4 (ebook) |
DDC 725/.8230954—dc23/eng/20240919
LC record available at https://lccn.loc.gov/2024002623
LC ebook record available at https://lccn.loc.gov/2024002624

New York University Press books are printed on acid-free paper, and their binding materials are chosen for strength and durability. We strive to use environmentally responsible suppliers and materials to the greatest extent possible in publishing our books.

Manufactured in the United States of America

10 9 8 7 6 5 4 3 2 1

Also available as an ebook

For Ma and Baba

CONTENTS

Introduction: Architectural Mediations — 1

1. A Material History of the Cinema Hall — 39

2. Designing the Malltiplex — 73

3. The Multiplex Film — 109

4. Nostalgia and Fear in the Smart City — 145

Epilogue: Moviegoing in the Age of Hindutva — 175

Acknowledgments — 185

Notes — 189

Bibliography — 201

Index — 217

About the Author — 229

Introduction

Architectural Mediations

Dil Dhadakne Do (Let the Heart Beat, Zoya Akhtar, 2015) is a film about an ultra-rich but soon-to-be bankrupt Delhi family and their friends on a luxury cruise in Turkey and Greece. Several Bollywood stars lead the cast, including Priyanka Chopra, Ranveer Singh, Anushka Sharma, Farhan Akhtar, and Anil Kapoor. It displaces the big romantic plot typical in other films of this ilk with a narrative centered on a sibling relationship and broken conjugal units. Its visual and sonic landscapes, along with its dialogue, heavily lean toward a new and distinctive realism that has been steadily making its way into mainstream Hindi cinema in the last two decades. Discussing the making of the film in an interview with critic Anupama Chopra (2015), the film's actors humorously talked about the process of making a commercially viable film in an industry in which the lines between mainstream, popular, *hatke* (a blanket Hindi colloquial term to describe any atypical film), and parallel cinema have all blurred. As Ranveer Singh, Bollywood's reigning male A-lister, recalled:

> Basically, we were shooting "Galla Goodiyan," a high-energy one-take song, and there is a section where Anil Sir, Farhan, and myself have to freestyle. So in the first take, in our freestyle section, Anil Sir and I did what comes out of us *naturally* . . . [pokes his tongue out and does an exaggerated hand and torso dance gesture] . . . She [the director] goes up to Bosco [the choreographer], she sits him down and says, "Bosco!" And this conversation goes on for ten minutes. She is trying to brief Bosco about how to tell us what to alter . . . And Bosco is just doing this [nodding] the whole time. He comes up to us, and he's like, "Baba, *yah se single* [points to torso], *yah se thoda multi* [gestures to face] [single from the torso and and a little multi from the face]." (emphasis added)

As the actors recalled, when some of them slipped into their "naturally" inflated acting styles, the director shouted, "Bring down the single!" The stars were being instructed to perform their dancing bodies as "single screen" and their facial expressions as "multiplex." These sharp and comic two-word directives, "single" and "multi," served as code-switching instructions for modulating performance based on the perceived environments of the single-screen cinema and the multiplex. In a way, then, the film's bifurcated circulatory life once it was released to theaters—some single-screen or stand-alone theaters and some multiplexes—found its way on to the set to bifurcate the body of the star. Whereas Singh's face was instructed to channel a multiplex sensibility, his dancing body was instructed to evoke classic and familiar Hindi film affects—excess, exaggeration, and irreverence—but within the character-specific realism of the film. This signals that the different physical sites of Hindi cinema's historical reception—the long-standing single screen and the more recent multiplex—are differentially linked to, among other things, histories of performance, dance choreographies, music, dialogue, sets, costumes, editing, color palettes, lighting, and sound. These linkages, as quickly implied through new industry lore, are encoded with a bifurcation of taste based on gender, geography, and class. The single/multi split, as etched on Singh's body, carries other hegemonic implications: the body is the repository of "lower" (and working-class male) libidinal energies associated with the single screen, whereas the head/face is meant to address middle-class intellectual sensibilities. In other words, metamorphic architectural sites of film exhibition have long mediated the history of popular cinema across changing performative idioms, audience tastes, and the body of the star, and have in turn shaped the industrial trajectories of production and distribution.

Zoya Akhtar made her directorial debut in 2009 with *Luck by Chance*, a poignant satire of the inner world of Bollywood. In the 2010s, she has emerged as India's most successful female director and one of its most distinctive auteurs. She has a diploma in filmmaking from New York University's Tisch School of Arts. In addition to *Dil Dhadakne Do*, her other notable directorial ventures include *Zindagi Na Milegi Dobara* (You Only Live Once, 2011), a dramedy about three thirty-something male friends on a road trip through Spain, and *Gully Boy* (2019), an underdog story about a Muslim rapper from the slums of Bombay,[1]

loosely based on the lives of two real-life musicians, Neazy and Divine. Akhtar also wrote, developed, and partially directed *Made in Heaven* (2019) for Amazon Prime Video's India catalog. It is one of the few TV series in India that have extensively depicted homosexuality and sexual intimacy among gay men, and it simultaneously unravels the violence and psychosis embedded in the marriage industry, a thematic mainstay of popular Hindi cinema.

Her actor-producer-director brother, Farhan Akhtar, directed *Dil Chahta Hai* (What the Heart Wants, 2001), a breezy coming-of-age film about three posh Bombay boys that is now a bona fide cult favorite. It was his first film. Zoya Akhtar worked on the film's casting. Her friend, New York-based costume designer Arjun Bhasin, who was then in India to work on Mira Nair's *Monsoon Wedding* (2001), agreed to do the wardrobe for the film because "it spoke to me in a language that Hindi cinema hadn't before." In a recent piece celebrating twenty years of the film, a journalist wrote, "20 years ago, Farhan Akhtar and his team did make the Hindi movie industry itself a different place. *Dil Chahta Hai* helped change Hindi cinema's standards for coolness and prestige, its depictions of India's elite, and arguably, even its conception of its core audience" (Pathak 2021). *Dil Chahta Hai* is indeed particularly memorable for being one of the few films of the time that paid close attention to aspects like script continuity and synergies between characters, color palettes, and set design. Together, the Akhtar siblings embody the gentrification that popular Hindi cinema has undergone in the last two decades. But more crucially, their films are avowedly for cosmopolitan, film-literate spectators. Like several industry professionals, they belong to a film family. Their parents are Javed Akhtar and Honey Irani, prolific scriptwriters and lyricists who have been instrumental figures in Hindi cinema since the 1970s. In that decade, Javed Akhtar and his screenwriting partner Salim Khan created some of India's biggest commercial blockbusters using the recurring trope of the angry young man, played to perfection by superstar Amitabh Bachchan.[2] These films were immediately resonant (especially to young, male audiences) in a restless country reeling from acute political unrest and unemployment.

The industrial succession of genre, style, screenwriting, and production practices embodied in these generations of a single family unfolded alongside broader shifts in the Indian economy. The year of *Dil Chahta*

Hai, 2001, also marked a decade of India's newly privatized and liberalized economy. The multiplex was barely four years old. The "multi" was far from being a prominent industry idiom. In the next fifteen years—by the time *Dil Dhadakne Do* went into production—it had radically transformed the country's media landscape. The multiplex overshadowed the single-screen cinema and its related cultures of public leisure. The meanings of the cinema hall changed. It became unrecognizable from its past versions and allegories. Major transformations in industrial visions of "core audiences" followed. The multiplex enabled directors like Zoya Akhtar and Farhan Akhtar, among several others, to successfully meddle with the syntax of the mainstream and the popular without the affectations of avant-garde, indie, or art cinema.

The multiplex established a new nexus between media industries and architecture in the subcontinent. Almost always located inside a mall, the multiplex simultaneously produced, participated in, and symbolized broader shifts in the Indian economy: leisure spending, global aspirations, and urban life. These new meccas of leisure and entertainment changed the shapes of cities. How did they reimagine, reframe, and rewrite the existing relations between gender, class, and urban space? To be clear, this reordering came at a cost: entire population segments were marginalized and made insignificant in industrial imaginations. Class-based solidarities between cinema, retail, and exhibition industries strengthened. Those who remained outside this economic and socio-spatial assembly were left out of the picture. Still, the numbers of those who could afford to watch movies at the multiplex swelled. By catering to the mutable desires and anxieties of a rapidly expanding and heterogeneous middle class, the multiplex radically altered the politics of theatrical space and moviegoing. Since its inception in 1997, the multiplex takeover of the exhibition landscape has been based on selling built environments as the key consumer experience. This has led to the emergence of new kinds of media architectures and new configurations of what can be included within the ambit of media industries. After all, the current assemblages of moviegoing in the subcontinent now include not only retail but also food and beverage, surveillance and security, and hospitality industries, among others.

Projecting Desire tells the story of this moment of historic transition as it played out across media industries, architecture and design,

popular cinema, and public culture. I argue that the architectural mediations of India's moviegoing cultures are key to imagining, planning, and policing the contemporary media city. Although class has been the most discussed aspect of these changes, this book shows that these spatial transformations must also be studied through their gendered designs. What does the post-globalization transformation of India's screen and exhibition industries look like when placed in a longer arc of ideas about urban planning and architecture? To answer this question, I position the politics of both media architectures and gendered space within their historical contexts. In India, these politics are mired in long histories of caste- and class-based anxieties around the sharing of private and public space. Gender resides at the heart of these anxieties. In this book, I ask, how do these sociohistorical coordinates (albeit in morphed contemporary formations) continue to define the affective relationships between media architectures and the cultural politics of public leisure?

In the era of the single screen, it was common for women to be absent from late-night shows, or at least to be heavily outnumbered at the cinema, depending on a variety of factors: time, location, and the reputation of the theater, its amenities, and sometimes the film itself. Conversely, the absence of women is unimaginable at the multiplex, and even more so at the mall, a space built on the very premise of female consumption. The mall and the multiplex cannot exist outside of one another. The multiplex succeeds only if the mall succeeds. Both gain legibility and legitimacy through the constant presence of the consuming, globalized woman. How, then, can we trace gender—at once as fantasy, ideology, tactic, and strategy—in the material life of these built environments?

Projecting Desire extends the disciplinary concerns of media industry studies, global media studies, and feminist media studies to include architectural theory, design, and urban planning. I integrate industrial analysis and organizational ethnography, in-depth interviews, participant observation, discourse and textual analysis, and archival work with spatial and urban histories. Representation has long been the privileged site for the study of gender in film and media studies. This book instead locates gender in the materiality of built space. Each chapter highlights the crystallization of gendered imaginaries of privacy, risk, safety, desire, consumption, and hygiene. Thus, my inclusion of architecture at large—both inside and outside the film theater, inside and

outside the film text—also invites an expansion of the category of the spectator: she is not bound to or held by the cinematic apparatus alone. She navigates various affective relationships to the city and its built environments—she is a citizen, a shopper, a consumer, a viewer, and an audience category—and her gendered identity intersects with income, class, caste, age, religion, and ability, among other factors. At times, one identity (for instance, citizen) supersedes others, while at others, she is imagined as hyphenated figure (the shopper-spectator). Although a diverse range of industrial agents (mall builders, multiplex architects, corporate surveillance firms, media and film professionals, the popular press, fashion, and beauty industries etc.) imagine her—coherently and independently—as a spatial subject, she also produces those very spaces.

I thus explore the Indian multiplex as a novel media formation that produces a new kind of anxious and disciplined gendered body. In the multiplex-within-the-mall format of moviegoing, spectatorial imaginations of India's moviegoing audiences move from the subaltern male to the consuming middle-class woman. This is an overarching industrial shift across production, distribution, and exhibition. Spaces that, for several preceding decades, had been designed for the male "mass" spectator, are now built for the female shopper. Crucially, this shift reverses the enduring relationship between cinema and exhibition space: the latter is now designed to surpass the former. What emerges is an industrial focus on the production of environments that cultivate the amplified presence of the female shopper-spectator. Constant mitigation of class- and caste-based anxieties around her safety in public space now dominates the relationships between consumption, cinematic pleasures, leisure, and urban design.

The chapters that follow study the various topographies of India's thriving *multiplex culture* while historicizing it within the larger context of the country's pre-liberalization exhibition economies. Revisiting the techno-architectural histories and spatial politics of cinema halls in the colonial and post-independence periods, I examine the relationship between public architecture, national identity, and the citizen-spectator to study the latent and apparent cultural anxieties that the Indian multiplex so successfully capitalized upon. The role of television—both public and private—as a maker of India's middle class from the 1980s is vital here.

Significantly, it generated assorted taste cultures. Television brought the pleasures of privatized media consumption into Indian homes and became the crucial link: first between the single screen and the multiplex, and then between the home and the multiplex. Television primed the Indian middle class—a category it also produced—for the pleasures of the multiplex. To be sure, this media historiography is not linear, or a story of successive technological triumphs, but rather intersecting and recursive.

With this context established, I track the arrival and spread of the globalized nexus between media and urban architecture, private investments, and the state to demonstrate how India's multiplex culture is industrially produced and continually reinvented. Placing the new discursive category of the "multiplex film" in the architectural ambit of its expanded exhibition space, I ask, how is the site of exhibition imagined at the site of production? Such multiplex-engendered shifts in the vernacular of popular cinema are unique to the subcontinent, despite the seemingly "global" nature of multiplex architectonics. They are also crucial to the prehistory of streaming video in India. Finally, through an analysis of a renewed nostalgic discourse for the "lost" single screen, I demonstrate how the Indian multiplex, now twenty-five years old, has begun to legitimize itself as elemental to the narrative arc of the country's moviegoing history and culture. Overall, this book moves away from the study of media industries, texts, and audiences as distinctive sites. It advocates for an intermedial approach to understanding this three-decade-long transition that is ongoing in India's entertainment cultures. This story, however, cannot be told outside of the story of urban India's spatial and architectural transformation.

In other words, the cinema hall and its material environment cannot be studied as an insulated site (see also Benson-Allott 2021; Zhou 2021; Larkin 2008). Its spatial politics emerge from and are tied to other sites: urban geography, the home, contiguous screen cultures like the television and mobile phone, and the gamut of other built environments that we must inhabit when we go to the cinema. Crucially, the material and aesthetic regimes that emerge at specific historical junctures reflect not only the dominant political expressions of the day, but also their regional and global indexicalities. For example, the former prime minister

Jawaharlal Nehru's influence on post-independence Indian architecture was inscribed on modernist theaters of the 1960s and 1970s and manifested as a style and material ontology that appealed to many socialist states at the time, such as Hungary (chapter 1; see also Fehérváry 2013). The post-globalization affinities between new consumer cultures, vibrant color, and materials like glass share regional aspirations with heavily regulated cities in Southeast Asia and the Middle East, like Singapore, Dubai, and Shanghai (chapter 2). Although this is not a comparative project, my contention is that we must converse with the imaginative geographies that served as aspirational blueprints for the work of urban planning and design in the subcontinent. Doing so offers generative insights into the network of exchanges and ideas that underline intended spatial designs and material choices.

At its core, then, *Projecting Desire* offers an interdisciplinary conversation between media studies and architecture. The vantage point it offers is from New Delhi. Delhi as a media city, and especially the city's uniquely traumatic relationship to gender, is understudied and overlooked in media and film studies. Film production centers like Bombay, Madras, Lahore, and Calcutta have understandably remained the privileged sites of scholarly inquiry (see Siddique 2022; Mukherjee 2020; Dass 2015; Bhaumik 2011; Chatterjee 2011; Mazumdar 2007; Hughes 2006). However, as the Indian capital, Delhi has been the laboratory for the country's many experiments with urban design, modernization, and globalization. Delhi is home to some of the country's famous colonial-era Art Deco cinemas like Regal, Rivoli, Delite, and Golcha. India's first modernist theater, Sheila Cinema, opened there in 1961. The first multiplex in South Asia, PVR Saket, was also built in the capital in 1997. The country's biggest and most successful multiplex chain, PVR Cinemas, operates out of Delhi. In the last two decades, Delhi has also emerged as a location, landscape, and character in popular Hindi cinema, which had always preferred explorations of its own city, Bombay. Delhi's celebrated post-independence cinema halls, its new multiplexes, and the multiplex films based in the capital are all significant characters in this book. I bring them together in a spatial journey to show how media, gender, and architecture are woven together in the creation of a global media city.

Delhi: Media City

The Indian capital in its modern form came to be in 1947, after the Partition of British India. Cataclysmic trauma and gendered violence thus undergird the city. Like other cities across Latin America, Africa, and Asia, Delhi is also a "postcolonial media city"—that is, a city where media production and consumption have grown exponentially since the 1970s, often in ways outside the purview of state or corporate control (Sundaram 2010b).[3] After independence, the new Indian nation was able to retain not only the name of the empire but also its capital, which was already populated with monumental buildings that provided instant national dignity and authority (Dasgupta 2014). A new technocratic modernism was envisaged for the city based on science and planning (Sundaram 2010b). A "New" Delhi was to be built again. This time, urban planners from the United States helped create a masterplan. Ravi Sundaram writes about the planners' preference for decentralization as the primary toolkit for solving problems of urban density (19–20). Yet the new city was also immediately overrun by thousands of refugees fleeing the horrors of Partition. Delhi became a post-Partition refugee city, and this unresolvable shock profoundly shaped the peculiar physiognomies of the capital: fear, anxiety, a visceral desire for accumulation, and a sense of constantly living in the aftermath of immense loss.

Delhi's media and architectural cultures cannot be studied without looking at its excessively fraught relationship to gender. This too has its historic origins in the mass-scale sexual violence that ensued in the capital during and after Partition. In the summer of 1947 alone, twelve million people were displaced; over a million lost their lives; and more than 75,000 women were abducted, assaulted, and raped (Butalia 1998; Menon and Bhasin 1998). Violence against women was not perpetrated solely by opposing religious communities. Several women were poisoned or immolated by members of their kin to prevent their imminent sexual "defiling." The women who had survived these traumas were to their families—especially the male members—constant reminders of masculine failure. Hyper-aggressive masculinity, acute anxiety and panic, frequent accidents, and deaths continue to fracture the affective

psychogeography of the capital. Delhi, as a difficult and anxious space—especially in the aftermath of the infamous gang rape and murder of Jyoti Singh in December 2012[4]—has also emerged as a significant narrative location in the multiplex film and subsequently on India's streaming platforms, with several crime shows based in the capital, including *Paatal Lok* (Netherworld, Amazon Prime Video, 2020), *Delhi Crime* (Netflix, 2019), and *Indian Predator: The Butcher of Delhi* (Netflix, 2022) (more in chapter 3).

Because of Delhi's especially shattered relationship to gender and public safety, it offers a vantage point that is distinct from those of other major Indian cities. Take for instance Bombay. In popular and anecdotal narratives, on social media and elsewhere, Bombay is often touted as a relatively safe place for women. Women's ability to travel alone late at night and to stroll along the beaches, the famed ladies' compartment in the local trains, and the sheer number of women in the city's workforce all give Bombay a more democratic gendered character. Indeed, my navigation of the two cities is starkly different. In Bombay, I travel vast distances in cabs, autorickshaws, and local trains, alone and without an eye on the clock. I walk back from friends' houses late at night. These quotidian acts are not so effortless in Delhi. My navigation of Delhi is inseparable from a strong vigilance about my surroundings. In 2004, the first year I lived in Delhi, as a college student, there were less than five multiplexes in the city. The Delhi Metro had just opened with two routes. By 2023, most of the city's single-screen cinemas have shuttered or had been converted into multiplexes. The vastly expanded metro has women-only compartments, female staff, CCTV cameras, and "Quick Reaction Teams." Yet these changes in the infrastructural fabric of the city have not alleviated concerns about public safety and especially safety for women. Jyoti Singh's gang rape and murder was a stark reminder of the cosmetic nature of this infrastructure: a woman can watch a film with a male companion in a plush multiplex, but she may not return home safely. Delhi's "multiplex market" therefore cannot inhabit any space or watch films about the capital in the capital outside of these discourses. This shapes both urban design and the nature of media consumption. *Projecting Desire* offers insights into various significant and overlooked moments and events in the evolution of Delhi's media history. Delhi is an ancient city with a proclivity for violent and often

sudden displacements of one vision of urban life and modernity with another. Each new layer of planning and design sits atop coercive efforts toward a collective "forgetting" of the past. Yet what lies beneath belies repression, and continues to fracture and haunt the present.

* * *

Besides being a fearful city for women, Delhi's environment is synonymous with another material failure: the air in the city is regularly unbreathable. The air quality index frequently veers into severe, with the city's residents reporting serious health problems from air pollution. Clean air is a highly prized commodity in the capital. The rich retreat into their homes with air purifiers, and air-conditioned malls and multiplexes morph into mirage-like sites that offer a few hours of respite from the dense smog for students on a budget and others who cannot afford private clean air. The pandemic undid any illusions of breathing in silos. Delhi was the worst-affected city in the two horrific waves of COVID-19 that swept India in 2020 and 2021. In chapter 4, I discuss how various industrial agents positioned the pandemic using the metaphor of the "interval": an interruption in the film narrative that is structurally and formally unique to Indian cinema. And yet, the pandemic and its collision with the advent and rapid uptake of streaming video in a media market as large as India is more than just an interruption. It marks a rupture in the very idea of collective spectatorship. COVID-19 makes just about anybody, irrespective of their caste, gender, and class, vulnerable to invisible contagion. The present surfeit of streaming television and the easy availability of every film on a digital platform (often within a month of release) further alienates the spectator from the theater, despite the historic pleasures of the big screen.

Projecting Desire therefore begins a conversation around two central questions that will no doubt animate future work on the topic: what does a look "back" at the multiplex from our digitally determined, video-on-demand present tell us about the movements of media through space in the last three decades? and how might risk, as a category that belies established modes of control and mitigation, alter the spatiotemporal formation that we have come to understand as the multiplex? To be clear, I use the pandemic and the arrival of streaming video primarily as a temporal bracket for the Indian multiplex story, which begins in the

1990s. Because these developments are recent and are currently unfolding in real time, it remains too early to determine how they may take shape. By analyzing the transformation of media cultures through the entrenchment of the Hindu Right, the arrival of streaming video, and ideas about social risk and leisure after the pandemic, this book sketches an updated account of the contemporary moviegoing industry, which has undergone far-reaching changes just in the last decade.

Architecture as Media Industry

Much like media texts, built environments often defy the grand narratives that may have propelled their designs and origins. As architectural theorist Stan Allen writes (2009), architecture "will always be marked by the constructive/creative criteria of practice." That is, "material practices trust in the intelligence of architecture's audience, understanding that architecture has many publics, and that the significant work of architecture is one that allows continual revision and rereading, teasing out new meanings as the context changes" (xvii). To the media theorist, this might sound intriguingly close to home. Both media technologies and texts remain open to practices and meanings that differ significantly from their original contexts and intended uses (see also Spigel 2022; Larkin 2008). What can media studies and architecture gain from each other? Architecture as a discipline is grappling with the swift changes wrought by film, media, and intelligent design, with the term "contemporary" and its relationship to twentieth-century modernism emerging as a hotly debated concept in the field (see Colomina 1996, 2007; Chattopadhyay and White 2020). Media studies too is leaning into spatial, material, and other "offscreen" interpretations of media consumption, spectatorship, and reception that surpass traditional locations of the screen and its related cultures (Spigel 2022; Benson-Allott 2021; Zhou 2021; Neves 2020; Sundaram 2010b; Gray 2010; McCarthy 2001). In his work on China, for instance, Joshua Neves (2020) discusses the omnipresence of the state-owned City TV across a mélange of places ranging from bus stops to elevators. He positions this as a form of non-domestic television, calling it "unhomely television" to describe "a mode of economic organization, everyday living, and televisual address" (346). An important aspect of China's urban TV systems is the way they display

images of the city within the city, on sidewalks, public transport, and other architectural and infrastructural forms (346). Moving away from the overarching concept of "televisuality," Neves (2014) suggests that this "city-within-the-city structure shores up new forms of *paravisuality*, where what is pictured onscreen is not distant (tele-) but near" (173). This reframing necessitates a study of the networks and the agents that exist between text and environment.

This book is animated by similar questions: who are the figures that build, fund, manage, and maintain built environments for media consumption? Which gendered publics does this architecture address? How are they in dialogue with traditional media industry players? What new forms of *paravisuality* does this extended ambit engender? Spectatorship, in other words, is enmeshed in other acts of spectation: malls, for example, are extensively advertised across billboards in the city and inside the mall itself, through images and advertisements on multiple screens, displaying their many pleasures and facilities. Commodities are no doubt an inextricable part of the sensorium, but what is being advertised is a certain sense of spatial arrival—the cinema theater is only a part of the story. As I discuss in chapter 3, Delhi's residents come to its malls and multiplexes to watch films about their city (framed within the city). Indeed, is it thus surprising that a cluster of dark and ironic films about Delhi in the throes of a severe spatial, moral, and emotional crisis emerged alongside—and for—the multiplex public in the last two decades?

Despite these convergences and shared epistemologies, *architecture* and *design* have yet to emerge as significant keywords in media studies. Much of the existing work in this vein has looked at media and space with particular attention to technological proliferations (Couldry and McCarthy 2004; McQuire 2008; Sundaram 2010b; Berry, Kim, and Spigel 2010). These interventions have been generative in understanding media convergence, the role of digital technologies, satellite television, dense communication networks, and the entanglements between media and technologized urban life that led to new meanings of the private and public. Scott McQuire (2008) argues, "the contemporary city is a *media-architecture complex* resulting from the proliferation of spatialized media platforms and the production of hybrid spatial ensembles" (vii).[5] To recall, Sundaram and Neves have rightly advocated for extending the

category of the media city to cities of the Global South like Delhi and Beijing, offering the more expansive "media urbanism," a term that signals "the formal and informal technologization of the urban, including its new and contested role in everyday life, our dreams and desires, and techniques of governance" (Neves 2020, 315). *Projecting Desire* is aligned with such conceptual turns in media studies but does something different: rather than offer a historical account of how media technologies have altered the production and experience of urban space at large, I demonstrate how gender is the key conceptual frame that determines the contemporary relations between popular culture, public leisure, and built environments in the Global South. I also focus on how such a lens can generate new understandings of a traditional site of inquiry: film exhibition.

Exhibition is an understudied and overlooked site in Indian film and media studies. Much of the scholarly attention has focused on the social and political significance of the film text and its representational politics (Gopal 2011; Mazumdar 2007; Dwyer 2006; Virdi 2003; Gopalan 2002; Prasad 1998; Thomas 1985). Recent studies on contemporary production cultures and the making and many meanings of the "global" in an entertainment industry like Bollywood (Govil 2015; Punathambekar 2013; Ganti 2012) have been key to filling the lacunae in the economic, social, and cultural networks of Bombay film in and outside the subcontinent. The few accounts of film exhibition so far have studied the politics of participatory audiences and "crowds" in cinema halls.[6] Scholars have also worked on the arrival of cinema in colonial India and its encounters with public and urban culture at large (Srinivas 2000; Hughes 2003; Bhaumik 2011; Dass 2015). Stephen Hughes (2003) has called for the urgent need to reconsider Indian film studies through sites of exhibition. Along with scholars like Lotte Hoek (2013) and Ravi Vasudevan (2003), Hughes argues that the film text in South Asia is often altered through the conditions of its exhibition. Locating cinema within its "living, dynamic, and reciprocal relationships" (Hughes 2003) with audiences has the potential to disrupt meta-narratives of film history in the subcontinent. All these studies have provided important insights into class, gender, caste, and other local sociocultural relations at play in the cinema.

While this book also centers the site of exhibition, it is not an ethnographic account of active audiences. Instead, *Projecting Desire* brings to

light the industrial trajectory of film exhibition in India as it emerged alongside a sociocultural history of built environments and the material choices that make public space. Taking multiple screen cultures as essentially intersecting, it underlines the role of television as central to the configurations of private and public media consumption and gendered spectatorship in India. Through this intermedial approach, this book opens the connotations of exhibition beyond the cinema hall to various other adjacent industries and with deep cultural politics and histories of their own—like architecture and material environments—that remain understudied in media and cultural studies.

In *A Short Introduction to Media Industry Studies*, Daniel Hebert, Amanda Lotz, and Aswin Punathambekar (2021, 27) call for broadening the boundaries of media industry studies beyond a focus on audiovisual industries to encompass broader cultural forms and convergences across industries that may have been studied separately thus far. They rightly assert, "*how* media texts are made, promoted, and made available shapes what is made, and that the circulation of bits of culture further infuses them with meaning and significance that is then negotiated through practices of consumption" (28). At the same time, in *The Stuff of Spectatorship*, Caetlin Benson-Allott (2021) argues that media industry studies tend to marginalize non-human elements, focusing more on workers and organizations. She in turn calls for "an analysis of the material culture of industries that deliver and thus mediate content for media consumers" (9). Consumption, after all, is the key to media circulation. *Projecting Desire* continues in the vein of both recent interventions: it broadens the traditional boundaries of media industry studies by locating the audiovisual in the architectural, and by looking at urban design and material choices as cultural forms. By bringing mall builders and planners, architecture firms, and overlooked agents who work for the multiplex—for instance, the food and beverage teams—to the front, my book expands the range of *which workers* and *which organizations* count as constituting a media industry. Further, I map the rise of a range of material and aesthetic regimes—and the proliferation of certain consumer objects at certain historical junctures—as a part of larger ideological legacies actively championed by the Indian state.

Benson-Allott also points out that new cinema historians have considered theater design and architecture as key aspects of film spectatorship.

This subfield focuses on specific case studies of cinema audiences, exhibition cultures, and reception. There is also an increasing focus on the objects that populate film theaters. Through such analyses, as Szczepaniak-Gillece and Groenig write (2016, 140), "we can extrapolate what exhibitors, theater patrons, and film producers thought spectatorship should, could, or might be" (quoted in Benson-Allott 2021, 12). However, most new cinema history scholarship focuses on Western cinema histories and, as Benson-Allott (2021) observes, tends to overlook the ideological paradigms of exhibition. It is also entangled in medium specificity—focusing on film alone—and has not yet been able to accommodate the "messiness of media convergence" (13). Film cannot be isolated from the larger media convergence it exists in, as "cinema is a material practice enmeshed in a network of other legal, economic, cultural, and discursive institutions as well as media ecologies that include television, radio, and digital media" (13). New cinema history's focus on film as a sociocultural institution (as opposed to a singular art form) and its engagement with local social relations is indeed a productive lens. Although my book speaks to this subfield and broadens its purview by theorizing from the Global South, I primarily follow scholars Benson-Allott (2021) and Zhou (2021) in expanding the focal point of spectatorship beyond the cinema theater.

Such an approach helps us reconsider what film exhibition means, a commitment I share with Chenshu Zhou's (2021) *Cinema Off Screen: Moviegoing in Socialist China*, in which she centers China as a site from which theories of film exhibition can be developed. Studying the points of contact between film and audiences in socialist China across several "interfaces" like exhibition environments (open air), or the bodies of viewers and projectionists, spectatorial memories, and nostalgia, Zhou writes, "film exhibition is best seen as a system in which the film shown on screen is only one among many interfaces" (5). Feminist film scholars like Vivian Sobchack (1992), Laura Marks (2000), and Giuliana Bruno (2002) have developed theories of haptic and embodied spectatorship that consider the relationship between the spectatorial body and the architectonics of theatrical space. Bruno (2002) argues that architecture is the "maker of cinema," and that the haptic—the theory of contact—is crucial to the networks between space, bodies, and architectures (6). Bruno writes that film and architecture form a tactile bond and an emphasis on the haptic shapes our sense of space and motility, "ultimately,

mapping our ways of being in touch with the environment." Film must always be "housed," and it is through the public architecture of the theater that the "motion picture is a social, architectural event" (6). Prefiguring new cinema history, Bruno tellingly states,

> One can never see the same film twice. The reception is changed by the type of physical inhabitation the site yearns for, craves, projects, and fabricates, both inside and outside the theater. Thus, we can be utterly different spectators when we watch the same film in different places, for different models of spectatorship are figured in the architecture of the theater itself. (6)

Projecting Desire is indebted to this shift in cinema studies from the optic to the haptic as a feminist strategy of reading space, in which the spectator becomes a voyager moving through an emotive terrain. Theories of embodied spectatorship are particularly suited to the South Asian context, where active and participatory audience encounters with the screen and the cinema hall have long ruled exhibition circuits. Yet while this book draws on theories of tactile and embodied spectatorship, it is centrally concerned with site-specific historic, social, affective, and economic lives of media consumption. It argues that the history of India's media consumption—and its film exhibition sites—must be traced along and integrated with histories of postcolonial design and architecture.

Anne Friedberg's (1993) work on the history of the shopping mall as an architectural and social space in America is also relevant here. She traces the origins of the shopping mall to the mid-nineteenth-century arcade and the multi-storied department store, structures that were meant to maximize the commercial effectiveness of the public interior. Friedberg also argues for aligning activities like shopping and tourism with television and film spectatorship in modern urban spaces. Reading shopping as a powerful metaphor for spectatorship, she shows that the beginnings of consumption and the origins of the department store, packaged tourism, and proto-cinematic entertainment gave birth to the *flâneuse*. This urban female subject—the counterpart to the male subject in Western modernity—became the target for a new consumer address. Friedberg's observations remain eminently insightful in global understandings of the gendered cultural politics of the shopping mall.

Global parallels can be drawn among malls and multiplexes as spaces that offer class-based safety centered on controlled interiors; however, the history of the Indian mall and multiplex cannot be traced to the architectural lives of European arcades or American department stores. These theaters are also fundamentally different from contemporary American associations with the suburban "sticky multiplex."[7] Finally, understandings of the *flâneuse* in the Western metropolis and her encounters with the realm of Euro-American cinematic spaces (and film genres) are far removed from the national and regional contexts that I discuss here. As Zhou (2021) puts it, "relying heavily on thick, first-person descriptions, phenomenological studies produced by Western film scholars have only illuminated experiences of Western subjects watching (mostly) Western films in settings familiar to mainstream Western audiences" (7). This book thus underlines that the architectural, spatial, and socio-political symbolisms of the shopping mall and the multiplex in South Asia—their origins, geographies, and cultural lives—are quite different from their Western trajectories. Specifically, my analysis is tied to the sociocultural histories of gender and space in South Asia. Moreover, as I discuss in the next section, studies of film exhibition in India have much to gain from theories of media regionalization.

Multiplex Studies: Toward a Regional Paradigm

A small but significant body of work can be designated as *global multiplex studies*. Much of this work has discussed the spatial, sensory, and embodied qualities of multiplexes-at-large.[8] The only book-length work on the Indian multiplex thus far is Adrian Athique and Douglas Hill's *The Multiplex in India: A Cultural Economy of Urban Leisure* (2010). Athique and Hill provide a broad contextual understanding of the political economy and leisure infrastructures of the multiplex. They also discuss the multiplex's key distinguishing features in terms of a consumer economy and offer short sketches of a variety of multiplexes across India. Two recent books in media industry studies have also briefly addressed the Indian multiplex through different but equally productive frames. Nitin Govil's *Orienting Hollywood: A Century of Film Culture Between Los Angeles and Bombay* (2015) devotes a chapter to the multiplex and studies it through the long history of exchanges between

Bombay and Los Angeles. Using the theoretical lens of the "copy" as a dynamic, transformative, and emergent phenomena that cannot be encapsulated by imitation alone (41), Govil locates the arrival of the multiplex, with its overt nods to American patterns of consumption, within a much larger history of failed Hollywood interests in Indian film exhibition.[9] Amit Rai's *Untimely Bollywood: Globalization and India's New Media Assemblage* (2009) presents the multiplex as an apt example of what he calls Bollywood's larger media assemblages, which are unstable, heterogeneous, and ridden with the potentialities of the non-linear.[10] The multiplex, as Rai suggests, is not only a new space of exhibition, but it reframes the relations between bodies, desires, pleasures, and affects through the multiplication of tactility. Technologies of sight, sound, and taste, as well as their promotion of endless "choice" through population segmentation, all converge at the multiplex.

Projecting Desire joins this body of scholarship but offers several new directions. I introduce gender and region as two significant vectors of meaning-making. By foregrounding the nexus between gender and architecture as the structural basis of India's new entertainment cultures, I tackle a vital and overlooked dimension of the industrial and cultural shift toward the multiplex. This book is not about the multiplex as much as it is about understanding the multiplex as a formation that generates insights into a broader study of the cultural shifts across a range of media industries, film production and narrative style, built environments, urban design, and the politics of gender and space.

Because multiplex technologies aspire to a "global" experience of elite stratified leisure, a study of localization alone yields limited perspectives. In other words, although the materials, objects, and surfaces that populate exhibition spaces might appear universal, their affective meanings are tied to long location-specific cultural histories. Where do these cultural histories originate from? Brian Larkin (1998) reminds us that while exhibition technologies may be transcultural, their impact on a specific location must be approached through an understanding of how theaters evolved within a nexus of prevalent social relations. The production of specific cinematic environments depends on "a negotiation between built space, the apparatus itself, and local social relations" (48). Expanding these concerns to global media studies as a field, Bhaskar Sarkar (2022) argues that all attempts at standardizing media businesses always

collide against "local industrial modes and aesthetic regimes, the global begins to take shape from this encounter, the various forces changing in the process." Simply put, my aim here is to move away from looking at how Western exhibition formats and their architectural styles were localized in the Global South—or, in Sarkar's words, take up the challenge of "*globalizing* the global." Hence, understanding why PVR Cinemas—a company run by two brothers whose family previously owned a single screen in Delhi—became the country's largest and most profitable exhibition enterprise involves delving into the long arc of India's screen and moviegoing cultures. What emerges from this arc is the powerful and understudied concept of the *regional*. At various junctions through this book, I demonstrate that spaces for media consumption have always offered regional citations: spatial, material, and infrastructural imaginations guided by Soviet Russia and Eastern Europe, Singapore, Manila, Jakarta, Dubai, Shanghai, and Seoul exist in Delhi.

I borrow the definition of regionalization from platform studies, a subfield that is seeing robust scholarly engagement with scalar media.[11] According to JungBong Choi (2010), regionalization is "a tendency to construct geocultural spheres of proximity and intimacy beyond the nation-state's boundary with identifiable logics and patterns" (116). Marc Steinberg and Jinying Li (2017) further posit that regionalization emphasizes geography, "relying on the contingency and immediacy of space" (173). The regional therefore encompasses both subnational contexts (North India as a region) and the grouping of multiple countries into geocultural regions (South Asia, Asia) (Steinberg and Li 2017, 173). Much like platforms (a term that originates from architecture), built environments encompass political, industrial, and aspirational proximities. A regional paradigm helps us move beyond some of media globalization's heavy emphasis on virtuality and deterritorialization (Steinberg and Li 2017). It "foregrounds the territorialized inquiry of the 'where' of media" (175). What insights can we glean from a regional paradigm of inquiry into the origins of the mall-multiplex as a gendered media environment in India?

Geocultural traffic produces material affinities at specific historical junctures. A mall in Lucknow, the capital of India's most populous state, Uttar Pradesh, is called Singapore Mall. The planner-architect of Select Citywalk, New Delhi (one of my case studies), was trained in Jakarta and

heavily inspired by mall cultures in Indonesia and the Philippines. As I write this introduction, Select Citywalk is hosting its third Korea Fair in New Delhi in collaboration with Kotra, a Korean trade-investment promotion company. Together, they are selling several products associated with the Korean Wave: skincare, K-pop merchandise, stationery, and screenings of K-dramas with Korean snacks. Shah Rukh Khan is the brand ambassador of Dubai (as space). In several "My Dubai" ads, Khan glides through the city's markets, waterfronts, malls, and restaurants, surprising and delighting consumers (Visit Dubai 2022). North/South binaries and an overt emphasis on localizing the "global"—shorthand for the Western—often obscure these important regional textures of cultural globalization (see also Neves and Sarkar 2017). As popular and industrial discourse moves to streaming platforms as the "next" of the Indian multiplex, understanding media regions become elemental. Tracing a prehistory of streaming video in the subcontinent thus requires territorializing exhibition infrastructures within the regional lives of built environments.

Architecture, thus, has emerged as a vital media industry in the contemporary era of media convergence. Plotting media-architecture networks against specific moments in global, local, and regional media histories allows for a more expansive understanding of the shapes and turns of public culture. In other words, the connotations of architecture and materiality depend on the sociohistorical juncture at which they appear in each environment. Understanding architecture as a vital media industry shows that the nation remains an enduring category despite the heightened presence of rapid and transmutable media technologies and formats. Film exhibition now encases a multitude of other industries that have traditionally remained outside the purview of media studies. This has led to an expansion and a new density in the material environments of media spectatorship. The spectator can no longer be targeted by the pleasures of cinema alone. She inhabits a densely intermedial world. Architecture is the skin that provides the necessary cohesion for all these industries to blend and become legible to the spectator. Architecture shapes several other consumer and leisure industries—including, in this context, film production and industry vernacular—that attune themselves to its spatial vocabulary.

Space, Place, and the Indian Middle Class

Much has been written about the Indian middle class and its relationship to globalization, gender, and consumption across media and cultural studies, anthropology, sociology, urban studies, and history.[12] Here, I follow anthropologist Mark Liechty's (2003) theorization of the middle class as a *cultural process or practice*. Writing about youth culture, media consumption, and the middle class in Nepal in the 1990s, Liechty argues the middle class is not a given social category. Drawing on Weber, he writes:

> The middle class is a constantly renegotiated cultural space—a space of ideas, values, goods, practices, and embodied behaviors—in which terms of inclusion and exclusion are endlessly tested, negotiated, and affirmed. From this point of view, it is the process, not the product, that constitutes class. (16)

Because they are neither workers nor members of the capitalist elite, the middle class and their paramount relationship to things and goods (as the primary consumers) remains unstable, ambiguous, and anxious. Middle-class lives cannot be separated from high materialism; "middle class culture is uniquely embedded in the social trajectories of things" (Liechty 2003, 31). However, the terrains of desire and meaning-making that are tied to things shift enormously across time and space, making cultural production or the performance of everyday life essentially elastic. Liechty asserts, "what class practice does—what makes class a reality—is its production of cultural space" (38). Therefore, although new built environments have rightly been read as spaces of aspiration,[13] in a city like Delhi, the production of cultural space and the role that malls and multiplexes play in imbricating people's identities with consumer goods varies. My case studies are primarily located in south and central Delhi, which are traditionally more upscale than other places in the city. However, malls and multiplexes have mushroomed all over the capital. While they may be hypothetically united, it is everyday practice that makes space. In other words, narratives and articulations of class, caste, gender, and religion in the posher malls of South Delhi are by no means indicative of the whole picture. A multiplex in the eastern or western

parts of the city, like Naraina, Rohini, Janak Place, or Vikaspuri, will offer other accounts and will be entrenched in other urban histories. The multiplex as a formation, then, does not settle into easy categorizations of simply inclusion and exclusion as it intersects with class-as-process.

Television is primary to understanding the middle class as *people who consume*. Like several other parts of the world,[14] the Indian experience of globalization was felt strongly through the ubiquitous presence of television and advertising. This, in turn, played a central role in shaping the politics of neoliberalism and its related desires and anxieties.[15] The ubiquity of television led to an intimate entanglement of the private and the public (Kumar and Punathambekar 2014). Purnima Mankekar (2015) demonstrates that it was in the televisual home that people began to form new emotional convergences with commodities in globalized India. She has used the term "commodity affect" to describe these emotional convergences between people and new commodities—that is, the "relay of intensities between subjects and commodities" (116). Through the production of commodity affect, television was able to create new sensory regimes: "domestic spaces became affectively charged spaces of consumption" (116). The nexus between the domestic home and affective consumption was centered on the middle-class woman.[16] The mall and the multiplex not only provided the material environments for these emotional convergences between people and consumer objects that began with television-at-home; they also produced new temporal and affective entanglements with sensory stimuli like surround sound, air conditioning, cushioned theater seats, polished surfaces, and bright saturated colors.

Bollywood films from the mid-1990s joined the frenzy of commodity-spectacle.[17] Narratives began to focus exclusively on the consumerist lifestyles of affluent Indians (Mankekar 2015; Ganti 2012; Mazumdar 2007; Mehta 2005). The first crop of successful Bollywood films to be supported and promoted by the Indian state (1994–2000) were "clean family films," shorthand for conservative patriarchal narratives populated by rich upper-class characters saluting the new neoliberal Hindu nation. As many scholars have pointed out (Rajadhyaksha 2003; Mishra 2009; Mehta 2011), the "clean" depiction of the Indian family was fundamental to what the term Bollywood signified.[18] In chapter 3, I look at how the multiplex film counters the dominant tropes of the Bollywood

film, especially by fracturing the family as a site of national recuperation. The "multi" has thus emerged as a socio-symbolic double space. It offers physical expression for a new world of gentrified desires, while simultaneously engendering new codes of cinematic realism that critique those very worlds.

Projecting Desire extends the key concerns of these bodies of scholarship—on gender, class, globalization, and consumption—into the domains of public architecture and material environments. How do the cultural politics of neoliberalism, Hindutva, and aspirations to look and feel like a "global city" find spatial coherence? Using film exhibition and its gendered materiality as entry points, I look at how many concurrent and concentric desires and anxieties—national, regional, local, class- and caste-based, and gendered—are embedded in media architectures. Further, I expand arguments about gender, class, and taste as entangled sites to the new discursive category of the multiplex film (more below), which is distinct from both satellite television and the extravagance of Global Bollywood. The nexus between media and architecture is historical, but it is by no means stable. If we see the middle class as an inherently anxious cultural practice, then, media environments too must be examined as sites that contain within them tools to strategically accommodate the changing patterns of gendered consumption and emergent sociocultural identities.

Historicizing the Multiplex: The Case of PVR Cinemas

Before multiplexes spread across the country, a company in Delhi called PVR Cinemas, owned by brothers Ajay and Sanjeev Bijli, tried, tested, and perfected this new formation for leisure and entertainment.[19] PVR remains the largest and most successful multiplex chain in India. It is my primary organizational and industrial case study. In 1997, the Bijli brothers, who were only tangentially involved in the exhibition business in the decades before liberalization, became the entrepreneurs responsible for India's first multiplexes in the south Delhi neighborhoods of Saket (PVR Anupam) and Vasant Kunj (PVR Priya). Within a decade, PVR had managed to become the first film exhibitor in the country to secure private equity investment, expand to peri-urban and B-towns with the cheaper PVR Talkies, convert several old "heritage"

single screens to multiplexes, and expand to about a hundred screens (PVR Cinemas 2015). By 2015, PVR was India's largest exhibition chain, with 474 screens in 45 cities and 107 locations, and was among the top ten multiplex chains globally—30 to 35 percent of Hollywood box-office shares in India and 22 to 25 percent of Bollywood box-office shares come from PVR. The following decade (2008–2018) saw an exponential rise in their fortunes, with "7-Star" theaters like PVR Director's Cut and various kinds of digital cinemas like IMAX (Image Maximum) and ECX (Enhanced Cinema Experience). By 2018, the company was building theaters equipped with 4DX screens (which allow films to be augmented with effects like motion, wind, and scent) and moving toward the Superplex: fifteen-screen cinemas with virtual reality lounges, play areas, and babysitters for children, gourmet dining, and a host of other attractions. In March 2020, PVR had 900 screens in 69 cities and was selling close to 1.45 million tickets annually (Bijli 2021b). Although these numbers are a drop in the ocean for a country as populous as India, they indicate that this company's multiplex ecosystem now owns the largest part of the existing pie.

The history I produce in this book does not merely chronicle why these entrepreneurs had such meteoric success, but rather sheds light on the legislative terrain involving Delhi's real-estate and land-allocation practices, and the industrial structures of film exhibition. India's first multiplex, PVR Anupam, arrived in the middle-class neighborhood of Saket in New Delhi six years after the liberalization of its economy in 1991. It opened in a community center—the name given to a cluster of small shops (sometimes around a cinema)—in one of the city's several centrally planned neighborhoods. This community center had a rundown cinema called Anupam, opened in 1983 by the Ansals, who were then major real-estate players in the capital. By the mid-1980s, middle-class audiences had retreated from the cinema and were immersed in the pleasures of home video and satellite television (more in chapter 1). Piracy was rampant. Film exhibition at large was an industry in decline. In 1997, the Ansals leased their failing theater to the Bijlis, who revamped it under the name PVR Anupam. A researcher working for SARAI's collaborative project, Publics and Practices in the History of the Present,[20] wrote at the time, "According to newspaper reports the entertainment tax of Anupam PVR shot up from Rs. 30 lakhs to Rs. 4.5 crores after the

changeover. The area around the theatre has changed radically, with big brands mushrooming in the neighborhood. More PVR cineplexes came up in Vikaspuri and Naraina" (Ravikant, Vasudevan, and Sundaram 2003; henceforth *PPHP*).[21] Jai Arjun Singh, a journalist and film commentator who has lived in Saket since 1987, recounted the momentous changes in the life of the neighborhood after the arrival of the country's first multiplex in his blog *Madhuban Fine Dining and PVR Memories*. On November 25, 2005, he posted,

> In the mid-1990s, strange things began to happen in our colony. Rumors grew of a light from the east, of a man named Bijli who had tied up with an Australian company to set up India's first "multiplex" here. Rich relatives in other countries sent secret missives disclosing that multiplexes were cinema halls with *three or four screens* instead of one. We gaped in disbelief. Anupam shut down, then several months later we saw scaffolds and workers and large tarpaulins obscuring the building. In mid-1997 PVR Anupam opened, and I went to see the first film shown there, *Jerry Maguire*, nothing of which registered because I was too busy alternately leaning back in the plush sofa chairs and sinking my feet into the carpeted softness of the floor. Things would never be the same again in our modest little Saket, which had, only 30 or so years earlier, been forestland where men would go rabbit hunting.

After PVR Anupam awed Delhi's middle classes, the Saket community center came to be known as the famed PVR Complex. It changed dramatically and rapidly. Fast-food chains like Pizza Hut, Barista, Café Coffee Day, and Subway knocked out the five or six scattered shops that had once populated it. Singh (2005) notes that in fifteen years, the Saket community center transformed "bit by bit, layer by layer, from a modest, bare-boned little colony center into a bustling hub of Delhi yuppie-dom." The Saket success story was to be emulated all over the country. The average ticket price (ATP) at a multiplex is 200 rupees (it can go up to 1000 rupees depending on the location and scale of multiplex), which is at minimum a 300 to 500 percent increase from ticket prices at the single screen.

Despite India's turn to post-liberalization consumer culture, PVR's initial years were marked by struggles to legitimize this new format

of film exhibition. They sought to relocate moviegoing within a larger spectrum of urban leisure, with shopping and dining as its vital parts. Gender became a handy tool for justifying why something as affordable as movie tickets were now 300 percent more expensive. In two early interviews, Ajay Bijli said, "there are times when anti social elements enter the cinema with low priced tickets and create problems for women" (*Indian Express*, March 20, 1998, quoted in *PPHP*) and "It is Utterly ridiculous... Cinema is not an essential commodity. It's like asking Pizza Hut to control the price of 20% of their pizzas. I'm running a theatre for a certain clientele. A cheaper cinema is doing it for another clientele. Why confuse the two?" (*Hindustan Times*, 11 January 2000, quoted in *PPHP*). Such rationalizations were needed because the multiplex was changing exhibition structures to such an extent that municipal and government agents, along with those associated with the existing Motion Pictures Association, feared that it would "kill cinemas in the city" (quoted in *PPHP*). This amalgamation of film exhibition with shopping transformed Delhi's administrative practices of leasing and allocating land for commercial enterprises and, in turn, its real-estate market. In 2000, the trade magazine *Theatre World* (quoted in *PPHP*) carried a story titled "The Future of Things to Come." Here, the author imagined the family of superstar Amitabh Bachchan at a multiplex, and wrote,

> this will be a superplex where Mr. Amitabh Bachchan would like to watch movies, Mr. Harivansh Rai Bachchan can have a stroll around the art cafe, Mr. Abhishek Bachchan can have a romantic evening. In one of the restaurants, Mrs. Jaya Bachchan can shop for herself and whatever she wants.... in whole this is the place where we have something for everyone in the family.

Whereas the three male members of this family are imagined surveying the movies, the arts, and romantic possibilities (presumably with an unnamed woman), Jaya Bachchan—a successful star and actor in her own right—is consigned to shopping. But without her, there is no vision of the family in the "future of things." These early accounts help us understand how a remediation of gender—and, by extension, selling a new spatial experience for the family—were fundamental to the

multiplex-led transformation of the city's real-estate fabric. Reflecting on twenty-five years of the Indian multiplex, Ajay Bijli told *Theatre World*,

> Liberalisation started in 1990's but till late 1990's nothing much had changed in the Indian film exhibition industry. Ticket prices were low, occupancy was below 20 per cent when B-grade films was the norm. Infrastructure was poor, zero governance and piracy was at its zenith which kept families away. Poor returns served as a disincentive for producers as exhibitors lost business. The multiplex culture was unheard of in India 25 years back. The real revolution that PVR brought about led to the huge betterment of every single link of the cinema production, distribution exhibition and ancillary chain. . . . PVR gave a platform to the common man where he can bring the entire family together. . . .
>
> Design is an integral part of this warm and welcoming ambience. . . . Our architectural intervention has a clean, emblematic and powerful sense of arrival. (*Theatre World* 2022, 13–15)

This marks a change from the company's early years, when they lobbied to raise ticket prices, marketed themselves to niche audiences, and stringently controlled the boundaries of the cinema hall. Although these primary ideas remain, the last three decades have also seen an immense heterogeneity in who constitutes "middle-class" and where class boundaries lie. The multiplex is no longer just Saket and Vasant Kunj—and Bijli's comments about the "common man" must thus be read in the context of the company's desires to accrue different socialites in different places. Now, PVR operates in many Tier-2 and Tier-3 cities and actively campaigns against being associated exclusively with elite cinemas.

Why was this "platform"—fusing architectural ambience with family—so attractive to the middle class? After all, they did not need much coaxing to shift their movie-watching habits from the 1,000-seater single-screen cinema to the 200-seater multiplex. It was because they had already imagined themselves as a class of consumers through cable and satellite television in the 1980s and 1990s. Bijli has talked about Delhi's importance as the litmus test for the early years of India's multiplex encounter (2021a):

> I started the first multiplex in 1997 because from 1994 to 1997 there were no malls, no shopping centers, so I had to pick up an existing cinema and

carve it out into a fourplex. Delhi was my market. I was very fortunate that in every cinema I opened people liked good sound, good seating, hygienic atmosphere, and I didn't realize that the appetite for people to watch movies was so massive. So, all I had to do was create a very good conduit between the filmgoers and filmmakers, the infrastructure had to be made world-class.

Other things I noticed, McDonald's was there, KFC was there, and people were graduating towards a very clean environment . . . an ecosystem was forming around it . . . so my timing was okay.

As Bijli's comments underscore, the mall-multiplex—fused in an unbroken signage of new technology, new architectures, and new infrastructures—was able to capitalize on several preexisting middle-class and upper-caste anxieties and effectively package and market them as national progress, innovation, and "world-class" infrastructure. Likewise, Bijli's "timing was okay," as the Indian audience had already been primed for privatized modes of spectatorship through a decade of immersive cable, home video, and satellite television. Television and advertising had remade the home as a key site for media consumption and generated varied taste cultures. They had changed people's relationship to their material environments. The multiplex thus powerfully initiated itself into the cultural production of the new middle class and, first and foremost, sought to expand the affective qualities of the televisual home: comfort, controlled air and food, sofas, enhanced on-screen color, choice, and new sonic and linguistic engagements.[22] Soon, the "multi" seeped into the production practices of a cinema culture long accustomed to the dynamics of single-screen cinema.

The Multiplex Film: Decoding a Vernacular

As the multiplex expanded its reach across the country, the new vernacular of the "multiplex film" emerged in the Bombay film industry. This vernacular further gained in circulation through the popular press and audiovisual film journalism. The multiplex film is for the multiplex audience, and signals a taste culture rooted in the spatial imaginations of the mall-multiplex, as distinguished from the multiplex-other, the "single-screen audience." Certainly, this evokes a longer history of elitist

associations between class and taste in Hindi cinema (see also Ganti 2012). However, as discussed above, the "multiplex audience" is not a self-evident category. Yet there are now multiplex heroes, multiplex directors, multiplex stories, and, as noted in the example at the beginning of this introduction, multiplex modes of performance circulating as shared popular wisdom among filmmakers, filmgoers, fans, and critics. They congeal around the materiality of the multiplex: actors don't need to project their voices as much because Dolby Atmos delivers sharp surround sound, and precise aspect ratios and enhanced projection allow for low-key lighting, darker frames, and sharper contrasts. Song-and-dance sequences can be eliminated because the temporal order at the multiplex is not beholden to three-hour slots four times a day (see also Rai 2009). This materiality offers new opportunities for film personnel and their industrial practices, and guides their financial, aesthetic, and formal decision-making. I argue that when contextualized within the political, economic, and techno-architectural developments of the last three decades, the multiplex film can be understood not so much as a genre but as a vernacular. It is a useful point of entry that helps producers, directors, distributors, and exhibitors give coherence to narrative, ideological, and formal experiments with dominant tropes of popular cinema. In other words, the multiplex film is an *imprecise category* that simultaneously accommodates the proliferation and contraction of genres, while keeping its edges amorphous. To be clear, the multiplex film is part of the mainstream. Successful "multiplex directors"—directors who have found commercial and critical success with their atypical films catering to niche audiences, including Zoya Akhtar, Anurag Kashyap, Vikramaditya Motwane, Shoojit Sircar, Vishal Bharadwaj, and Dibakar Banerjee, among others—belong to the mainstream industry and work across various capacities as producers, screen and dialogue writers, and even music composers. They are extremely film literate, thoroughly entrenched in industrial networks old and new, some of them belong to Bollywood's long kinship linkages, and they work with major stars.

How, then, might we trace this imprecise category of multiplex film in mainstream cinema? Here I identify three prominent ways that span a diverse array of films. They do not share generic unity but can be accommodated under the discursive vernacular of the multiplex film. The

first is undoing the primary representative nucleus of the nation-on-screen, the Indian family. The family begat Hindi cinema's most enduring archetypes: the long-suffering mother, the punitive father, the dutiful son, the loyal brother, the infantile girlfriend turned ideal wife, and the religious iconography of domestic architecture. The multiplex film moves from the mythic quality of epics like the *Ramayana* to the psychological realism of the novel, thus undoing this persistent narrative trope. It also moves the family back to contemporary India from their hermetic Bollywood worlds in London, New York, and Sydney. In doing so, it immediately unsettles the category of the ideal woman (mother and wife) and man (father and son). In the multiplex film, the family is often a site of oppression and violence (*Dev.D*, *Oye Lucky! Lucky Oye!*, *Gangs of Wasseypur*, *Titli*, *Ugly*, *Gully Boy*) or is insignificant or missing (*Pink*, *NH10*). In other instances, it is understated, casually in and out of the narrative, or largely "dysfunctional." Sons now confront fathers about double standards, hypocrisy, and extramarital affairs (*Kapoor and Sons*, *Dil Dhadakne Do*). In a sharp observation, film critic Jai Arjun Singh (2016) discusses a scene from *Zindagi Na Milegi Dobara* (Zoya Akhtar, 2011). One of the characters, Imran, has orchestrated the trip to find his estranged biological father, who abandoned his mother before he was born. His friends are unaware of this. When father and son finally encounter each other, they demonstrate restraint, subtlety, and even humor. This is radical in a universe where the trope of the *najaayaz aulaad* (illegitimate child) has long remained the ultimate mark of shame and led to many a climactic scene saturated with crescendos. As Singh writes,

> the scene is deliberately hesitant and underplayed and derives much of its impact from little touches such as the father carefully rolling a joint while speaking to the son he has never seen before. There is no apologizing, no dialogue-*baazi*, and there isn't even a background score—if you were hoping for heightened emotions and epiphanies, the wind is taken out of your sails.

Another multiplex film, *Titli* (Butterfly, Kanu Behl, 2014), deftly undoes the family trope and, in so doing, signals how production ecologies are reshaping themselves. *Titli* was jointly produced by Yash Raj Films, an iconic production house associated with major mainstream

hits for over forty years, and Dibakar Banerjee Productions, a relatively new player that mostly helms small-budget, unconventional films. *Titli* is a film about the nihilistic interior lives of three working-class brothers who make their living through violent carjacking and murders. The youngest brother, the titular character Titli, played by newcomer Shashank Arora, is trying desperately to escape his oppressive life and attempts to buy a parking plot in an upcoming suburban shopping mall. The film unravels in a claustrophobic, labyrinthine house, perpetually lit by a jarring tube light, from which neither the characters nor the audience have any escape. The domestic is steeped in several cycles of emotional, physical, and sexual violence perpetrated by the family on each other. The narrative is partly influenced by the autobiographical details of director Kanu Behl's troubled and violent upbringing in a lower-middle-class neighborhood in East Delhi, where the film is set. This first-time director cast his father as the family's patriarch. *Titli* was the official Indian selection for the prestigious Un Certain Regard at Cannes. The film was only released in multiplexes.

The multiplex film's second significant deviation is gender. The multiplex hero is often a character who has not achieved anything heroic, is frequently lost and confused, and is rarely fighting for anything bigger than his infantile issues.[23] In a spate of recent films, successful and critically acclaimed "multiplex actor" Ayushmann Khurrana has essayed male heroes who are timid and underconfident (*Bareilly ki Barfi*, 2017; *Meri Pyaari Bindu*, 2017), or dealing with several decisively unheroic ailments for the upper-caste Hindu man: erectile dysfunction (*Shubh Mangal Saavdhan*, 2017) and premature balding (*Bala*, 2019). In *Dream Girl*, he plays a cross-gender voice actor, and in *Shubh Mangal Zyada Saavdhan* (2020), Khurrana became the first "hero" to portray a gay man. The multiplex hero's masculinity thus is often fragile and fractured, and his preoccupations are trifling compared to the trials of his predecessor and occasional contemporary, the heroic Hindi film hero, who fights and self-destructs for big love, honor, family, and patriarchal justice. Extending his multiplex oeuvre to streaming, in a recent Netflix film, *Chandigarh Kare Aashiqui* (Chandigarh Falls in Love, Abhishek Kapoor, 2021), Khurrana plays a bodybuilder (the film's title alludes to Chandigarh as a spatial embodiment of Punjabi hypermasculinity) who unknowingly falls in love with a transwoman. Despite his initial shock

and anger, he chooses to educate himself on matters of gender and sexuality and stay with her.

The multiplex heroine can be read as a self-conscious attempt to release the female protagonist from one of her four stereotypical avatars: the mother, the sexually unaware juvenile girl, the courtesan, and the vamp.[24] The multiplex film has largely done away with these stock characters and, although the Bollywoodesque song-and-dance sequence endures, it is sometimes as a self-referential parody. These changes are also moored to recent industrial shifts in Bombay. Several female actors have questioned the industry's inherent sexism and inequality, opposed wage gaps, refused roles that negate their value on screen, and worked beyond the supposed career death knell of marriage. The discourses surrounding the contemporary female star as an economic and sociocultural force to be reckoned with have significantly contributed to changes in representation on screen.[25] Several female stars own production companies, and established production houses now make films with no significant male lead—a move unthinkable in the pre-multiplex era.[26] Yet despite these developments, we should pause before declaring the multiplex film a complete or entirely new feminist triumph over older stereotypes.[27] Although it can offer a plethora of new possibilities for the female actor, it also crystallizes new stereotypes.[28] Prominent among these is the figure of the sexually assertive, expletive-spewing, feisty small-town girl who smokes and drinks with abandon as a direct and neat inverse of her virtuous and chaste predecessor—ultimately, both figures remain upper-caste patriarchal fantasies.[29] Popular Hindi cinema before the multiplex was not devoid of nuanced depictions of masculinity or femininity. The multiplex has been fundamental to creating the industrial conditions for an accelerated shift in the ways in which sex, gender, and sexuality can be depicted on screen.

Finally, the multiplex film offers a return to landscape in a multitude of ways beyond the overarching urban/rural divide. Both interiors and exteriors foreground realism. Suburbs, underbellies, small towns, and conflict zones appear frequently. The Bollywoodization of Bombay Cinema saw the privileging of hyper-real lavish interiors. Ranjani Mazumdar (2007) discusses the emergence of a virtual and simulated city filled with global signage and the erasure of spaces like the slum, streets, and crowds from Bombay's cinema. Several multiplex films dislodge

themselves from these design catalog interiors of the Bollywood film and take the spectator through immersive spatial, temporal, and sonic encounters with new landscapes: *Gully Boy* (2019), *Ugly* (2013), *Gangs of Wasseypur* (2012), *NH10* (2015), *Masaan* (2015), *Haider* (2014), *Shanghai* (2012), *Dev.D* (2009), *Oye Lucky! Lucky Oye!* (2008), *Aamir* (2008), *A Wednesday!* (2008), *Omkara* (2006), and *Black Friday* (2004).

Haider (Vishal Bhardwaj, 2014), for example, is an adaption of Hamlet that also draws heavily from Kashmiri journalist Basharat Peer's *Curfewed Nights*, a memoir of his boyhood in the valley under Indian occupation. Peer is credited as the film's co-writer. *Haider* depicts a desolate, eerie, militarized Kashmir starkly emptied of the Indian tourist gaze. As film critic Raja Sen (2014) rightly observes, it is a film "that makes you smell corpses." Calling Kashmir the Hamlet of the film, director Vishal Bhardwaj said in an interview, "Our way of looking at Kashmir has either been cosmetic—only for shooting songs—or rhetoric, where we show a man in a *pheran*, holding a Kalashnikov. *Haider* is the first film where we see Kashmir from the inside. I don't think we have made a mainstream film about the issue" (Harneet Singh 2014). Bhardwaj calls *Haider* a mainstream film because all the people who worked on the film—producers, actors, lyricists, musicians, singers, choreographers—were entrenched industry players. Bhardwaj himself is an acclaimed and established director. However, a film that takes the spectator into Papa II, the Indian army's infamous torture camp in 1990s Kashmir, unsettles the category of the terrorist, and questions the legitimacy of the national project in the valley is thus a far cry from the mainstream. Thus, while the multiplex film cannot be stabilized into generic or formal coherence, as a vernacular it can offer generative ways of exploring the distinctive shift in the tonal, visual, and sonic cultures of popular cinema, which in turn engender new sociocultural identities. Ultimately, this vernacular is tied to the ways in which the multiplex and its materiality are imagined at the site of production.

Book Overview

Projecting Desire begins with an industrial history of film exhibition in Delhi before the multiplex, and ends with an analysis of the contemporary multiplex's imbrications with the COVID-19 pandemic and streaming video. My intention here is not to offer a linear history of

successive media technologies as they "replaced" each other, but to demonstrate how the "old and new remediate each other."[30] The bulk of the research for this book was conducted in Delhi in 2015 and 2016. Locating moviegoing within prevailing aesthetic regimes, material and infrastructural choices, and the search for architectural identities necessitates studying how various concurrent agents like the Indian state, cinema theater owners, architects and planners, and the English-language press imagined their stakes in shaping the politics of leisure. Thus, I use interviews with the current owners of several of the city's old colonial-era and modernist single-screen theaters, along with materials from their family archives like opening brochures, publicity materials, and architectural blueprints, to chart a material history of the cinema hall within the greater architectural palimpsest of the three crucial decades—the 1960s, 1970s, and 1980s—that preceded the arrival of the multiplex (chapter 1). This historical account underlines the centrality of these decades to the emergence of a strong architectural desire for a postcolonial "modern" national subject and spectator amenable to discipline through design. It also offers insights into nascent middle-class desires for commodities and privatized media consumption—visceral affects that the multiplex reconfigured to build its spatial empire.

Chapter 2 explores the post-liberalization architectural projects for public leisure in India. It maps the emergence and evolution of a specific industrial design against the framework of the rapidly changing Asian city. Traveling through Delhi's famous Select Citywalk Mall and its in-house multiplex, PVR Select City, this chapter offers insights into how these spaces create a new gendered moviegoing experience. Here, I integrate spatial and industrial ethnographies with an analysis of corporate literature like the PVR brand book, employee manuals, annual reports, and publicity plans. What can these media architectures for public leisure tell us about the everyday work of shaping neoliberal fantasies and desires? I argue that by expanding the range of media industry players to mall developers, multiplex architects, interior designers, hospitality professionals, and security and surveillance companies, the mall-multiplex collectively produces a specific figure: the shopper-spectator. The design and execution of these built environments are primarily meant to ensure her safety—sexual and emotional—and thus assuage long-standing anxieties around gender and space in South Asia.

Chapter 3 expands on the relationship between the shopper-spectator in the mall and the spatial vocabularies of the new multiplex film. Production, distribution, and exhibition exist in a dialogic relationship, and this nexus determines how films are woven into the skin of exhibition spaces. In other words, the multiplex film can read neoliberal desires for what I call *anxiety tourism*. The multiplex makes the disquieting landscapes of these films palatable. Looking at both text and the discourses around it, I offer an analysis of three recent multiplex films set in Delhi: *Pink* (Aniruddha Roy Chowdhury, 2016), *NH10* (Navdeep Singh, 2015), and *Dev.D* (Anurag Kashyap, 2009). I argue that the multiplex is writing a new history of relations between cinema and space that marks a significant disjuncture from its antecedent, the single screen—a thoroughly public site full of unpredictability and excess, where middle-class fears found no safe refuge.

Chapter 4 tracks the ongoing transmogrification of Delhi's cinemas across the performative and widely reported/photographed "dying" of the single screen and the heightened hyper-real architectonics of the multiplex. In doing so, it charts the capital's physical interaction with globalization, built environments, and technology. A strong current of nostalgia envelops these spatial transformations. Film and exhibition industries profit from nostalgia campaigns: the multiplex seeks to assure its spectators that the loss of the single screen and all that it signified need not be absolute. The pleasurable parts of it can be reconfigured and rehabilitated, safely, within their new disciplinary regime of moviegoing. Although the single screen might be "dead" in the capital, existing mostly as haunted ruins, it is always symbolically present at the multiplex. This chapter argues that in its attempt to marginalize certain affective worlds of film viewing, the multiplex cannot simply bypass the long history of the Indian audience's socially transgressive relationship to the cinema theater and neatly proceed "after" the single screen. Instead, it often conceives of itself as a space that is here to salvage and protect the uniquely *Indian* ways of watching films. It attempts to show the globalized Indian spectator where she came from and what she can become. It is both a bridge and a capsule: when viewed from the skin of the multiplex, the unfettered city outside becomes perplexing and dangerous. Nostalgia and anxiety—two sides of the same coin—are then essential ingredients for activating the tactile pleasures of the multiplex.

This chapter also briefly addresses the COVID-19 pandemic, which arrived at a moment when India's screen and exhibition industries were already negotiating encounters with the digital via streaming platforms. I offer some preliminary insights into how these ongoing shifts signal the cultural production of a new spectatorial body, amenable to novel forms of bio-surveillance and datafication of self.

A short epilogue summarizes the book's key analytical contributions and contextualizes them within India's current political scenario: the rapid rise and entrenchment of the Hindu Right, supported by Bollywood and other big businesses. A flourishing politics of Hindutva now undergirds every aspect of the India's socio-political-cultural fabric. Indeed, it can be argued that what currently shapes the sweeping materiality and cultural politics of place and space in the subcontinent is a violent regime of fear and hatred. In Hindutva's diktats over popular culture and public space, the nation's intimate anxieties around gender rise to the surface once again. They emerge as enmeshed in religious majoritarianism and alpha nationalism, frequently expressed through vigilante publics and violent reception cultures. India's new built environments cannot barricade themselves away from these forces, and the potential for violence thus lurks beneath the polished surfaces of the mall-multiplex. The book closes with some reflections on moviegoing in the age of media convergence and streaming platforms.

A word on access: my entry into the industrial world of Delhi's film exhibition also says something about the city. The shift from single screens to multiplexes marks another significant passage, from a largely family-owned exhibition economy to layers of corporate control. My access to both these spaces happened "by chance," to use an Indian English term. Notably, it was easier to enter PVR's corporate domain as an English-speaking, middle-class, upper-caste young woman affiliated with a major American university; a cold text to the company CEO yielded a wealth of access. Although I was unable to meet him, he instructed his staff to help me. Curiously, after I had visited their Gurgaon office multiple times and interviewed several employees, they suddenly asked me for a letter from my university and a copy of my passport. This material proof endorsed my social and cultural capital, and I was able to continue my research. However, for several months into my fieldwork, I had no access to any of the families who owned the city's single

screens, until one day, I accompanied a friend to her uncle's because we happened to be in the neighborhood. On hearing about my research, my friend's uncle declared that the president of Delhi's Cinema Theater Owners' Association (and owner of Liberty Cinema in Karol Bagh) was his best friend. He made a phone call on my behalf that would lead to other phone calls between friends and colleagues, and these personal recommendations helped me access the familial networks and scattered personal archives of the owners of Delhi's last single screens. *Projecting Desire* thus offers a layered chronicle of a media city in flux through these and many other sites of meaning-making, which taken together help us understand the larger sociological relations between gender, material environments, anxiety, and public culture in South Asia.

1

A Material History of the Cinema Hall

In the 1963 romantic comedy *Tere Ghar Ke Samne* (In Front of Your House, Vijay Anand), superstar Dev Anand plays Rakesh Kumar, a USA-returned architect whose modern house designs have Delhi's upper and middle classes swooning. He is in heavy demand as the city's post-independence colonies are established, plots are auctioned, and new social classes are legitimized. Nouveau riche elites and upper- and middle-class identities are increasingly tied to new spatial and material aspirations for the domestic house. Our heroine—the hugely popular Nutan starring as Sulekha—is a girl belonging to this architectural time: fashionably dressed and groomed, confident and occasionally coy, with a crafty sense of humor. She shares an affectionate relationship with her parents and her goofy army man brother Ranjan/Ronny. Notably, Sulekha is overtly invested in planning and designing her house and making a style statement. Unconvinced that someone as young as Rakesh could be skilled enough for her purposes, she marches into his firm to enquire about the architect who designed a particular house in Defence Colony, a post-independence settlement built in the 1960s for army veterans, and now one of the capital's wealthiest neighborhoods. To her surprise, the senior firm owner reveals that the architect for the Defence Colony house was none other than Rakesh. Immediately, Sulekha drops her hostility, and her guard and invites him over for a meal.

Rakesh promptly falls in love with Sulekha and is commissioned to build the grand house of her dreams. What follows is a comedy of errors. Rakesh is unaware that their families are arch-rivals, especially their fathers, who have bought adjacent plots of land for the very performance of outshining the other by building a more magnificent house. Rakesh—now stuck between his girlfriend and their warring parents—is assigned both the projects. In the film's climactic sequences, Rakesh builds two identical houses across from each other and delivers several monologues on erasing differences, acceptance of one's neighbors, the harmony of

the undivided household, and the urgent need to belong to the new age: thinly veiled metaphors for national unity. Rakesh's character embodies the central tenet of Nehruvian modernism: the work of architects and engineers was not limited to the rationalization of built environments but fundamentally geared toward temperance of the intimate relations that would play out within those designs. Nehru hoped that modernist architecture would help the country break from both its colonial and pre-colonial histories, ushering in a new technocracy where design eclipsed difference. Modernization of the domestic house was the key to the modernization of the nation at large—"modernism offered a shimmering vision of escape from everything conservative, traditional, and limited" (Kalia 2006, 135). Anger, hostility, and an assertion of difference (as espoused by the stubborn traditional patriarchs) had no place in this *nayaa zamana* (new era). For Nehru—and Rakesh as the perfect Nehruvian subject-protagonist—architecture and a spatial taming of the landscape at large offered a rational and scientific way out of the mayhem of Partition and decolonization.

The 1960s, a decade after decolonization, marked a new and crucial period in the nation's urban and architectural identity: the era of the monumental Art Deco waned (though it persisted in a domesticated and thoroughly modernized form), Prime Minister Nehru's grand experiments in city planning through Le Corbusier's Chandigarh in the 1950s percolated into the nation's spatial consciousness, and cities and towns became increasingly dotted with new modes of middle-class living in modernist apartment blocks—both private and those built by the likes of government agencies such as the Delhi Development Authority. Indian Cinema transitioned to color. Anglo-Indian and European architectural firms were on their way out, and Indian engineers, planners, and architects—each often did the others' work—were tasked with formulating the nation's infrastructural, architectural, and material lives. This was not unique to India but was a phenomenon that could be traced across several cities like São Paulo, Brasilia, Cairo, and Istanbul in the post-WWII decades. Urban middle classes turned to modern architecture "for buildings that represented neither previous local elites nor the quasi-colonial and/or feudal indigenous traditions with which they were associated" (Lee and James-Chakraborty 2012, 21). It is therefore unsurprising that the reigning matinee idol of the era, Dev Anand, was cast as

an architect instrumental in bringing together two warring families into a singular unit—through a spatial solution—in *Tere Ghar Ke Samne.*

This chapter offers a material and spatial prehistory of the multiplex within the greater architectural palimpsest of the three crucial decades—1960s to 1980s—preceding its arrival. Two major developments occurred: first, the shadow of Nehruvian modernism loomed large over cinematic built environments in the 1960s and 1970s. India's first modernist 70 mm theater, Sheila, designed by American theater architect Benjamin Schlanger, opened its doors to Delhi's spectators in 1961. These decades witnessed a transition from the opulence of the Art Deco theaters (often built in the colonial era) to a decisive starkness, control, and abstraction in design. Central to this transition was an attempted nullification of gender in favor of an undiluted citizen-spectator: the ornate femininities of Art Deco were discarded for the principled frugality of modernism. Second, television became a quotidian object in the 1980s, which led to a solidification of the middle class as a social category, particularly marked by their new gendered relationship to media consumption. Moving away from a linear single screen to multiplex story, I trace the infrastructural and affective prehistory of the multiplex as dispersed across multiple media ecologies like the architectonics of the cinema hall, television, VCR, and media texts. This historical account underlines the centrality of these three decades to the emergence of a strong architectural desire for a postcolonial "modern" national subject and a citizen-spectator amenable to discipline through material design. It also offers insights into nascent middle-class desires for commodities and new media infrastructures, the arrival of a new gendered modernity via television, and the pleasures of privatized media consumption—affects that were lengthened and spatially remediated by the multiplex in the following decades.

The arrival and spread of cinema as a social and urban public activity in Colonial India, and particularly Bombay, has been well documented (Arora 1995; Hughes 2006; Srinivas 2000; Dass 2009; Athique and Hill 2010; Bhaumik 2011; Mukherjee 2020).[1] Cinema, in colonial societies like India or Africa, was a foreign and elite form of entertainment at its inception: "instead of being marked a lower-class activity, it was often identified as an elite, racially coded, leisure practice" (Larkin 1998, 48). The first few decades (1900–1940s) thus saw the manifestation of

colonial and elite Indian fears about cinema-going, movie theaters, and film culture at large coalesce around two key aspects: rampant anxieties about gender, space, and caste-based intermixing, which were managed along the contours of the changing connotations of private and public space in Indian domestic and socio-political life, and the emergence of a taste politics that was allied to race, class, and caste status. These taste politics were also mapped to the varying material conditions at the site of exhibition and as well as location. Strong traces of these foundational anxieties remained remarkably resilient across several postcolonial decades and continue to haunt contemporary media cultures, thus necessitating a quick detour before arriving in the 1960s.

Moviegoing in Colonial India

Though it is Delhi—the timeless capital of the Mughals, the British Raj, and the postcolonial state—that offers the greatest expressions of monumental architecture, Bombay is the harbinger of the material cultures associated with cinema-as-modernity. Colonial Bombay was India's first cosmopolitan city, enveloped in a robust cinematic culture that snaked through real estate and infrastructures like transport and electricity.[2] In *Bombay Hustle*, Debashree Mukherjee (2020) charts a capacious and exhaustive account of the many practices of film production in colonial Bombay (1920s–1940s). To understand them mutually, she offers the generative term *cine-ecology*, "wherein bodies, institutions, technologies, and environments collectively shape the production and circulation of cinematic meaning" (3). In this ecological account, Mukherjee argues for locating cinema—and indeed its "material and epistemic instability"—within its entanglements with other media, bodies, and things (9). Financial resources, speculative practices, energies, affects, pleasures, risks, objects, technologies, bodies, and infrastructures collided and dispersed to continually produce both "Bombay" and the cinematic practices that characterized and textured this momentous city. Mukherjee also underlines the importance of gender and the woman as a *cine-worker* during this period. Women started to inhabit public spaces in the city, their economic agency grew, and the film actress (especially with the coming of sound) came to embody the many pleasures and anxieties of a new modernity where the shapes of public and

private were being persistently redrawn. Though Mukherjee's book is not concerned with sites of exhibition, her conceptualization of cinema essentially as an unstable ecology with amorphous boundaries that is simultaneously responsive to the material conditions of its immediate circumstances, is a productive lens for studying exhibition and their built environments as enmeshed in similar networks of gendered material relations. Consider for instance the following report from a leading English daily, *Times of India*, which routinely carried detailed reports on theater constructions in Bombay between 1919 and 1940. On September 10, 1919, the Empress theater opened in the elite neighborhood of Lamington Road and was described thus:

> Next week will see the opening of a new cinema house which this company [Excelsior Theatres] believes will not be so much a rival to existing theatres as will supply a want for a good class cinema show in a district where there has been considerable development in recent years. The new theatre Empress which is situated in Lamington Road and is intended to supply the residents of the Byculla and Malabar Hill neighborhood with a cinema exhibition of the class which is now given at the Excelsior and the Empire without the necessity of making which may be well in these days of a gharry and taxi famine an inconvenient journey for *entertainment to which the English resident may have no hesitation in taking his wife and children, and an entertainment which will appeal to the educated Indian with a taste for British drama and what is best in cinema art.*
>
> Both externally and internally the design of the Empress is certainly pleasing to the eye. Externally one has visions of white colonnades and tasteful palm gardens in the making, and internally the decorations in gold and white alone give a sense of coolness and comfort which is accentuated by the breeze created by half a hundred fans which will be augmented in the near future by other "invisible" fans in the auditorium and the addition of a dozen exhaust fans which will expel the foul air through the roof. The accommodation is exclusively composed of chairs and settees, and the higher priced seats are in the circle. The Empress will be one of the few theaters in Bombay that will have a fixed screen, and this will ensure absolute steadiness in the pictures. The very latest cinema apparatus has been introduced, enclosed in a chamber, which is guaranteed to be fireproof and on the electrical arrangements every care

has been bestowed. There will be a cloakroom for both ladies and gentlemen and it is proposed to establish a bar in the circle as well as on the ground floor, where there will be the advantage of dainty little tables set in the palm gardens. (emphasis added)

This report speaks to the dense and layered mélange of materiality with race, gender, and class and signals toward an index of an increasingly confident colonial modernity; and as Manishita Dass (2021) has astutely stated, "transformational rupture and disorienting change" is intrinsic to any manifestations of modernity (131). Further, it firmly locates the cinema theater and the act of moviegoing within an assortment of other infrastructures, technologies, and objects, along with urban geography and ecological environment. Cinema theaters increasingly began to alter the makeup of neighborhoods and offered their residents new spatial vocabularies. They engendered unprecedented material and infrastructural desires: the Empress proposed an encounter with film through a fixed screen and assurances that the projection equipment will be housed in a fireproof chamber, along with the availability of cloakrooms, and "dainty little tables" in indoor palm gardens, thereby giving structure and voice to unique desires and affects spectators did not know they had or needed. Cool colors were meant to imaginatively transcend the hot, tropical experience of Bombay, and infrastructural investments in exhaust fans proposed to transfer the spectator into a different realm of air quality. While ostensibly geared toward the "Englishman and the educated Indian," such designs were also for their wives and children, for without such assurances, the Empress would betray itself as space for public leisure in a cosmopolitan city.

Theaters were also instrumental in establishing "central" and, by exclusion, "peripheral" zones in the city. On June 8, 1938, the *Times of India* reported on the construction of the Metro Theater, focusing heavily on its relationship to the city's real estate and technological movements. Opening with nostalgia about bioscopes that came to Bombay just twenty-five years prior, the report charts "the extent of changes that time has brought in designing accommodation for film's vast audiences." The report places the newly constructed Metro Theater at the center of Bombay's topography, or the center of the European town. The centrality afforded to the theater's location can be traced through the report's

attention to geographical elements: roads, public transport, and historical anecdotes calling Dhobi Talao "not an uninteresting place at all." Further particulars are provided on land acquisition, contracts with Hollywood production giant Metro-Goldwyn-Mayer, and compliments from American and European architects, besides commenting on how "new buildings are entirely changing the face of the tract that extends north to south" (*Times of India* 1938). In other words, the cinema theater was indispensable to the cultural, social, economic, and infrastructural projects of urbanization and modernization. Gender was at the heart of such projects. While these elite theaters were seeped in racial ideas of space, what we subsequently see is the steady domestication of these foundational imaginations.

Indian upper- and middle-class notions of space and space-sharing have always stemmed from the conceptual boundaries between the "inside" and the "outside" or the "private" and the "public." Spatial segregations were centered on gender and caste, key sites that needed fortification from miscegenation. Several historians (Chakrabarty 1991; Chatterjee 1993; Kaviraj 1997) have discussed how Indian elites appropriated and translated European concepts of private and public space.[3] Notably, an important distinction between European and Indian ideas of public space was that the concept of universal access did not exist among the latter. There was no place in the Indian cultural context that anybody could access for their pleasure. Colonial rule changed Indian elite encounters with the "outside"—which remained threatening and unpredictable, but became a little less obscure. While the colonial state had little interest in creating inclusive enclaves for everyone it governed, the cinema hall quickly became a container for shaping anxieties and encounters with the unknown. By the 1920s cinema-going became a wildly popular form of entertainment. Space-sharing became unavoidable, and European and Indian ideas of public and private began to converge at the theater.[4] In a fascinating account, Poonam Arora (1995) has discussed how the sudden cinematic availability of the white woman for the native male gaze led to racial panic. The colonial city was designed to make the European woman visually unavailable to Indian men. The earliest cinemas, often owned by elite Indian men, quickly made class- and caste-appropriate gender segregations for women of their communities. This left the European woman twice "exposed": both in the space of the

theater and on screen. All this led Constance Bromley, a former secretary, and manager of the Opera House, Calcutta, to return to England and write an alarming newspaper article: "Films that Lower our Prestige in India: Imperilling the Prestige of the White Woman." Here, she says:

> All respectable Indians keep their women folk set apart from the public gaze. They walk and take air in parks and secluded places especially reserved for them where no man may set his foot. The *purdah nashin* ladies are heavily veiled and when they visit any place of public entertainment it is usually in boxes—the front of which is entirely covered with what looks like a huge mosquito net—seeing, but unseen. (1926, 5; quoted in Arora 1995, 39)

Finally, Arora observes that the cinematic image was supplemented with film posters displaying white women, widely circulated across the city. Bromley suggested that European women look to the Indians for a solution, and as a gesture of courtesy to their native sisters, they should only visit the theaters "in high neck dresses or cover their bare shoulders with a shawl or cloak out of respect" (Bromley 1926, 5; quoted in Arora 1995, 39).

Despite the right to access the cinema, the risk of spreading disease and contagion, along with moral/sexual depravity, was completely associated with working-class men and *bazaar* publics.[5] Manishita Dass (2009) argues that elite Indians with access to education aligned themselves with refined tastes and ways of conduct, comparable to the British. The divisions were not so much between the colonizer and the native as absolute categories but between the upper-class-and-caste educated Indians and the "mass" of the illiterate poor.[6] The owners of India's first indigenous theaters were distinctly uncomfortable about opening their theaters to the working class, as their bodies were imagined as repositories of "otherness" and, by extension, disease, infection, and pollution.[7] Native audiences with a taste for Indian films—simplistic, escapist, stunt-heavy, thrilling, and much inferior to Western counterparts—were also associated with the lack of social and physical hygiene, and their very presence as a collective sparked fear of dangerous space. Distaste for Indian films was an important signifier of one's exalted social status. Dass further asserts that class was "understood more in terms of cultural capital than

as something defined by purely economic indicators" and is emphasized in the ICC Report as a "key factor responsible for the fragmented nature of the Indian cinema-going public" (85). Thus, "Indian" and "Western" were not just descriptive categories, but contained within them were troubling connotations of taste cultures. "Indian" as a derogatory racial category signaled a lack of intelligence for comprehending anything more than simplistic stunt-action films (89–93). The ICC Report, therefore, was fundamental to the naturalization of a spectatorial bloc known as the "Indian mass audience"; industrial perceptions about this imagined public continue to show remarkable transhistorical resilience.

In a nutshell, the primary unease that upper-class Indian audiences expressed in their navigation of the cinema had to do with their classist and caste-based notions of security (mostly sexual security of Hindu women) and hygiene (centered on the eating and polluting habits of lower castes). Because the families that owned and built the country's theaters often belonged to the same class and caste status as their spectators, they were able to construct a space designed with several kinds of precautionary segregations (seating, ticket counters, ticket pricing, quality of chairs, bathrooms, etc.) to appease elite and middle-class uneasiness to an extent. What they could not control was who came to the theater. An exclusion of working- or lower-class audiences would have been economically disastrous for both single-screen theaters and the film industry. Instead, they tried hard to ensure that within the theater, despite inhabiting the same material and ecological environment, working-class men and upper-caste women shared as little space as possible. Despite a constant assuaging of racial, classed, and caste-based fears of boundary crossing, the cinema was ultimately a space where the limits of private and public, as conceived by both elite Indians and the British with varying levels of overlaps, had been irrevocably transgressed. This was concurrent to the changing meanings of private space via the architecture of domestic homes and a newly decolonized nation's incessant search for a robust material identity.

Art Deco: Modernizing the Monumental

The dominant architectural style of India's cinema halls till the 1960s was Art Deco. An understanding of what Art Deco signified in the

subcontinent, and its relationship to national identity is key to understanding modernism through materiality. Swati Chattopadhyay (2014) makes a compelling case for why Art Deco persisted in India long after it declined in other parts of the world. While it did arrive as an architecture of the empire, "it was not deemed imperial, rather its attraction was modernity" (223). Here, it is important to make a distinction between style and mode in architecture. Style denotes formal qualities that are common to a range of buildings, while mode refers to the unique specificities used to create distinctions against an established stylistic "background" (Upton 1997, 101; cited in Chattopadhyay, 239). Studying Art Deco as a mode, rather than just a style, argues Chattopadhyay, allows for a more capacious understanding of its relationship to the larger social and cultural context in South Asia.

While cinema halls remained the greatest expressions of Art Deco in the subcontinent, its relationship to domestic and residential homes from the 1930s to the 1960s is integral to understanding how this mode changed the arrangements of gender and space. Heavy urban migration from the 1920s led to the formation of the single-family home and apartment living (Rao 2013; Chattopadhyay 2014). This accelerated a shift in both patterns of consumption and the societal role of women, supported by a new anti-colonial critical mass of middle-class professionals. The separation of male and female quarters in the household became obsolete. Further, advertisers and designers shifted their focus to the mistress of the single-family home and her desires and needs. As Chattopadhyay points out, "popular magazines, as well as the *Journal of the Indian Institute of Architects*, were not only keen to portray single-family living as both the ideal and modern mode of living; they were projecting it as the norm" (245). In November 1937, the Ideal Home Exhibition was held in Bombay and organized by the Indian Institute of Architects. Showcasing Art Deco as both the aesthetic and convenient choice for residents, it attracted over 100,000 visitors in twelve days. This exhibition had a bit of everything, from raw materials (tiles, paints, cement) to electrical fixtures, from novel modern furniture designs to new media technologies like radio (see McGowan 2016). These visions into the future of the modern, ideal Indian home were not limited to Bombay but spread to several other cities and towns across the subcontinent. For example, Chattopadhyay (2014) shows that several Art Deco houses built

in Calcutta in the late 1940s removed partitions between the drawing and dining rooms and brought the bedrooms to the front of the house with common verandahs. This changed the understanding of privacy as a front-back issue, thus overturning the need to move from public to private rooms in the household: "the plan suggests a fundamentally reconfigured view of domestic privacy in keeping with the logistics of the single-family home orchestrated by the woman of the household" (250). Thus, it is difficult (and often reductive) to understand Art Deco and modernism as two distinct architectural phases.

In the first decade post-independence, Art Deco cinemas were subsumed within the greater vocabulary of a newly decolonized nation's desire for a homegrown identity through architecture. This also necessitated a rehabilitation of Indian cinema, long considered an inferior imitation to Euro-American cinemas. The opening brochure of Liberty Cinema in Bombay (1949) strongly reflected these desires:

> At the conclusion of World War II, the cry for independence reached its crescendo and the Indian movie industry began in right earnest on this wave of sentiment. A great need then arose for a proper presentation of Hindi films which were till then confined to cinemas at Lamington Road and such areas. All South Bombay's cinemas screened only English pictures. The need for an outstanding cinema for the Hindi film industry stared Mr. Habib Hoosein in the face. *This had to be no ordinary cinema as it now bore the stamp of independence and it had to be "The showplace of the nation."* With the opening of Liberty, a major milestone is passed in the history of showmanship in India. It marks the beginning of the showman's consciousness of his product. *It is a statement to the Indian people that no theater can be too good for them and no screen too good for Indian pictures.*
>
> To the Indian picture goer and producer, who complained that the finest facilities were being used to show foreign products, the LIBERTY, comes as the first promise of a brighter future . . . in the shape of an ultra-modern, air-conditioned, luxury cinema dedicated to the showing of the best Indian films. It stands as a pledge from the Indian exhibitor that he will stand by the Indian film industry first . . . an industry that has suffered so many postwar reverses and has so often lacked adequate support. (emphasis added)

Liberty, among other cinemas, marks the beginnings of robust postcolonial aspirations for indigenous exhibition infrastructures, and the urgent need to legitimize Indian cinema as a valid product that must be placed within the taste cultures of the monumental Art Deco. The cinema hall was much more than a site for elite urban leisure; it aspired to be a major architectural player that would powerfully shape the material modernity of the new nation. Global connections and import of technical and other infrastructures (like sound and projection equipment and in some cases even special seats) from the west were inherent to this new modernity, which would later also show up in the strategic hiring of Euro-American architects and planners like Le Corbusier and Otto Koenigsberger to design post-partition cities (see, for instance, Lee and James-Chakraborty 2012).

Four years after Liberty, Delhi made its postcolonial theatrical debut with Delite in 1954. Delite remains operational to date and is family owned, which was the norm before the corporatization of the exhibition industry with the arrival of the multiplex. According to the theater's current proprietor, Shashank Raizada, Nehru had specifically requested a cinema that would surpass the capital's colonial legacy theaters (Raizada 2016). Delite was built on a plot of land bought for the highest price paid for real estate in the country in 1950: 6.5 lakhs. It was also the first air-conditioned theater in North India. The sound equipment was imported from the Radio Corporation of America (RCA) and the projectors from Simplex. The seating capacity of the hall was 1,100. A special curtain with brocade work arrived from England. The cinema opened with the Hindi-Urdu film *Angarey* (Flames, K.B Lall, 1954), starring the reigning superstar Nargis. Delite, however, was not just a site for film exhibition. It had a proscenium stage and hosted magic, dramatic, and dance performances. The present-day theater has a gallery of photographs from its glory years, with members of the Raizada family posing with several ex-presidents, prime ministers, and Bombay film stars. It also built a ninety-seater cafeteria within its premises that remains popular.

The capital was divided into Old and New Delhi. British architects Edward Luyten and George Baker designed New Delhi: the heart of colonial design. Old Delhi, formerly known as Shahjahanabad, was the grand capital of the Mughal Empire and home to the city's long Islamicate history and architecture. The new British capital sought to eschew

the congested, densely populated Mughal city (Metcalf 2002; cited in Sundaram 2010b, 16). Old and New Delhi met at cinemas like Delite that occupied both the literal and liminal border between the colonial and the native cities. The opening brochure of Delite reflects these spatial histories and related anxieties:

> Shri N. Kothari the able genius, under whose wise and watchful guidance, sturdy beautiful buildings are springing up one after another in quick succession in Delhi . . . has made a substantial contribution to increasing the attraction of the town. We are glad to say that 'Old' Delhi is also receiving 'Master' touches to make it vie with the new. Selected Indian and Foreign films of the highest artistic, moral, educative, and technical merits will beautify our screen. (Chandra 1954)

Notably, Delite offered a significant shift in how it imagined its spectators. It was pitched to the masses. The publicity pamphlet that accompanied the opening of this theater stated that the "chief aim has been to provide recreation to the masses, who after the day's labor owe it to themselves to have some relaxation: physical as well as mental. The theater belongs not to the indolent rich but to the common people who have worked day and night and sweated in the sweltering heat to have the theater completed against heavy odds." Cinema was not a site for luxury entertainment, but a "necessity like a public park to invigorate the individual after the day's toil and soothe his frayed nerves." Delite's nod to the masses must be contextualized within postcolonial India's move toward architectural modernism and asceticism as the fundamental conditions of the new nation. Cinematic form, the film theater, and moviegoing as an assemblage of public leisure were foremost meant to organize along the needs of a decolonizing nation seeped into the rhetoric of development. Going to the cinema "is the only diversion within the limited means of an ordinary middle or poor class person" (Chandra 1954). The recognition of the urban poor as a legitimate spectatorial class for Delite, poised as the "Magnificent—Aristocratic Air-Conditioned Theatre in the North" is in keeping with the postcolonial state's discourses on poverty. A discourse of scarcity, the Gandhian rhetoric of asceticism, and poverty—as a virtue—were the essential ingredients for the formation of a postcolonial subjecthood.

As Farhan Karim (2019) writes, "the austerity discourse set the tone for India's postcolonial design and architectural modernism, even though the participating low-income population gained little if any power over the actual production of its architecture" (6). These ideas, set in motion in the 1950s, would continue to find greater expressions in the 1960s and 1970s. India's theaters relinquished Art Deco's adornments in favor of a more mechanized and starkly industrial space for exhibition. Recognition as spectators did not release the working classes from a larger elitist politics of crowd control.

Rational Architectures: Sheila Cinema, Modernism, and National Identity

India's first modernist and 70 mm theater, Sheila, opened in Delhi in 1961. Moving away from the Art Deco mode, it opted for a new modernist materiality, one that had steadily made its way through several towns and cities from the mid-1950s after Le Corbusier's experiments in Chandigarh. Nehru's influence on North India's spatial and infrastructural vocabulary was paramount, as were his ideas about the new Indian citizen who would inhabit these built environments. Nehru saw Chandigarh as the ultimate victory of modernist, rational, and thoroughly urbane architecture over the uncertainties and entanglements of traditional architecture and villages (Kalia 2006; Sundaram 2010b). At an architectural seminar in the capital in 1959, Nehru spoke at length about his visions for the postcolonial Indian city:

> Architecture to a large extent is a product of the age. It cannot isolate itself from the social conditions.... The static condition in regard to architecture in India in the last 200 or 300 years ... really was a reflection of the static condition of the Indian mind or Indian conditions. The great buildings which we admire date back to an earlier period. We were static even before the British came. In fact, the British came because we were static. A society which ceases to go ahead necessarily becomes weak.... We should not be afraid of innovation. I have welcomed very greatly one experiment in India, Chandigarh. Many people argue about it, and some dislike it. It is the biggest example in India of experimental architecture. It hits you on the head and makes you think. You may squirm at the impact,

but it has made you think and imbibe new ideas, and the one thing which India requires in many fields is being hit on the head so that it may think. Therefore, Chandigarh is of enormous importance. (1959 175–176; quoted in Kalia 2006, 146)

How might we locate India's modernist theaters in these contexts of the country's larger architectural aspirations for development in the 1960s and 70s? What kind of spectators did they seek to entertain or—to borrow from Nehru—"hit on the head"? It was only in the 1960s that cinemas in the country transitioned to sites that exclusively exhibited films (several Art Deco cinemas were often also venues for live entertainment). This necessitated infrastructural improvements like the clarity of pictures, sharp color, and advancements in audio. Sheila Cinema, built in Delhi's Paharganj neighborhood, spoke to Nehru's visions in several significant ways. It was the modernist prototype and played a pivotal part in the introduction of a radically new architectonics to India's exhibition landscape.

Like most of the country's single screens, both dead and extant, Sheila is family owned. D. C. Kaushish, the proprietor, was an audio buff and took a keen interest in all aspects of exhibition technology. He also frequently traveled to Los Angeles and New York. It was through these trips and his association with the Motion Pictures Export Association of America that Sheila Cinema was given its shape and form, and eventually content. He named the theater after his wife. It opened in January 1961 with the Hollywood epic *Solomon and Sheba* (King Vidor, 1959). According to his son, the current owner of the cinema, Uday Kaushish,

> it was quite a sensation at that time, the audience was completely floored, it was the first time they had heard multichannel reproduction and 7 channels of magnetic sound and completely different fidelity from what had been experienced earlier. I mean, people came just to look at the place. Of course, we had a lot of people coming in from all over the country looking from the exhibition trade, so a lot of people took the plunge to go into widescreen and convert old cinemas and build new ones. (Kaushish 2015)

Sheila had begun construction in the 1950s, with the standard design for the country's cinemas of the time, with a stage and proscenium.

D. C. Kaushish, however, happened to be in New York. He witnessed the successful commercial trials of the 70 mm: "color rendition was flawless, lines were in sharp focus and there were no blurs, and the reproduction was life-like." He sent a telegram saying, "Stop Construction!" India had no precedents, and architects and technicians did not quite know how to handle the job. D. C. Kaushish eventually met American modernist architect Benjamin Schlanger in New York. At this point, Schlanger had been a major exponent of the "immersive" theater in the United States for nearly thirty years. Besides several cinemas across the USA, Schlanger also designed the United Nations General Assembly Hall, Metropolitan Opera and New York State Theater, Lincoln Center, Kennedy Cultural Center, and the Colonial Williamsburg Twin-Theaters. Uday Kaushish recounts,

> So, Ben Schlanger was initially told that there was a project in Delhi that was underway, so he asked for plans, which my father was carrying. He started to modify them and create new designs along with Professor Harris of Columbia University, who was in the acoustics department—he designed the layout of the cinema—it's a classic academy design from the '50s and the '60s with a balcony and a mild reverse slope at the bottom which basically ensures that everybody, at least the first row of people, does not die of craning their necks to look at the screen. It was quite a departure from what was there before which was a standard stage layout so the whole place was redone, brought down completely, and redesigned. After that, we were ready for over nine or ten months and waiting for license and approvals. Otherwise, we would have been the first 70 mm in Asia, but we were three months behind Japan because of the delay of the electricity department. (Kaushish 2015)

Jocelyn Szczepaniak-Gillece's (2018) work on the history of the modernist American theater sheds significant light on Schlanger's work and legacy. As a theater designer, architect, and engineer, Schlanger saw the necessity of introducing functionalism to theater design. Drawing on the legacies of modernism in American art, literature, and architecture in the 1920s, Schlanger rose as one of the biggest proponents of the neutralized theater, where the ideal cinephile could immerse himself into the image in an unadorned environment. As Szczepaniak-Gillece

discusses, for Schlanger, an ideal theater should negate everything from the local environment to the spectatorial body itself: "here, then, are the disciplinary aspects of cinephilia: awe, silence, and stillness that are beneficial both for filmic observation and for keeping an audience in place" (6–7). Schlanger also made a sizable contribution to the industrial literature on theater design in America. He argued in *Motion Pictures Theaters of Tomorrow* that the theater of the future should no longer remain partitioned spaces of seats and stage and screen area but should strive to become a part of the film. The proscenium arch should be destroyed as much as possible and is where

> the slaughtering should begin and concentrate itself . . . it is here where the mood is determined. It is mostly this transition that should enable the viewer to feel as little conscious of the surrounding walls and ceiling as possible so that he can completely envelop himself in that which he is viewing. (Schlanger 1931, 12–13)

Like their global counterparts, Indian Art Deco cinemas had sought to enthrall moviegoers through the production of interior fantasies via mirrors, ornate ceilings, statues, and gardens. The neutralized theater had no patience for such ostentatiousness, considered utterly feminine by the proponents of Art Moderne.[8] Sheila gave "him [the spectator] large, airy, naturally lighted lobbies instead of the conventional foyers with moldings, carvings, carpets, mirrors and chandeliers of the oriental movie palaces" (Kaushish 1971), thus wholly embracing the neutralized theater in theory. Szczepaniak-Gillece notes:

> within the very bones of the neutralized theatrical architecture can be found deliberate attempts to negate spectatorial difference, to enforce immersion and bodily forgetfulness, and to construct a transcendent subject more able to project himself into the screen. The neutralized theater, in essence, should be considered the fourth limb of the apparatus: camera—projector—screen—and auditorium. (2018, 15)

While the modernist theater was the mother of the multiplex in both the USA and India, their local trajectories and cultural meanings differ significantly.

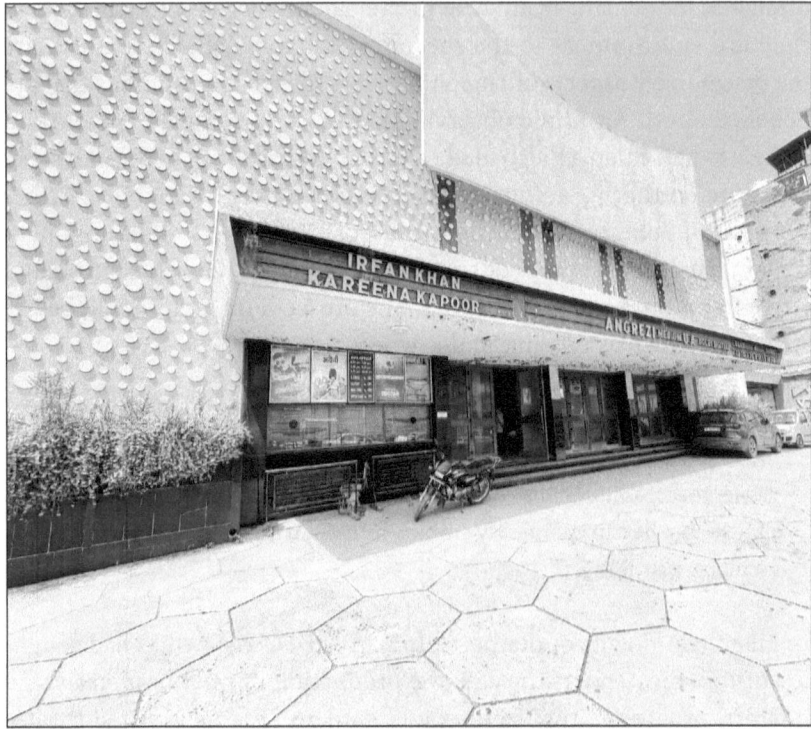

Figure 1.1. Sheila Cinema exterior. The theater shut in 2020, soon after the pandemic began. The last film it screened was *Angrezi Medium* (English Medium, 2020). This photograph was taken in May 2023, as it was being demolished. Photo by author.

Unlike Delhi's other modernist theaters like Chanakya, Sheila was not located in one of the city's traditionally elite neighborhoods but in the commercial, densely populated, and working-class Sadar Bazaar, next to the New Delhi Railway Station, a conduit for migrant laborers to enter and leave the city. Despite its location and geography, it chose to exclusively play Hollywood films for the first fifteen years. This was the first time in the country's postcolonial exhibition history where Hollywood films were screened for more than three or four consecutive days. A press and publicity brochure released in 1971 celebrating 10 years of Sheila Cinema opened with the following lines:

> A new era in the world of entertainment in India began on January 12, 1961, with the inauguration of Sheila Theatre '70' at New Delhi. Sheila

pioneered in bringing to this country international standards in building design, viewer comfort, theatre maintenance and above all the art and science of movie presentation. All through this span of 10 years, SHEILA has remained at the top and our endeavor is to continue to do so. (Kaushish 1971)

Sheila's spectator is imagined as a male subject who can both embody and appreciate the new techno-architectural dynamism of the theater, thus fulfilling the key spatial utility of the modernist theater: the screen must engulf the spectator. Sparseness in space was coupled with a celebration of advanced infrastructural capacities like sharp color, lifelike audio, and immersive theaters, showcasing a mix of imported and indigenous technologies. Marking the film as an interchangeable object, Sheila sought to foreground their "incomparable high fidelity stereophonic sound, and our superb picture presentation makes him feel part of the action, on the screen." The screen was curved slightly to give it an illusion of depth. Walls were painted in a neutral off-white to eliminate cross-reflections on the screen so that "nothing comes between you and your favorite movie-play." Sheila also emphasized the prevalent spatial discourses around light and cleanliness that prefigured the multiplex: the presence of large and well-lit lobbies, its location in a safe compound, a pride in transcultural exchanges in sound and projection technology, all emphasizing superior architectonics. As described in their 1971 brochure:

> We maintain an adequate interval of time between the shows for smooth departure and arrival of our patrons who do not have to clash head-on or go out through back alleys. We have our own stand-by generators, ready to take over in a split second if the city supply fails. The show must go on, on schedule. Parking lot, arrangements for first aid, exceeds the safety standards prescribed for theatre buildings in India. Sheila conforms to the highest international safety standards (as our Consultant Ben Schlanger is himself the author of the New York Safety Code for theatre buildings).

Their tickets were priced higher than the rest of the city. India's first multiplex—PVR Saket in South Delhi—priced its tickets at par with

Sheila. Sheila developed its indigenous movie-projection system called SHEILARAMA, described thus:

> Using a still larger, giant-sized screen with a 20-feet curve, it will be able to screen special cinema-type of movies but more importantly than that, it will be able to present Indian films in greater depth truly engulfing the spectator in action. This is a technical breakthrough of major importance, which is India's own, and the country will not have to pay any royalty on it. Seating will be rearranged to enhance your sense of participation and yet another era of excellence in motion picture presentation will be ushered in by Sheila Theatre '70.'

Besides Hollywood fare, Sheila carefully picked a few Indian films to exhibit. In its first years, it chose to interlude its constant stream of Hollywood releases, with two Indian films: B. R. Chopra's Hindi-Urdu *Kanoon* (Law, 1960) a songless film, and Satyajit Ray's Bengali films *Kapurush* (The Coward, 1965) and *Mahapurush* (The Holy Man, 1965). According to Kaushish, they experimented with these atypical films because they catered to a "high-end audience." Despite these aspirations for class-based taste clusters, the primary audience for this cinema did come from the densely populated middle- and working-class neighborhoods of Sadar Bazaar and Paharganj, even though people came from all over the city to witness the new modernist marvels of Sheila.

The owners found ways to balance class and space. The theater's location was met with skepticism from the exhibition industry. According to Uday Kaushish (2015), "In the 1970s, when the cinema opened my father was ridiculed by everybody: who is going to go to a cinema near the railway station to see a film when Connaught Place [center of Delhi's colonial design] doesn't run for so long." To ensure that the audience base in proximity to the cinema came regularly, D. C. Kaushish began printing a summary of every film that they ran, both in Hindi and Urdu, on either side of a page. These pamphlets were then placed at the booking counter. This meant that several non-English-speaking audiences came in to watch Hollywood films, as they had already familiarized themselves with the narrative and plot, "so that created a wider base of available audiences for us as well, otherwise, we would not have been able to sustain the long runs that we enjoyed with films" (Kaushish 2015).

This emphasis on the working class's right to public space was echoed in several developmentalist states—for instance socialist Hungary (see Fehérváry 2013)—during this period. In a letter congratulating the cinema on completing ten years, the then President of India, V. V. Giri, emphasized Sheila's location in the city: "they have a splendid show house in a locality inhabited by the working class." Prime Minister Indira Gandhi (1971) said,

> The film medium provides the most widespread form of popular entertainment in the country. Those connected with the industry—producers, directors, and actors as well as theatre owners, are in a position to influence the minds of people and to *improve their taste and discernment*. (emphasis added) (quoted in Kaushish 1971)

The state's desire to improve the "taste" of moviegoing publics and in turn exercise control over the potential excesses and unpredictability associated with this act of leisure has been a long-standing aspiration, first echoed by the colonial British government, the developmentalist Indian state, and again after the privatization of the economy and in favor of the multiplex. These disciplinary regimes have all sought to define the limits of the spectatorial experience by design, despite discourses on both "good" cinema and the ideal spectator changing significantly with each period.

Modernist architectures of the 1960s and 1970s were about crafting a national identity that championed neutralization, across the citizen-subject, architectural flamboyance, and gender. The Indian government was a central player in the all-pervading developmentalist ethos of these two decades. Karim (2019) argues that the government embraced both large-scale industrialization and accumulation and as well as Gandhian ideals of anti-consumerism and asceticism: "by blending these two apparent opposites—growth and control, abundance and austerity—the government weaved an ambivalent postcolonial modernity" (4). These ideas found their greatest expressions in material and built environments. What these distilled spaces sought was a semblance of control in a nation overrun by the cataclysmic dislocations of decolonization and Partition. Modernism, as unleashed in Chandigarh and soon after in capital cities like Bhubaneswar and Gandhinagar, at its heart, sought

to make a neat break from the past. Ravi Kalia (2006) observes that the clean lines of modernist architecture "never represented much of a threat to a religiously pluralistic India, anxious to create a secular identity" (148). Nehru heavily championed secular modernity through architecture. He found India's pre-colonial architecture "static" and "repelling" (1959; quoted in Sundaram 2010b, 30). Commenting on South India's ancient temple architectures, Nehru said,

> I just can't stand them. Why? I do not know I cannot explain that, but they are oppressive, they suppress my spirit. They do not allow me to rise, they keep me down. The dark corridors—I like the sun and air and not dark corridors.

Sundaram (2010b, 49–50) argues that in this distaste for darkness and ghostly corridors, Nehru echoed Western modernity's classic thesis. He discusses how in post-partition Delhi, the modernity dialogue became a mix of technological celebration, information, and modernization, culminating in the 1962 master plan: the city was viewed as a machine, run by a technocratic apparatus. Decentralization was its central philosophy. Delhi was to spread out into cellular neighborhoods, district centers, and factory areas, all regulated by law.

India's urban planners and architects, thus, were tasked with the work of building environments that would negate individual identity, as well as ethnic, regional, and religious differences through the act of becoming a neutral citizen through space. In the documentary *Nostalgia for the Future* (Rohan Shivkumar and Avijit Mukul Kishore, 2017), architect Ashok B. Lall reflects upon the architecture of the home in this period in the capital that needed to house both post-Partition refugees and government employees who constituted the new nation's bureaucratic class:

> When you come to a new imagination, everything is according to a concept of what constitutes modern living. All these, at that time, modern or futuristic advantages of the city, like piped water supply, sewerage, and electricity, motorized transport meshed into this idea of the garden. That on the one side, and also, I think there was an engineering mindset. So, architecture is very basic and is not imbued by any of the cultural values

overtly, although those are implicit in the way things were done. Whether people were happy with it or not is very difficult to say, but on the whole, it was a very happy place. It was partly because all those who came to inhabit the new spaces were partly immigrants. For them, this was not too much of a disjunct because most of them were employees of the state. As far as the refugees are concerned you make the best of what you get. I think there is a deliberate intent of the state, a conscious move towards what they call modernity. And also the state's belief in itself as the provider. For the people who were working out the details of the provision and the policy like housing standards, layouts, or design, I'm not sure whether for them this was a conscious understanding of a new position. For them, it was much more mechanistic, not so much ideological.

The modernist theater was integral to this "present" mode of architectural identity dominated by new technology and neutral space, championed by Western modernity. It was an "architecture for the free"—both from British imperialism and its pre-colonial history. The new nation sought to begin again from an imaginary vacuum: a zero space. Filmmaker Avijit Mukul Kishore's voiceover in *Nostalgia for the Future* offers a poetic rendering of this ethos:

> The nation is a home. Community is a home. The body is a home. Modernity wanted to close the gap between these homes and dissolve community into nationhood and into the body, until the nation became the body.

To borrow a phrase from Fehérváry's (2013) work on socialist Hungary, the Indian citizen-spectator of the 1960s and 1970s should have—at least theoretically—prioritized the "material project of becoming" (17). As she writes:

> qualities of things—colors like grey, substances like wood and concrete, shapes like right angles, and organic curves—came to provoke affective responses to the socio-political and economic ideologies with which they were aligned. The affective powers of such qualities outlived the regime that generated them, shaping the way a socialist era middle-class negotiated the post-socialist 1990s and constituted a new middle class. (13)

There are many stark parallels here with the Indian scenario. Concrete materiality of the 1960s and 1970s gave way to steel, chrome, and glass architectures of 1990s. Each of these material choices offers generative insights into the shape of public consciousness around the use and occupation of space. It underlines the role of successive governments and their economic policies and sheds light on the work of architects and planners who were chosen to concretize these visions. It provides a material history of globalization and the role of media architectures in that trajectory.

In the 1980s, television began to enamor the middle classes, and cinema halls went into a period of decline. They reemerged as a place for middle-class leisure in the late 1990s with a reconfigured built environment and a new vocabulary of media architectures, this time for the more individualistic, consumption-friendly globalized Indian, who could no longer be imagined as either parsimonious or entirely male. Besides television, the middle-class abandonment of the cinema hall was also linked to a few other developments; primary among them was a preoccupation with cleanliness and respectability. As the numbers of those who constituted the middle of the class strata intensified, so did the work of boundary maintenance. In Delhi, for instance, the implications of the English/Hollywood film in the capital changed around 1984. Soft porn films were now imported into the country, leading to the emergence of the disreputable morning show. The "morning show" refers to the exhibition of soft porn films for floating and migrant working-class populations in several cinemas, especially in the older parts of Delhi (Singh 2008). This, along with the rise of genres like the rape-revenge and snake-woman (*naagin*) films in the 1980s, led the growing urban middle class to further distance themselves from the debased and queer worlds of popular cinema. Several commentators in the Bombay film industry also lament that this spectatorial bloc stopped coming to the theaters during the 1980s because the halls were not "clean" anymore. Cleanliness signified both filmic image (a B-grade aesthetic) and the public act of space-sharing in the theater, a space now associated predominantly with working-class men, signaling a return to the fears of intermixing reminiscent of the first decades of film exhibition in colonial India.

Next, I discuss how the proliferation of television and VHS tapes across domestic spaces in the 1980s offers important insights into the

gendered world of the multiplex and marks the beginnings of an audience imagination that continues to animate both globalized television and contemporary streaming video cultures.

The 1980s: Gender, Technology, and Televisual Publics

In the 1980s everyday life became synced to the temporal regime of television. The frugal modes of a development-oriented state made way for advertising and consumption. India hosted the Asian Games in 1982, an important turning point for the infrastructural capacities of television. By the late 1980s, 70 percent of the population had access to television, under a government-mandated "Special Expansion Plan." Television set ownership increased from 2 million in 1981 to 23.4 million in 1990, sparking a dramatic rise in the sale and purchase of consumer goods (Rajagopal 1993; Mankekar 1999; Gopal 2019). Aswin Punathambekar and Pavitra Sundar (2017, 401–405) argue that this period is crucial to India's postcolonial media history because, for the first time since independence, citizens could partake of joy and the pleasures of the now. Moving away from a perpetual and exhausting self-sacrificial march towards the future, television made "quotidian aspects of middle-class life unremarkable, relatable, and crucially, desirable" (403). It sedimented the category of the middle-class as a subject position:

> To be a middle-class Indian in the time of television was to be oriented to the present—to consumption and pleasure in the present—like never before. The generic characteristics of the sitcom (its episodic structure and comic mode for instance), and the dailiness of broadcasting helped garner the middle class's consent as the nation gradually divested from the temporality of development. (404)

Television's cultural significance was powerfully established in this decade, as it became the key to both a "global nation" and a "global market" that came to dictate the 1990s and after.

This period also saw a crucial shift in the Indian state's attitudes toward the televisual public as a bloc it could discipline (at home), as opposed to the more unpredictable and "vulgar" cinema public moored in the politics of the crowd on the street. Television in India started in

1959 as an extension of radio. Writing about development communication, Abhijit Roy (2008) says that the postcolonial state's purpose here was to homogenize citizenship, create a structured audience, and "also make them imagine the nation entirely as a statist space" (30–32). Development thus became the "grand leveller." Roy argues that inherent in the discourses of development is the idea of "growth," and thus the addressee of developmental communication was conceived of as a child. This is also evident in several films by Raj Kapoor from the 1950s and 1960s where he repeatedly plays the infantile child hero. Through omnipresent dialogues on "growth" and the nation as perpetually on the road to becoming, the state imagined its citizens as desexualized beings. Roy's approach offers a layered understanding of the intermedial spectator of these decades: "what transpires is that the citizen was possibly imagined as a male child that would never grow or a grown-up infant not to be enticed into the pleasures of the world. The broadcast public, directly under the aegis of state pedagogy, could never be the libidinal 'vulgar' public of popular cinema" (33). Yet the cinematic popular continually punctured the texture of development communication; the more sexually emboldened the heroine in the 1960s (*Sangam*, 1964; *An Evening in Paris*, 1967; *Bobby*, 1973) and the restless industrial masculinity of Bachchan's angry young man in the 1970s were far cries from the ideal desexualized/neutralized child citizen-spectator, along with the aural terrain of film songs that saturated the dreamworlds of the nation.

Indeed, the 1980s can be read as the decade that offered a bridge between anodyne state programming and the "wild" energies unleashed by popular cinema. The expansion of television infrastructures was supported by the arrival of the Sony videotape and cheap electronic goods (Roy 2008). However, a handful of shows on Doordarshan (India's state-owned channel and the only one that viewers could watch till cable television arrived in the early 1990s), along with other media flows via videotapes, began to disrupt the dominant and binary understandings of "vulgar" films/pedagogic television for development. Sangita Gopal (2019) points out that the 1980s was also a decade where the women's movement in India gained tremendous currency, leading to multiple reforms in laws governing violence against women. Television was an active participant in this national conversation and "gender emerged as a key site through which television, though increasingly compromised

through private capital, could pursue its social itinerary" (48). Doordarshan employed women in large numbers (as opposed to film and radio). Women viewers had also been earmarked for "special attention" in its programming. Prioritizing women on television and making shows that documented not only their "realities" (women were often seen in isolation as absolute categories) but also their hopes would enable television to "serve as a critical interface for reflecting *and* reflecting *on* gender" (Gopal 2019, 49–50). Scholars like Mankekar (1999) have extensively studied the interweaving of religion and nation in the cultural and social representation of women on Doordarshan, and their negotiated readings by viewers. I want to highlight a different strain of programming and certain overlooked infrastructural entanglements that offered unusual visions of gendered modernity on television and video in the 1980s. My contention is that these shows and the televisual publics that they created and addressed are crucial to understanding the historical interplay of media technologies, built environments, and taste cultures.

Here, I want to briefly draw attention to two popular television shows—*Idhar Udhar* (Here and There, 1985) on Doordarshan, and the immensely successful Pakistani teleplay *Dhoop Kinare* (The Edge of Sunshine, 1987) that spread like wildfire through videotapes across North India. Both shows brought with them new articulations of gendered modernity and helped cement certain audience imaginations that both the multiplex and streaming platforms continually reactivate. *Idhar Udhar* debuted a year after another similar sitcom: *Yeh Jo Hai Zindagi* (Such Is Life, 1984, henceforth *YJHZ*). Punathambekar and Sundar (2016) rightly observe that *YJHZ* was the first Indian sitcom that relinquished the momentous for the non-events of the quotidian. *YJHZ* also introduced the middle-class apartment in the city as the site of staging the contemporary, thus separating from the larger joint family home with generational conflicts. Further, leisure is an important feature of the life of Renu, the show's female protagonist, who shares an apartment with her husband and her unemployed brother. As national subjects, Indians could finally move from scarcity and the deferral-driven temporarily of development to living in and valuing the present (Punathambekar and Sundar 2017, 416–419). *Idhar Udhar* took matters of gender, leisure, pleasure, desire, and the amusements of daily life even further. It was directed by screenwriter Anand Mahendroo (who went on to make several other

successful television shows for the next three decades) and produced by Shobha Doctor, who had also produced Doordarshan's first social messaging soap, *Hum Log* (We the People, 1984). Doctor had already garnered a reputation for being able to bring in private advertising.

Idhar Udhar's narrative centers on two friends, Sunita, and Poonam, played by real-life sisters and now veteran actors Ratna and Supriya Pathak. The friends, one an air hostess, the other an ad agency executive, are paying guests in Bombay, in the home of Aunty Braganza, who leaves for an extended trip to Australia. They are comically inept and uninterested in domestic labor, hatching a plan to rent their living room to a male subletter who (they hope) will do all the domestic work in a bid to gain their affections. Thus begins a comedy of errors where the two women end up sharing space with Aunty Braganza's nephew Ronny Gonsalves (Ravi Baswani), a struggling actor, who pretends to be their paying guest. Such a living arrangement between twenty-something unmarried men and women was not only radical in 1985, but the portrayal of adult women as fundamentally uninterested in and incapable of domestic responsibility was a far cry from the other responsible and somber female figures on television who were meant to balance myriad national anxieties. There is rarely any mention of the families of Sunita and Poonam; they are independent, agentive women going about their careers, and their leisure pursuits consist of fashion, makeup, food, and men. The sitcom's mise-en-scène consists mostly of the various interior spaces of a small one-bedroom apartment. The bedroom that the two women share is messy, littered with clothes, makeup, and unmade beds. They are often found simply lying around, conversing, playacting, and having fun. A slew of older neighbors who live in the same building (whom they refer to as "uncle" and "aunty" as is common in India) keep interrupting their lives, yet no judgments or questions are raised regarding their right to occupy space alongside more traditional modes of living and being. Following *YJHZ*, *Idhar Udhar* too offered a temporal rupture from the not-yet of development programming. The sitcom is scattered both temporally and narratively, rapidly transitioning between various themes and story arcs that sometimes bear no connection, perhaps mirroring new and disparate urban realities for young professionals. The uncommon female protagonists in *Idhar Udhar* were based on the premise of an emerging female audience whose aspirational realms

constituted of a career, city living, unconventional space-sharing, and an easing of the burdens of the heteropatriarchal home—and, by extension, the nation. This was a new gendered national subject who was simultaneously desirous and desiring, embodying other dialectical qualities beyond the tradition/modernity balance: she could be cautious (Poonam) yet impractical and wistful (Sunita). Her decisions and actions were meant to first and foremost evoke joy and irreverence. She was not the bearer of a national past but a perhaps an early prototype of a lighter, less disciplinary future. For a brief interlude, the comical, single middle-class woman in the city marked a new site of meaning-making for both the female actor on television and female viewer at home.

Simultaneously, in major North Indian media markets like Delhi, Punjab, and Uttar Pradesh, the infrastructures of videotape circulation and the rise of video markets enabled the flow of libidinal energies and televisual affects from across the border. Pakistani teleplays like *Dhoop Kinare* and *Tanhaiyaan* (Loneliness, 1985) found cult fandom in the late '80s, introducing once again new visions of modernity. PTV's (Pakistan Television Corporation) *Dhoop Kinare*, written by legendary playwright Haseena Moin, chronicled the lives of a cohort of doctors in a hospital in Karachi. Central to the plot was the unconventional romance between the protagonists, Dr. Zoya Ali Khan (Marina Khan) and Dr. Ahmer Ansari (Rahat Kazmi). For middle-class Indian women, Marina Khan—who subsequently went on to become a major television star in Pakistan—epitomized a stylish and elegant new vision of the modern South Asian woman. She was a slightly exotic but familiar figure who was missing from their country's programming. A cursory glance at the show's still active fan pages on social media indicates that the character of Dr. Zoya Khan inspired multiple women on both sides of the border to study medicine. In an evocative short piece titled "Heat and Lust" filmmaker and cultural critic Paromita Vohra (2014) recalls her enthralling encounter with *Dhoop Kinare* in a small town in Gujarat in the summer of 1987:

> Five minutes into *Dhoop Kinare*, we were hooked and cooked. Everything was forgotten. Why did we love it so much? Maybe because it had been some time since we had had a really engrossing series on Indian TV. *Buniyaad* was long over. There were barely any Indian films that resonated

with young, urbanized middle-class audiences. Here was a world, which felt utterly familiar—the same importance to family, the same language, food, and clothes—yet ineffably different, just a little bit exotic. It was desi cool, something Indians of my generation didn't precisely have yet.

We also identified passionately with Zoya. She seemed to be a regular girl like us, excited to explore the world, not interested in being told what to do, hoping romance was going to find us soon but not squeezing into any boxes in the hope of approval or love.

The affective charge of this show in post-Partition Delhi and Punjab cannot be overstated. As a journalist put it,

> We watched these because there was nothing else on Doordarshan, and nothing else but Doordarshan. But Punjabi migrant families such as mine, and families that had grown up speaking Urdu—people who were culturally or linguistically close to Pakistan—continued to ache for PTV bootlegs. In Delhi's underground Palika Bazaar, one Sikh shopkeeper still deals almost exclusively in cross-border fare, selling the older serials to diehard fans while also doing brisk business in a slew of new ones. (Kaur 2014)

These and multiple other anecdotes emerging from video markets, and strewn across the popular press, nostalgic fan pages, and YouTube comments—among other sites—indicate that televisual media memories and media encounters that shaped the gendered spectator of the 1980s cannot be limited to studying Doordarshan programming alone. Videotapes and their infrastructural networks created new linguistic media markets and media regions. In fact, in parts of Amritsar and other border towns, where Doordarshan's signal was weak, people regularly tuned into PTV and listened to Radio Pakistan (Krishna 2016). Brian Larkin (2008) argues that cultural performance, or shared linguistic heritage—in this case Urdu, Punjabi, and Hindustani—are "soft" infrastructures and that "much of what we experience as urban reality is mediated by how infrastructural networks connect urban areas into wider cultural, religious, and economic networks" (19). Moreover, new technologies and infrastructural arrivals do not replace the old but "call into being new mobilities and sometimes intensify older ones" (Graham

and Marvin 1996; quoted in Larkin 2008, 6). Dormant cultural forms, networks, and other modes of exchange can become reenergized at new temporal moments (Larkin 2008). Thus, two decades after the success of *Dhoop Kinare* in India, domestic television giant Zee TV launched a channel called *Zindagi* (Life) in 2014 to rekindle this success through the airing of a new crop of Pakistani television shows. While Ritika Pant (2019) has called this moment a "neo-global" flow outside western zones of influence, where Indians were able to witness a "parallel modernity" from Pakistan (akin to Larkin's theorization of the popularity of Indian films in Nigeria), I argue that what Zindagi successfully resuscitated was a gendered spectatorial bloc—with economic agency and discerning media tastes—that became solidified as a cultural category in the 1980s.

What I want to underline are the temporal overlaps and recursive relations between television, the VCR, and the multiplex as techno-infrastructures that became generative sites for one another. After all, the multiplex reconfigured the media-architecture assemblage that began in the middle-class home, where privatized viewing and some uncommon programming (and its representational politics) merged with the technological capacities of color television and its appendage, the VCR. Both relied on the infrastructural networks of the videocassette. At the heart of these technological, infrastructural, and architectural projects was the gendered spectator. Therefore, the creative head of Zindagi, Shailaja Kejriwal, used the multiplex both as metaphor and as taste category to explain why a successful Indian channel was investing in broadcasting Pakistan dramas at a time when television was already incredibly globalized and Hinduized:

> In TV, the time had come for multiplexes. While there are blockbusters made for a majority of audiences, there is also a section that needs to be catered to. I selected the Pakistani shows keeping in mind the 'television multiplexing scenario'. The people who would prefer multiplex over single screen were also the people who would watch Zindagi over *saas–bahu* melodrama. (Kejriwal 2015; quoted in Pant 2019, 171)

Zindagi's parent channel, Zee TV, defined the intended audiences for these shows as those same upwardly mobile women—"educated, lived in the metros, were exposed to international media and had high

disposable incomes"—who were the early adopters of cable television but were subsequently dissatisfied by the dominance of long-running soap operas with conservative themes (Kaur 2014). What the multiplex enlarged through its spatial and temporal devices was the accommodation of heterogenous taste cultures and gendered subjectivities that were created by 1980s television and home video but were soon drowned out by the steady Hinduization of both television (see also Rajagopal 1993) and Global Bollywood. Therefore, the success of the multiplex—and the multiplex film—in the subsequent years emboldened Zee TV to revive this audience base for television. What emerges then is an interplay of media convergences, techno-architectures, and audience imaginations that began with television in the 1980s: the woman who avidly consumed a show like *Dhoop Kinare* on a VHS tape and found Dr. Zoya Ali Khan to be a new aspirational model (for instance, my mother) is rebooted as the "television multiplex audience," whose media consumption is profiled as assorted and global (for instance, me). To further disrupt notions of rupture, this figure is recodified as the female audience for streaming platforms. Zee Zingadi had to stop its programming in 2016 as geopolitical affairs between India and Pakistan deteriorated and the Hindu right wing's cultural diktats prevailed. In 2019 it moved its operations online and has since produced and distributed, among other Pakistani shows, *Churails* (Witches, 2020), a ten-episode series about a group of feminist vigilantes who use extrajudicial means to seek revenge on abusive men. These shows now stream on Zee TV's digital platform Zee 5. These examples demonstrate that while television, videotape, and streaming video might seem to be linear and successive technological regimes, they are in fact concentric and recursive in their creation of sociocultural categories, media geographies, and infrastructural networks. Each can draw upon and galvanize the other at specific political and temporal moments. The multiplex, therefore, continually emerges from and spills into this media history of privatized consumption.

* * *

After liberalization, and the arrival of cable television (1991), the film industry and the exhibition sector mutually began the process of reaccumulating respectability that was "lost" to television in the 1980s. While the industry (now with the active support of the state) geared

itself toward the South Asian diasporic audiences in profitable markets like the USA and UK, multiplexes and malls started reorienting the cinema hall toward the new middle class—specifically, women primed on a decade of television and home video. The stark shift from the neutral and concrete of developmentalist architecture to the vivid and glassy spatial vocabularies of the mall and multiplex—distinctive from the Art Deco—undergirded the arrival of an intermedial spectatorial imagination. This spectator could no longer be desexualized (desire was inherent to a capitalist subjectivity), or a hyper-masculine urban warrior. The expanded media ecology of the domestic home in the 1980s had produced a gendered spectator whose affective world was diverse and recurrently in the process of becoming.

The overlays between the frugal imaginations of development and the new intensities of consumption as they collided in built environments are evident from the following anecdote: one of India's most successful mall-multiplexes is Select Citywalk in the South Delhi neighborhood of Saket. Originally, this site belonged to the DDA (Delhi Development Authority) and was designed as a part of the Delhi master plan of 1962 by renowned modernist architect Kuldip Singh. In his proposal for the District Center at Saket, Singh suggested that there should be a management strategy for this center that would ensure that it ran in accord with the intent of the design. He also insisted that there would be no "misuse" of the design by tampering with the buildings. When the initial plans for Select Citywalk mall were drawn up in the mid-2000s, the planners realized that they had to work with government drawings from the 1970s, which could not be changed. The design was seemingly fixed. After a detailed investigation of the tender documents, they discovered a line that eventually led to the creation of an entirely new spatial idiom: "internal changes may be permissible subject to approval by the DDA" (Sinha 2015). The outside façade of the building was kept the same: a neutral, "monotonous" brownstone—signature DDA architecture. Inside, extravagant interiors began to be constructed for Delhi's new mega mall and multiplex.

This chapter has offered a material history of the cinema hall and related media technologies like the television and the VCR in India in the pre-liberalization decades of the 1960s, 1970s, and 1980s. It argues that the cinema hall and practices of public leisure must be understood

as a part of the larger ideological debates around a newly decolonized nation's architectural identity. Such a contextualization is crucial to understanding how architectural and material choices had always anticipated certain spectatorial collectives before the multiplex. Here, I also bring attention to the work of architects like Benjamin Schlanger as significant albeit overlooked players who shaped the capital's postcolonial media histories and media architectures. My aim has been to delve deeper into what architecture and design meant for those involved in building a cinema synchronized to the temporal and aesthetic orders of the day. Global architectural styles like Art Deco and Modernism and their articulation in postcolonial India offer a wealth of insights into the linkages between an emerging cultural identity and the everyday usage of utilitarian designs for public leisure. While gender, class, and caste have always been inscribed into the spatial imaginations of any public site, what this chapter demonstrates is that at certain junctures in history one overarching identity—like the citizen—is meant to ostensibly suspend others. In this march toward a singular and disciplined national identity in the decades dictated by the straight and clear lines of modernist architecture, television offered a vital break. It engineered new socioeconomic, spatiotemporal, and material convergences through the 1980s and 1990s. Television and home video were not only key to the production of consumption-induced happiness as a capitalist affect but also created heterogenous taste cultures. The techno-architectural assemblage of the domestic home, the television set, and the VCR (with the videotape) produced contiguous surfaces that reflected new visions of gendered modernity. Thus, what the mall-multiplex animated, lengthened, and reconfigured were the desires and anxieties of those spectators who were already enchanted by their glass screens at home.

2

Designing the Malltiplex

On a blistering afternoon in July 2015, I arrived at one of New Delhi's poshest mega-malls and multiplexes—Select Citywalk—located in the upscale neighborhood of Saket. Select Citywalk belongs to one of Delhi's most prominent "mall hubs"—a cluster of swanky malls placed next to each other, carousel style. It opened in 2007, and houses PVR Select City, a multiplex the company describes as their "South Delhi statement." Across the road are the fourteenth-century villages of Khirkee and Hauz Rani, now congested, densely populated lower-middle-class and working-class neighborhoods. The narrow, choked road that divides the glimmering Select Citywalk complex from these historic villages is almost always chaotic and jam-packed with cars, buses, taxis, auto-rickshaws, pedestrians, and several stray animals. I was there to interview one of the mall's primary developers and architects, Pranay Sinha.

His company office was located behind the mall, which I crossed to get there. The mall entrance was divided into "Ladies" and "Gents" queues, reminiscent of most public spaces in India, especially those involving journeys: railway stations, airports, metro stations, and cinema halls. My bag went through a machine, though nobody was really looking at the monitor. A female security guard in a blue *salwar kameez* with an SLN Security badge greeted me with a polite *namaste*. I was ushered into a cubicle with a makeshift curtain. She did a very light, very cursory body search lasting no more than a few seconds, and I was free to enter the mall. Once inside, I found that I was unable to walk quickly across the waxed and shiny floors. I slipped and almost fell, twice, while I was nearly blinded by the reflective glass surfaces of storefronts. As I sat across the desk from Pranay Sinha, I asked him about the slippery floors—hoping to make a light joke as an icebreaker. Sinha was hardly surprised. He told me it is deliberate. By eliminating the demising gap (a marble column) between two stores they had established a

seamless glazing all over. The mall is a glasshouse. The architect candidly explained,

> The mall generally wears a fragile look and feel so women who are walking around will feel that they are in a glassier environment. They will be more conscious of what they wear, there will just be a feeling of so much glass that they'll feel the need to behave better. (Sinha 2015)

They referred to women, and "better behavior" implied an explicitly gendered performance of class position and style, one that is in congruence with the material environment and distinctive spatiality of the Indian mall-multiplex. Unable to turn all of Delhi into a high street, Select Citywalk has conceded that their shoppers will have to brave the frenzy of heat, pollution, traffic, slums, choked streets, and crowds just before entering the mall. Upon arrival, they find themselves overwhelmed by glass. This can trigger various concurrent affects: confidence, comfort, disorientation, and even anxiety.

Journeying through Delhi's famous Select Citywalk mall and its in-house multiplex, PVR Select City, this chapter offers insights into how these spaces create a new gendered moviegoing experience. What can these media architectures for public leisure tell us about the everyday work of shaping middle-class fantasies and desires? I argue that by expanding the range of media industry players to mall developers, multiplex architects, interior designers, hospitality professionals, and security and surveillance companies, the contemporary mall-multiplex collectively produces a specific figure: the shopper-spectator. The design and execution of these built environments are primarily meant to ensure her safety—sexual and emotional—and thus assuage long-standing anxieties around gender and space in South Asia. Through a stylized design, going to the cinema is culturally produced and packaged as a controlled and policed encounter. Ultimately, this chapter demonstrates that to understand the gendering of the present cultures of moviegoing in the subcontinent, we need to study the nexus between a new range of media industry actors and the built environments they engineer.

Here, it is important to recall that the economic policies of post-liberalization India in the early 1990s had revolutionary effects on the

circulation of public culture. The middle classes were confronted with a multitude of goods that previously did not exist, even in their imagination. Lower-middle-class and middle-class aspirations changed irrevocably (Mankekar 2015). Commodity and consumption-culture took over the Indian landscape, becoming visible everywhere: films, television, newspapers, billboards, and magazines. These were expressed in new public architectures like the mall, the multiplex, the coffee shop, hotels, global restaurant chains, and so forth. Several scholars have referred to these spatial phenomena in different terms; Anthony King (2004) argues that India's new built environment is meant to create "spaces of global culture," where the new middle classes can see their aspirations physically reflected in the material spaces they inhabit. Ranjani Mazumdar (2007) has used the term "surface culture" to define expressive forms of architecture, advertising, fashion, print, television, and film that privilege a display of commodity culture as the new urban sensorium (110). Christiane Brosius (2010) has referred to it as the "Dubaisation" of Indian urban spaces and cities—the creation of a "simcity" or a simulated city with no origin. Adrian Athique and Douglas Hill (2010) term it "transnational architectures," where the design reflects cultural and architectural shifts occurring elsewhere, a part of a global project to rebrand existing cities like Shanghai, Beijing, and Vancouver (130), while Nitin Govil (2015) has called it a "new architecture of urban visibility" (117).

While the relationships between film and television landscapes, globalization, and commodity cultures are more visible, I want to underline the centrality of gender in this larger nexus of sensory politics, and the tangible ways in which it is inscribed into the textures and folds of contemporary media architectures. The mall-multiplex assemblage not only regulates class- and caste-based anxieties about sharing public space, but also determines the entirety of the haptic field within which the shopper-spectator's body must find its appropriate bearings. An interrogation of the industrial diagram of the mall and multiplex reveals that all of it is entirely predicated upon a visible reassurance of safety and hygiene, in a manner that can ensure the constant presence of the middle-class and upper-caste woman, followed by children, families, couples etc.[1] What undergirds this architecture are varied materialities that shape the sonic, temporal, and textural grammar of India's thriving "multiplex culture."

This chapter follows the path one takes to go for a movie at a multiplex in India. One must first enter and navigate the mall and almost traverse its entirety before arriving at the multiplex. By the time the spectator encounters the site of cinema, she is completely saturated in the ecology of the mall. Her body is attuned to mall lights, temperature, air, smells, sights, and sounds. It prepares her for the multiplex. Therefore, I too begin at the mall.

Select Citywalk: New Designs for Public Leisure

Select Citywalk was the first mall of its kind to appear on Delhi's urban horizon. The age of the shopping mall in India has also heralded the expansion of the ambit of media industries. Several kinds of specialists are now involved in the creation of the mall-multiplex dyad. How do they anticipate the shopper-spectator's desires and design a space for her? Select Citywalk, for instance, was developed to a great extent by Starcenters, a shopping center development and management firm specializing in branded retail. Cofounder Pranay Sinha had previously worked in shopping mall development in Southeast Asia, especially in Singapore and Malaysia. Sinha recalls the first time he stepped on an escalator in Jakarta in 1995—in that year there were only two escalators in India, one in Delhi and one in Bombay—and became mesmerized by shopping centers:

> As an architect I always stood for architecture that was commercially viable and life invigorating. And I couldn't see that quality happening in passive institutional buildings like a National Institute of Immunology. How many people will go there? And anyway, what is the big deal—you made a big red building. Look at what the rest of the world is making. So, when stepping into the first shopping centers in Jakarta, it was pretty much like *advertising meets architecture*. And there's suddenly happy architecture, there are lights, there is a JC Penny's, there's such so much of joy all around. It was cheerful architecture. *Most architecture is very passive.* This was for the people. For the masses. Children were loving it; *women were loving it.* (emphasis added) (Sinha 2015)

Sinha's telling comments point to the central elements that intersect to undergird India's new architectural manuals for public leisure: a

conscious movement from socialist to commercial architecture, marking the associations of the former with a bland/passive State and the latter with the mobile pleasures of capitalism; the influx of advertising into the language of both architecture and cinema; the rooting of a younger, neoliberal gendered subject firmly at the heart of this design; and inclinations toward emulating built environments closer to home: East Asia (and later the Middle East). The "old" Nehruvian middle class—self-restraining, frugal, and austere—is decisively *not* the audience for these new architectures. To date, it is not uncommon to see older Indians stand hesitantly in front of escalators in malls and multiplexes, while impatient younger crowds urge them on with a mix of kindness and exasperation.

How did we get here? Who were the people who knew what to do? Sinha's professional trajectory is tied to the history of mall development in India, which in turn is marked by a shift towards the understanding of new consumer markets over just building and design. Between 1999 and 2004, Sinha worked in different capacities on several of the country's first major shopping center development projects in metros like Bombay (Crossroads and Inorbit), Hyderabad (GKV), and Calcutta (Forum), a majority of which also had multiplexes. He calls himself the "mall guy" of India's first forays into integrated built environments for entertainment and Select Citywalk, as "an institution . . . was a way of doing things, it was a school of thought."

The multiplex is on the second floor. To get there, I must walk across most of the mall to reach an escalator on the other end. It gets me to the multiplex floor. The pattern repeats: I cross the totality of this floor too because the multiplex is at the opposite end from the escalator. This was a condition precedent to Select Citywalk's contract with PVR Cinemas. As Sinha explained,

> A shopping center is for shopping first. If you are not able to become the chosen marketplace, you may as well not exist. You are not there only to make people happy; you are there because you a running a very complicated machine. And that machine has to perform the function it has been purchased for.
>
> For the multiplex, you have to go as far as possible to reach the food court. You go through the mall, you get reminded once again who is in

the mall, you check out that store and say, I gotta come back during the week. So, weekends, family will come and see movies, the wife will come again without the family on a weekday because she is reminded again and again and again who is in this mall. It stays on her mind. *If you ask a South Delhi woman, which store is where, she'll tell you accurately on a plan. That was our objective.* (emphasis added)

This synergy between design and the gendered subject was achieved through several judiciously calibrated decisions. For instance, Select Citywalk attempted a careful "blend of indoors and outdoors" taking inspiration from Delhi's old commercial shopping centers like Connaught Place and South Extension, along with East Asian shopping malls: "our initial concept was that we will not be an alien spaceship landing in South Delhi. We will become the mall that reflects South Delhi rather than imposes itself upon South Delhi" (Sinha 2015). The architects felt that India is culturally closer to the denser cities of East Asia—in Thailand, the Philippines (see, for instance, Trice 2021), Malaysia, and Indonesia—than the United States with its suburban, mall-on-highway template.

Several cities in East Asia—since the 1980s—have been preoccupied with buildings that would serve their new leisure and consumer economies, surmounting their tropical climates to become symbols of a glossy new cosmopolitan modernity. In Jakarta, for instance, President Sukarno oversaw the building of the city's first departmental store, the now historic Sarinah Mall, inaugurated in 1966. It was the first building in Indonesia to have infrastructures like air conditioners, escalators, and cash registers (Tan 2022). In the subsequent privatized mall boom that followed through in the 1980s and 1990s, Jakarta "has developed a vast network of urban microclimates from shopping malls, gated suburban communities, cinemas, and high-rise office towers, much of which are mostly accessible by private cars" (Tan 2022). It is this creation of microclimates that offer an ecological, material, and spatial discontinuity from the "outside" that unites built environments in cities like Delhi, Manilla, Kuala Lumpur, Bangkok, Jakarta, and Dubai. These are also places that see heavy intra-regional traffic through business exchanges, tourism, and migration. DP Architects, for instance, designers of the colossal Dubai Mall (and similar such projects across East Asia and the Middle East), are now building a nine-floor mall in the Delhi suburb

of Noida. In the trade press, it has been described as "India's tallest and most opulent retail project" (*Architect and Interiors India* 2023), and its location is intended to draw residents from East Delhi, Ghaziabad, and Greater Noida—signaling new multiplicities in the geographical imaginations of Delhi's consuming classes.

Yet, as Sinha's comments underscore—despite the manufacturing of an urban amnesia about the "before"—these spaces cannot completely shock people away from their local and regional identities and ties to place and geography. Especially in India, if malls are to remain open to the ever-expanding and diverse middle-class, they must be accessible through public transport. Thus, Select Citywalk's commercial design was meant to create measured contradictions between the familiar and the aspirational. The left side of the mall was given the name *Staple Diet*, representing tradition, anchored by Indian retailers. The right side, called *High Voltage*, was meant for international fashion brands like Zara. The center, representing high-end Indian brands, was called *Celebration*. The left and right zones were further sub-classified. Staple Diet constituted of a grocery, pharmacy, optical stores, etc.: "[The] left side was Delhi the way it has been, staple diet, retail that Delhi is used to going, demonstrated success—so the right side was future Delhi (where Delhi is progressing), so the woman five years down the line, as she will be" (Sinha 2015). High Voltage was further nicknamed (after post-privatization television channels) across three floors as *FTV*, *MTV*, and *Pogo*. The ground floor (*Fashion TV*) was meant to have stores that were high-end retail for window shopping, "you can see but you can't buy." The first floor (*Music TV*), which housed PVR Cinemas, re-created community complexes around Delhi's earliest multiplexes, Priya and Anupam, primarily consisting of youth-oriented retail like books, music, sports, coffee, and electronics. The second floor was meant for children's retail. The center, *Celebration*, was for "brands India is proud of." These were High Design (leather bags), Fab India (handloom), Forest Essentials (Luxury Ayurveda), and Good Earth (Luxury Interiors).

It is not surprising that the mall's various design templates on paper were nicknamed after television channels. It was, after all, satellite television that preceded the arrival of these new aspirational fields and produced the need for a space to just shop. Much like the mall, the desire for the commodity went beyond just acquisition. As discussed before,

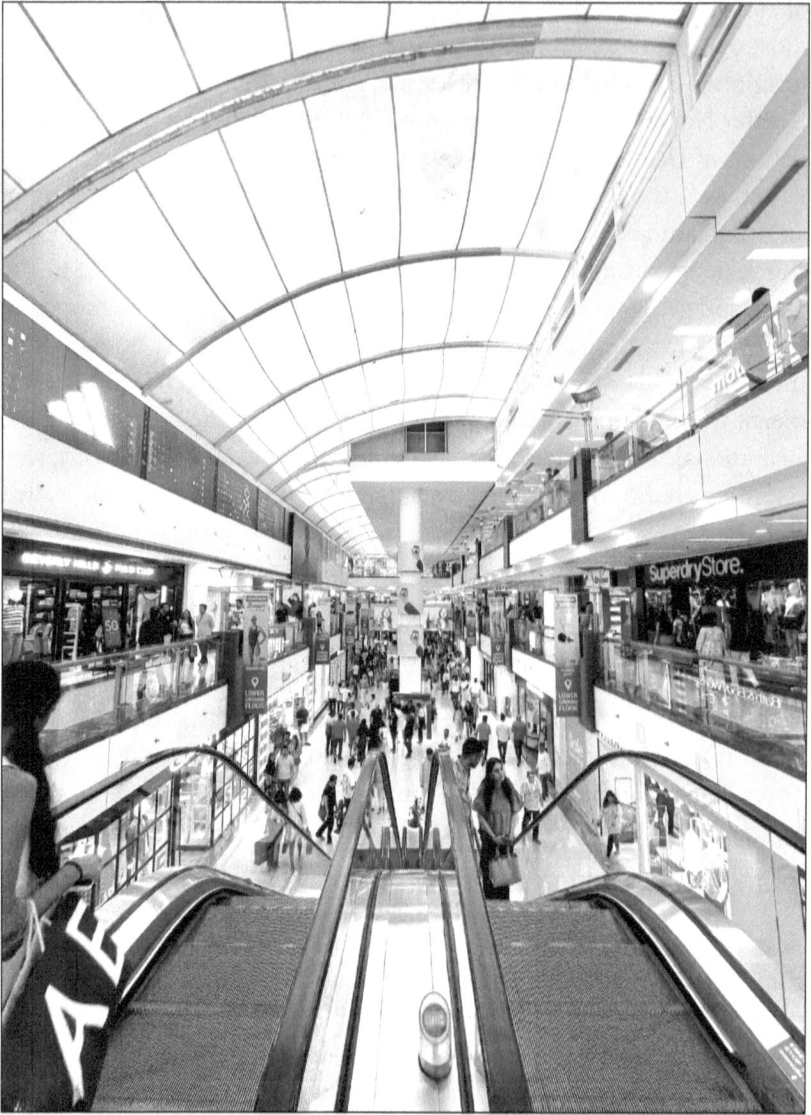

Figure 2.1. Select Citywalk interior. Photo by author.

Purnima Mankekar (2015) uses the term "commodity affect" to describe this phenomenon. She argues that desire in "commodity affect" lies in the pleasures of gazing and longing for a commodity that one cannot possess but it helps them imagine the possibilities of life with it, or "what life could be like" (115). Bollywood films from the mid-1990s were also

replete with the creation of simulated landscapes that reflected these convergences between class identity and an intimate desire for commodities. The subject that anchored all the moving parts of this machine was the female shopper-spectator. Select Citywalk located, observed, identified, and defined their primary clientele: the "South Delhi Woman." It was a powerfully defined vision of this figure that underpinned all the mall's infrastructural and architectural decisions. According to Sinha:

> Let's first choose our shopper. So, we said that okay, where are we? What comes to your mind when you think South Delhi? South Delhi is about showing off your wealth, wearing good clothes, doing a lot of makeup. So, whatever was coming to mind about South Delhi had to do with women. We said that let's make this center primarily targeted towards the South Delhi woman. She will become our boss. Whenever in doubt, ask her. Think of her and you'll have your answer. Who is in the mall determines who comes to the mall, what quality and what quantity. (Sinha 2015)

Here, it is important to recall that the intensity of globalization from the early 1990s was matched with equally strong middle-class anxieties about the loosening of established gendered norms. In the early and mid-1990s, Indian television was bombarded with a series of women-centric television dramas that aired on the government-owned and -operated channel Doordarshan. According to Mankekar (1999), this reflected "the state's need to mobilize women not just toward the twin goals of development and modernization, but also as custodians of the unity of the nation: women thus had to be constituted as loyal and patriotic citizens who would protect the integrity of the nation" (107).

Yet, this figure was also expected to embrace modernity and consumption—and thus become a desiring subject. It is here that we must briefly conjure the figure of the "New Indian Woman." Popularized in the late 1990s by the English women's magazine *Femina*—which also hosted the Miss India beauty pageant—the "New Indian Woman" was "a wife and a mother as well as a citizen and a consumer, a woman who is Indian rather than regional in identity and fluent in English" (Dewey 2008, 208–209). Between 1994 and 2000, several Indian models and beauty queens won global beauty pageants like Miss Universe and Miss World. This was a vital moment where globalization and the new

consumer economy collided with the idealized visions of Indian middle-class and upper-caste Hindu femininity. These women represented India on the global stage, signaling the country's "arrival." Scholars (Parameswaran 2004; Munshi 2004; Kumar 2010; Dewey 2008; Mitra 2012) have discussed how these beauty queens were seen as symbols of empowered middle-class femininity at this juncture in the nation's history. The beauty queen with her "authentic Indian heart that pulses beneath the outer cloak of West's body politic" (Parameswaran 2004, 366) was a symbol, meant to inspire the middle-class "girl-next-door" to be upwardly mobile and dream big.

The continuing endurance of this figure cannot be overstated. She is an intertextual vision who is found across a multitude of media: while she originated in women's magazines and beauty pageants, she quickly moved to film and television, and then into architecture and design. As Sinha explained,

> We defined South Delhi as one word, which describes South Delhi Woman: contradiction. She is contradiction. She is doing *karva chauth* and she is hitting the vodka lounge. She is carrying a Mont Blanc and she's got her *pallo*. She is rooted in tradition, but she is embracing modernity. That to us was the essence that we felt our mall has to have.

This new "brand" of Indian woman (Sunder Rajan 1999; cited in Mankekar 2015, 125)—state and media endorsed—had to be a "consuming subject." This could not happen "without her sexualization as an actively desiring subject" (John 1998, 382). A narrative of productive tension ensures that this figure, despite being a sexualized subject, remains safe and palatable, so that the nation can root itself via the figure of the consuming shopper-spectator frequenting the mall. Select Citywalk, for instance, celebrates traditional Hindu festivals like Holi and Diwali, along with Valentine's Day and Women's Day. Personal grooming and beauty are the two cornerstones of the New Indian Woman, and her arrival on the global fashion map is essential to the mall's gendered design. From the 1990s, a fashion-architecture complex has steadily gathered momentum, driven to a large extent by new visual cultures of popular cinema: for instance, the arrival and fetishization of the gym body (across gender and sex), its positioning within stylized spaces in

film, and the visibility of stars and celebrities along an amplified signage of global fashion. In the last few years, India's film stars and social media celebrities have been heavily solicited by several international brands ranging from cosmetics to watches; they now frequently appear at international film festivals like Cannes as product ambassadors. The mall-multiplex built environment begins from these larger discourses in fashion, cinema, and visual culture and flows into the social media–led present. In my last few visits to the mall, I noticed its architectural address to a new crop of social media influencers. Certain parts of the mall have been popularized as Instagram-friendly with new restaurant designs and food presentations explicitly targeted toward an Instagram aesthetic. A strong visual economy of selfies, makeup tutorials, product reviews, and reel making abounds alongside a multiplicity of celebrations that address the heterogeneity of Delhi's mallgoers: "patriotic feelings" on Republic Day, romance and friendship on Valentine's Day, environmental concerns and tree planting on Earth Day, and profiling celebrity moms at the mall on Mother's Day. Keeping up with global trends in gendered consumer address, the mall has also recently introduced gender-neutral bathrooms and celebrations of Pride Month.

Select Citywalk introduced a process called "tenant mixing" to Indian retail in 2007. Tenant mixing is an exercise in choosing which brands and stores will occupy space in a shopping center. According to Pranay Sinha, everything was carefully selected for the South Delhi Woman/New Indian Woman. Prior to this store selection process, Indian shopping centers would sell store space to whoever had the buying power; with tenant mixing, a very specific shopper is profiled and then a wish list of brands is drawn up. Through strategic leasing, they are convinced to occupy a predetermined space in the mall, as conceived in their design—"based on what you need and not what they are offering." Their motto was "concentrate on women, fashion will find its way into our mall" (Sinha 2015). Perhaps in a prescient move, Select Citywalk spent considerable resources on becoming the "beauty hotspot" of the country. Cosmetic brands like Mac, Clinique, Body Shop, and Estée Lauder abounded: "on beauty the South Delhi woman spends more than she earns, because she wants to look prettier." I was also told that, because South Delhi women tend to be lighter-skinned (because of their ethnic Punjabi origins), all kinds of colors would suit her skin tone. The architects and developers

felt that the top three priorities for the mallgoing Delhi woman were "beauty, kids, and home, in that order." Special attention was paid to ensure all the country's children's wear brands were in the mall, as well as those specializing in home décor; "since 2004 people have been partying in each other's homes so they want to change the look very often." Cross-level visibilities were created to reduce obstructions:

> you automatically have people become more conscious of what they are wearing, more people like you coming to the mall, so you know that you will bump into somebody—so you can't just go to the mall like that. That will make them buy more clothes. (Sinha 2015)

Once the shopper-spectator was identified, the next step was to ensure her sexual safety. The architects focused on the car park in the mall's basement, a secluded space from where safety threats often tend to emanate. Believing that more women would come to the mall if they did not have to bring their chauffeurs along, they put a clause in their contract with the car park security company that 30 percent of ushers had to be women, to create "a car park which is inviting for women and where women see more women." Sinha went on to add that now the car park has over 50 percent female employees (belonging to the lower-middle-class or working-class service populations). Fashion brand Allen Solly designed outfits for these car-park employees in pop colors: "these became selling points for us when we went to a brand to take a store with us. These were the things that represented what we stand for." They were also "paranoid about protecting their mall and their women shoppers," and were the first ones to introduce sniffer dogs in their basement. In 2007, malls in India had an average of seven to ten CCTV cameras; Select Citywalk opened with 225. They even had RDX (explosive) detectors, apparently before they became common in the country. Several other security devices were embedded in the design like DVR detectors (real time video surveillance), facial recognition software, slip and fall detection, and intelligent cameras. They also decided not to have benches in the mall's open areas, so as to discourage boys from "sitting there and ogling at women."

Select Citywalk has several acres of open space, or what they call a plaza, in front of the mall. This area was initially supposed to be a surface-level car park, much like in several of Delhi's older shopping

districts. But the architects felt the need to create an open urban space to attract women (and by extension, families). The plaza was thus made into a landscape garden: "that became our anchor, people will come here because of *vatavaran* [environment] they'll come here because it's a nice open urban space. Where do you have that in Delhi?" (Sinha

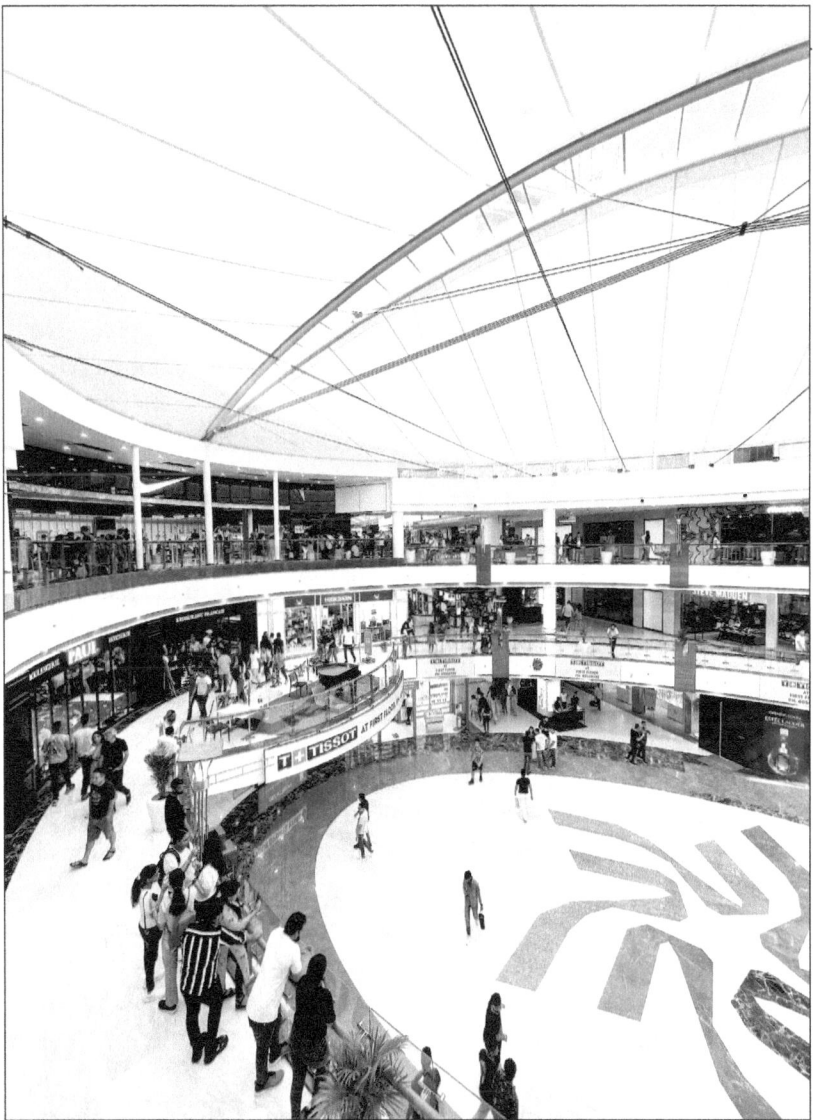

Figure 2.2. Crafting a fashion-architecture complex at the mall. Photo by author.

2015). This was an odd observation about a city known for its historical monuments and large Mughal era gardens. Sinha elaborated:

> One of our objectives was to create not just shops, but to create energy. To create spirit, soul. And those are the most difficult things to create. Shops you can get someone to build. But the intangibles are the ones that are the most elusive. For us, the plaza was that. For us the plaza was a respectable anchor, it was a community space, it was an urban space, to us it was a Trafalgar Square. What is this thing that creates a busy energy when you go to open urban spaces? You got a food truck somewhere, you got coffee. People like watching people. Cafes will be open, so that the man is sitting in CBTL [Coffee Bean and Tea Leaf] and the woman is seeing that her husband is busy, he has met up with friends, I can shop some more. Or she is able to see that the maid and child and all of those people are sitting, I can shop some more. Everything was designed to make her comfortable so that she could shop more, and we could take home a better return for the owners.

Shilpa Malik, one of the first few female architects working in mall development in India, was responsible for the plaza design. She ensured that it was green, filled with fountains and other water bodies that were human and children-scale. The plaza was supposed to attract children as a quasi-playground, and in turn it would bring their mothers to the mall.

The mall visit is an entirely new but already immensely popular leisure practice for upper- and middle-class Indians. We go to the mall to partake of its interminable pleasures: shopping, eating, air conditioning, movies, to gaze and be gazed upon. Financial security is also the key to preserving family honor and the sexual modesty of women: this is the ideological base upon which the new meccas of class performativity—the mall and the multiplex—are built and managed. A precariousness about retaining class-and-gender-based morality is inscribed in these new manuals for public leisure, where reassurance is often camouflaged as convenience. The mall is thus a necessary symbolic and material passage to gain access to the multiplex: a space where the cocooning refines itself. When you come to the mall, in Sinha's words,

> You are able to park your car comfortably, you are in an air-conditioned environment, you are able to snack during, before, or after without having

to break your heels on a broken pavement. So, the multiplex allows a person to come, park the scooter or car or take public transport and reach the mall, like you reach any other place. But once you enter the mall, you are in a *safer* zone, you are infrastructurally happier, you are able to watch your movie with the latest technology: it's all much better. (Sinha 2015)

The multiplex is an exhibition space that exists literally inside the mall but that, imaginatively, spills out of its physical boundaries—as a haptic repository for a new culture of spectatorship. Anne Friedberg (1993) has discussed how the shopping mall and cinematic spectatorship must be read as analogous forms in their production of subjectivity: "the shopping mall has not replaced the movie theater: it has become its logical extension" (120). Friedberg has shown how the mode of spectatorship activated by the multiplex "extends the spectatorial flânerie" of the VCR and television as both allow for a deferral of time and space. The static form of consumer address offered by shop windows in the mall is transformed into the liveness of film when one reaches in the multiplex. Here, moviegoing becomes an activity closer to watching television, "providing the cinematic spectator with the absolute presence of the (almost) always available" (141). The proliferation of media that surrounds the "race-, gender-, age-, and class-bound body" thus produces a fluid subjectivity implanted with a virtual gaze; the shopper and the tourist are brought together into a "virtual mobility." Experiences of both the public sphere (the shopping mall and the multiplex) and the private home (television and VCR) are now subject to such a mobilized virtual gaze (143–147). Extending these arguments further, scholars like Laura Marks (2000) have discussed the eye as a tactile organ that touches the haptic surface of the film (haptic visuality), and the modes of somatic and embodied reception that it produces. Pranay Sinha's comments about what the "multiplex allows" also point to the many surfaces and textures that determine the haptic and somatic field of contemporary spectatorship. The film, in other words, is a part of the story, and its classical site of reception—the film theater—exists within a carefully coded built environment. It is this materiality—gendered, classed, and caste-based—that frames the film, the act of moviegoing, and the possible ways in which it can be received. The film-spectator dyad can be concurrently broken and enhanced through spatial and material reordering. This then requires an

exploration of the elements that constitute India's multiplex culture, and the regimes of desires, anxieties, and disciplines that they are meant to generate in spectators. How does the multiplex further a gendered film-going experience set in motion by the mall? Next, I discuss how the multiplex follows the mall's larger strategy of creating new maps for public leisure, with the figure of the shopper-spectator as the primary focus of this carefully regulated diagram.

PVR Cinemas: A New Script for the Screen

In the last two and half decades, the Indian multiplex has not only focused on changing cultures and habits of spectatorship, but also engendered new ways of being at the cinema. The multiplex, in other words, has rewritten and recast several decades of spoken and unspoken codes of cinema-going by identifying persistent gendered anxieties as the key site upon which to construct new exhibition spaces. At its core, the multiplex is marketed as an antidote to the single screen that exists in middle-class imagination, as a hot, dense, and uncontrolled but thrilling space teeming with restless and euphoric emotions, sparked further by the big blockbuster being screened therein. In what follows, I delineate four intersecting aspects that constitute the multiplex's spatial address and the architectural, material, infrastructural, and tactile fields they propagate. Collectively, they do the work of reshaping spectatorial tastes, behaviors, and their affective entanglements with infrastructures at the cinema. These are: (a) color, (b) sound, (c) hospitality and food, and (d) risk, dirt, and hygiene.

Color

As in several other parts of the world, India's march towards globalization and capitalism has largely been defined by visual and material cultures saturated with the constant use of electricity and color. As Ranjani Mazumdar writes, "A plethora of surfaces in the city are covered with brand advertising and overproduced electricity generated images of stars and models. The navigation of these spaces generates an optical regime of magic and presence" (2010, 154). Multiplexes are an essential part of this new urban sensorium, and their play with color and aesthetics is key to understanding how they seek to shape spectatorial entanglements with new exhibition

spaces. At Select Citywalk, PVR introduced India's first six-screen cinema, a multiplex with two internal tiers: Gold Class and Premiere Class. It has two Gold Class and four Premiere Class theaters, thus spatially marking stratifications between the elite and the middle class. According to PVR's Brand Book, "PVR Gold Class' overall look and feel is luxurious and intended for an audience segment who desire a great, exclusive experience and for whom the money involved is largely inconsequential. To add to this a wide variety of freshly prepared food and beverage for total indulgence" (PVR Cinemas 2015). This was distinguished from PVR Premiere, which was built for a slightly different audience segment. The company's definition: "PVR Premiere: These are the next level premium cinemas for the audience segment that desire a great cinema experience and will pay a degree of premium for it. The interiors and identity of these cinemas are plush, sophisticated, and cool" (PVR Cinemas 2015). According to Agneet Kumar, the Senior Vice President of Design at PVR, the Gold Class was meant to evoke a very exclusive lounge-like interior that is distinguishable from the mainstream (Premiere). The mainstream "is very cult, very young, it's very trendy." The Gold Class, in contrast, must feel opulent and much like a luxury hotel (Kumar 2016). In terms of infrastructures, these were distinguished as some of their most technologically advanced theaters. Their aesthetic was meant to amalgamate seamlessly with the greater environment of the mall.

PVR's brand colors are red and gold. Agneet Kumar explained why the company chose this color scheme:

> Red and gold is all about luxury and this brand is all about giving an experiential experience to the customer. So, we chose gold and red because it signifies opulence, luxury, *comfort*, longue-y, *warm*. These are all warm colors, and these are all gender-neutral colors. If I was to choose a blue or a pink or a purple, they would be very gender specific. We don't want our cinemas to be very girl-y or boy-y or whatever, they have to be gender neutral and at the same time they are very rich, warm. (emphasis added) (Kumar 2016)

Krisztina Fehérváry (2013), writing about the significance of the color gray in Hungary, discusses how colors have aesthetic qualities that "powerfully link material environments with political affects" (1). In capitalist

Figure 2.3. Moviecation at the multiplex. PVR Select City. Photo by author.

consumption, color often signifies pleasure and possibility, along with the freedom of expression via personal style. Crucially, Fehérváry (7) shows us that class positions are often determined by the extent to which people have control over their material worlds. Following the insights of the semiotician Charles S. Peirce (1955), she expands on the significations of material objects; their sensuous qualities have the potential to become "qualisigns": "to be comprehended as a qualisign, qualia such as color must also appear in multiple realms (objects, substances, bodies)" (8). This helps us "bundle" a variety of seemingly unrelated objects/materials into a coherent style: an aesthetic. The "luminosity" associated with olive oil for instance, is amenable to iconic extension to signify qualities like power, life force, spirituality (Meneley 2008; cited in Ferhérváry 2013, 8). Thus,

> aesthetic regimes that are grounded in particular material properties become aligned with wider socio-cultural values in ways that seem to inhere in the material, naturalizing, for example, the relationship between state socialism and qualities of grayness, or capitalism with color. (8)

Finally, it is our embodied experience of materiality that gives it meaning. Socialization, suggests Fehérváry, draws our attention to certain aspects of the material, and continuous interactions over time and space help us attach significance to those qualities.

Likewise, in India, during the decades post-independence, subsequent governments aligned themselves with specific architectural and material projects. The multiplex's choice of brand colors thus not only speaks to a more encompassing aesthetic heralded by privatization (the brightness of red) but also taps into the iconic emotional charge of middle-class India's most enduring and prized possession (the gravitas of gold). There is no greater qualisign in the subcontinent than the metal gold: it simultaneously signifies currency, asset, power, family heirloom, intergenerational wealth, status, totemic jewelry, aspiration, life force, and luck. It has also been the primary economic asset for generations of Indian women across classes, often given to daughters when they marry. Gold/bling is also a significant aesthetic quality for the new middle class, both in their home interiors and personal style in fashion and clothing. PVR's brand colors and aesthetic choices tap into these larger expressive realms and enhance their values by adding new dimensions through spatial socialization over time.

The company quickly recognized that one of the primary ways in which they could persuade shopper-spectators to come to the theater was by packaging the act of simply inhabiting a built environment as a worthwhile investment of leisure time. Though India leads the world average in terms of the number of films produced each year, it falls far behind in terms of exhibition. It has only 7 screens per million people (as compared to 125 screens per million in the United States and 16 screens per million in China). Since the late 1980s, cinema theaters have also faced tough competition from entertainment options available at home, like television and video, and more recently, streaming video (see my epilogue). PVR privileges "going out to the movies" as an experience onto itself. Gautam Dutta, CEO, further elaborates:

> Because the product that we peddle is not our product. Its someone else's. So, *we are really like a box in which the cake goes*. We are really like the packaging . . . in which the cake goes. We say that we are not in exhibition industry we are in experience industry, and experience really cannot be

marketed. *It needs to be felt.* The whole idea is delight factor. So, what we say is we are seduction marketers. We are here to seduce. (Dutta 2007)

This seduction is also infrastructural: the *felt experience* that Dutta is referring to is one where "softer" design elements, physical objects like cushioned chairs, and as well as the sensuous qualities of food and beverage offer passage into a realm of hard infrastructures like atmospheric sound and film projection with precise aspect ratios. Together, they sculpt a new proficiency of *feeling* at the cinema. As I discuss next, these elements engender a new cinephilia where the spectator shops for films that privilege atmospheric sound or are shot with IMAX cameras—corporeal experiences that cannot yet be replicated at home.

Sound

The Indian multiplex decisively positions itself as the space for cinephiles who can appreciate the unique technical prowess of a film. India has always been a nation of fervent moviegoers, yet the erstwhile space for them—the single-screen cinema—engendered a more ad hoc, star-oriented form of fandom, one that not only exceeded the film text but also molded itself to meet the material conditions of the site of exhibition.[2] The multiplex's attempts have congealed around disciplining the filmgoing body politic to adhere to Western norms and create new affective assemblages between the Indian cinephile and exhibition technologies. A precursor to this is the rise of an urban cinephile culture through the circulation of DVD and film downloading, both of which have become possible with the arrival of high-speed internet since 2000 (Mazumdar 2010). Now, the multiplex seeks to address an expanded and digitally proficient cinephilia by recurrently stretching the possibilities of immersive spectatorship, albeit with new sensory interruptions (see also chapter 4). This cinephilia, however, is not simply limited to film appreciation stemming from global cosmopolitan taste cultures. Most of PVR's offerings like IMAX and ECX (Enhanced Cinema Experience) focus on the fetishization of the infrastructural capacities of large screens, precise aspect ratios, a range of film formats, 4K digital film projection, and Dolby Atmos surround sound: "it's entertainment so real

that you feel it in your bones, so magical that it takes you places you have never been; so all-encompassing that you're not just peeking through the window, but are part of the action" (PVR Cinemas 2015). Atmospheric sound is a central element of the multiplex era of filmmaking in India. It has moved the sonic empire of popular cinema beyond the film song and dialogues with loud crescendos to new cultures of sound design that have changed spectators' affective associations with the ideological dimensions of a film.

Consider, for instance, the case of the immensely successful *Uri: The Surgical Strike* (Aditya Dhar, 2019; henceforth *Uri*), a slick propaganda film based on a heavily dramatized version of events that took place between India and Pakistan in the disputed territory of Kashmir in 2016.[3] The film begins with a placard that informs spectators that it is a "tribute to a New India." In an extremely manageable length (for a Bollywood film) of 2 hours 12 minutes it delivers a distilled, clear-eyed narrative of an Israel-inspired "surgical strike" on Pakistani terrorist basecamps led by Major Vihaan Shergill (Vicky Kaushal) with two characters representing (in a flattering light) Prime Minister Narendra Modi and National Security Advisor Ajit Doval. Clearly inspired by films like *Zero Dark Thirty* (Kathryn Bigelow, 2012), *Uri* was designed with the faculties of Dolby Atmos in mind. In an interview, sound designer Biswadeep Chatterjee said,

> I don't know how I would have approached this film if there was no Dolby Atmos, and being an action film, even the regular audience, they have reacted to the sound, which is a huge deal for us. Because sound is not really supposed to be heard, sound is supposed to be felt, it is supposed to be discreet. In a war film or in a horror film, it becomes far more obvious, because what happens is . . . their perception becomes very different, so when you have a bullet traveling across, [and] . . . somebody shoots a character in the front from behind, Dolby makes it possible—it is possible with surround sound. If the bullet comes from on top of my head, then it comes from the top speakers. If there is a chopper that flies over my head, I can actually have the chopper travel , I can hear the chopper on the speakers above. So . . . this is totally immersive sound in its true sense. Thanks to Dolby Atmos I could detail every path of the bullet, every flash, every machine gun fire, every bullet shell drop, all these things were possible. (Dolby Atmos 2019)

To this, director Aditya Dhar added that if someone is viewing this film on a screen that does not have Dolby Atmos, they would lose about 30 percent of its intended meaning. *Uri* is not a dialogue-heavy film, and it has no song-and-dance sequences or romantic plots. What it offers is an exceedingly stylized visual regime of weapons, drones, digital surveillance, satellite technologies, augmented reality, and gamified warfare, along with tall, able-bodied, quick-thinking, chiseled soldiers who are ready to fight. The surgical strike scenes and the film's climax—where a cluster of Indian troops enter Pakistani territory to kill terrorists and blow up their camps—are almost entirely devoid of dialogue and lean heavily on tracking shots and sounds: footsteps, gunshots, and explosions. The images on screen are often barely lit, except with the soldiers' night-vision goggles emitting a military green. The high jingoism of previous anti-Pakistan war films is unnecessary; Islamophobia and violence are framed as the only tempered and rational outcomes for "New India." The two female characters in the film—an intelligence agent and a pilot—are perfect technocratic subjects, able to deftly (and simultaneously) play caretaker to an ageing mother, work with satellite surveillance, and torture Kashmiris. *Uri* thus effectually deploys the multiplex's sonic infrastructures to galvanize the narrative merger of technology and patriotism. It is a powerful example of a new Hindutva-fueled military-entertainment complex.

By threading the multiplex into its production design, *Uri* demonstrates how several new material and infrastructural regimes animate each other. The film offers a dual representative nucleus: technically, it speaks to advances in India's film and exhibition technologies, and ideologically to its military might and ruthless patriotism. Therefore, cinematic sophistication, multiplex infrastructures, and visions of a militarized national modernity are meant to concurrently captivate the spectator. When walking out of the theater after watching an immersive film like *Uri* she should find herself in a techno-architectural sensorium befitting what she saw on screen. The multiplex therefore offers her a necessary continuity as she imagines herself as a new digitally proficient national subject and a cinephile who can grasp these new sonic and infrastructural domains.

PVR currently has nine different kinds of multiplexes, each designed for a specific class demographic. In each of these cinemas, different

elements are foregrounded in the packaging and conditioning of the cinematic experience, depending on the imagined class positions of the cinema's audience and its location. All of them, however, are driven by the singular goal of creating a heightened experiential environment—an endeavor to which sound is fundamental. On March 28, 2016, the company launched the Superplex, the country's largest and most infrastructurally advanced cinema theater. The Superplex is promoted as the new and improved version of the multiplex: it has fifteen screens, including three luxury Gold Class theaters, one IMAX, one 4DX screen, and nine mainstream screens, all equipped with Dolby's newest atmospheric sound technology. Bollywood star John Abraham, known for his stunt-action films, launched the 4DX theater, which is meant to "stimulate all the five senses" (Lal 2017b). The 4DX theater is equipped with motion seats and various kinds of special effects like fog, wind, lightning, water, and scent in both 2D and 3D. Films must now make themselves amenable to an evaluation of whether they can meet the infrastructural prowess of these new theaters. As an excited reviewer for *Batman v Superman: Dawn of Justice* (Zack Synder, 2016) wrote, "Buy tickets for the 4 DX screen and we promise the moving seats, mild wind and light spray of water will make up for the lacunae in the script" (Chowdhry 2016). Like *Uri*, several other recent commercial blockbusters across Indian languages, like *Padmaavat* (Sanjay Leela Bhansali, 2018), *K.G.F* (Prasanth Neel, 2018) and *Baahubali* (S. S. Rajamouli, 2017) have centered the multiplex's precise and three-dimensional sonic infrastructures in their production designs. P. M. Satheesh and Manoj Goswami (Dolby Atmos 2018), sound designers of the epic *Baahubali*, revealed that each sword in the film (and there are many) was given its own unique sound. The film also has sequences with no sound—again, imaginatively channeling the cinephile in the multiplex to remain quiet and engaged. However, this celebration of sound design and technology and the immersion they offer, is only made possible through the introduction of a new culture of hospitality, food, and service at the cinema.

Hospitality and Food

While PVR leaves no stone unturned in ensuring a hospitable environment for shopper-spectators, they also have strong ideas about which parts of

the subcontinent are "culturally ready for a multiplex," and by extension have expectations for customer service and hospitality. PVR has a set of indexes for determining where to build their multiplexes.[4] According to their Business Development Head, Vijay Kapoor, the three questions that drive theater building strategy are "When do I have to be in a city? Then, where do I have to be? And what do I want to build?" (Kapoor 2016). There are certain criteria that the city needs to fulfill. As Kapoor explained,

> How do I choose a city is not only based on the city populations. City population can be much more in Bhagalpur and Bihar for example: they may have 5 million people. But for me it is zilch, because they don't have the spending habits, rowdy behavior, uncertain political climate so on and so forth. So, when I would like to see a city, I would like to see a city, which even if it has 1 million population, then that population is conducive to watching movies in a particular way.
>
> So, the questions I will ask are: Is it safe for the customer to visit? For example, if someone tells me to open a cinema in Aligarh, I will resist. So much of communal riots and this and that. I don't want to go into those places.

Bihar and Bhagalpur are relatively economically underdeveloped compared to more metropolitan areas, while Aligarh is a Muslim-majority city and home to the historic Aligarh Muslim University. After location comes further reassurance. Vikas Sabharwal, Vice President, Architecture and Design, at PVR Cinemas elaborated:

> The moment they (audiences) enter inside, we have movie information on one side and a clock on the other so that they can check the time. *People in India still need reassurance.* Despite all the halls being clearly marked with the name of the show and the timings, many people still ask about the next show and whether they are at the right place at the right time. We try to give them that reassurance through the presence of various people around the hall. One has to understand that the experience you are referring to is not just about the set-up, but in also making the set-up work for the customer and make him feel comfortable. *We offer a service rather than a product, and the human touch is still very important in the Indian context.* (emphasis added) (Sabharwal 2016)

The provision of this reassurance is the responsibility of the PVR staff at the site of the cinema. Staff training, conduct, and behavior are crucial to the corporate customer service. According to their Brand Book,

> Our goal as a company is to have customer service that is not just the best but legendary. And to that effect we never stop innovating. You will experience it in everything around. From our exclusively trained and immaculately turned staff to our extremely engaging customer relations program, every detail is tuned to the highest degree. (PVR Cinemas 2015)

The PVR Cinemas Employee Manual has a section for its staff called "Do's and Don'ts at the Cinema Location." These are prominently displayed in several locations in the PVR corporate offices in New Delhi. The do's include performing to the best of "your abilities to achieve customer delight" and greeting "patrons with a smile, giving a human touch to delight them on every occasion." The don'ts includes losing calm and composure and displaying undesirable behavior with a fellow colleague or even an agitated customer.

Customer delight, according to Agneet Kumar, is defined as "above happiness" (Kumar 2016). The induction and training process for ushers at PVR is an intensive one. There is a two-tier induction process lasting a couple of days. The first happens at the corporate company level and the second at the site-specific cinema. Recruitment is made through employee referral schemes, newspaper advertisements, and campus interviews. The primary recruitment in the company happens at the level of employees who work at the site of the cinema, at "customer touch points" like ticketing personnel, ushers, and those employed at the food counters. Each PVR Cinema, depending on location and size, has an average of 75–100 employees. This is spread out across five departments: Enterprise Service Provider (ESP), Housekeeping, Food and Beverage, Engineering (including projectionist and sound personnel), and Security. They are also instructed on "how to use the staffrooms, the washrooms and how you have to present yourself in terms of looks" (Kumar 2016). This kind of specialized corporate vocabulary for a cinema hall, and the range of personnel who are now employed in film exhibition, is entirely new in the Indian context. Single-screen cinemas, for instance, were owned and operated by several male members of the same family across generations.

Sara Dickey (2000) has studied the relationships between gender, domestic labor, and private/public space in the upper- and middle-class Indian households. The presence of servants (domestic workers/labor) in these households is a crucial status symbol. As Dickey notes, the cleanliness of the domestic worker is of paramount importance to the employer. Women—responsible for maintaining the boundaries of inside and outside space—are deemed to be the best judge of the essential qualities of the good domestic worker. Cleanliness is determined by the way the domestic worker presents herself physically in terms of dress and "neatness." Dickey writes, "the cleanliness of all those in the household is crucial to the image that middle-and-upper-class people want to project of proper selves and homes" (2000, 475). Another dangerous zone is the unsupervised flow of "lower-class" culture, which includes language, taste, and manners. Upper-class children, who are still malleable and vulnerable to these influences, are often shielded from too much intermingling with the children of their domestic workers. The multiplex draws heavily from these ideas of domestic service already long prevalent in maintaining class- and caste-based barriers in the Indian household.

Like the mall, the multiplex strategically employs women to attract more gentrified spectators. Women are often employed to handle front-end jobs like ticketing because "they are most hospitality driven, they are warm, they are more welcoming" (Sabharwal 2016). The presence of female staff in a single-screen cinema in India was almost unheard of. This form of gendering of labor nods to the carefully regulated internal space of the Indian household. Men and women play different roles in maintaining class status. While men contribute through financial security and the prestige of a "respectable" occupation, women control the "symbolic aspects of the domestic realm," especially the appearance of the home, health, manners, and cultural practices (Dickey 2000, 482). Consider the following example: the company has special theaters called PVR Playhouse, designed only for children aged 5–9. It employs female staff trained in childcare for them. They double up as theater managers and babysitters. PVR Playhouse is a forty-nine-seat mini theater equipped with play seats, beanbags, a special kid's menu, custom designed mini-popcorn tubs, 3D glasses, and cartoon-themed interiors. For children who might find it difficult to sit through the entire two-hour duration

of a film, there are also slides and a small play area. Parents have the option of either accompanying their children to the film or leaving them there with the PVR staff while they watch another show. Along with the children's theater, PVR also offers specially timed shows for senior citizens, along with healthier menus and other assistance facilities. What these examples show is that the company's brand identity and industrial efforts are tied to a hospitality ethos centrally based on attracting female consumers. The strategic hiring of female staff as managers, caretakers, and babysitters makes the symbolic space of the theater a safe site, manned by a well-mannered, polite staff just adequately—but not excessively—like the spectator. They also aid in the cultural production of a unified class identity in a privatized public space like the multiplex.

A key aspect of hospitality is food. There are few sites as political and sacred in India as food and beverage consumption. Food is one of the central bastions of caste politics and religious identity. Here, the multiplex must move carefully between the global cosmopolitan, the regional, and the ultra-local. While alcohol is still out of the picture in a "family environment" like the multiplex (drinking in public for women in India continues to be mired in thick layers of moral policing), food and beverage sales at the cinema have been raking in massive revenues. PVR chief Ajay Bijli estimates that almost 30 percent of the company's revenues now come from food and beverage sales. They have also launched their own gourmet popcorn brand, 4700BC. On offer is standard American fast food associated with the movies: nachos, popcorn, pizzas, hotdogs,

Figure 2.4. A PVR Playhouse theater in Bangalore. Source: PVR publicity film *PVR Playhouse Kids Day Out Event* (PVR Cinemas 2019).

soft drinks, and ice cream. Along with these, there are sandwiches, dumplings, and customized offerings depending on location: *dosas* in Chennai, *chole bature* in Chandigarh, and *chaat* in Bombay. Menus range from no-onion-no-garlic options for the staunchest among the vegetarians to low-fat yogurt and muesli for those watching their diet.

In the higher-end multiplexes in Delhi, PVR has introduced in-house sushi (Simply Sushi) and brought on board a renowned sushi chef from one of Delhi's premier hotels. Mayak Tiwari, Executive Chef of PVR Cinemas, said, "The idea is to provide the facilities of a restaurant inside the cinema hall, but at the same time—the food should be convenient to eat while watching a movie. It's really important to make sure the food isn't too fragrant, since it's being served inside the theatre, and you have to think of the other customers" (Ahuja 2016). While efforts to offer non-aromatic food in India are quite ambitious, it does signal toward a tempering of the built environment through a lexicon of Westernized fast-food choices, and an organization of moviegoing as an act increasingly associated with full-fledged dining out, and not just casual snacking. After spending a day at PVR's most luxe offering, Director's Cut in Ambience Mall Delhi, a journalist wrote,

> If there's anything that's making me bet my money on DC [Director's Cut], it's not the films or even the chairs, it's the on-seat, gourmet food deliveries, that by the way, come supported by a slick menu and a remote control. This nifty amenity has a torch to help you pick from the cinema's 'Finger', 'Fork' and 'Spoon' selections and call a butler-esque dude, who appears out of nowhere (in my defense, auditoriums are dark) at the press of a button, only to promptly return with finger (or fork/spoon) licking preparations from their exclusive kitchen. (Pandey 2014)

Caetlin Benson-Allott's (2021) book sheds light on the history of alcohol consumption in American cinemas and how it changed viewers' reception of film as well as of theater designs. Like alcohol consumption, which can mean different things depending on race, class, and location, the material presence of an expansive food menu is paramount to "framing moviegoing as an experience." As Benson-Allott notes, "once alcohol is on the menu, it effectively turns movie theaters into restaurants which also happen to show movies." This makes

spectators increasingly ready to view moviegoing along a larger spectrum of recreation (133–135). The Indian multiplex too, despite its lack of alcohol service, follows this thought. For instance, their extensive and customized food menu often comes with multisensory nodes of access (touch, light, finger, press, button). The significant distinction here is that inebriation changes spectatorial response to the film being screened. In the American context, cinema-going with alcohol service ranges from the megaplex to boutique cine-bistro to microcinemas like the Alamo Drafthouse. It is not always tied to the mall-multiplex assemblage. Encasing the Indian multiplex, however, is the mall, which offers a plethora of food and drink options in the form of restaurants and bars, besides the ever-popular food court. The social politics of public alcohol consumption in India and its gendered and class-based implications are outside the scope of this book. Suffice to say that in the absence of alcohol, the Indian multiplex must plan its food and beverage materiality differently, while remaining legible to the larger global lexicon of exhibition as part of a larger spectrum of leisure.

Finally, this class-based index of hospitality and food ultimately rests on the perceived elimination of "unhygienic" elements both literally and figuratively.

Risk, Dirt, and Hygiene

In the work of risk mitigation, the mall and the multiplex share a symbiotic relationship. As an amalgam, they collectively understand spatial risk and share the work of its regulation. This is done through a constant alleviation of localized class- and caste-based anxieties while simultaneously addressing long held desires for public architectures that reflect the global present-spectacular. During my research, I frequently encountered terms like *hygiene*, *safety*, and *security* as the "three pillars" upon which PVR's brand identity stands. The Business Development Head, Vijay Kapoor, spoke about "developing and changing consumer habits" in the country:

> The movie watching experience changes. You are watching a movie in a dingy environment and suddenly you find Italian marble and other *shosha* [Hindi colloquial term for glamor], with very secure, very safe,

Figure 2.5. Inside PVR Select City. Photo by author.

very hygienic place, you would love to. Why not? People get addicted. I know a few of my properties in Delhi, people come from Jalandhar and Lucknow to watch movies. That's an experience. That's how you change. (Kapoor 2016)

Notably, these were not qualities associated with the cinema hall in the subcontinent in the decades prior to the arrival of the multiplex. The cinema was often a space full of risk, marked by clandestine visits from those who were not quite supposed to be there. It was a space for transgressions, both pleasurable and uneasy. To remake spectatorial practices, the multiplex sought to polish and scrub away the risky corporeality of the single screen.

One of the feelings they sought to erase was that of transgression in public, which remains a key site of navigation for women. The corporatization of moviegoing means that the exhibition site becomes a brand

in need of promotion as an independent entity, existing wholly outside the film text. PVR seeks to maintain an aura of "something exciting constantly happening" (that was the organic norm at the single screen). Except, at the multiplex, spectators are now faced with a multitude of corporate entertainment events meant to keep them engaged: ultimately, "if I am caught coming out of a PVR I should not be ashamed" (Dutta 2007). Another transgressive act for women is simply being outside the home. Historians (Chakrabarty 1991; Chatterjee 1993) writing about the concept of private and public space have elaborated on how the outside was associated with dirt and disorder, filth, and chaos. The home was thus defined as the antithesis of these. Household waste or the dirt that goes outside the home marks the boundary between the inside and the outside. David Morley (2000) observes, "as housewives of the world, women are expected to be the epitome of cleanliness themselves" (70). At the unenclosed single-screen cinema, an extension of the street, the anxieties around cleanliness often revolved around the squalid conditions of the women's bathrooms—which prevented hygienic middle-class women from being at the cinema for three long hours. At the multiplex, restrooms rival those of luxury hotels. As Nitin Govil writes,

> the Indian multiplexes' pristine public restrooms invite the consumer to identify cinema as another space of social exclusion, based on a propriety founded on the divisions of class and caste. Here the "public" restroom is a kind of utopian space, off-limits to the lower classes, except perhaps for the janitor who is responsible for the sparkle. The multiplex toilet elides the form of "degraded" urban experience deemed antithetical to the project of the newly globalized Third World City. Simultaneously *of* the city and *outside* the city, the multiplex's public restroom is a strange kind of oasis, a denial of alterity that threatens to contaminate the global city from within. (2015, 136)

Ranjan Singh, Publicity Manager for the now disbanded Bollywood production house Phantom Films, known for primarily their many multiplex films, shared the following anecdote (Singh 2014). The year was 1994, three years before the arrival of the country's first multiplex. The film industry had lost its middle-class audiences to the homebound pleasures of television and VCRs. The 1980s was a "garish" and "dark"

decade and with no quality "clean family films." That changed in 1994, with the blockbuster family film *Hum Aapke Hain Koun..!* (Who Am I to You? Sooraj Barjatya, 1994), credited widely for being the film that made gentrified spectators return to the cinema. According to Singh, in the months prior to the film's release, the makers toured several single-screen cinemas, paying particular attention to the clean-up of the ladies' toilets. Without it, they saw no possibility of bringing the gentry back for repeated viewings, and crucially they wanted also to imbue the film with an affective cleanliness that surpassed its virtuous narrative.

Being outside after dark and in dimly lit conditions poised another set of problems for women's access to public space. At the single screen, it is frequently possible to see no women at all, especially during the night show (9 p.m. to midnight). The mall and the multiplex are spaces that cannot be imagined devoid of women, at any time of the day or the night. Bright lights and activity therefore must flood the multiplex. As Agneet Kumar, Chief Architect of PVR, elaborated, "we are providing an infrastructure which is bright, safe, well occupied, action packed and since it's a multiplex the ticket prices are more, so you generally don't have nuisance creators walking in because nobody wants to pay a three hundred buck ticket as opposed to a fifty buck ticket that you end up paying to a single screen" (Kumar 2016). This is also geared toward a refining of the demographic politics of the multiplex: "we keep ourselves branded to a certain section of society." For instance, for couples, the Gold Class theaters have special "Love Seats": the hand rest that divides two seats can be eliminated at will. Small acts of transgression for unmarried women, like secretly going to the movies with one's partner—long associated with the single screen—are now sanctioned and given social legitimacy for those who can afford to date at the multiplex.

Despite their commitment to a demographic politics of class, there is, however, a sophisticated degree of minute customization in place to evoke measured nostalgias among spectators. PVR focuses on standardizing elements like seating, bathrooms, ticketing, audio, and film projection, but the softer elements of interior design of each cinema are meant to reflect the "kind of crowd that is coming in." The middle and upper classes are not without gradation. For instance, in Delhi, many characteristics of theaters in IT-heavy suburban spaces in the city like Gurgaon—populated by "DINKs" (double income no kids married

couples)—will differ from those of cinemas located in the city's older affluent neighborhoods: colors, wall art, the number of screens, the depth of the cinema, the timing of the shows, the number of security staff, and so on will all be fine-tuned to their location.

Yet, occasionally, the multiplex finds itself up against spectatorial cultures and idiosyncrasies that continue to elude corporate categorization. One of these is the cultures of fandom associated with the male star. Some PVR multiplexes in Tamil Nadu, where superstar Rajnikanth enjoys God-like stature, have designated a space in the theater where fans can come and perform ritualistic *pujas* with incense sticks (typical in single screens). I asked how such behavior is conducive to PVR's moviegoing culture. In response, Vijay Kapoor, the Head of Business Development, said, "No, it's okay for us. See, you can't hurt the audience. India is a very sensitive market. You have to respect the sensitivity and sensibility of everybody. So, we have dedicated a space: this is where you can go and do your *puja* with your incense sticks. You can't be insensitive to the people's feelings" (Kapoor 2016).

This anecdote about Rajnikanth fans performing Hindu worship rituals inside a multiplex complicates the neater and more overarching narratives of orderly spectators in a globalized regime of light and glass architectures. New architectures cannot completely erase old spectatorial affects (also see chapter 4). Despite the multiplex seeming like a location-neutral, flat "non-space," the corporatization of film exhibition

Figure 2.6. The multiplex's gendered address. Source: PVR's publicity film celebrating 25 years of the company, *Iss Andhere Mein Bahut Roshni Hai* (Dedhia 2019).

has in fact sharpened local attunements to existing spectatorial pleasures and anxieties. India remains a "sensitive market" where "people's feelings" belong to the industrial dictum of moviegoing. These spectatorial affects are not just tied to enduring cultures of fandom but are fundamentally class and caste coded—despite efforts to keep the multiplex a calm and sanitized space through a politics of exclusion, rampant bad behavior prevails. People litter, and spill food and drink with abundance; as the middle class, they are entitled to cleanliness, but not responsible for it. Class and caste coding is also highly visible in spectators' attitude toward the multiplex staff, who are often treated badly and bear the brunt of hostile and rude behavior for small mistakes like a delayed food order. Company HR and hospitality manuals instruct employees to not talk back to customers, lest they be offended and power relations upset. On numerous occasions in multiplex across cities like Delhi, Kolkata, and Bombay, I have observed incensed men and women berating servers, while they stand silently and wait for the moment to pass. What such incidents highlight is that despite conflating class with "good audiences," the multiplex is ultimately unable to entirely order spectators to into its behavioral regime, or eliminate heated exchanges, dirt, grime, and other murky things from its environs.

* * *

This chapter has outlined how the last two decades have seen a large-scale overhaul of the entire territory of media industry players traditionally involved in film exhibition. It has explored one of Delhi's prominent public leisure sites—a mall and multiplex assemblage—and the many conceptual elements that go into the meta-architectures of these spaces. This includes planning, design, development, execution, and publicity. Select Citywalk and PVR Cinemas are prototypes of a multitude of other mall-multiplex ecologies that now define urban entertainment and leisure in urban India. What emerges from this mix is the centrality of a new regime of gendered space: one that is industrially calibrated and folded into the material textures of these spaces. Film exhibition in India can no longer be studied without considering the shopping mall. The mall is a liminal space, facilitating the passage of spectators from one polished interior to another more insulated interior, thereby breaking up the more jarring transition from the street to the multiplex, and offering

continuity. The mall is the essential enclosure for the multiplex. Spectators are shoppers first. Categories like cleanliness, dirt, risk, and hygiene are all anchored in traditional middle-class and upper-caste gendered anxieties around sharing space, both private and public.

Those who design malls and multiplexes are also tasked with writing the visual signage of the global city. Architecture and design firms frequently dabble in several major urban development projects ranging from corporate offices to condominiums that take the shape of vast residential projects. They work across several cities in Asia and the Middle East known for global commerce and urban redevelopment, including Singapore, Dubai, Bombay, Abu Dhabi, Manila, Jakarta, and Shanghai. Drawing upon their expertise, the mall-multiplex continues to largely center itself in the work of ever expanding the collective desires and fantasies of the new middle class—a process that began with the arrival of color television and home video. This chapter finds that without a visible reassurance of the sexual and emotional safety of the middle-class woman writ large on their material and architectural choices, these spaces cannot legitimize themselves in India. Therefore, the mall-multiplex's recasting of the cinema hall as a new experience begins with "cleaning" as essential assuaging. The analogous changes in the vernaculars of popular cinema then must be deciphered within this new spatial regime of what the "cinema hall" has come to mean.

3

The Multiplex Film

This chapter expands on the relationship between the shopper-spectator in the mall and the spatial vocabularies of the new multiplex film. A significant number of these films have chosen to narrativize the dark and unintended consequences of globalization as the key trope, leading to a surge in location-centric realism on screen. Crucially, the multiplex spectator and the built environment they inhabit are mutually imagined at the site of production. In other words, the multiplex film can read neoliberal desires for safe *anxiety tourism*. In a secure environment, surrounded by cohorts of their own socioeconomic class, marveling at the sparkling interiors and Dolby Atmos sound, the multiplex spectator can journey through the uneasiness of those urban experiences that are carefully and continuously scrubbed from the mall. The multiplex engenders a psychogeography where a film can address the complex and uncanny sides of the nation's contemporary condition and simultaneously negate the need to make this experience public, when it can so easily be appropriated in private. It makes the disquieting landscapes of these films palatable. The Indian multiplex is writing a new history of relations between cinema and space, marking a significant departure from its antecedent, the single screen: a thoroughly public site full of unpredictability and excess, where middle-class fears found no safe refuge.

Delhi has emerged as a privileged site for the multiplex film, an endeavor that diverges from the industry's relationship to depicting its own city, Bombay (see also Mazumdar 2007). Integral to the rise of the Delhi film is the centrality of everyday gendered violence in the city that has long plagued the capital but become a dominant part of public discourse after the brutal gang rape and murder of Jyoti Singh on December 16, 2012. She was also given the name *Nirbhaya* (the fearless one) in both press and popular discourses. The overwhelming and routine anxieties of navigating the city as a woman have

found powerful narrative expressions in the Delhi film. Here, I discuss three recent films—*Pink* (Aniruddha Roy Chowdhury, 2016), *NH10* (Navdeep Singh, 2015) and *Dev.D* (Anurag Kashyap, 2009)—that have thematically engaged with gender and space in the capital. Though these multiplex films belong to diverse genres—a courtroom drama, a slasher, and a twist on a familiar melodrama—when read together, they offer portraits of a globalized city where presence of women in public is ostensibly accepted, but their partaking of the "wins" of a neoliberal life continues to remain thick with apprehension. These films weave together fiction and documentary, peppering the narrative with references to real incidences of violence that have occurred in the city in the recent past. Reading these films spatially reveals how the multiplex spectator is anticipated and embedded in narrative and thematic junctions of the new multiplex film.

In foregrounding realism across narrative and mise-en-scène, these films also draw upon the contemporary culture of the reality spectacle. Moinak Biswas (Vasudevan 2002; cited in Kapur 2009, 162) has discussed the "reality effect," which is essentially an aesthetic of immediacy directly inspired by television's obsession with the contemporary. Jyotsna Kapur (2009) traces the arrival of the "conspiracy thriller" genre in neoliberal India, and argues that unlike live television, where anything can happen, cinema is a more controlled rendition of the event, giving it "closure." As she writes, "closure domesticates the event into social relations of power" (163). While the films discussed here do not explicitly draw on a singular event in the city, in several ways, they not only allude to the gruesome events of December 16 (*NH10* and *Pink*) but are also in dialogue with the widespread incidences of arbitrary rage-related deaths and murders, molestations, harassments, kidnappings, accidents, and media scandals that have besieged the capital (*Dev.D*). Together, these films comment on an overwhelming and acute urban crisis that cannot be contained within a singular event. The multiplex is the perfect capsule within which spectators can have controlled encounters with traumatic events and nihilistic landscapes. In privileging an aesthetic of immediacy—where several small and big events collapse into an interminably anxious landscape—these films can leverage the architectonics of the multiplex to narrate the all-too-familiar and disquieting experience of being a woman in the city.

NH10 is the story of an elite insular couple who live and work in suburban Delhi and decide to take a road trip to the neighboring mostly rural state of Haryana. This trip quickly goes awry when they encounter the world outside their secluded lives. *Pink* focuses on the aftermath of an incidence of sexual harassment where a group of men stalk and harass a group of female friends who are known to them. While *NH10* broadly belongs to the relatively unexplored genre of the road-trip-gone-wrong horror film in India, *Pink* reworks one of the most familiar narrative tropes of Hindi cinema: the courtroom drama. Finally, *Dev.D* is an adaptation of *Devdas*, a text frequently used to discuss narrative structures, ideologies, melodramatic codes, and gendered representation in popular cinema, both before and after its Bollywoodization. *Devdas* has been made eight times since the 1950s. In the multiplex rendition, the film radically breaks with the iconic canon, especially in its interpretations of the stock characters of the virtuous girlfriend/wife, the courtesan/prostitute, and the melodramatic hero, and offers a thoroughly multiplexed version of a mainstream classic.

A Capital in Crisis: The Delhi Film

Delhi as landscape and character had barely existed in popular Hindi Cinema before the multiplex moment, barring a couple of films like *Chashme Buddoor* (Far Be the Evil Eye, Sai Paranjpye, 1981). Delhi's emergence as a prominent new player in a spate of multiplex films has subsequently spilled over to a number of prestige shows on India's streaming platforms. Examples include *Khosla Ka Ghosla!* (Mr. Khosla's House, Dibakar Banerjee, 2006), *Delhi-6* (Rakesh Omprakash Mehra, 2009), *Oye Lucky! Lucky Oye!* (Hey Lucky!, Dibakar Banerjee, 2009), *Dev.D* (Anurag Kashyap, 2009), *Love, Sex aur Dhokha* (Love, Sex and Betrayal, Dibakar Banerjee, 2010), *Band Baaja Baaraat* (Bands, Horns, and Revelry, Maneesh Sharma, 2010), *Do Dooni Chaar* (Two Times Four, Habib Faisal, 2010), *Delhi Belly* (Abhinay Deo, 2011), *Vicky Donor* (Shoojit Sircar, 2012), *B.A. Pass* (Ajay Bahl, 2012), *Fukrey* (Wastrels, 2013), *NH10* (Navdeep Singh, 2015), *Titli* (Butterfly, Kanu Behl, 2014), *Pink* (Annirudha Roy Chowdhury, 2016), and shows like *Delhi Crime* (2019), *Made in Heaven* (2019), and *Paatal Lok* (Netherworld, 2020) on digital platforms like Netflix and Amazon Prime Video.

Ravi Sundaram (2007) points out that Delhi's psychosis, which is marked by two major events of large-scale, visceral communal violence (Partition in 1947 and the Congress-organized Sikh Massacres following the assassination of Prime Minister Indira Gandhi in 1984), presents a unique case of a postcolonial media-saturated city where "fear has become implicated in the larger social theater of urbanity" (31). Deeply intertwined with Sundaram's thesis is an additional layer of the city's present pathology: rape culture and the aftershocks of the Nirbhaya gang rape and murder. Initially, the Delhi film did not tackle this palpable anxiety. The narratives sought to revise representational tropes, often sketching new female characters: economically independent, ambitious, and sexually active (*Band Baaja Baaraat* 2010, *Queen* 2014). Post-2012, however, the Delhi film has started to venture into the fearful domains of everyday violence.

Many directors working on these films are from the city and draw on their experiences of growing up in the bedlam of globalization and media frenzy. Eschewing the designer city of the Bollywood film, these directors privilege close explorations of the city's various neighborhoods, with considerable attention to the cultural details of speech, mannerisms, and costumes along with location shooting. Dibakar Banerjee is one of the most prominent directors and producers associated with the multiplex film and especially the Delhi subgenre.[1] His first two films, *Khosla Ka Ghosla!* (Mr. Khosla's House, 2006) and *Oye Lucky! Lucky Oye!* (Hey Lucky! 2009) both chronicled in different ways the lives of Delhi's middle-class Punjabi residents after liberalization. Banerjee extensively drew upon his experiences of growing up in the city and discussed this relationship to space and class in an interview:

> Apart from the fact that I grew up in Delhi and know it well, what fascinates me is that it's the city where the fault lines of India are exposed the most. Where absolute feudalism conflicts with absolute consumerism.... When Khosla Ka Ghosla released, everybody associated Delhi with India Gate or Qutab Minar or such historical staples. Outside of Garam Hawa and Jaane Bhi Do Yaaron, nobody had gotten into the belly of Delhi. Nobody got into the actual bloodstream of Delhi. But as I was from Delhi, I was not even conscious of [the stereotypes]. And Kanu (Behl; director—Titli [produced by Banerjee]) is also from Delhi, though he's

about eight years younger, but from roughly the same background. Extremely middle-class. Neither upper nor lower, but absolutely, firmly in the middle of the middle class. (Ganapathy and Mallick 2015)

The Delhi films also often draw on real incidents that have happened in the city in the recent past reflecting the uneasy, sometimes comedic, and frenzied responses to globalization. *Delhi-6* (Rakesh Omprakash Mehra, 2009), for instance, fictionalizes a real event: the bizarre case of the monkeyman that terrorized the working-class residents of the city in the summer of 2001. Newspapers had initially reported that a black monkey (*kala bandar*) was attacking people at night. This creature soon morphed into a monkey-human hybrid, stirring up an intense media storm and several hoax calls to the Delhi police. The authorities finally concluded that this was an illusion, a result of "mass hysteria" and "fear psychosis," but the lower- and working-class residents of East Delhi insisted that there was a real monkeyman. Sundaram writes that "so excessive was the representational and affective world of the event that it was not easily amenable to forms of criminal profiling" (2007, 33). He argues that the monkeyman terror in Delhi was a form of postcolonial haunting; the violence and killing of the Muslims during Partition in 1947 and Congress Party–organized massacres of the Sikhs following the assassination of Indira Gandhi in 1984 had not been commemorated or given any memorials. The city, therefore, has an "unredeemed debt to its dead" (2007, 31). The memories of these killings and losses survive in ghostly archives of personal stories and stray literature, and often find haphazard releases through moments of acute crisis in the capital, ranging from fatal accidents to infrastructural shortages like water and electricity.

A Trigger Event

Delhi's notoriety for sexual violence is often expressed through the informal moniker "rape capital of India." The Jyoti Singh rape led to unprecedented and large-scale public protests about the unsafe public environment of the country and the need for more stringent laws for dealing with gendered violence. The English-language press played a significant role in shaping the discourse on rape and women's safety following the incident. When the news of this incident first reached the

leading English daily, *Times of India*, three things struck the editor: "the girl was a student, she had been to an upmarket mall, and she had been watching an English-language film, *The Life of Pi*. He told the crime reporter to write 500 words for a page 1 lead" (Jolly 2016). This incident was considered a major "trigger event" in the discourse around rape in the country, and especially Delhi, because "the victim was perceived to be from the right class, she was perceived to have been blameless for the crime, and she was raped by strangers" (Jolly 2016). In other words, the incident in many ways fed into the deepest fears of the middle class—sexual violation of their women by working-class migrant males.[2]

The English-language press considered Jyoti Singh to be a "PLU" (people like us)—from an upper-class, upper-caste background that is the same as those of the employees at these newspapers and the middle classes who read them. PLU also means that the person has a social life, goes out, and is employed. According to Smriti Singh, a former reporter for *Times of India*, "There is this term we use called PLU—it means 'people like us' . . . Whenever there is a murder or rape case involving a female, in your head you have a checklist as to whether the story qualifies to be reported or not. You have to think whether the victim is a PLU" (quoted in Jolly 2016). Similarly, Aditi Saxton, from the now-defunct news magazine *Tehelka*, said (in Jolly 2016), "It fed very much into the 'people like us' narrative because of the decision she took to go to a movie and take a bus home—all of these decisions are familiar to women belonging to a certain socio-economic class." Jyoti Singh, however, was not PLU; she was very much a "PLT" (people like them): she came from a lower-middle-class background, and her father was a laborer at Delhi airport. It was reported that she was a medical student, which, when coupled with her presence in an upmarket mall, led to this confusion about her class status. According to Manoj Mitra from *Times of India* (in Jolly 2016), "She was actually from the PLT ('people like them') side. But people didn't realize that because she happened to come out of a mall in South Delhi which was frequented by middle-class people." Women who are raped and who belong to the PLT category—non-urban, non-English-speaking, lower-class, lower-caste, and older—rarely find space in the press. In the case of Jyoti Singh, by the time the newspapers had managed to clear the confusion regarding her social and economic status, the story had taken on an

independent life. Finally, the report finds that the rise in dialogue and discourses around rape in urban India is directly linked to the arrival of middle-class women in the workforce (also the total female participation in the labor force in India remains just 27 percent). The presence of middle-class women in the urban workforce has increased significantly since the 1990s; it is the safety of this class that theoretically dominates urban design—and public opinion on rape.

The arrival of young, poor male migrants in the city is seen to be the primary threat to the sexual safety of the middle-class woman. Since the December 16 gang rape, reporters claim that it is easier to get stories commissioned on rape, and increased rape coverage has persisted since 2012. However, the insistence is on certain trigger words like "gang rape," "juvenile" (one of Jyoti Singh's rapists was a juvenile), and "brutality" as newspapers hope to recreate the effect of the 2012 incident (Jolly 2016), which took on the nature of a media event with fervent newspaper campaigns asking for death penalty for rapists. Thus, the horror of December 16 was a watershed moment in acknowledging the many violent reactions to women's arrival and mobility, and their right to access the city. It also disclosed the tendencies toward selective public outcries, dependent on whom the victim is perceived to be. This is crucial to any understanding of why a preoccupation with the sexual safety of middle-class women has taken center stage. It also led to a revision of laws around rape and the establishment of fast-track courts to deal with cases of sexual violence, though marital rape remains unrecognized as a criminal offense. A committee led by an ex–Supreme Court justice, J. S. Verma, produced an extensive and visionary report detailing the deeper societal and economic causes of violence against women. The suggestions of the Verma Committee report, however, remain largely unimplemented. It is also acknowledged that the government issued the death penalty to the rapists to satisfy the outpouring of public outrage.

How does the multiplex film accommodate this moment? Importantly, the rape scene had been a staple in Hindi Cinema before "clean" Bollywood. It was, however, a peculiar caricature—one important way to mark the villain was through his attempt to rape. In the 1980s, a spate of "avenging woman" films emerged in popular cinema. This was a response to women's movements and protests over violence and several publicized rapes that occurred in the country then. The narrative arc

of these films was as follows: the heroine-as-protagonist is raped; she then goes on to seek revenge and retribution.[3] Lalitha Gopalan (1997) suggests that because female bodies in Indian cinema have been used as a stand-in for sex and for scopophilic pleasure, rape is never neatly cordoned off from this ideology. Therefore, the "avenging woman" genre was ultimately a masculine creation despite centering the female protagonist; ultimately, she had to assert her power in a violent and masculine manner, keeping the final authority of the state intact. In the post-1990s era of the family film, rape and violence largely disappeared from the screen. They had no place in the melodramas and romances meant for global distribution to a large and economically profitable NRI market. The multiplex film shows a noticeable shift from this hegemonic Bollywood aesthetic and foregrounds violence and anxiety as the central indices through which we can inhabit the contemporary city. Thus, an analysis of cinematic form in the aftermath of a major crisis offers an archive of public resonances. In this case, traces of the 2012 rape and its affective impacts on women in the city are evident in the multiplex film's spatial imagination and construction of the capital's "realism" on screen. At its heart, it inscribes the multiplex spectator into the content.

Rage, Landscape, and the City of Glass in *NH10*

NH10 largely follows the road-trip-gone-wrong genre, popular in American cinema, but offers a stark and destructive portrait of an encounter between the planned global city and its boundaries. It evokes one of the most pervasive fears felt by most women in the capital: the terror of navigating the city alone at night. *NH10* effectively used the atmospheric and overhead sound technologies of the multiplex to make spectators feel a palpable sense of suffocation and paralyzing dread twisting through the suburban city of glass, high-rise apartments, offices, malls and car windows, unknown figures on the streets, dense smog, hushed whispers, screeching tires, shattered glass, desperate pleas for help, and the sound of an iron rod scraping against gravel.

The city-village tension—a staple of several national cinemas—undergirds the narrative of this film. The city here is an artificial postindustrial built environment of glass architectures that collides against the atmosphere of rage emanating from the surrounding barren

landscapes. *NH10* borrows heavily from the classic Hollywood slasher and rape-revenge films, both of which have engaged extensively with the rural-urban divide. Carol Clover (1992) has argued that the female protagonist's revenge in these films is ultimately an allegory for the city's revenge on the country. The male group dynamic suffuses these genres, leading them to acts they may not be capable of singularly, thus signaling "patriarchy run amok" (121). The politics of the male group is leveraged in both *NH10* and *Pink*—a direct legacy of the December 16 gang rape. Another characteristic feature is the power relations between men and women that make rape/violence an avengeable act. Rape, as Clover rightly says, is a political act, and the fantasy of female revenge "brings with it detailed and sometimes trenchant analyses of quotidian patriarchy" (144). The city-village tension is not new in Indian Cinema. What is novel is the use of the identifiable American slasher to narrativize the contemporary urban crisis, especially given that mainstream success has long evaded horror as a genre in the subcontinent.

The rural-urban divide was a fundamental concern for popular cinema post-independence. The city was a dominant metaphor for loss and displacement, often signifying cruelty and capitalist greed. The village occupied the realms of guilt-free nostalgia.[4] Post-globalization, gritty urban realism was replaced by a designer aesthetic, or what Ranjani Mazumdar (2007) has called the "panoramic interior." The light-filled interiors and sets of the Bollywood family film spanning across homes, colleges, malls, coffee shops, and restaurants that the characters inhabit mimicked a simulated experience of shopping. As Mazumdar says, "The panoramic interior expresses a crisis of belonging, fear of the street, and the desire for the good life—all at once. In this architectural spectacle of light space, the absence of dark space is significant" (148).

NH10, in many ways, undoes the panoramic interior of the Global Bollywood film. It relinquishes the fantasy of the interior for the terror of the exterior. *NH10* is named after National Highway 10, a 405-kilometer road running from Delhi to Punjab and crossing the state of Haryana. The film opens with shots of Gurgaon, 32 km southwest of Delhi, a part of the National Capital Territory (NCT). It is a part of the state of Haryana, infamous for all kinds of crimes against women, especially female infanticide and honor killings,[5] leading to the state having one of the lowest sex ratios in the country. Gurgaon is a template for India's uneven

urbanization. While it is the IT hub of Delhi, full of Fortune 500 companies, fancy condominiums, mega-malls, and fine-dining restaurants (see also King 2004), the suburb struggles with high crime rates: rapes, robberies, and assaults are on the rise. Gurgaon—a suburb of Delhi, but part of Haryana—is also in sharp contrast to the rest of the predominantly agrarian state, with rampant electricity and water shortages. Gurgaon's big corporations operate with their private power backups. The private real-estate giant DLF (Delhi Land & Finance) and post-modernist architect Hafeez Contractor are largely responsible for Gurgaon's built environment. Through the 1980s, DLF used the Haryana state government's pro-land policies to grab land from the local farmers to build a five-phase planned township—the largest in Asia—called DLF City (Kalyan 2011). Gurgaon is an artificial space that belongs to postindustrial global capitalism, and what urbanists have called "a city which, rather than being a single coherent entity, consists of a number of large spectacular residential and commercial developments with large environmentally and economically degraded spaces between them" (Hall 1998, 80; quoted in Kalyan 2011, 29). Unlike Silicon Valley, where infrastructure preceded corporatization, Gurgaon is "developing in reverse"; tall glass buildings are often served by dirt roads (Martin and Baxi, 2006, 79).

In *NH10*'s establishing shots, we see Gurgaon at night through the windows of a car. A couple is casually arguing about having to go to a work party. The sequence, shot and framed at eye level, is deftly edited to produce in the viewer a sensation of moving with the couple in the car, watching the city lights go by. The protagonists, Meera (Anushka Sharma) and Arjun (Neil Bhoopalam), are an elite corporate couple who live and work in Gurgaon. They are headed to a party. Halfway through the party, Meera must head back to work. We see her driving alone; it is winter, the streets are thick with fog. Two shadowy characters emerge on a bike and begin to stalk her, quickly trapping the car and smashing its windows with a rod. This shattering of glass, the symbol of Western architectural modernism, with a primitive weapon—an iron rod—sets the stage for what is to come. The iron rod becomes a recurring motif through the narrative, and an especially potent symbol after the Nirbhaya rape (an iron rod was used to brutalize her). These scenes—the chase, stalking, entrapment, and shattering of the car window—imply that catastrophe is an imminent possibility, even in a global city. The

Figure 3.1. Establishing shots of NH10; glass architectures everywhere.
Source: *NH10* DVD.

foggy road in the dense Delhi winter is lit with muted yellow lights, precluding a point of view beyond the immediate stretch of empty road ahead. The shot is once again framed tightly, with an eye level camera placed inside the car, much like the film's establishing scenes. This time, the same techniques are used to trap the spectator in the car, offering no escape from the attack.

After this close call, from which Meera does manage a quick getaway, the couple report the incident at a police station. The officer-in-charge advises them to get a gun and asks Arjun to not let his wife travel alone at night. He discharges them with a comment on the situation: "this city is a growing child, sooner or later, it's going to jump." Meera suffers from post-traumatic stress as she tries to move on from the incident. Arjun suggests they take a weekend trip. The couple has since acquired a gun. The first ominous stop on this trip is the Delhi-Haryana tollbooth, marking both a literal and metaphorical boundary crossing. The toll keeper tells them that one of his colleagues was recently killed. Four men in a Pajero shot him when he asked them for the toll fare. Like other multiplex films, *NH10* speaks to the contemporary reality spectacle. This scene refers to what has been called rage-related "random acts of violence" in the capital, a bizarre and dangerous phenomenon. In the last two decades of rapid globalization, an unlikely byproduct—rage— has overtaken the capital. Several incidents of people being beaten, shot, or killed over minor scuffles on the road or at home have been reported.

Figure 3.2. Meera is attacked; a heavy rod smashes her car window, foreshadowing the film's key trope. Source: *NH10* DVD.

In 2011, four men killed a seventeen-year-old boy because he did not give them a screwdriver. In Khan Market, one of the city's wealthiest areas, an airline pilot ran over a restaurant manager when their vehicles grazed each other (Magnier 2011). A man killed his friend for not giving him a cigarette; a call-center worker was shot for spilling someone's food. In a famous case, model Jessica Lal was shot dead in a bar for refusing a drink to Manu Sharma, the son of high-profile politician (also dramatized in the multiplex film *No One Killed Jessica*). Urban alienation, frustration, and quick accumulation of wealth have been cited as reasons for these unfathomable crimes. According to sociologist Ashis Nandy, "there's something increasingly desperate in people" (in Magnier 2011). *NH10* offers a chronicle of this unravelling desperation.

The next stop on the trip is a roadside eatery, where they witness a gang of men brutally attacking a young couple and dragging them into a jeep. Arjun tries to interfere, but he is quickly shut down with a slap. The gang leader, Satbir (Darshan Kumar), tells him to stay out; the girl is his sister. The gang drives off with the couple. In a displaced attempt at bravado, and to subliminally make amends for the night his wife was attacked, Arjun decides to chase this gang. Meera pleads with him to let it go, but as an upper-class urban man threatened, he says he only wants to scare the "idiot villagers" with this new gun and "teach them some manners."

Predictably, the decision proves fatal. Arjun spots the gang's jeep parked in a desolate location off the highway. They end up witnessing the honor killing of the young couple, Pinky and Mukesh. This too is loosely based on a real-life incident: the Manoj-Babli honor killing of 2007 in which the relatives of the newlywed couple murdered the girl for marrying within their sub-caste, or *gotra*, an act prohibited in the community's societal norms. The Khap Panchayat, a caste-based religious council among the Jats in Haryana, ordered the killing. Notably, it was the first time that a court convicted the perpetrators, as these kinds of extrajudicial bodies had been operating for years in the country's villages with covert state approval.

In *NH10*, the couple is savagely attacked: Pinky is force-fed poison and then shot, while Mukesh is repeatedly stabbed with a rod. They are then dumped into a makeshift grave. The gang has by now also found Arjun and Meera spying on them and captured the two. They are locked out of their car and the keys are taken from them. Their car is the only semblance of a safe interior space available to this couple in the wilderness. A loss of access to this remaining vestige of their old life indicates a loss of every resource they can muster: communication (phones), quick mobility, and even money. Arjun manages to shoot one of the gang members, and they make a run for their lives, now left with nothing but whatever survival skills they can gather. They falter, and Arjun is stabbed. They eventually find an unmarked tunnel under a train track, where Meera asks a badly injured Arjun to wait while she goes to find help. From here, Arjun's part in the narrative is over and the rest of the film chronicles Meera's lone journey through the night. The film's color palette and tone now entirely shift to dark colors like black, grey, and green with small incursions of a sickly yellow expressing the terror and desperation of the long night. The mise-en-scène, for the most part, consists of the bleak "outside" made up of dust, gravel, stone quarries, knives and rods, and barren landscapes—thus evoking for the multiplex viewer the *offscreen* space that surrounds their bubble.

As the day turns into night, the film's frames—emptied of glittering city lights—take on a spectral quality. The characters descend into more violence and brutality. In the next few scenes, a harrowed Meera runs through the desolate dirt roads of rural Haryana trying to find help. The gang is chasing after her. She finds a police station where a junior officer

refuses to help her the moment he hears the words "honor killing" and asks her to leave immediately. Subsequently, the superior officer shows up, and at this point, they have an eerie conversation in his car. He tells her that the police do not function in vacuum, and they are a part of the society in Haryana. He asks her about her caste, but Meera does not have a clue. Surprised that she can function in society without ever knowing her caste, the officer tells her that any 12-year-old in these villages will know all the details of their caste. This officer too offers a symbolic dialogue: "Gurgaon mein jahan aakri mall khatam hota hai, wahan aapki democracy aur Constitution bhi khatam ho jata hai" (Democracy and constitution end with the last mall in Gurgaon). He then insinuates that Mukesh and Pinky should not have gone against their caste laws. Meera realizes that the police are complicit with the murders and stabs the officer in the eye with a pen and escapes.

Finally, Meera locates the house of the village chief, an elderly woman called Ammaji (Deepti Naval.) An exhausted and injured Meera faints, and she is taken to a room in the house. When she narrates the incidents of the night, Ammaji's demeanor changes. She locks Meera in the room. In a chilling realization, Meera finds herself lying on the bed of the murdered Pinky, and the dead girl's pictures and clothes are strewn everywhere. It is revealed that Pinky was the daughter of the village chief Ammaji and Meera has found her way into the same house. She is handed over to Pinky's brother Satbir and the rest of his gang, made up of their male family members (cousins and an uncle). Yet again, Meera manages a close escape and makes her way back to the tunnel where she had left Arjun. By now, the gang has killed him and left a message for her on the walls: "bloody whore."

These are the darkest frames in the film, signifying Meera's transition to the final girl. While this is a visual design that is in in sharp contrast to the multiplex environs with their bright colors, rarefied air, soft cushioned seats, and hyper-palatable popcorn, it is also only visible through the technological capacities of the multiplex that accommodates low-key lighting and a sound design that lends itself to quieter echoes of struggle: breathlessness, whispers, and hurried footsteps. In the final scenes of the film, Meera becomes ruthless. She drives back to the village and finds three of the remaining gang members looking for her: Satbir, his

cousin, and their uncle. She crushes the cousin and the uncle with the jeep. She grabs an iron rod and pummels Satbir to death, stabbing him multiple times, perhaps visually enforcing a cathartic revenge fantasy in the aftermath of the ghastly details of the Nirbhaya gangrape becoming public. Ammaji appears on the scene and is shocked to see all the men dead. She tells Meera that Pinky was her daughter, but "jo karna tha woh karna tha" (what needs to be done, needs to be done). Meera repeats these lines and walks out of the village as the sun rises.

Ideologically—despite its portrayal of an orderless universe where the woman must seek retribution herself—*NH10* breaks with the dominant ideology of the "avenging women" films of the 1980s in several significant ways. As a multiplex film, it privileges layered explorations of the spatial, and among categories like "civilized," "savage," "urban," and "rural," that were not a concern for the prior avenging-woman narrative in India. Meera is unable to rein in the authority of the state or restore an acceptable social imaginary in the final moments of the film (as was the custom with the avenging-woman narrative of the 1980s) because it is evident that the state in the form of the police is complicit—and a parallel system of filial justice operates outside it. The tension between patriarchy and the state is left unresolved, and the "phallic female" does not find restitution within the moral world of state-judiciary. The state approached midway through the film is quickly dispensed with (a stab in the eye with a pen) and all but disappears in the end. In an interesting twist of events, Pinky's own mother, the village matriarch Ammaji, has ordered her murder.[6] The matriarch's role in orchestrating the murder is revealed at the very end of the narrative, as throughout the audience is led to believe that it is the family's men who are the sole perpetrators of the murder.

The "rural" honor killers—while depicted as explicitly misogynist and violent—are not the sole problem. The film repeatedly signals towards a pervasive culture of misogyny that exists everywhere, including the corporate offices of elite India. Further, the "phallic female" is no longer a figure that emerges under duress or rape but has begun to assert herself in everyday spaces. In the initial scenes of the film, despite making a successful presentation, Meera is chided by a male colleague for being favored by her boss for being a woman. Soon after, unknown men attack

her on the road, but the police tell her that she invites danger by traveling alone at night. In two separate instances (at the roadside eatery and in he tunnel where Arjun is hiding/murdered), Meera spots misogynistic messages scrawled on the walls. Neither Meera nor Pinky is raped in the film (though both are brutally beaten). In her final acts of resolution, Meera does not seem to follow a desire to regain the lost honor of the brutalized female body/family. The lines between Meera's own trials and those of Pinky's blur in the film's climactic sequences.

Finally, the multiplex spectator, keenly aware of the cocoon she inhabits, is a far cry from the spectatorial imaginations that guided the avenging-woman films. To recall, the 1980s saw a retreat of the middle classes from the cinema halls into the new private worlds of the VCRs and color televisions. The rape scene, and for that matter most scenes of violence against women, entirely disappeared from the post-1990s clean family film that consciously tried to eschew the gaudy aesthetics of the 1980s. A few new trends filled the sex/sexual titillation slot: the heroine began to dance in sexually aggressive manner across exotic landscapes in fashionable clothing (Mazumdar 2007) and the *item number* where a female (and sometimes male) actor is displayed in an erotic/highly sexualized manner in a song sequence (collapsing the earlier distinctions between the heroine and the vamp). Stringent codes around kissing and scenes of physical intimacy have also loosened prominently. The rape scene as titillation became unnecessary. The multiplex film brings violence against women, sexual and otherwise, back on the screen in non-caricaturist ways. This removal of clichés from scenes of brutal violence makes them much darker that what we have witnessed so far: for instance, in another recent multiplex film, *Udta Punjab* (Punjab Is Flying High, Abhishek Chaubey, 2016), the heroine (Alia Bhatt), a lower-class migrant girl, is repeatedly gang-raped and drugged by a group of men who have kidnapped her. The audience does not see any graphic rape scenes; the screen repeatedly fades/cuts to something else once the violence is about to ensue, leaving the imagination to do its disquieting work. The actual rape scene, which was crucial to the avenging-woman narrative, is now situated both on and offscreen. Given the realism of these films, the audience is already aware—through press, television, web—of the gory details of several rapes. These new modes of addressing the spectator alter the meanings of not only the avenging-woman

Figures 3.3. and 3.4. Meera walks the streets of the village with an iron rod; Meera as the "final girl" smoking a cigarette as a small act of defiance, after crushing two of the gang members with the jeep. Source: *NH10* DVD.

narrative in Indian cinema but also, crucially, the gendered relationship between the city and the village, or in this case, the inorganic city, and looming specter of the village.

NH10 leans heavily on the slasher genre to narrativize the violent interaction of two starkly different but closely coexisting worlds. Meera and Arjun move from one closed space to another before the horror on the highway unfolds; they are in a car, an elevator, their bedroom, or a colleague's party in a posh apartment. They are a nuclear couple, unaware of their caste and entirely unused to other public spaces, or the codes of social life that govern other parts of the country. The smashing of Meera's car window early in the film is a symbol of one space invading another, a foreshadowing of the violence that is about to ensue. It reminds the viewer that the capitalist chimera of a deterritorialized suburb can only go so far. While glass architectures were initially celebrated for their influx of air and light in the West (McQuire 2003), lowering heating costs with a greenhouse effect, in the blazing subcontinental sun they did the opposite. In their desire to keep up with the architectural vocabularies of the Global North, Indian malls, multiplexes, housing enclaves, and corporate offices have been quick to adopt the materiality of glass and pay prohibitively for cooling. For those shut out of these environments, glass symbolizes conspicuous consumption: "a glass tower broadcasts the ability of the owner-occupant to pay for all of this" (Burte 2009; quoted in Kalyan 2011, 49). The other purpose of the glass is hypervisibility, without any tangible encounters with the outside. The shattered glass of the car window then opens the portal for a tactile and violent encounter with the repressed landscape beneath the shimmering city.

In March 2015, soon after the film's release, I asked a female friend who worked in a Gurgaon corporation and drove her private vehicle on the highway for a couple of hours every day to commute from South Delhi if she had watched *NH10*. She said she had seen the trailer, immediately grasped its gist, and reached her trigger threshold. She also made sure her parents—perpetually anxious about her safety during this commute—did not watch this film. While she frequents Gurgaon's many malls and multiplexes, and is the perfect Delhi shopper-spectator, this film grazed *so* close to her that she could not bear to look at it at all.

Privilege and Rape Culture in *Pink*

Like *NH10*, *Pink* belongs to the post-2012 cinematic consciousness. It moves beyond the shock of violence and into women's encounters with the state, the police, and other societal agents post-assault. *Pink* also comments on public scrutiny, surveillance, and the invasive "look" that envelops the lives of women who partake of the wins of a neoliberal life and live outside of familial and domestic units. As they exist at the margins of the private and closed domestic household, their everyday lives automatically become public.

Pink quickly delves into the heart of things: context is not established but must be assumed on the part of the multiplex spectator. It begins with a black screen and ambient sound: pleasant background conversation, a mix of voices at a party. The next few scenes are brief flashes of intercut sequences: a group of men are in a car, speeding to a hospital. One of them is badly injured and bleeding from his eye. In another cab, a group of three harrowed women are speeding home. Something bad has happened, but we do not know the scale. The details are subsequently revealed: all of them were at a rock concert, after which they headed to a hotel room for drinks. One of the women, Minal (Taapsee Pannu), swung a beer bottle at one of the men, Rajveer (Angad Bedi), and fled the hotel. Minal's roommates (the other two women in the cab) are Falak (Kirti Kulhari) and Andrea (Andrea Tariang), young professionals living together in a Delhi suburb. After the bottle-swinging incident, Rajveer and his friends, Dumpy and Vishwa, begin a relentless cycle of harassing the trio of women. Notably, Rajveer is the nephew of a well-connected politician in the city. Vishwa and Minal are high-school friends and the common connection between the groups.

A fourth member joins the male group dynamic. Ankit Malhotra (Vijay Varma), who was not present on the night of the incident, is especially vindictive towards the girls for hurting his friend Rajveer. His chauvinism also exceeds that of his peers; he often leads the gang in pursuing the women: they first face verbal and cyber harassment and later Andrea is chased in the street. When Ankit tries to get their landlord to evict them by falsely accusing them of being sex workers, Minal decides to file a police complaint. Like Meera in *NH10*, Minal too faces

reluctant state agents, and is advised to not take on these wealthy and well-connected men. Minal persists and is subsequently kidnapped and molested by Ankit and gang in a moving car. They threaten her and tell her to drop the police complaint. Here we are also introduced to Deepak Sehgal (Amitabh Bachchan), an old neighbor and retired lawyer, who has thus far silently been observing the events. Minal is arrested for attempting to murder Rajveer, and a case of prostitution—illegal is India—is filed against all the women.

The plot turns here: Deepak Sehgal volunteers to fight the case for the women. What follows is a courtroom drama, a narrative tactic deployed in numerous popular films. The court has long been a prime site for melodrama and heavy monologue. As a multiplex film, *Pink* avoids this terrain and offers an uncomfortable view of the state-patriarchy nexus at play through institutions. Vastly different accounts of the precipitating incident are offered by both sides. Minal claims attempted rape, while the men claim that they were offered sex for money. The women are subject to deep surveillance and humiliation; several private details of their lives—financial, romantic, sexual, familial—are evoked to cement their position as available public women and prostitutes. A final turn in the plot appears when one of the female protagonists, Falak, breaks down and admits that they did take money—an admission proved false later. Here, the narrative transforms to a question of consent, irrespective of whether they are sex workers. This enrages the prime accused, Rajveer, who finally cracks and declares that the women "got what they deserved." The film ends with powerful monologue on consent from Bachchan: "No is not just a word but also a complete sentence unto itself. It does not need an explanation. The person saying it could be somebody known to you, your friend, your girlfriend, sex worker or it may be your own wife. No means no, and someone says no, you stop." The men are finally found guilty in court. The film closes with a shot of the female trio standing on their balcony looking out at the sun setting over the city.

Pink is another foray into the relentless anxiety that lives in the heart of a city on edge. Except for the lawyers played by Piyush Mishra and Amitabh Bachchan, the film is led by a cast of relatively unknown actors (some of them have subsequently gained in stardom). Delhi—as constructed on screen—is once again foggy, polluted, and hostile. Minal's

Figure 3.5. Mobile horrors and panic in the city: Meenal is molested in a car. Source: *Pink* DVD.

abduction and molestation in a moving car is a chilling and recognizable scene. Keeping with the realism of the multiplex film, this scene speaks to the numerous incidents of rapes reported in moving vehicles in the city—prominently, the Nirbhaya gang rape, where she was driven around in a bus for two hours. Most women and sex workers in the city know that being dragged into a moving vehicle is one of the persistent threats that they must navigate daily. *Pink* also comments on the quotidian regimes of gendered surveillance that envelop the lives of women: the inescapable stare, the gaze, the look. In an early scene in the film, Deepak Sehgal is *looking* at Minal in their neighborhood park where she is jogging. Minal recognizes and returns the stare, even though there is no narrative connection between the two characters yet. As one film critic noted, "I realized the reason she [Minal] knew the stare is because all girls do. *All girls*" (Sen 2016).

Those associated with the film have denied that the 16 December incident influenced the narrative. Yet it is evident that the film is in dialogue with the BBC documentary *India's Daughter* (Leslee Udwin, 2015). The documentary has controversial interviews with the rapists in prison and their defense lawyer, all of whom reveal misogynistic and violent views that may appear outrageous to those unfamiliar with gender and power in North India, and particularly in Delhi. As the documentary reveals, the mere presence of women in public is reason enough for them to be violated. *Pink* is a narrativization of this premise. The rapists' lack of regret for their actions was especially unsettling for many. One of them

stated (in *India's Daughter*) "a decent girl won't roam around at 9 o'clock at night. Girls are far more responsible for rape than boys." In *Pink* too, Rajveer (an entitled, rage-filled Delhi man) makes a clear distinction between the women at home and those "available" in public, emphasizing the endurance of feudal binaries.

Moving away from the tendency to frame uneducated, lower-income migrant males as the primary threat to the sexual safety of middle-class women, *Pink* comments on the more prevalent trends of rape and sexual violence: intra-class and often perpetrated by men known to the women. Rajveer is an elite upper-caste man, from a wealthy family, with an MBA from a prestigious institution. He and Minal not only have a common friend but also inhabit the same spaces. The film underlines that class status and wealth do not offer a ticket to gender sensitivity. While the film was a critical and commercial success, viewers felt that *Pink* ended on a wish-fulfilling note. Spectators are aware of the harrowing and socially embarrassing process of reporting and fighting rape in court in India, especially if the criminal belongs to a political family. As a master's student wrote after watching the film,

> Of course, the film is a fantasy. In the actual Indian legal system, one can hardly imagine an old feminist male lawyer patiently and emotionally explaining slut-shaming to an engrossed courtroom and receptive judge. One can hardly imagine the misogynist rich boy going to jail: the independent bourgeoisie girls getting off scot-free . . . (Gattuso 2016)

A review in *The Guardian* suggests that while watching *Pink*, "Trigger warnings may be obligatory, but that's testimony to how close the film gets to uncomfortable truths" (McCahill 2016). Indeed, as the film's paratexts reveal, its climax was altered to offer poetic justice to audiences. In the original script, the men win the case (Sharma 2016).

Unlike *NH10*, *Pink* then chooses to uphold the state as a just dispenser of justice. The contexts of each film allow for this difference in outcome. *NH10* unfolds over one night in the desolate badlands of Haryana; it is meant to show a nihilistic breakdown of the urban machinery of social/state order. *Pink* is set over a period of a few months in Delhi and builds its narrative through a gradual escalation of everyday violence and harassment. While *NH10* is an avenging-woman/horror film, and *Pink* is

a courtroom drama, both omit the classic melodramatic mode in Hindi cinema. Particular attention is paid to dialogue, written in more colloquial tones. Long monologues about the moral space of women, family, and nation are absent. Both the films are shot on location; the spectator is meant to navigate the tense and polluted streets of Delhi and the maze of small villages in Haryana along with the characters. Elaborate sets, costumes, lavish houses, and song-and-dance sequences, and the presence of the parents and joint families of the protagonists are done away with. The mise-en-scène of the girls' rented apartment in *Pink* also breaks from the designer Bollywood set. It is an archetypal Delhi flat, the kind often shared by young professionals. The design is simple, yet effective, without much play with lighting or color palettes, offering an unadorned perspective into the domestic intimacy—and eventually terror—shared by the three women.

The other significant space in the film is the courtroom. Here, the courtroom transforms from an expansive, elaborate colonial set where the patriarchal state delivers its justice to a cramped, overwrought, and disorganized room where people, police, and lawyers all jostle for breathing space. The poetic Urdu of the classic courtroom drama where cases were argued using dramatic words like *adaalat* (court), *muqadama* (case), *mujrim* (accused), *kanoon* (law), *haazir* (appeared), *baizzat bari* (acquitted with honor), and *qaidi* (the arrested) are replaced with a more colloquial mix of English-Hindi. We hear words like "consent" and "marital rape." *Pink* attempts to show the nexus between the powerful political elite, the corrupt police, and the buying/bribing of witnesses by casting superstar Amitabh Bachchan[7] (who channels both the iconic angry young man from the 1970s and globalized Bollywood's "father" figure) as the defense lawyer who is ultimately instrumental in bringing justice to the female protagonist. The film upholds the power of the state while also underscoring the importance of male allies. *Pink* makes a powerful comment on the relationships between the state, space, and the single woman in the city as the protagonists are without marriage, children, or stable male partnerships, which is the pivot for their discrimination. The spectator is not witness to the actual events that transpired between Rajveer and gang and Minal and friends till the very end when the credits roll, and we see a flashback—marking another mode of suspension of the necessity of the actual rape scene.

Multiplexing the Mainstream in *Dev.D*

Anurag Kashyap, director of *Dev.D*, has a proclivity for making multiplex remakes of his contemporary director Sanjay Leela Bhansali's films. For fans and those familiar with the Bombay film world, this is almost humorous, as each filmmaker represents the absolute inverse of the other. Bhansali stretches Bollywood's world of hyperbole and the artificial to its limits, often making revisionist historicals that aid Hindutva politics (*Bajirao Mastani* 2015, *Padmaavat* 2018). His films are often overwhelming, oversaturated canvases of color, spectacle, visual and sonic excess. His actors are so engulfed in costumes and makeup that they seem almost non-human, hybrids between paintings and the physical form. In 2002, Bhansali made his Bollywood version of *Devdas* starring three of the industry's biggest stars, Shah Rukh Khan (as Devdas), Aishwarya Rai (as Paro), and Madhuri Dixit (as the courtesan Chandramukhi).

Kashyap is a vocal critic of the current Hindu Nationalist Bharatiya Janata Party (henceforth BJP) regime and remains one of the most important figures associated with the "offbeat, edgy film"—so much so that one film critic asserts that the multiplex film could easily just be called "the Anurag Kashyap movie" (Ramnath 2016). He gained widespread acclaim in 2007, after a long-drawn censorship battle, with the release of *Black Friday*, a police procedural set in the aftermath of the 1993 Bombay Blasts. Kashyap has since become one of the industry's most prominent directors, with several notable films like *No Smoking* (2007), *Gulaal* (Color, 2009), *That Girl in Yellow Boots* (2010), *Gangs of Wasseypur parts 1 & 2* (2012), *Ugly* (2013), *Bombay Velvet* (2015), and *Raman Raghav 2.0* (2016). His films are easy contenders for the multiplex, as they usually lack big stars and prioritize location shooting and landscape. Thematically they often return to issues of crime, urban dystopia, student politics, terrorism, substance abuse, and privilege.

The multiplex remake of *Devdas* is significant because there is no other tale and no other characters in the Indian film pantheon more familiar than this story and these characters. The self-destructive, melodramatic hero Devdas is commonplace in the everyday linguistic tapestry of South Asia: any man who is too melancholic about romantic love becomes a "Devdas." *Dev.D* thus embodies the heart of the multiplex

film: familiar yet foreign, unsettling yet comforting. By locating the story in present-day Delhi—not in colonial Bengal in the 1800s as in the original—Kashyap uses the city and its recent tragedies to explore addiction, desperation, longing, and anxiety in a globalized delirium of technology, privilege, and power. Released in 2009, *Dev.D* is an early multiplex film, but one that helped considerably solidify this discursive category.

The genesis of the filmic Devdas is Sarat Chandra Chattopadhyay's eponymous 1917 Bengali novel. The story is as follows: Devdas Mukherjee, son of a wealthy landlord, and his neighbor Paro (Parvati) are childhood friends. Devdas is sent to London for several years to study and when he returns as an adult, Paro hopes that their friendship will turn into romance and marriage. Devdas's parents are opposed to this alliance: Paro belongs to a lower socioeconomic class. Unable to confront his parents or his girlfriend, Devdas abandons her. A jilted and humiliated Paro is quickly married off into another landowning family. On the eve of her marriage, Devdas returns and repents, but it is too late, setting the stage for melodrama. Subsequently, a lost and aimless Devdas encounters his old friend Chunnilal, who introduces him to a beautiful courtesan: Chandramukhi. She promptly falls in love with Devdas. Thus begins Devdas's decent into alcoholism—unable to forget Paro and unable to love a prostitute, our hero languishes and pines. As his health fails and his days grow numbered, he makes a final journey to Paro's now marital home and dies on her doorstep. On hearing the news of his death, Paro rushes out, but her new family prevents her from leaving the confines of their estate to avoid a scandal.

It is perhaps expected that in a melodramatic cinematic culture, *Devdas* been made eight times. Scholars (Sarkar 2008; Mishra 2009) have argued that melodrama as a genre has special resonance in postcolonial societies because they share a common logic—both repeatedly belong in the "waiting room of history," both are characterized by the logic of "too late." Bhaskar Sarkar (2008, 48) also discusses the excesses of the Bhansali version: working with enormous budgets and technological prowess, and eschewing any pressure to depict realism, these sets are elaborate self-aggrandizements of the economic power of Global Bollywood. The opulence, however, cannot be divorced from the affective and cultural world of Indian cinema at large because, as Sarkar says,

"in trying to match the script of Hollywood filmmaking and to emerge out of critical oblivion, Bollywood cannot simply abandon the aesthetic, dramaturgical, and emotional conventions of Indian cinema" (2008, 47). *Dev.D* marks a refusal of all the above. It rejects the familiar expressive and aesthetic world of *Devdas* and offers an existentialist, psychedelic new world where the "too late" logic of melodrama is entirely passé. If *Devdas* (2002) is homage to Bollywood itself (Mishra 2008) then *Dev.D* can be read as a deliberate anti-homage: the harbinger of a cinematic affect that can no longer accommodate the temporal codes of classical Indian Cinema or Bollywood.

Dev.D begins in contemporary Punjab. Dev (Abhay Deol) is an insolent teenager who is sent off to London to discipline himself. Dev and Paro (Mahie Gill) are childhood friends are in touch via texts and phone calls. Their exchanges are mostly sexual. The couple faces little resistance from family. While Paro's lower-class status is established, it is not a significant barrier. Instead, petty arguments, egotistical fights, and insecurities plague their relationship. Dev is philandering, narcissistic, and thoughtless. After hearing some false rumors about Paro's sexual exploits from a jealous male friend of hers, Dev rejects and humiliates Paro. Heartbroken and betrayed, Paro marries another suitor. On her wedding day, Dev realizes the rumors were false but is far too proud to make amends. That the backdrop for this sequence of events is Punjab and its mustard fields is significant because these locations are already laden with other dominant meanings for the Indian spectator. *Dilwale Dulhania Le Jayenge* (The Braveheart Will Take the Bride, Aditya Chopra, 1995) (also starring Shah Rukh Khan)—whose unmatched success in 1995 set the stage for Bollywoodization of Hindi Cinema—strongly established what Punjab came to mean in Global Bollywood. It became a site for safe homecoming and (clean) romantic union. *Dev.D*'s first act of betraying Bollywood conventions, then, was to negate the connotations of this iconic location by imbuing it with heartbreak, illicit liaisons, and violence.

Leni (Kalki Koechlin), a half French–half Punjabi teenage daughter of a diplomat in Delhi, enters the plot. A leaked MMS of her performing oral sex on her older boyfriend wreaks havoc in her idyllic, privileged life. This scandal is too much for her parents: they move to Canada, where her father commits suicide. Leni's mother, too, abandons her and sends her

back to India to live with her grandmother in rural Punjab. Finally, she escapes to Delhi, where she meets a pimp, Chunni. He gives her accommodation and helps her finish high school and enroll in college. She begins a dual life: a college student by day and a high-class role-playing sex worker by night. Being a fan of Madhuri Dixit (who plays the courtesan in the 2002 version of *Devdas*), she adopts the name "Chandramukhi" and is known as Chanda through the rest of the film. By now, Dev has moved to Delhi, spending his days stalking Paro in a haze of alcohol and drugs. Eventually Chunni encounters an inebriated Dev, discovers that he is rich and careless, and brings him to Leni/Chanda.

The film moves to Delhi's backpacking district Paharganj. Dev's indulgent life is funded by his bed-ridden father from Punjab. After he makes several calls to Paro, she comes for a visit. The meeting ends badly. Paro calls out Dev's narcissism and reminds him of his past insults. She urges him to move on. Subsequently, he develops a tentative relationship with Chanda but is unable and unwilling to forget Paro. Dev cannot come to terms with Chanda's profession and hastily leaves her too. In a drunken state, he mows down seven people sleeping on the streets with his new car. Escaping arrest, he spends several days aimlessly wandering and gradually becoming penniless and homeless. After hitting rock bottom, he seeks out Chanda once again and is ready for redemption. In the closing shots, we see Dev and Chanda on her motorbike, heading to the police station to turn Dev in.

The film garnered several positive critical reviews and has since gained cult status. A leading film critic said,

> Kashyap's real surprise lies in the way he makes the story work, about how he avoids cinematic pitfalls and makes perhaps the most honest version of the character. In *Dev D*, Abhay Deol isn't charming like Dilip Kumar or melodramatically tragic like Shah Rukh Khan, but he is the character as he should be: the scumbag.... Randomness often happens in our newly experimental cinema, but it's always great to see a film where no detail is an accident, where the director gets to execute his vision exactly as he wants. (Sen 2009)

In previous iterations, Devdas has evoked sympathy, romance, longing, and sentimentality, but in this version he has very few redeeming

qualities. Besides being copiously misogynistic, the character is almost sociopathic, unable to form real emotional attachments to his doting family or his girlfriend Paro. He is a self-serving, dislikable, and unheroic character. Most of his interactions are laced with verbal or physical abuse. He is often violent. In the classical version, the "soft hero" Devdas is given a romantic death. In *Dev.D* the abusive, narcissistic Dev persists, in the hopes of acquiring a modicum of human decency. Devdas embodied the rhythms of delay and slowness; Dev epitomizes the inconspicuous, insulated present, constantly seeking rapid gratification.

Dev.D also experiments with the two female characters, reworking two classic and recurring tropes: the infantile girlfriend/wife in the village and the prostitute in the city. As Kashyap (2008) put it in a blog post, "When you make a film like *Dev.d*, one is dealing with a hell of a lot, perceived Indian morality being the mother of them all." Here, Paro is self-assured, symbolizing a new sexualized modernity which since the 2010s is a staple of the multiplex film. A multitude of new communication technologies—mobile phones, cameras, computers, scanners, and the cyber cafe—surround this character in aiding her sexual desires. She is not defensive when Dev questions her morals. Eventually, she retires her childhood fantasies and happily moves on with her new husband. In the classical version, Paro is unable to forget Devdas and reconcile to the reality of her marriage. However, the mere presence of a sexually assertive female character—a straight reversal of her infantile chaste predecessor—does not necessarily preclude this new image from remaining a male fantasy figure.

While it is unclear why Leni's only option in this narrative was sex work, this character—a role-playing multilingual adolescent prostitute—does offer a few twists on the enduring figure of the tragic courtesan.[8] In *Dev.D*, the home is a cruel and unsafe space, and it is at the seedy brothel that Chanda finds some measure of dignity and independence. It is Chanda who is finally able to liberate Dev from himself—a closure made impossible in the melodramatic logic of *Devdas*. Leni is academically gifted, bikes to college, reads, and blends invisibly into the student crowd at Delhi University. At night she transforms into Chanda—a cocaine-snorting, wig-donning multilingual theatrical prostitute with a painted face—a rebellious nod to the tragic courtesan in Hindi cinema, often an excessively ornamented figure. Chanda exists alongside

an intense haze of neon pink and red within Paharganj's empire of hotels and backpacking hostels. She offers us a hybridized mix of the inner/outer dichotomy, and it is often hard to tell where the dividing line lies.

Kashyap has elaborated on why Dev ends up in Delhi's Paharganj. In a series on *Dev.D*, written for his now defunct blog *Passion for Cinema*, he said,

> [Paharganj] looks like either Mongkok or some back street of Hongkong.... That is where all the drug peddlers are and all the guys who want to end up with a white woman are found. All the white woman looking for nirvana end up here with some junkie or a peddler or a pimp. This place is like none else. This is where all the rich kids land up to have the white experience. That is where Dev lands up to find himself and he floats. This place has it's own atmosphere and it is seductive. The shooting style changed with the place. (Kashyap 2009c)

Indeed, it is when the film's location moves to Paharganj that it begins to acquire a distinctive visual language. Kashyap's nod to locations like Hong Kong is not incidental but speaks to transnational contact zones made possible through media (both DVD-generated cinephilia and through piracy), tourism, and migration (see, for instance, Srinivas 2003; Vitali 2006). Therefore, to the cinephile in the multiplex, a Hong Kong–inspired mise-en-scène with neon tones and highlights, fast tracking shots of budget hotels, packed bars, stylized brothels, drugs, anonymous crowds, and backpacking foreigners will be immediately familiar. Delhi's underbelly thus fuses with other transnational locations in global cinema, imaginatively collapsing into Paharganj, cast as a heterotopic space, or the other of the multiplex spatiality—once again, evoking the offscreen, or the forbidding city outside.

Readers might be surprised to know that *Dev.D* is not only a musical, but one that introduced a new sonic scene to both the Bombay film industry and audiences. Music director Amit Trivedi debuted with this 18-track album (an incredibly high number even for a music-driven industry) that came to define the multiplex film. The film has no song-and-dance sequences, yet the music is pervasive: filling up the screen and doing almost all the narrative cueing. Dev's hedonistic forays in underground bars are shot in fast motion, with frames composed to match

Figure 3.6: Chanda and Dev in a squalid hotel, framed against the atmospheric city. Source: *Dev.D* DVD.

the sonic tempos of Trivedi's techno-punk-bhangra hybrid score. Ramna Walia (2014, 57–58) has drawn attention to how Kashyap used a special S1–2K camera to capture a hallucinogenic, kinetic urban underbelly. Departing from the dulcet duets and shy romances that dominated the syntax of the Hindi Film song, *Dev.D* offered a mélange of brass, punk, rock, and folk. Some of the film's songs were remixed within the text itself, recurring in a different form as the narrative shifted. Kashyap (2009c) recalls rewriting the film as a musical after sampling the soundtrack. In Kashyap's words, *Dev.D* "is about the times we live in of fast food, fast cars, fast cash, where love is confused with lust and viceversa. Where one doesn't know what they want, drifting is the name of the game and people are living from one high to another and everyone is looking for the next fix."

Finally, Delhi and its distinctive urban events take center stage in *Dev.D*, once again conjuring the reality spectacle. Leni's MMS video is a direct reference to the well-known DPS MMS Scandal of 2004, where two students from Delhi Public School made an MMS of themselves in a sexually compromising position. It was one of the first instances of urban India's encounter with the ubiquity of technology and the consequences of the private leaking into the public, especially for young women. Forgetting became impossible. Following this incident, the government banned cell phones in schools and colleges for a time. The second real incident in the film was a reference to the Sanjeev Nanda BMW case of 1999. Nanda, a young scion of Delhi's extreme elite, was drunk

driving back from a party. He ran over six homeless people and fled the scene immediately. The Supreme Court acquitted him after a large bail and two years of community service. The Nanda case was a shocking display of apathy, privilege, and power in a city where a small cohort of people had suddenly amassed great sums of money after the privatization of the economy. Novelist Rana Dasgupta reflects upon one this case, calling it one of the city's "most popular parables":

> Nanda's speeding BMW is a symbol of gleaming, maleficent capital, unchecked by conscience or by the roadblocks of the state. The scene of the impact, a 100-metre stretch of road strewn with organs, severed limbs, and pools of blood, is like a morality painting of the cataclysmic effects of this marauding elite in the world of ordinary people. (2014, 234)

The multiplex spectator—though not always anticipated in a place like Parharganj—is nonetheless expected to be as intimately familiar with these events as they are with the old *Devdas*, thus setting the stage for a new collision of the dystopic and the nostalgic. Discussing the film, Kashyap (2009a) said he made it to underline the present obsolescence of Devdas as an adjective. In his words:

> *Dev.D* is a take-off point from *Devdas*. . . . Devdas has gone beyond being a book or a movie. It has become an adjective; it's in our everyday usage. Whenever we see somebody moping around, we say, hey, don't be a Devdas! The idea was to explore that adjective that it has become, and through which I wanted to talk about the youth, how they . . . look at love, life, and relationships in today's day and age, where it's the age of fast cars, fast cash, fast food, instant gratification. . . . Does it really happen that people are longing for one woman for the rest of their lives? Because I don't see that happening today. It has changed. So it was trying to explore all that through using Devdas as a medium. . . . This film is about second chances. . . . We give up on people and say *iska kuch nahin ho sakta* (nothing has become of him). *Lekin uska kuch hota hai kya* (but does something finally become of him). The film is trying to see that.

Dev.D—an early multiplex film prototype—in many ways laid the foundations for an anti-homage to Bollywood, its founding texts, and

iconic locations. Though it was unable to offer a feminist revision of the classic text, it did signal that melodrama had become anachronistic in the new vocabularies of the multiplex film. It made way for cinematic expressions of a new anguish: intimately tied to the existentialism of a globalized life, rampant with violent encounters between humans, technology, and the desire for speed.

<center>* * *</center>

In chapter 2, I discussed the industrial production of public safety as the central tenet of India's multiplex culture. The multiplex is—or aspires to be—a self-contained site that seeks to eliminate dirt, unpredictability, and potential class- and caste-based intermixing. It creates an architectural silo that privileges domestic and familiar comfort for middle-class viewers. In *Conjugations: Marriage and Form in New Bollywood Cinema* (2011) Sangita Gopal looks at how the first decade (approx. 1995–2004) or so of the "multiplex film," which she defines as a low-budget, nonformulaic genre, was about "reckless genre mixing and code-switching" (137). The second generation of multiplex films (second half of the '00s) reconfigured a classic staple of Hindi cinema: the social. The social film (later known as the *masala*) was meant to appeal to "everybody" in a 1000-seater single screen, but its frontal address was to the subaltern audiences seated closest to the screen. Gopal contends that the middle-class viewer on the balcony "is in one sense left out of the picture; she apprehends the image less viscerally and thus consistently demands a more realistic route to identification" (2011, 130). The reconfigured social thus began to cohere around the "multiplot" film to accommodate the expansion of the multiplex's spectatorial base—which had far begun to exceed elite clusters in big cities. The multiplot film moved away from one couple/a single love story (the core of the social film, with the heterogeneity of the single-screen audience mediated by the single couple form) to narratives where several couples were loosely connected through a story arc, or what David Bordwell has called "network narratives." Gopal's argument is that these multiplot films, often incorporating parallel editing and split frames, were analogous to the architecture of the multiplex, which "affords a multiplicity of events to occur within its domain" (141). By reflecting multiple realities and linking them, the multiplot film therefore constructed the rapidly expanding and internally

diversified middle class as the ideal multiplex audience. Moreover, these films reflected the spatial discontinuity—from real life—that the multiplex offers (Gopal 2011). Indeed, the multiplex film in its early years was characterized by low-budget formal and generic experimentations, along with new subgenres like the multiplot film that reordered older forms like the social film. Yet, as I have also discussed in the introduction, the multiplex film by now has crystallized into a fluid industrial vernacular where the mainstream and alternative fold into each other. Rather than looking at the multiplex film as a genre, here I position it as an imprecise category and an entry point that accommodates a range of formal, aesthetic, and ideological routes, along with a simultaneous expansion and contraction of multiple genres. The films I have discussed here offer a significant rupture from echoing the world inside the multiplex and its diverse subjectivities—all of which are nonetheless middle class. Films like *NH10*, *Pink*, and *Dev.D* mark a return to the psychogeographic uneasiness of our globalized lives. They powerfully invoke place and space as anchors of gender relations in the *offscreen* outside the mall-multiplex. The love story, that long staple of Hindi cinema, is not merely reconfigured but rendered an impossibility in the diegetic logic of all three films. As Jyotsna Kapur (2009) observes, "it is the world that has been shut outside the mall that reappears on the multiplex screen as a thrill for those who live as tourists in their home cities" (156). How may we understand this incongruity between space and film? The home, in literature and art, has always been the primary site for haunting, doubling, and dismembering, while the labyrinthine streets of the modern city have induced anxiety. In Freud's famous 1919 essay, the origins of the uncanny, or the *unheimlich*, lie in the *heimlich*. The uncanny therefore is a productive force in inferring the connections between psyche and dwelling, the body and the home, and the individual and the metropolis (Vidler 1992, x). The uncanny often refers to the *domestication* of terror—the "fundamental propensity of the familiar to turn on its owners, suddenly to become defamiliarized, derealized, as if in a dream" (Vidler 1992, 7). Thus, the uncanny was, in its first incarnation, a bourgeois fear, acutely experienced in material security of the interior, where the pleasures induced by terrors were kept under control. The uncanny also has had a long-standing relationship with its metaphorical home, in architecture: from haunted houses that invite terror,

to the larger domain of the city made strange by spatial incursions of modernity. Several postcolonial cities like Delhi modelled their urban planning on Euro-American notions of spatial segregation, welcoming architectural modernism and design philosophies like rational grids and transparent spaces. However, as Sundaram (2010b) has shown, these plans for a modern technocratic machine city were often undone by the traumatic realities of lived experiences and a breakdown of infrastructure. Thus, the planned and unplanned city often collapsed together, and as Homi Bhabha says,

> In a feverish stillness, the intimate recesses of the domestic space become sites for history's most intricate invasions. In that displacement the border between home and world becomes confused; and, uncannily, the private and the public become part of each other, forcing upon us a vision that is as divided as it is disorienting. In the stirrings of the unhomely, another world becomes visible. (1992, 141)

Following the theoretical contours of the uncanny, likewise, I suggest that the multiplex offers a safe perch for a thrilling and temporary suspension of the boundary between the insulated self and the city outside. While it is a site that seeks to project itself as an extension of the home theater, it becomes unhomely by making another disorienting world full of hidden psychic histories visible through the multiplex film, *but* within carefully regulated interiors. This is also vital to understanding the genealogies of streaming cultures and the meanings of "complex television" in India. Although they might be initiated by global platforms like Amazon and Netflix, what they draw on and are enmeshed with are the visual and aural spectatorial desires produced by the architectonics of the multiplex. Thematically, they are indebted to the generic imprecisions of the multiplex film. Several directors, producers, screenwriters, and actors discussed here were also the first cluster of media creatives who were approached by global streaming platforms. Most of them now work across multiple formats and mediums.

This chapter has put the multiplex film in conversation with the architectonics and socio-spatial symbolisms of the site of its exhibition through an analysis of three films that narrativize the entanglements of gender and space in globalized Delhi. It has shown that the work of

imagining the spatial and infrastructural capacities and limits of exhibition space begins at the site of film production. Scholarly focus on representational politics in cinema has often overlooked the industrial histories and the acutely gendered domain of exhibition. The multiplex has triggered unprecedented changes in the industrial practices of production and distribution, which must now angle themselves toward a new and expanding gendered materiality in exhibition. It has rewritten the spatial relationship between film and spectator and a created a new politics of gendering across representation and reception. In other words, through the creation of an apparent disjuncture between filmic space and exhibition space, the two sites have steadily sharpened their attunement to each other.

4

Nostalgia and Fear in the Smart City

A search for "Kamal Cinema Complex Delhi" on Google Maps will show a pin dropped to a specific address between Safdarjung Enclave and Green Park, two major South Delhi neighborhoods. While this complex offers a row of restaurants, a few utility shops, and grocery stores, there is no trace of a cinema. Kamal Cinema disappeared sometime in the 1990s, no one quite knows when. Three decades later, it nonetheless continues to exist in the city's everyday parlance—a busy bus stop there is still labeled Kamal Cinema—and life goes on. A few minutes away from the disappeared Kamal stands the eerie Uphaar: a massive, ruined structure, known as the infamous site of one of Delhi's most horrific fire catastrophes in June 1997—a tragedy that claimed the lives of 59 spectators and seriously injured 103 others. The theater's owners and managers had been severely flouting fire safety norms for years. Uphaar Cinema's broken and charred windows—from which many jumped to escape the burning building—and its fire-scathed walls remain, quietly looking upon the busy Green Park Extension market. Several single-screen cinemas—vanished, shut, ruined, dead, demolished, sealed—exist as anachronistic incursions into the city's new and aspirational built environments: malls, smart homes, coffee shops, multiplexes, and gated residential complexes. This is the global assemblage within which India's vast middle and upper-middle classes now encounter film. The "lost" single screen, however, remains emblematic of the excesses and emotions that the multiplex and its related geographies seek to obliterate or safely reconstitute: urban memory, nostalgia, anxiety, and sensory pleasures of belonging—for *just* a few hours—to the crowd at the cinema.

This chapter tracks the ongoing transmogrification of Delhi's cinemas—across the performative and widely reported/photographed "dying" of the single screen and the heightened hyper-real architectonics of the multiplex—to chart the capital's physical interaction with globalization, built environments, and technology. A strong current of

nostalgia envelops these spatial transformations. Film and exhibition industries both profit from nostalgia campaigns; the multiplex seeks to assure its spectators that the loss of the single screen and all that it signified need not be absolute. The pleasurable parts of it can be reconfigured and rehabilitated, securely, within their new disciplinary regime of moviegoing. In other words, while the single screen might be "dead"—existing mostly as haunting ruins—it is always symbolically present at the multiplex.

The multiplex is increasingly preoccupied with two related techniques to attract spectatorial attention: advanced sensory infrastructures, specifically aimed toward enmeshing the spectator's body with the architectonics of exhibition space, and campaigning for big-screen nostalgia in the age of digital platforms and personalized entertainment options in the smart home. I argue that in its attempt to marginalize certain affective worlds of film viewing, the multiplex cannot simply bypass the long history of the Indian audience's socially transgressive relationship to the cinema theater, and neatly proceed "after" the single screen. Every new sensory regime of moviegoing must be emotionally attuned to local and cultural specificities, and to the preexisting histories of pleasures and anxieties: classed, caste-based, and gendered. The multiplex, thus, often conceives of itself as a space that is here to salvage and protect the uniquely Indian ways of watching films—while concurrently defining "Indianness" as a journey of linear and spectacular progress. The familiar tactility of the single screen can be and is repositioned. It attempts to show the globalized Indian spectator where she came from and what she can become. It is both a bridge and a capsule: when viewed from the skin of the multiplex, the unfettered city outside becomes perplexing and dangerous. Nostalgia and fear—two sides of the same coin—are therefore essential ingredients to trigger the tactile pleasures of the multiplex.

Analog Nostalgia: Still Searching for the Single Screen

Why do India's neoliberal spectators—who willingly and routinely pay exorbitant rates for the privatized multiplex—still long for the pleasures of the crowded single screen? To explore this allure, this chapter begins by chronicling the events surrounding the recent closing of one of the

city's historic colonial-era theaters, Regal. Regal was built in 1932 in Connaught Place (henceforth CP), the heart of Delhi's colonial design. Designed by British architect Walter Sykes George, this cinema was the epitome of elite and European cultural sophistication and cosmopolitanism. It had managed to survive the multiplex onslaught till 2017, despite three other heritage theaters in CP (Plaza, Rivoli, and Odeon) becoming multiplexes by the mid-2000s. Regal's owner, Vishal Choudhary, had been struggling to keep the theater alive for the past decade. Profits had dwindled and, as a heritage site, the building was in dire need of expensive repairs and renovations. Choudhary decided to close the theater, and as a poetic farewell to Delhi, the "last shows" at Regal on March 30, 2017, were two popular Hindi films from the 1960s and 70s: *Sangam* (Union, Raj Kapoor, 1964) and *Mera Naam Joker* (My Name Is Joker, Raj Kapoor, 1970).

The choice of films was not incidental but designed to activate certain memories among Delhi's spectators. Choudhary was inundated with letters and requests from fans to close the cinema with Raj Kapoor's films.[1] This cinema was superstar-actor Raj Kapoor's favorite theater in the capital; his films regularly premiered there, while the entertainment press and gossip mills worked hard to report his secret rendezvous with co-star Nargis at their special room in Regal. The "crowd" for these two last shows were the city's upper and middle classes. Spectators, journalists, and employees of the cinema recalled stories from the bygone decades of Regal's glory. The event was extensively covered in print, television, and social media. Regal had remained an elite cinema till the 1970s, after which it joined the rest of Delhi's cinemas in decline (also see chapter 1). By the 1990s, Regal mostly screened B-grade films and catered to poor and working-class male spectators to stay afloat.

The discourses surrounding Regal's demise belong to a larger terrain of nostalgic reportage from the Indian English press around the death of the single screen. Press reports bear titles such as "The End of Single Screens" (*Times of India*, April 22, 2016), "Delhi's Single-Screen Cinemas Inch Closer to the Final Curtain Call" (*Hindustan Times*, August 27, 2016), "Lights Out: Single Screens in Delhi Face the Inevitable as Demonetization Pushes Them off the Edge" (*The Indian Express*, January 4, 2017), "The Last Picture Shows: The Slow Death of Single-Screen Cinemas in Delhi" (*Scroll*, January 30, 2017), "Curtains for Single-Screen

Theaters" (*Live Mint*, March 23, 2016), and "Final Show" (*Outlook*, January 20, 2017). These reports are peppered with anecdotes and stories about single screens and a quick recall of the key reasons for their brutal demise: the might of the multiplex, high rates of entertainment tax, and the BJP government's demonetization policies.[2] The closing of Regal, however, generated an incredible amount of press and brought to light the omnipresence of urban nostalgia for an old media assemblage. An account of Regal's last show in the *Huffington Post* described the details of the scene:

> It was 1:30 AM when we staggered out of the theatre, after a four-hour film that was far too long even by Bollywood standards. But the show wasn't over yet. The cheering and singing that had started as our movie—Raj Kapoor's first color film *Sangam*—ended on Thursday night, continued as members of the audience, some 500 of them, poured out into the streets in front of Connaught Place's Regal Cinema. (Basu 2017)

The report goes on to talk about the "carnivalesque" atmosphere of the night and the television cameras that stood ready to capture spectators singing in chorus as they walked down the stairs to the lobby: "the theater—usually silent and empty by this time—buzzed with activity." This crowd seemed eager for bad infrastructures and pre-globalization exhibition technologies: they embraced the poor sound, the hazy picture quality, the unsanitary auditorium, and the lack of proper air conditioning. The report concludes,

> As the men and women who had decided to spend a Thursday night watching the last day, last show at Regal filtered out, *Delhi at night didn't feel so unsafe*, and momentarily, you felt transported to another time, another era. A Bengali family watched other fans pull out posters to take home as keepsakes. The Banerjee's had visited Regal for decades, and watched two shows at the theatre this week, for memory's sake. What did the theatre have over multiplexes? (emphasis added)

Delhi at night didn't feel so unsafe. The middle and upper classes could embrace the publicness of the single screen (Regal stands on a busy commercial road), especially at night, under specially engineered

environments: a grand farewell, intense press coverage, classic films, old couples; an orchestrated nostalgic occupation of a formerly upscale theater, now in ruin. Under these "right" circumstances, Delhi's elite spectators became actors in a collective performance of embodied filmgoing. They remembered their parts—and how to play them—despite two decades of embracing the multiplex's corrective regimen. Their muscle memories had remained intact. Many of them rushed to buy tickets in black, another fast-fading practice associated with single-screen cultures. This refers to one of the prominent informal economies surrounding the cinema, where working-class men would often buy tickets long before a popular film's release. When the theater had a full house and demands for last-minute tickets soared, they would make themselves quietly visible to the distraught fan and offer a way out of their misery. Tickets in black cost twice or thrice the usual amount but most spectators were willing to pay. The pleasure and thrill (of participating in a minor illegal act) to gain access to the packed cinema hall, saturated with all kinds of expectations, exceeded all else. On Regal's farewell night, people's reminiscences collided with an acute communal appetite for the theater's cheap coffee and humble samosa. The cinema's employees were overwhelmed with requests for "*wahi* samosa, *wahi* coffee" (*that* samosa, *that* coffee) (Lal 2017a). Spectators must "taste" the theater one last time. Old stories about Regal were recounted so frequently that they became myths and fables. Several young multiplex goers—who had never been here before—also arrived to recreate prosthetic memories of what they had heard from their parents and grandparents and found things to be "exactly the same!"

What this indicates is that globalized multiplex spectators, despite their long abandonment of theaters like Regal, occasionally want to return to the "original scene." An immersion into single-screen materiality and the distinctive sensory pleasures associated with the bygone persist as strong romantic fantasies. Middle classes desire boisterousness and emotional surplus; they want to code their pre-globalization moviegoing as a culturally unique, special practice that remains buried beneath the multiplex empire. They want single-screen cultures to be historicized, celebrated as their heritage, and inherent in their experience of the city. The multiplex is not a space that can provoke distinctive and colorful stories about going to the cinema. It has no oral or anecdotal history. As

a journalist-blogger wrote, reflecting on the closing of another theater, Cinema Excelsior, in Old Delhi (Routray 2014): "There are many monuments in Delhi. This is one of a kind too."

While researching this chapter, I interviewed a few multiplex spectators about their sensory associations with the single screen. While many of them began to enthusiastically discuss the "golden days," traces of tensions around gender and class often tinged these memories. Four men in their mid-late thirties recalled:

> SPECTATOR 1: Golden Days! There were six to eight theaters: Plaza, Ratan Talkies, Vasundhara, Meenakshi, Uphar, Sujata, Mini Sujata, Welfare, and Sainik Theater. Now all have closed, taken over or refurbished into multiplexes . . . but still cannot forget that *lathi* charge entrance nor *gutka* chewing crowd, special entry for ladies, stale popcorn, oil dripping samosa, but above all vendors running openers on bottles with that sound, *trring trring* and you knew that intermission was one minute away.
>
> SPECTATOR 2: I'd like to pay tribute to single-screen cinemas in Delhi, which are very dear to me. These places planted the seeds of my love for movies. Sapna Cinema—I had the privilege of staying two minutes away between the years 1985 to 1993. The convenient proximity meant that my folks took me almost on a weekly basis to watch movies. The place was run-down, and the popcorn was always stale, but I loved it. A memorable moment was one that I don't even remember . . . my parents reminded me of it. The year was 1986, I was 8 years old. My folks took me to watch *Karma*. I remember going for the show, but here comes the memorable part . . . remember the climax when Dilip Kumar sten guns the map of India around Dr Dang on the wall? My parents said, I stood up from my seat and started applauding. The rest of the audience took a cue from me and started clapping wildly too! Perhaps I was so emotionally overwhelmed by the scene that I don't remember it . . . I'd like to say thank you to these grand dames for all the good times. The coming of multiplexes changed the cinema-going experience, but I still yearn for the old days.
>
> SPECTATOR 3: Once I went to see *Namak Halal* and in balcony (an alien term for today's generation) only one fan was operating so

entire crowd was sitting around it. Ticket price are around 25–30 rupees max. No AC, No cushioned chairs, No crystal-clear screen. *No cleanliness*, etc. But the fun is different . . . the eatables are super tasty and cheap. You sing along the song playing on the screen. The crowd out there know how to cherish that film. The whole experience is nostalgic.

SPECTATOR 4: We once went to watch Manisha Koirala's infamous *Ek Chhotisi Love Story*[3] and my god the scenes outside the theatre were like as if it were a big Diwali smasher or an Eid release . . . a lot of theatres had been vandalized though by Shiv Sainiks and the right-wingers . . . all the while we were inside in the dark and the danger of being caught by police was palpable with the image of being carried out handcuffed with a black hood over our heads! In fact, all the *junta* were conscious of the fact that the theatre could be frisked at any point . . . *it was like going and watching a porno . . . there was not a single woman in the hall* . . . (italics added)

I solicited these responses from a Facebook group for Hindi film fans. This group has several active female members. Very few of them spoke about single-screen moviegoing. Here, nostalgia fell silent. Two women finally came forward:

SPECTATOR 1: Watched *Hum* [We, Mukul Anand, 1991] in a theatre and when the song Jumma Chumma started everybody started doing a pelvic dance movement. We watched from the balcony; my mother was aghast! We didn't watch another Hindi movie for a while, but I was hooked. The uninhibited madness made me a fan for life.

SPECTATOR 2: We all watch shows at multiplexes now. But there will be people from our generation who will watch *Queen* at a multiplex, or I saw *Highway* at the multiplex for instance but would never go out and watch a Salman Khan Eid release at a multiplex because there is a certain way in which you *act* there [at a single screen]—you catcall, you barely hear the dialogues, you throw coins at the screen, you clap along—*so there is a particular way in which you have to act out the experience of watching a Salman Khan film, which women don't do.*[4] I have noticed the glaring absence of

women from those places. I have walked down Anwar Shah Road on an Eid release and not seen a single woman in front of Navina Cinema. Not one! (italics added)

These responses can be read as testaments to how single screens essentially turned spectators into performative fans (see also Srinivas 2000). This was a fandom that simply could not be contained by design. The single screen, despite incorporating some measures for control, was ultimately a public and capacious space. Multiple agents like the police (*lathi* charge), political parties, or even local mafia bosses exercised their "rights" on theatrical space. These mediators were not there for regulation alone, they were audiences too. Fan-spectators operated within this open ecology and were energized by the spirit of their environment. Women—often unaccustomed to such publicness and space-sharing in other aspects of their everyday life—had an ambiguous and sometimes unsettling relationship to these spaces. They had to self-censor and sometimes sneak in and out to avoid being caught at the cinema: acts of wild dancing, hooting, whistling, and fainting belonged to male fans.

Indeed, single screens were spaces where many forms of male homosocial bonding—that may otherwise be coded queer in any other time-space—were abundant. Amit Rai (2009) has drawn an evocative sketch of the scene outside a single screen in Bhopal in the late 1990s. Noting that men made up the entire crowd milling about outside the cinema, Rai observes that urban space and masculine performativity together gave the event of media exhibition "the suspense of an open threat" (41). The queue for tickets is "where it all starts"; "a single file of lanky, sweat-drenched men, leaning on each other for support; and every now and then a massive surge, and a push-and-tug war would start and then die down" (43). Rai calls this "loitering zone" a politized space because it contains the potential to subvert the norms of social space. It is this "sexualization of media populations" that is inherent to the nature of film exhibition, especially at the single screen, that managers of these spaces seek to control and police (50–51).

Yet, as the last comment from a female viewer I interviewed reveals, there are still moments when multiplex spectators actively seek out the "open threat" of the single screen. The owner of Liberty Cinema

in Delhi's Karol Bagh, Rajan Gupta, confirmed this. Gupta said that he always has a full house for a Salman Khan film because "they [multiplex goers]want the experience of audience participation. They cannot watch these films in a multiplex because everybody is quiet. At the single screen the clapping is so well timed, it starts exactly on time and stops right before the next dialogue!" (Gupta 2016). Salman Khan—with an enormous fan base of subaltern Muslim men—is one of the few remaining male actors in the industry still synonymous with the single screen. One spectator responding in the Facebook group even took the younger members of his family to a single screen so that they could *really* experience India's moviegoing culture. He said,

> So finally, I saw Bajrangi Bhaijaan last night at the famous Gaiety Cinema in Mumbai. Forget the script/story for a moment watching this movie amidst a sea of crazy Salman Khan fans was an experience to cherish. Couldn't hear half the movie for the whistles/cheers that went around the nook & corner of this cinema hall. I mean there were like dozens of guys dancing during 'Selfie Le Le' . . .
>
> Say whatever you may about this actor . . . but I have never seen such a crazy fan following at least in last one decade . . . I chose this cinema hall keeping in mind this kind of an environment, my advice to all is to do the same and to watch it in some crazy single screen kinda cinemas: if you really want to enjoy or feel the "Salman Khan experience."

To summarize, elite audiences sometimes return to the single screen pursuing an affective reenactment of that which is lost and cannot be found or felt at the multiplex.

Laura Marks's (2002) theory of "analog nostalgia" is a helpful tool to understand this nostalgia for the lost customs surrounding film exhibition. In her study of digital video, Marks found that a strong nostalgia existed for the analog form among digital filmmakers. This was especially prevalent among the generations of filmmakers who were entirely trained in digital video formats. Analog and digital videos have different ways of recording the world. In the case of the analog, it has a body that is subject to the decays, dropouts, and other electronic realities of the world, "so we in turn share the video's embodied perception" (148). It was an intense desire for the somatic "arrival" of a new blockbuster that

drove the frenzy around the "first day, first show" that Rai describes. Analog video, like the single screen, "retains that sense of dumb wonderment in the face of the world" (148) or encountering something for the very first time. This extended beyond the film into the larger carnivalesque atmospheres of film exhibition. Encounters at the single screen were not limited to the first show; in fact, every show contained a "first" encounter that could morph into anything from a collective dance performance to a violent fight. Unpredictability was the fundamental condition of this media event. Single screens offered a "raw" reality: as Marks observes, a characteristic feature of analog nostalgia is a desire for indexicality or a reference point in an age when most mediated experiences are simulations (153). The multiplexed spectator's retrospective fondness for the single screen is a manifestation of this yearning to experience an embodied pastness in the present.

This nostalgia, however, is for the privileged. While the multiplex audiences can visit the single-screen sensorium for a Salman Khan film, the opposite cannot happen. A multiplex film cannot belong to the loose space of the single screen. The Indian State is complicit in the elimination of a whole spectatorial segment: while offering tax and other concessions for multiplexes, the government has canceled the licenses of several single screens in Delhi over different issues with electricity, land, and exhibition rights. Anand Vivek Taneja (2005, 259) argues that the image of the new "liberated" woman in Bombay cinema is only meant for elite audiences, while all other desires for visual pleasure is considered illegal and or/despicable. The rapid closing of the city's single screens means that lower-middle-class, poor, and subaltern spectators are entirely being pushed out of the exhibition sector. As a journalist deftly put it,

> The Delhi Times is filled with upper middle class people who have returned to be present at Regal's grand farewell party, and are happy to pay Rs. 300 in black to let their mothers watch Raj Kapoor's Sangam and reminisce about their youth. There is no mention of the hundreds, perhaps thousands of viewers who could, until yesterday, afford to watch a film in a Connaught Place theatre, and who have quietly been added to the vast masses that will now no longer be able to go to the cinema. (Gupta 2017)

The Making of Moviegoing Heritage

The multiplex in India is now twenty-five years old. It has shaped a generation's moviegoing experiences. Notably, the multiplex now seeks a right to urban history and heritage, a place usually reserved for elite single screens like Chanakya (see Sahu 2018). In 2005, PVR Cinemas converted two of Regal's neighboring colonial Art Deco theaters, Plaza and Rivoli, into a special category of multiplexes called "PVR Heritage." As the company's brand book says, "PVR Heritage captures old world charm. Two of Delhi's oldest and popular cinema halls, Plaza and Rivoli now enjoy their new avatars as PVR Plaza and PVR Rivoli respectively. PVR has restored some of the best-loved landmark movie halls in which generations have grown up watching films in and given back patrons a part of cinema history." Here, PVR made a major exception: it decided to work with existing cinema designs whose locations were fixed. They were outside of malls. PVR wanted to "uplift the older cinemas and bring them to a higher level of experience." As Vikas Sabharwal from the company's design team explained,

> We are talking about Lutyens' Delhi here, and the interest was obviously there, but the conditions in and around the hall were still rather bad. Such cinemas belong to a different kind of movie experience, and we had to give back the old-world charm to these areas. Their interiors are very different from the other PVRs. We have given a classical touch to the interiors there . . . the furniture is Art Deco, the curtains have valences, we have put up chandeliers, and even the poster boxes are made of wood. We had to give the space a heritage look and feel, which appeals to the senses of the community around the hall. Such halls are not our revenue generators: they are more of visibility spaces for us. (Sabharwal 2016)

This conversion was simultaneous to the state government–sanctioned "Return to Heritage Project," which aimed to bring back the "lost glory" of the British-built Connaught Place. According to the New Delhi Municipal Corporation (NDMC), the "Return to Heritage Project" was undertaken to revive CP because "it may have lost its old glory but the charm of the market still works on the people" (Shahjahanabad Redevelopment Corporation 2024). It is useful to recall that the mall

and the multiplex are reformulations of the consumption and circulation practices associated with the traditional Indian bazaar. Amit Rai (2009, 36) suggests that the single screen and the multiplex should be seen as "different technologies of biopolitical control," both capable of combining time and sensation "at the affective interface between bodies in population and technological evolution." Thus, the state's desire to reinvent the "charm of the market" is in line with the corporate multiplex, which is situated at the intersection of crowd control, class- and caste-based segmentation, and the ideologies of the liberalized nation (also see chapter 2). The state's desire to reconstruct the past glory of CP was in tandem with the larger "beautification" of the city in preparation for the Commonwealth Games of 2010. What this translated into was a large-scale uprooting of several colonies of working-class populations and migrants and pushing them outside of the city (Dupont 2011). Such restoration projects for built environments also inherently delimit the appropriate bearers of urban history. A heritage is created for the new middle classes. They are invited to participate in a slice of their "cinema history": middle-class nostalgia is repackaged for itself. Cultural history is not for everybody.

The metamorphosis of exhibition space in Delhi has largely happened in the posher central and southern neighborhoods, and not so much towards the Mughal city of Shahjahanabad, or Old Delhi—where some of the oldest cinemas are located—now decrepit, ruined, fossilized structures. In the conversion of single screens into multiplexes, which requires laying a new structure upon an existing one, there is a decisive attempt to transform nostalgia into heritage—or an attempt to construct a linear narrative of the past "glory years." Svetlana Boym points out that nostalgia is a fundamental condition of the rapidly globalizing world, a phenomenon that has led to stronger local attachments. She argues:

> in counterpoint to our fascination with cyberspace and the virtual global village, there is a no less global epidemic of nostalgia, an affective yearning for a community with a collective memory, a longing for continuity in a fragmented world. Nostalgia inevitably reappears as a defense mechanism in a time of accelerated rhythms of life and historical upheavals.

The nostalgic desires to obliterate history and turn it into private or collective mythology, to revisit time like space. (2001, xvii)

The multiplex, however, is now old enough to participate in the "global epidemic of nostalgia" without needing the single screen. It has declared itself a legacy site, already nostalgic for the early days of globalization. In 2021, PVR Cinemas refurbished and upgraded their first two multiplexes in Delhi: PVR Priya and PVR Anupam. These two cinemas had started as single screens in Delhi's community centers, and then become the country's first multiplexes, rapidly enabling the gentrification of the Vasant Vihar and Saket neighborhoods. In the latest incarnation, they have shed their early multiplex architectonics and upgraded to the here and now. A publicity video (PVR Cinemas 2021b) for the refurbished PVR Priya, for instance, opens with "this is the place that has taken you places. Welcome back to the place where it all began. Experience cinema legacy in a new avatar." It goes on to say, "Legacy is never created it builds and evolves over time! PVR Priya, the original hangout of Delhi, has *always been* that iconic go-to destination for movies" (emphasis added).

A press report in *The Indian Express* (Malik 2021) on the "reopening" of PVR Saket (formerly PVR Anupam) notes, "Twenty-four years ago a sleepy corner in South Delhi buzzed with the words 'multiplex' and 'Dolby Sound.'" The company's publicity campaign is titled "India's First Multiplex is Back." Reflecting upon the comeback, PVR Chief Ajay Bijli said, "We have revamped the entire property with ultra-modern features, to live up to the expectations of today's insightful audience. Cinema is the cheapest form of out-of-home entertainment and has stood the test of time as we continue to offer even better movie viewing experiences to our patrons" (India Blooms News Service 2021).

This publicity campaign urges spectators to recall how PVR Saket changed moviegoing in India forever. A special wall is dedicated to two contrasted photographs of the 1997 First Multiplex and the present revamped version. Through this juxtaposition, the 1997 photograph seems anachronistic and quaint. India's multiplex generation will remember it as almost as an analog encounter with early globalization, akin to an old video game, vintage computers, and dial-up internet. The internet testifies to the power of this specific brand of "nostalgia tech" or "tech

archeology,"[5] as large digital communities are dedicated to retro artefacts and their afterlives.

On 15 September 2021—a month before the official reopening of the upgraded PVR Saket—the company released a three-minute teaser focused entirely on spectators' memories of the early days of this cinema. The choice of spectators for this publicity material is telling. In the first twenty seconds, we see a professional woman in a fashionable sari, laptop in hand, speaking in English: "when I walk into a PVR it feels like home. I have to say my fondest experience with PVR is catching Shahrukh movies." We see montages of young couples in their early twenties, a mother, and her son busy on the phone, two middle-aged male friends on a modest motorcycle who speak in a mix of Hindi and English, a couple of young female friends, an older man with an English diction easily recognizable as elite in the subcontinent, and a few of solo female spectators. They all inscribe a range of sensory firstness to this cinema: their first "real" tub of popcorn, first date, the first movie (some claimed to have had their first theatrical experience of film *here*), and a sense of *this place* being a central part of urban life and memory. In twenty-five years, spectators have "grown up here." The pair of young female friends discussed coming here as children and how it remains their special place as adults. We see them embracing outside the multiplex. The working woman with whom the video begins draws a long arc from her student days to being a professional now: of coming here with her college friends and subsequently with her family and colleagues. Shah Rukh Khan—the inimitable iconic star of Indian liberalization—is evoked multiple times. Unlike Salman Khan's, Shah Rukh Khan's fanbase famously consists of women across all ages. Therefore, the past life of these cinemas is not hidden or buried or obliterated, but carefully restored and displayed in the structure's new materiality. They have *always been here*. The multiplex, in other words, is monumentalizing itself.

Writing on the death and conversion of modernist icon Chanakya Cinema into a multiplex in 2008, Nitin Govil (2015) discusses how the very use of reinforced concrete as a material choice for Chanakya (and other modernist structures built in the 1960s and 1970s) started a ticking clock for its eventual ruin and decay. Reinforced concrete is a poor choice for South Asia's hot and rain-heavy climate. Ruin, argues Govil, "is a permanent feature of the architecture of the modern" (147). He

Figure 4.1. An upper-middle-class woman, probably in her thirties, recalls her first Shah Rukh Khan movie in India's first multiplex. Source: PVR publicity film *The All New PVR Anupam Is Coming Back Soon* (PVR Cinemas 2021a).

Figure 4.2. Two women, in their early twenties, draw sensory associations between the multiplex and their childhood memories. Source: PVR publicity film *The All New PVR Anupam Is Coming Back Soon* (PVR Cinemas 2021a).

Figure 4.3. A mother and her son, constantly on his phone—cue for today's digitized spectator—share intergenerational anecdotes. The word she associates with this place is "nostalgic." Source: PVR publicity film *The All New PVR Anupam Is Coming Back Soon* (PVR Cinemas 2021a).

notes that fears of obsolesce haunt the global present and, following Ackbar Abbas (2002), we can surmise that disappearance precedes "reinvention" in postcolonial cities. What PVR Cinema's current industrial strategy shows is that they may have anticipated both ruin and disappearance and proactively taken the (classed) nostalgic route as a measure out of those fates.

For instance, the Spanish architecture firm Studio Gronda was entrusted with the redesigning of Chanakya Cinema into PVR ECX (Enhanced Cinema Experience). Ipsita Sahu (2018, 74) notes that the demolition of Chanakya Cinema was an "iconoclastic event," because it had stood as a symbol of refined urban leisure and global cosmopolitanism. Delhi's elites and upper and middle classes felt an intense sense of ownership for this cinema and banded together to save the building through a public campaign, an attempt that eventually failed. Chanakya's conversion into a multiplex, then, was a loaded affair. Sensitive to upper-class public sentiments and nostalgia about this space, the Chanakya mall and multiplex developers narrativized the conversion as a progressive arc towards a restoration of the iconic. Sriram

Khattar, Managing Director of the DLF Rental Business that leased this space to PVR Cinemas, said,

> Chanakya has always been synonymous with great cinematic experience and we are very excited to bring back that magic to all the movie lovers, old and new. The launch of PVR ECX will showcase the best of multiplex technology within the contemporary luxurious environs of the newest retail destination in the city—The Chanakya and it will go a long way in *reaffirming an address that has always been iconic*. (emphasis added) (ANI 2017)

The architects focused on making spectators feel a "clean, emblematic and powerful sense of arrival." "L shaped wood-panels and floor-to-ceiling mirrors create a laberinthic [sic] experience thus conveying a spacious space when in fact is (in most of the cases) only two meters wide" (Studio Gronda 2017). The potentials and materiality of reinforced concrete are now dressed in glass, creating a sense perception of an infinite space where it does not exist. Then, a certain nostalgia is evoked for the pleasures of an "iconic" address and the big screen as a part of Delhi's cultural history. The multiplex is here to salvage and rebuild. The city outside may be a risky and fearful space, but at the multiplex, one can always "return" to the "undiluted" pleasures of the screen.

Risk, Threat, and Public Leisure

What makes a public space risky and how does it become safe? In the case of post-liberalization Delhi, risk and fear suffused the capital through cascading road accidents (Sundaram 2010a), fire tragedies, bomb blasts, rage-related violence, stampedes, and many cases of sexual violence, among other cruel fates. On June 13, 1997—also the year of India's first multiplex—the Uphaar Cinema catastrophe happened. For almost two decades now, as the city's film exhibition circuit has transformed beyond recognition, the owners of Uphaar Cinema have been in a long, drawn-out battle with the Supreme Court.[6] The cinema building has been preserved in its charred state, intact with broken chairs and burnt film reels in the projectionist's room, as "material evidence." Besides the cinema's private owners and managers, other local government entities

like the Delhi Vidyut Board (Delhi Electricity Board)—which did a hasty patch-up job of a malfunctioning transformer the morning of the fire—the Municipal Corporation of Delhi, and the Licensing Authority were involved in the catastrophe. An organization called the Association of the Victims of Uphaar Tragedy (AVUT) is run by the survivors and families of those who perished in the cinema. They maintain an active website called Remember Uphaar (https://rememberuphaar.com) with a video commemoration for the victims, some of whom were teenagers, along with a picture gallery documenting the devastation. Details of the court case and the court orders, fire safety rules, deviations in the theater's seating plans from government mandates, and more are all documented here. Because this cinema was in the upscale residential neighborhood of Green Park, several victims were middle- or upper-class. The AVUT was able to file and win a landmark civil compensation case from the Supreme Court in 2011, which awarded 25 crores in compensation to the families of the victims. The Uphaar tragedy has kept circulating in the news, and especially on Indian television, which has a marked penchant for the graphic and the sensational. Photographs from the fateful day have been used to create several kinds of new visual and sonic assemblies: injured and dead victims, deployment of a massive police force, firefighters, ambulances, mug shots of victims—all enhancing immense spatial anxiety about the increasingly volatile nature of public space in the city. When this archive of a horrific collapse of a single screen is placed against the multiplex's nostalgic commemoration of its beginnings in the city—in the same year—it becomes evident why public safety becomes a key asset in the globalized media city.

The absence of women and middle-class families also codes a public space as "risky." The de-gentrification of the single screen is the most significant cause of its decline and death. While some of the city's existing single screens take special consideration to ensure that women feel safe at the cinema, they know they are fighting a losing battle. Rajan Gupta owns Liberty Cinema in Karol Bagh, an important commercial and domestic old neighborhood in Delhi, which was populated by many Partition refugees in the 1950s to 1970s. On May 22, 2005, a bomb went off at Liberty Cinema, injuring over fifty people and leaving one dead. It was showing a Bollywood film considered offensive to Sikhs and had received some prior threats to stop screening the film. Gupta was reticent

to speak about the incident, but he did say that the "classes" have abandoned the single screens because the theaters cannot guarantee who will be in the "rest of the crowd." He said,

> What we used to typically bifurcate in our minds earlier was the masses and the classes. Earlier we used to get all the masses and all the classes. Now we continue to get all the masses, but we get fewer classes. One of the reasons is anybody who affords to pay yet more than we charge in the balconies, they prefer to go to multiplexes. One of the things in the multiplexes, which we cannot guarantee, is the rest of the crowd. In the multiplex there will be nobody who cannot afford a 200 rupee or a 150-rupee ticket. So, the people you rub shoulders with is entirely different. (Gupta 2016)

Gupta also believes that the classes have chosen the multiplex for the "feeling of safety," "just the way the masses look at women is itself offensive enough to drive people away to a place which feels safer, it's not that it is safer, it feels safer." Gupta has personally instructed his staff to ensure that when women do buy tickets they are seated where they can spot other women. This strategy was not publicized. The last row of the theater is entirely reserved for women so that nobody is sitting behind them: "without them [female spectators] actually knowing what was happening, over the years they tend to feel safer . . . and it's the perception which is important, not actually what is happening."

Along with infrastructural catastrophes and gendered apprehensions, road accidents add another layer of risk in globalized Delhi. Sundaram (2010b) has documented how road accidents became a mainstay of urban life and commuting in the city from the late 1990s as people's mobilities rapidly increased. The city became organized around travel, and road accidents were always in the news. He writes, "narratives of consumption and spectacle coexisted with stories of death and disorder, sharpening the sensory experience of the growing metropolis. While the reporting technique was almost surgical it created a heightening of sensations through its sharp headlines and allegories of a dark city" (145). Sundaram says that a quotidian act like traveling became a source of fear and dread. The widespread dependence on motor travel implicated the very act of movement into a specific "human machine

sensory environment" where sound, tactility, and growing impatience with other machines collapsed together. Boundaries between humans and machines on the roads thinned, and private and public tragedies overlapped. In the previous chapter, I discussed how Delhi multiplex films like *NH10* and *Dev.D* have explored these perplexing relations between the road, rage, and accidents in a new atmosphere of speed and sensation. Despite its fatal nature, speed is, after all, an addictive modern drug.

The city, thus, is largely a risky space, continually on the edge of speed-related catastrophes. Why then is the multiplex making infrastructural moves towards orchestrating encounters that privilege shock stimuli, and offer a borderless world between body and technology? Fear, in a risk society, is also a source of profit (Doel and Clark 1997; cited in Hubbard 2003a). Scholars (Hubbard 2003a; Beck 2003, Doel and Clark 1997) have noted that contemporary capitalist cities exist in a climate of "ambient fear": everyone is afraid of something and closely monitors the minutiae of their lives. The multiplex has eliminated fears around infrastructural collapse through heavy advertising of expensive and global architectonics, and terrors of overcrowding and stampedes through a strict politics of population control. What remains after erasure of the anxiety and shock of the unregulated is the curated, gendered spectatorial body open to endless possibilities of engineered encounters with various multiplex technologies.

"Don't Just Watch the Movie, Be in It": Sensory Immersions at the Multiplex

In 2018, PVR launched an "off-screen" addition to the multiplex, a virtual reality (henceforth VR) lounge, in partnership with the technology giant Hewitt Packard (HP). Located in the lobby, this lounge is aimed at offering spectators an intensive fifteen-minute burst of an immersive media space before they enter the theater. Millennial Bollywood star Ranbir Kapoor—grandson of Regal's symbol Raj Kapoor—came to inaugurate the lounge and said, "It is a mind-blowing experience to go through the VR experience. But being an actor, I fear that it might take away the audience from movie theatres as they may get hooked to the

VR experience" (IANS 2017). PVR CEO Gautam Dutta, however, did not share these fears, as the short temporality of the VR lounge was a buffer against "losing" audiences. Importantly, one had to buy a movie ticket to gain access to the VR lounge. Dutta elaborated further in the trade press:

> It is a whole new dimension of entertainment; an experience of a world that doesn't actually exist. It is created by computers that allow you to experience and interact with a 3D world that isn't real by putting on a head-mounted display. At the cinema, there are four VR pods equipped with latest ground-breaking technology by HP that delivers an unparalleled immersive and interactive experience, blurring the lines between what's real and what's not; for instance, from crouching behind turrets to diving on the ground, from avoiding strafing bullets to seeing a grotesque image lurking nearby, those few intense minutes in VR lounge keeps movie lovers fastened to the virtual reality. (Shopping Centre News Bureau 2018)

What emerges from the introduction of a new VR layer in the passage from mall to the multiplex—"an experience of a world that doesn't actually exist"—is a need to repeatedly amp up the dense sensory and sensational qualities of theatrical space. This is a part of a series of recent developments that focus on advanced sensory infrastructures at the theater. Besides the VR Lounges, PVR Cinemas has also introduced the Superplex and 4DX theaters. The Superplex (launched in February 2017) has a twelve-screen cinema, along with cafes, lounges, and a movie store. The Superplex "is specially designed to overawe customers with the sheer space, technology, aesthetics and functionality." 4DX projection targets the senses. It produces enhanced vibrancy in color and granular detail on the screen. As described in the company Brand Book,

> You will be able to experience special effects such as wind, fog, lightning, and scents that enhance what you see on the screen. 4DX enables you to connect with the movie, sending you on a journey with the characters, and ultimately freeing yourself from the flat screen.

> Moviegoing is no longer just a simple viewing but an all-encompassing experience. Don't just watch the movie, be in it. (PVR Cinemas 2015)

Hence, the multiplex reorients the "all-encompassing experience" of single screen into a novel encounter with sensory technologies (also see chapter 2). Marketed as the "absolute cinema experience," 4DX aims to make spectators transcend their aural and visual limits. The two main effects in play are motion seats and atmospherics. For instance, "fair air" is a sensory technology that shoots air forward from the screen to the spectators, mimicking the action in the film. Other elements like water, scent, fog, wind, rain, light, strobe, and bubble effects offer a "new layer of immersion for audiences." A journalist for *The Hollywood Reporter* describes his experience as follows:

> The audience gasps in unison as bullets whiz by Bollywood superstars Hrithik Roshan and Tiger Shroff in an intense shootout sequence which sees them battling villains in the high-octane blockbuster *War*. The crowd reaction is triggered not just by the onscreen action, but also by sporadic gusts of air, timed with the flying bullets, which blow from a vent in the headrest, as the seat itself shakes and rumbles in sync with the explosive sound effects. (Bushan 2019)

Thus, the film—which would shortly be available on streaming platforms—is no longer enough to "de-couch" the spectator. Sight, sound, smell, touch, and motion must all be concurrently animated. As Siddharth Jain, director of Inox Leisure, PVR's main competitor, put it, "Our challenge is, how do we de-couch the customer—why is he going to leave home and spend money at our cinema?" (Bushan 2019). PVR's Ajay Bijli elaborated further:

> I have to make sure that the conduit that connects the filmgoer with the film is phenomenal. If people say that the film was good, but the seats were not comfortable, the food was bad or the sound was not up to the mark, then I am finished. Therefore, the investment in technologies such as IMAX, 4DX, D-Box and Playhouse and formats such as Luxe etc. I can't be responsible for what is playing on the screen, but I will make sure that the environment is worth the money you spend. (Shashidhar 2019)

These amplified efforts to "de-couch" the spectator collided with the sudden arrival of the COVID-19 pandemic. The pandemic not only collided with the entirety of the clean and sanitized multiplex assemblage, but it also arrived at a time when India's screen and exhibition industries were already negotiating encounters with the digital via an explosion of streaming platforms.[7] The pandemic undid the multiplex's assured principles of safety. An invisible contagion compromised its spectacular architectonics and thoroughly controlled environments. Risk—a category assigned to certain undesirable bodies, catastrophic events like fires, and unregulated places like the single screen—could no longer be mitigated through a politics of exclusion. Risk now superseded neoliberal cultural categories of class, caste, and gender.

A New Regime of Risk and Hygiene: The Pandemic, Bio-surveillance and the Digitized Spectator

At the time of writing this book in 2023, it remains too early to map the total coordinates of pandemic-induced changes in the country's moviegoing practices across habit, form, and infrastructure. However, it is evident that this extraordinary bodily event accelerated what was already in motion: the multiplex intensified its engendering of the digitalized spectator and quickly began work on the new kinds of "smart" spaces they should access for leisure. In India, this collision between contagion and the material environment of the cinema theater led to the rapid production of a predominantly "touchless" encounter, available to a specific kind of digitized body. In several interviews between October 2020 and March 2021 with the English and Hindi language press, Ajay Bijli talked at length about why he remained hopeful about the future of multiplex moviegoing in India. In an interview with *CNBC TV International* (Bijli 2021b), he said, "80% of our consumers are below the age of 39. They are resilient, and they cannot be incarcerated at home. The human body is not designed to remain under a lockdown at home." Because Indians do not have too many other forms of "social outing" like theme parks or baseball games, they spend their leisure time at the movies.

Thus, citing India's "insatiable appetite for the movies," Bijli and his team began a recovery process for the multiplex chain through the PVR

Cares campaign: a visually stunning technical walkthrough of measures the company has taken to control contagion and contact at their theaters, to "win back the consumer's trust." An analysis of this campaign illuminates the presence of a sharply digitized spectator-consumer body at the center of it. In a promotional video (PVR Cinemas 2020a), we see visuals of PVR multiplexes polished and scrubbed like never before. An American-accented male voiceover introduces us to the protocols in place: the box office cashiers are socially distant behind safety shields, ticketing is mobile and contactless, with PPE kits and single-use 3D glasses available at the ticketing counters. Physical and pat-down security searches are replaced by a digital thermometer screening and a status check on the government-mandated Aarogya Setu application, which is built for "contact tracing, syndromic mapping, and self-assessment" and can only be downloaded on smartphones. The staff has doubled down on cleaning using a variety of disinfectants that belong to the new dictum of contagion: anti-bacterial microfilms on surfaces, electrostatic sprays on all surfaces, air quality and humidity checks, sterilized food packaging, crockery, and cutlery. PVR staff and employees are subject to constant health screening and COVID tests after surveys revealed that spectators feared the spread of infection via workers. Touch, thus, now arrives via technology: "We have modified our procedures using technology for seamless, yet personalized service. With digital payments and non-invasive thermal screening, the touch of care replaces the physical one" (PVR Cinemas 2020b). The "safe" spectator must then not only be completely at home in "touchless" environments but also somewhat of a techno-evangelist acquiescent to various forms of bio-surveillance and datafication of the self to participate in this new regime of what constitutes the hygienic.

Though these publicity images are meant to offer reassurance, stringent health checks and hyper-sanitizations can have the opposite effect: they can overwhelm the delights of moviegoing. What happens to the pleasures of the screen when the theater starts to resemble an expensive private hospital? In the pandemic-induced spectatorial regime, then, the hapticity of the digital viewer is redirected towards the cinematic spectacle. To compete with the enhanced potential of home-viewing, both film and exhibition industries are moving towards the "big event"

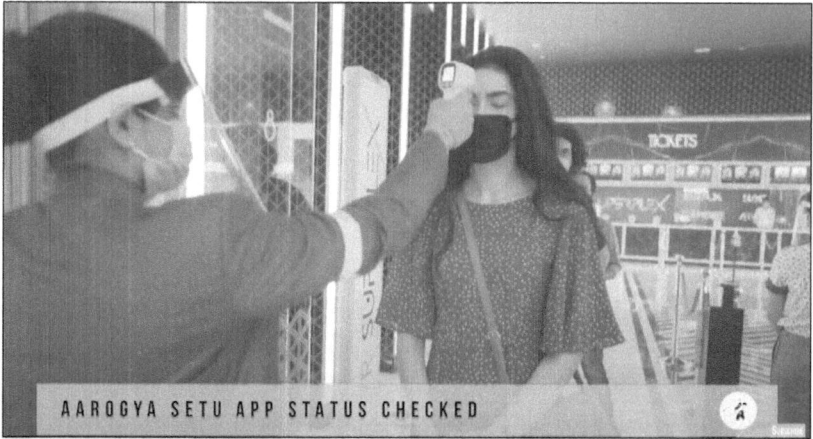

Figure 4.4. A masked female spectator gets her temperature checked by a masked female employee before entering the theater. Source: *PVR Cares* promotional video (PVR Cinemas 2020b).

film. This usually signifies a big-budget film with major stars released during a prominent festive holiday. For instance, *Sooryavanshi*—a Bollywood *masala* starring three big male stars—was finally released on November 5, 2021, after being stalled for two years. It was the first major mainstream release after the devastating second wave of COVID-19 in India, poised to attract a big audience. The film was not released on a streaming platform. Shortly before the film's theatrical release, its male leads, Ajay Devgn, Akshay Kumar, and Ranveer Singh came together for a short promotional video (T-Series 2021). Standing together in a multiplex, they appealed to the Indian viewer's spatial nostalgia for the big screen: "Friends, do you remember this place?" Calling the pandemic "an interval" in the relationship between cinema and spectator-in-the-hall, the stars enticed Indian audiences to come to the (multiplex) theater with their families for this Diwali special release. PVR Cinemas matched this fervor through new social media promotional campaigns underlining that going to the cinema was now as safe as going shopping and eating out, thus issuing a "public" invitation to partake in the enhanced pleasures and desires of consumption, but within a new cultural regime of safety via bio-surveillance.

Figure 4.5. Evoking the pleasures and desires of the cinematic screen, Ajay Devgn, Akshay Kumar, and Ranveer Singh promote *Sooryavanshi* in a multiplex. Source: #BackToCinemas promotional video (T-Series 2021).

Moving from *just* a film exhibition model, the company now seeks to produce a new and enhanced out-of-home entertainment experience. As Bijli (2021c) put it:

> We have to work very hard on becoming more and more experiential, it will have to be like Disney, what *Cirque du Soleil* did—it has to be very experiential when people go out not just from a technological point of view but also human interaction *people must feel very very good* when they go to the cinemas and think that this is something different: when I watch a movie at home it is utilitarian, but when I go out it's truly experiential. (emphasis added)

Cirque du Soleil is cited as an example of a potentially new form of theatrical experience that merges Disney animation with live-action acrobatic performances. While this may seem radical in the Indian context, it is ultimately an advancement of the multiplex's initial ambitions to craft a total spatial experience as *the* event, one that exceeds the film text. Bijli's thoughts are echoed by the company's CEO, Gautam Dutta (2020):

> The fundamental question is what business are we in? And we've checked with consumers as well and while we do show movies and we are in the business of movies but the industry we are catering to—we're in the busi-

ness of out-of-home entertainment and really that pie is very big, and the question is who would have ever thought that F&B [food and beverage] sales for a cinema company would be 1000 odd crores? Who had thought that a media business would touch 400 crores of advertising on screen?

The company is on its way to building new pilot theaters that will be completely redesigned touchless experiences and "as futuristic as we can make them" (Bijli 2021c). Such spaces inherently anticipate spectators on the right side of the digital divide, vaccinated and antibodied, completely at home with a variety of smartphone applications, and pliable to various forms of digital attendance and presence before, during, and after inhabiting the cinema. Audiences are therefore expected to acquiesce to this new spectatorial regime where their data is sought for their own good. They can once again partake of the pleasures of "public" consumption in the company of other digitized spectators who are proficient in accessing a touchless, smart space. The corporate work of contagion control, thus, becomes an expanded avenue for newer forms of border-policing sites for collective leisure.

While the central aim of the multiplex remains a spatial engulfing of the body, it has had to move away from simply creating awe in an aspirational environment. What more recent developments indicate is that the multiplex is offering several hyperreal immersions into technology, infrastructures, and architectures that cannot be replicated at home. The smart home and the multiplex have thus emerged as concurrent yet competitive spaces, especially in a new regime of risk unleashed by the pandemic. Contagion merges into renewed class-based fantasies of safety through hyper-technologized surfaces that can offer reassurance while still centering the pleasures of public consumption. The multiplex reads the Indian spectator's desire to locate herself in a thick network of screen-based tactility, and constantly shape-shifts to offer those perceptions in novel ways. It solicits a total politics of moviegoing: the "going" must surpass the movie, becoming an uninterrupted journey through cascading interiors that move with and through the spectator.

How then may we understand the connection between the multiplex and the fossilized single screen? How are they related to the larger affective

registers of fear and risk in the city? Anxiety is a thoroughly bodily event. Through trembling and palpitations, it taps into our sensory-motor schemas, becoming one of the most affective expressions of the body. According to phenomenologist Dylan Trigg (2006, 10) anxiety must have an object. The agoraphobe is lost in the myth surrounding the object, unable to dispel it. His solution is the bridge, which encloses him within a world "the edge of which marks a realm lost to its own haziness, as though it occupied a dreamscape removed from the existence of the waking subject." What lies beyond the bridge is a sharpening of the object of anxiety, and the dangers of it becoming "too clear, too real, too formless." Anxious subjects are fundamentally aware that the creation of a "home" requires a balance of illusion and indistinction, and that "place making" requires constant vigilance. Following Merleau-Ponty, Trigg suggests that to see something "clearly" means being neither too close nor too distant. A body or a home is often embedded in the greatest ambiguity. He suggests that the adjoining affect to anxiety is not anger as is often thought but is, instead, *nostalgia*. He says,

> As with the window frame, nostalgia holds things in place, allows us to pre-view the scene before returning to it time and again. The movement of returning is telling. When we turn away from the object of anxiety in repulsion, then we do so with a curious desire to turn back to the scene. There exists in those brief seconds an epiphany, an imageless realm that spellbinds us. Of course, by the time we have in fact returned, our anxiety has disappeared, now mastered by the act of possession. What remains is nostalgia for the deserted space. (2006, 12)

Similarly, if the multiplex becomes the metaphorical "bridge" in the interminable anxious landscape of contemporary Delhi, then it is unsurprising that its contiguous affect will be nostalgia for the "deserted space" of the single screen. Rem Koolhaas (2002) reminds us that "junkspaces" like malls, multiplexes, and nightclubs are characterized as interiors so extensive that their limits cannot be perceived. An active advancement of disorientation, through mirrors, polish, or echoes, rules their spatial politics. Junkspaces are sealed, "held together not by structure, but by skin, like a bubble" (175). The purpose of this "skin" is to captivate and fixate us (Trigg 2006). Thus, through the combined deployment of new

and enhanced sensory infrastructures and production of nostalgia for moviegoing as heritage and a culturally significant act, the multiplex can legitimize itself and its regulated environment. The vast and unpredictable city outside must remain obscure, blurred, and indistinct. It holds loiterers, unmanageable fans, missing female audiences, catastrophic events, ruined, and fossilized single screens. Additionally, now, it is too infinite for contagion control. Disciplining unruly behavior at the cinema need not hark back to the anodyne self-abnegation of modernist spaces. Middle-class nostalgias and desires for the tactility of the single screen cannot be completely erased but they can be reframed, repositioned, and reintroduced. What scares and repels us outside (shock, adrenalin, speed) can become enticing inside.

Epilogue

Moviegoing in the Age of Hindutva

Writing a book about India's contemporary entertainment industries or any act of public leisure necessitates acknowledging the country's collapse into violent majoritarianism. The BJP government led by Narendra Modi and Amit Shah came to power in 2014. The last decade has seen the transformation of right-wing Hindu nationalism from a hegemonic to a dominant force. A flourishing politics of Hindutva now undergirds every aspect of India's socio-political-cultural fabric. Indeed, it can be argued that what presently shapes the sweeping materiality and cultural politics of place and space in the subcontinent is a violent regime of fear and hatred. So powerful is its empire of coercion that even a global media industry as mighty as Bollywood must operate within its overt and latent diktats.[1] For India's minority communities—especially its 200 million Muslims—living in the subcontinent is not only increasingly precarious but also saturated with a constant stream of news about brutal violence directed at their community. While malls and multiplexes might polish and scrub their surfaces multiple times a day, ultimately, they cannot exclude themselves from a greater and more ominous politics of "national hygiene." In other words, potentials for violence lurk beneath and within spatial and infrastructural promises of new built environments and their veneers of global cosmopolitanism.

One of the arguments *Projecting Desire* makes is that exhibition space and its implied social makeup—as expressed through its architecture, infrastructures, and material environments—shapes production and distribution choices. The site of exhibition, however, can no longer be looked at as a spatial silo. Caetlin Benson-Allot reminds us that "when material culture becomes the frame for understanding media cultures, then nothing is out-of-frame—only out of focus" (2021, 254). Likewise, the preceding chapters brought into focus the new material domains of

film exhibition, their enmeshment other media technologies (like television and home video), and their relationship to other acts of leisure (like going to the mall). Architecture—always embedded in the history and cultural politics of place, space, and nation—structures these new assemblages of leisure, mediating the relationships between media texts and spectators. The story of globalizing India, in other words, can be found in its new built environments. If we listen closely, that story is about gender. In the closing pages of this book, I want to signal toward the ways in which the present political climate of the country infiltrates the regulated "safe" microclimates of the mall-multiplex. Has the multiplex—at twenty-five years old—achieved what it promised to deliver?

Consider, for example, the case of *The Kashmir Files* (Vivek Agnihotri, 2022), an unbearable propaganda film claiming to reveal the "truth" about the Kashmiri Pandit migration from Indian-administered Kashmir in the 1990s. Framing the Pandit departure from the valley as a "genocide," the film leaves no stone unturned in vilifying Muslims as vicious hatemongers and terrorists. Even Muslim children are portrayed as diabolical. *The Kashmir Files* also declares journalists, academics, intellectuals, and institutions with a robust and historic culture of student politics like Jawaharlal Nehru University as "anti-India"—a favorite trope of the Hindu right. The film was actively endorsed and promoted by several members of the BJP (including Modi-Shah, who met the director to personally congratulate him). It was then made tax free in all BJP-ruled states. Eager to attract crowds after the pandemic, many multiplex chains increased the number of daily shows to meet the "soaring demand" (Haider 2022). Numerous cinemas across the country—single screens and multiplexes—saw calls for violence against Kashmiri Muslims and Indian Muslims.[2] These videos were extensively circulated on social media. Journalist Rana Ayyub—an elite Muslim woman with a large following on social media (and a celebrity by all accounts)—chronicled her attempts to watch the film in a report (2022):

> As soon as I entered the theater in Mumbai, the audience broke into cries of "Bharat Mata ki jai" (Glory to India), a nationalist chant that has been repeatedly weaponized against Muslims. The man in the wheelchair soon joined the chants of "Sab mulle aatankwaadi" (Muslims are terrorists).
>
> I left before the movie even began. I tried again the next day.

The next day Ayyub left the theater after thirty minutes feeling "physically unsafe and humiliated" with the theater manager offering no help. In one of the viral videos (see Jafri 2022), a young middle-class man in a multiplex stands up as the film's credits roll. He loudly addresses his fellow spectators: "if every Hindu man who is twenty or twenty five years old marries a Muslim woman, then we can reduce their population in the next three generations. Marry their women and reproduce." Other spectators cheer him on.[3] Another video documents the scenes outside Delhi's historic Delite Cinema, where a large crowd of saffron-clad men chant fanatical slogans. Shakuntala Banaji (2018) has coined the term "vigilante publics" to describe how India's upper-caste Hindus have completely been co-opted into the political project of the far right: "feelings of group superiority and cohesion are enhanced by verbal and physical actions against those positioned as anathema to vigilante public sentiment" (335). Banaji rightly notes that spectacular violence is an embodied form of communication for vigilante publics. The Hindu right has a vast media and communications infrastructure ranging from WhatsApp groups to news channels, newspapers, television serials, pamphlets, brochures, and songs (342). Films like *The Kashmir Files* speak to this vast preexisting repertoire of Hindutva media. Such a text all but ensures the presence of vigilante publics at the theater: agents ready to legitimize its message through spectacular violence and drown out any dissenting voices.

In such instances, then, the multiplex recedes from its assurances of a safe and monitored space for women, a happy space for families, and an emblem of India's arrival into global cultures of cinematic taste and cinephilia-driven spectatorship. What these viral videos of xenophobic hatred at the cinema reveal is a certain porosity between incensed vigilante publics and ordered multiplex publics. Violence, a long material mainstay of cinema-going in India and elsewhere, apparently has no place in the industrial discourses of the multiplex. Yet, as the reception of *The Kashmir Files* demonstrated, the multiplex can and does merge with the single screen and other public sites when faced with a predominant national ecology of violence. In several videos documenting the affective charge of the film's reception, elderly women are copiously weeping and embracing each other, even as Muslim women are shouted out of the theater for protesting the film's polemics. Religious identity thus quickly supersedes any possibility of gender as a site of solidarity;

multiplex-going middle-class Hindu women can also be active participants in such spectatorial affirmations of xenophobic national pride and historical revisionism.

The Kashmir Files is the latest and most virulent example of a growing nexus between popular cinema, Hindutva, and violent reception cultures. Other such controversies, panics, and incidents of producers, actors, directors, and exhibitors compelled to toe the party line have been common in the last few years. Gender has been at the heart Hindutva's cultural politics. Fantasies about possessing Muslim women intersect with renewed intensities about protecting Hindu women from Muslim men. At the end of 2017, the many disputes and tensions surrounding Sanjay Leela Bhansali's *Padmaavat* laid bare these majoritarian anxieties as they clashed against the production, distribution, and exhibition of the film. *Padmaavat*, like most of Bhansali's oeuvre, relies on visual and sonic maximalism. It was one of the first mainstream Hindi films to release in IMAX 3D format, thus recognizing the economic might of the multiplex public as the primary spectatorial bloc. *Padmaavat* is based on the life of a fictional fourteenth-century Hindu queen, Padmini, whose only mention is in a poem. Sufi poet Malik Muhammad Jayasi penned it in 1540—a ballad about a Rajput queen so beautiful that a Muslim ruler (Alauddin Khilji, a real person) attacks her kingdom to possess her. The virtuous queen self-immolates rather than submit to the designs of the sultan. A rumor that engulfed the making of the film was this: there was apparently a dream sequence between Padmavati (Deepika Padukone) and Khilji (Ranveer Singh) that depicted them in a sexually intimate position. At the time, rumors were also rife that the two stars had been in a relationship for several years (they are married now). Other discourses that surrounded the film's production centered on questionable portrayals of the Rajput community, glorification of the Muslim ruler, and undermining the sacrifices of the pious queen. Members of the Rajput community, backed by fringe right-wing groups, vandalized the sets of the film several times, organized protests, assaulted the director, issued death threats, and placed bounties on the head and nose of Padukone—Bollywood's reigning female star. *Padmaavat*'s release (originally December 1, 2017) was pushed back indefinitely; the CBFC (Central Board of Film Certification) and a team of historians were called in to view the film and decide on its accuracy. Five cuts and

multiple disclaimers had to be included in the film. A song-and-dance sequence in which Padukone had a bare midriff had to be covered with CGI (computer-generated imagery). Finally, the Supreme Court stepped in and cleared the film's release; its title changed from *Padmavati* (the name of the queen) to *Padmaavat* (the title of the poem on which it is based). It was finally released on January 26, 2018. However, several single screens and multiplexes were simply too scared to screen the film, amid rampant reports of theaters vandalized and audiences attacked.

Ironically, the film—a revisionist historical—is entirely allied to the ideological project of the Hindu right. The director and the lead actors cried themselves hoarse reiterating that the film is a tribute to Rajput pride and glory (and by extension a cogent narrativization of an ancient Hindu India that valiantly fought a demonic Muslim foreigner) (Viacom 18 Studios 2017). What Bhansali meant by "any" viewer was the Hindu viewer. Far from the possibility of a dream sequence between the Muslim Sultan and the Hindu Queen, the two characters do not share any frames in the film. *Padmaavat* offers an immersive visual and aural journey through the ancient and brutal practice of *sati* and *jauhar*, where Hindu women were expected to immolate in the funeral pyres of their husbands. The film's most striking sequence is in its climax: hundreds of women clad in bright red bridal attire (including a pregnant woman and a little girl), led by the ethereal Padukone, commit mass suicide. Theaters were packed with police protection; a protesting mob stoned a bus full of school children in Gurgaon (Dayal and Nagpaul 2018).[4] No one was hurt, but the video went viral, adding to panic and hysteria.

Between the film and its production paratexts, the mediated spaces of its exhibition, their immersive infrastructures, and the contemporary discourse on gender lies the material specter of the Hindu right. While the multiplex film in its spectatorial address has sought to revise Hindi cinema's dominant representative tropes—particularly around gender—a film like *Padmaavat* marks a return to the majoritarian strains of chastity and honor that have long characterized Hindi cinema. The question, then, is not so much about whether a dream sequence ever existed between the Muslim Sultan and the Hindu Queen, even at the scripting stage. In contemporary India, the slightest possibility of such a dream can be fatal. Salma Siddique (2017) points out that while popular Hindi Cinema has always championed the transgressive love

story—interfaith and inter-class—India's present gendered anxieties are evident in campaigns like *Love Jihad*,[5] *Pinjra Tod*,[6] and *Beti Bachao Bahu Lao*.[7] Siddique says,

> Between urban Indian women's desire to reclaim public spaces and sexual agency, and the public outrage over rape and sexual predation that acquires protectionist undertones, is a nation held ransom to vigilante causes and calculations of inter-religious marriages, and the shifts in identity these might entail. (Siddique 2017)

India's new built environments cannot barricade themselves away from these forces. If indeed we are to make a case for studying expanded densities in the material environments of film exhibition, then we must also reckon with a new architecture of fear that permeates public life. The multiplex's careful designs can and do unspool when faced with spectatorial agendas that far surpass the film and the immediate spatiotemporal codes of exhibition. What the reception histories of films like *The Kashmir Files* and *Padmaavat* demonstrate is that assuaging (Hindu) middle-class anxieties around gender is increasingly embroiled with strategically appeasing the Hindu Right.

That reception cultures are increasingly volatile and unpredictable has led to new cultures of alarm and caution among media industry professionals. In 2016, for instance, Pakistani artists were banned from working in Indian film industries as geopolitical relations between the two deteriorated, once again, over Kashmir. This landed one of Bollywood's most powerful producer-directors, Karan Johar, and superstar Shah Rukh Khan in trouble—their films were up for release, and they had cast Pakistani actors in key roles. As the Hindu Right whipped up a frenzy and threatened to vandalize theaters that dared to screen these films, Johar and Khan had to take serious measures for damage control. Johar released an apology video in which he lamented his lapse of judgement and vowed to never work with Pakistani artists again. Pakistani actor Fawad Khan's role in the film, *Ae Dil Hai Mushkil* (This Heart is Complicated, 2016), was edited to the bare bones. The film was redubbed, Lahore superimposed with Lucknow—thus altering the intended version of the film to meet the altered conditions of its exhibition. The film—a romantic melodrama with some multiplex twists—was

released with an opening placard saluting the Indian army and thanking its soldiers. Shah Rukh Khan's *Raees* (Wealthy, 2017) found itself in similar troubled waters. Pakistani actress Mahira Khan is the film's female lead. A prominent right-wing organization (Maharashtra Navnirman Sena) demanded that a large fee be paid to the Indian Army Welfare Fund as "patriotism cess" for casting a Pakistani actor. Subsequently, Shah Rukh Khan personally met with the several right-wing groups, assuring them that Mahira Khan would not come to India to promote the film (Bhatia 2016). Between 2016 and 2018, it was also compulsory for audiences to stand for the national anthem before film screenings. In several instances, those who refused, or were not able to physically comply, were harassed, assaulted, and intimidated.[8] Being compelled to sing the national anthem and fearing the consequences of non-compliance, then, once again reveals the spatial and affective tensions between the ideal citizen of contemporary India and the ideal cosmopolitan spectator at the globalized multiplex.

* * *

A recent report by the media consultancy firm Ormax estimates that 23.7 million moviegoers have been lost to the pandemic (Grewal and Bhatia 2023). This "lost" segment is entirely above the age of thirty, making the median age of India's filmgoing audience 3.5 years younger (about twenty-four years) than what it was prior to the pandemic (about twenty-seven years). Alongside the pandemic, the meteoric growth of streaming platforms has been cited by most consultancy and news reports as the key reasons for a global decline in theatrical moviegoing. In India, streaming was initially hyped as the "next" of the multiplex, seen as a new frontier that would liberate creative professionals and audiences from the restraints of the box office and (for a moment) from the censorship laws that governed film and television. As this book has shown, the multiplex film is central to understanding the proliferation of genres in the streaming era. Many of India's acclaimed prestige television shows and direct-to-streaming films continue in the vein of the multiplex film, often privileging new representations of gender (including an explosion of queer stories), landscape, social realism, crime, and dystopia, and an overall move toward nuanced, novelistic character arcs—although the cultural diktats of the Hindu right now prevail over

streaming platforms too. The violent reception cultures that are increasingly marking the limits of the multiplex film are also present in the streaming economy. Without access to the public space of the theater as a stage for vigilante action and spectacular violence, Hindutva agents work through the institutional and legal harassment of creative professionals and platforms to curtail the political possibilities of streaming video.[9]

Multiplex spectators were imagined to be India's first urban digital audiences, quick subscribers to global platforms like Netflix and Amazon. To be sure, the country's digital audiences are already vast and heterogenous and cannot be neatly mapped on to the gender, caste, class, or spatial politics of the multiplex alone. Suffice to say that there are convergences among a substantial section of India's smartphone users, mallgoers, television viewers, multiplex spectators, and streaming audiences. This book has argued for spatially locating cinema and moviegoing within this recursive and expanded ambit of media convergence. Doreen Massey (1994, 3–4) reminds us that to think of space is to think of time (space-time), and that the spatial is "social relations stretched out." Further, power and symbolism are inherent to social relations and thus the spatial must also be conceptualized as a terrain of an "evershifting social geometry of power and signification." More recently, Debashree Mukherjee (2020, 317), in her extensive production history of Bombay cinema, has offered the analytic of "cine-ecology" to discuss a "proliferation of connections" highlighting cinema's relationship to other industries like cotton trade, other film centers beyond Bombay, and other media forms like the radio and theater. Likewise, in sketching the contextual elements and site-specific histories of the space-time of moviegoing, this book has mapped a capacious history of film exhibition in relation to architecture and urban design, shopping and retail, television and home video, local and regional histories, and the materiality of risk, violence, and fear. Studying Delhi, a media capital with a unique and traumatic relationship to gender, helps us dismantle overarching binary frameworks of the local/global and delve into the deep time of the capital. How did the Indian capital's search for a distinctive material ontology as expressed through its public buildings and housing projects shape its media cultures? How did an overwhelming fear of public space determine the shape and form of its globalized malls and multiplexes?

How might we trace an archive of gendered anxieties in a globalized media capital through popular cinema? What can middle-class nostalgia about the "lost" single screen tell us about the residual and affective life of media cultures seemingly caught a in nonstop delirium of transformations? In perusing these questions, *Projecting Desire* opens the field of enquiry and the network of relations that exist between popular culture, public leisure, and built environments.

What does moviegoing mean in the age of streaming? Why do we—as spectators—despite the many dangers of public commingling (contagion, violence, accidents) still seek the pleasures of the big screen? To partially answer these questions, I will return to the dancing body of Ranveer Singh, whose laudable attempts to keep his facial expressions multiplex and dancing body single-screen helped us chart the mediating power of exhibition on production in the opening pages of this book. Singh's latest film is a romantic comedy, *Rocky aur Rani kii Prem Kahaani* (Rocky and Rani's Love Story, Karan Johar, 2023). *Rocky aur Rani* is all classic Bollywood by a classically mainstream director, Karan Johar—lavish sets, spectacular songs, big romance, big stars, little realism. Shortly before finishing this book, I watched the film in PVR Select City on a humid Sunday afternoon in August. The mall was swarming with weekend crowds. The theater was packed with families, women, and several children. It appeared the crowds had overwhelmed the multiplex infrastructures: the air conditioning was malfunctioning, the sound seemed a little off, and the show started almost 30 minutes late. But the film, mounted as a commercial blockbuster, turned out to be a revisionist melodrama that sought to destabilize the gendered representational tropes that had long characterized Johar's cinema. Rocky Randhawa (Ranveer Singh) is a rich, gym-loving Delhi boy falls who falls for a liberal journalist, Rani Chatterjee (Alia Bhatt). Rocky and Rani's families are poles apart, setting the stage for intergenerational conflict. In the process, however, Rocky ends up confronting the social conditioning that has shaped his identity and his masculinity. The women in his family—his mother and overweight sister—take brave stands against the overbearing patriarchal rules that guide their lives. Angry, repressed fathers begin to transform and apologize. Estranged grandparents are given a romantic subplot. The liberal elite are called out for their disdain for the popular. The film is clearly an attempt on Johar's part to

address changing spectatorial tastes in the aftermath of streaming and many discourses on gender now present on social media. Johar's gamble paid off: multiplex spectators cheered, clapped, hooted, and whistled at each feminist subversion of a familiar, sedimented Hindi film trope. The film also met with overwhelmingly positive reviews celebrating a happy (though by no means stable) return—from the pandemic lockdown to the public event, from the couch to the big screen, from the tense reception environments of films *The Kashmir Files* to the warmth of the old-school mainstream *masala*. Like most other Hindi films, *Rocky aur Rani* is replete with intertextual references; Johar liberally cites not only his past oeuvre but also those of other popular directors like Yash Chopra, Subhash Ghai, and Sanjay Leela Bhansali. Rani's father is an effeminate *kathak* dancer, a point of confusion and ridicule for Rocky's conservative family. In the film's most subversive sequence, Rocky joins Rani's father for a public dance performance in a grand act of defiance. The song they dance to, "Dola Re" from Sanjay Leela Bhansali's *Devdas*, was originally performed by actresses Madhuri Dixit and Aishwarya Rai. It is in this sequence—where a muscular Ranveer Singh meticulously performs *kathak* in a feminine attire to a woman's song—that the single, the multi, and the OTT all spin together, scripting once again, a recursive media history where each site is continually activated by the other.

ACKNOWLEDGMENTS

This is a book about inhabiting space, and the architectures that undergird our mediated experience of the world. Through the long years of working on this project, I have moved in and out of several spaces and places, all of which have left significant material imprints on this book. The six years I spent at the Department of Radio, Television and Film at UT Austin are elemental to the basic architecture of book. First and foremost, I would like to thank my advisor, Shanti Kumar. Shanti believed in this project and my abilities as a scholar at a crucial and formative stage. His kindness and support went a long way in lessening the shock and strangeness of graduate school in America. The journey of this book has been one of arriving at all the places Shanti had anticipated and trusted from the beginning. I am grateful to Madhavi Mallapragada for her mentorship, intellectual rigor, her teaching, and most of all her friendship that sustained me in more ways than I can articulate. At UT Austin, I also had the privilege of learning from Janet Stagier, Tom Schatz, Mary Beltran, Joseph Straubhaar, and Kamran Asdar Ali. Janet and Tom were inspiring mentors who challenged me in so many productive ways, introducing me to a range of new thought and scholarship that continues to shape my thinking. Thank you, Kamran Ali, for your warmth, steady encouragement, humor, and for running the fantastic South Asia Institute. It was such a privilege to be part of that lively and interdisciplinary intellectual community, and I miss it dearly. My years in Austin were also enriched through friendship and conversations with Anne Major, Elizabeth Bolton, Caitlin McClune, Hena Bajwa, Sandy Chang, Alfred Martin, Jennifer Kang, Tim Piper, Geeti Shirazi Mahajan, Paul Popiel, Zack Shlachter, Colleen Montgomery, Paul Monticone, Kareem Khubchandani, Adolfo Mora, and Ramna Walia. Two important grants in graduate school went a long way in aiding my work: the Taraknath Das Dissertation Grant

from Columbia University's South Asia Institute and the Graduate School Dissertation Competition Grant from UT Austin.

My debts to Aswin Punathambekar are simply too many to be listed here. I was incredibly fortunate to have him as my mentor as a postdoctoral fellow at the University of Michigan Ann Arbor. Aswin has had faith in me and in this book through several roadblocks, unforeseen delays, the pandemic, bad drafts, and inchoate articulations. While I have learned tremendously from his scholarship, more importantly, Aswin continues to show so many of us how to be more empathetic as colleagues, mentors, and friends. I can only hope to emulate his radical pedagogy. A big thank you also to Mandira Banerjee and Ameya and Manan Punathambekar for warmly welcoming me into your homes in Ann Arbor and Philadelphia. I look forward to many more conversations over fantastic food! Several other colleagues have helped shape this book: thank you Samhita Sunya for generously sharing your notes on the process of writing one's first book that I turned to time and again. A manuscript workshop with Nitin Govil and Purnima Mankekar was an enormously valuable exercise that helped sharpen this book's key analytical frames. Nitin and Purnima made everything better through their deep engagement with the text and their enthusiasm for the project. I owe some of the best bits of this book to their responses, and to dialogues that emerged from that workshop. I must also extend my gratitude to the two anonymous peer reviewers for their detailed and encouraging feedback, which has been vital to the final shape of this book. I have presented early drafts of some chapters at various conferences, where comments and questions from Tejaswini Ganti, Rahul Mukherjee, Neepa Majumdar, Usha Iyer, and Marc Steinberg have enriched the project.

I could not have written this book without the generous help of several people in India. In Delhi, I am grateful to the staff of PVR Cinemas: Sahila Kalia, Deepa Menon, Agneet Kumar, Vikas Sabarwal, A. K. Gulati, Tarun Mazumdar, and Vijay Kapoor. They took time out from their busy schedules to speak with me and explain the inner workings of a major media and entertainment company. In several ways this book was built from the long interviews and conversations with Pranay Sinha, architect of Select Citywalk mall, and the owners of Delhi's extant and extinct single-screen cinemas: Shashank Raizada, Rajan Gupta, Devdutt Chitnis, and Uday Kaushish. In Bombay, I would like to thank Vikramaditya

Motwane, Ranjan Singh, Konkona Sen Sharma, Namrata Rao, Tarun Mansukhani, Ashim Ahluwalia, Ashima Singh, Ali Abbas Zafar, and Mukesh Sharma for their time and for giving me key insights into the contemporary Hindi film industry. Thank you to Aparajita Ninan and Anand Virmani and the Sharma uncle and aunty for opening your homes to me during the many months I spent in Delhi researching for this book.

Several editors have been instrumental in making this book exist. A book proposal workshop with Laura Portwood Stacer was immensely helpful. I have turned to Laura several times since for publishing advice, and she has always made time in her busy schedule to help me find solutions. It is an honor and privilege to be published alongside works in the marvelous *Critical, Communication, and Cultural Studies* series at New York University Press. I am grateful to the *CCC* editors for believing in the significance of this project and advocating for it throughout. Extra special thanks to Jonathan Gray, who shepherded this book from proposal to final revisions. While we all know (and are inspired by) Jonathan's field-defining scholarship, as a first-time author and junior scholar, I was doubly lucky to receive his stunning editorial skills and guidance. At every step, Jonathan patiently helped me navigate the challenging process of book publishing with grace and clarity. Without the team at NYUP of course, nothing would be possible. I am indebted to Eric Zinner and Furqan Sayeed for staying with the project and seeing it through multiple stages. The stellar production team at NYUP were instrumental to giving the book its final shape and form: I am deeply indebted to Ainee Jeong for overseeing production (and answering all my queries), Mary Beth Jarrad and Madison Greene for handling marketing, James Harbeck for the meticulous copyediting, and adam bohannon for the superb cover design, and the team at Arc Indexing for the index.

At University College Dublin, John Brannigan, Jorie Lagerwey, Martha Shearer, Porscha Fermanis, and Emilie Pine have been generous colleagues, helping me in navigate a new university, a new department, and many unfamiliar systems—especially during a pandemic. A publishing grant from the National University of Ireland has aided the book in its final stages. An early career writing workshop organized by my wonderful colleague Sarah Comyn helped me refine some ideas for this project. Shoutout to my friend and colleague Emma Bennett—I'm just glad to have her around.

I am so grateful that some of my friends double up as colleagues. Kartik Nair has graciously read and commented on several key parts of this book. He has also patiently answered my many calls and texts, often in the vein of "is it normal to hate your intro??" fired off at odd hours of the day and night. This book has also benefited from many dialogues with Sriram Mohan, who has been a source of great comfort, camaraderie, and support. Thank you also to Salma Siddique and Lia Wolock for being such solid comrades throughout.

My friends continually help me find a semblance of meaning in an utterly nomadic, and increasingly fragmented, and uncertain life: Thank you Aafreen Alam, Gaurav Khanna, Meera Mahadevan, Kakul Gautam, Astha Kapoor, Sahir Raza, Devika Shankar, Neel Debdutt Paul, Manshreya Grover, Sweta Singh, Mourvi Sharma, Vaishali Singh, Anuj Bawa, and Arif Ayaz Parrey. I struck gold in Austin when Vrinda Marwah showed up, embodying home, and the city we had both dislodged ourselves from but couldn't let go of: Delhi. I cannot imagine my years in Austin—and life at large—without her. Karan Mahajan helps me make sense of our itinerant lives, a conversation we've kept up for years. He also lent his novelist's eye to the book at the proposal stage, helping my sentences stand up straighter. Everyone who knows Sara Marzagora can attest that her friendship is a gift, and I am especially grateful for her meticulous guidance on professional stuff, and of course her rare emotional sharpness and wit. Special thanks are also due to Ankur Khanna for the stories, and for helping me find humor in darkest of places; Anna Joseph for her love and care, and for making sure I always have a roof over my head in Bombay; and Arjuna Desai for his unwavering generosity over the years. Without my daily *guftagu* with Meghna Chaudhuri and Madhuri Karak, I would be lost. I am grateful to them for years and years of friendship, support, care, and for suffusing my life and work with joy and making every space—from an airport to yet another new city—feel a little less alienating. To my parents, I owe everything. Despite the destruction of our lives and the vast challenges they face, they continue to fight, and make room for me to be able to write and work. I dedicate this book to them.

Early versions of some sections of chapters 2 and 3 were published in *South Asian Popular Culture* and *Feminist Media Studies*. A small section of chapter 4 was published in the *International Journal of Cultural Studies*.

NOTES

INTRODUCTION

1 I have chosen to use the name *Bombay* throughout the text to indicate that the urban character of the city and its historical associations with film and media production and circulation predates—by decades—the official name change to *Mumbai* in 1996. The change came at the behest of the Marathi nationalist political party (Shiv Sena), who have long advocated for an exclusive ethno-nationalist state for Marathis. *Bombay* is therefore also more reflective of the city's inherent ethno-religious diversity.

2 The "angry young man" was a violent, hyper-masculine figure who rose from the margins of society to fight societal, institutional, and judicial injustice. Examples include *Zanjeer* (Chains, 1973), *Deewaar* (The Wall, 1975), and *Kaala Patthar* (Black Stone, 1979), among others (see Mazumdar 2007; Virdi 2008).

3 The only book-length work on Delhi's media histories and technologized cultures is Ravi Sundaram's *Pirate Modernity: Delhi Media Urbanism* (2010b). Sundaram writes that Delhi has seen the evaporation of boundaries between technology and urban life. Technology has spilled beyond mills and dams to now encase the entire city, its infrastructures, media forms, and networks "like an all-pervasive skin." Pirate technologies and media proliferation also undid Delhi's careful post-Partition centralized urban planning. A few recent books in anthropology have engaged with urban space, gender, and infrastructure in Delhi. See, for instance, Ethiraj Gabriel Dattatreyan's *The Globally Familiar: Digital Hip Hop, Masculinity, and Urban Space in Delhi* (2020) and Rashmi Sadana's *The Moving City: Scenes from the Delhi Metro and the Social Life of Infrastructure* (2022).

4 On December 16, 2012, a twenty-three-year-old physiotherapy student named Jyoti Singh Pandey and her male friend—after watching a film in a multiplex in the upmarket Select Citywalk Mall—accidentally boarded the wrong bus, which was being driven by six joyriders including a juvenile. Jyoti Singh was subsequently gang-raped, tortured, and beaten by these six men and succumbed to her injuries eleven days later in a hospital in Singapore. This incident triggered unprecedented, large-scale public protests in the capital and around the country that led to legislative changes in India's rape laws.

5 McQuire's work on the media city mostly focuses on the spatial transformation of the Western metropolis—cities like Paris and New York—through concentric and successive regimes of media technologies beginning with photography in the mid-nineteenth century, moving to cinema in the twentieth century and to the

ways in which digital and electronic media are embedded in urban infrastructures in the twenty-first century.

6 For an account of Bhojpuri film and its audiences, see Akshaya Kumar, "Bhojpuri Cinema and the 'Rearguard': Gendered Leisure, Gendered Promises" (2016). For an ethnography of filmgoers in Bangalore, see Lakshmi Srinivas, *House Full: Indian Cinema and the Active Audience* (2016).

7 Jocelyn Szczepaniak-Gillece notes that in discussions of American moviegoing history, there is a prevalent nostalgia about how the grand movie palace was replaced by "digitality and the sticky, chilly, and gloomy mall multiplex" (2018, 20).

8 Athique and Hill (2010, 9) argue that multiplex development trajectories universally display the following social vectors: economic restructuring and corporate control of the film industry, a reorganization of leisure that privileges the integration of previously dispersed activities, and a spatial restructuring that especially emphasizes certain modes of living over others. For multiplexes in the United States and Canada, see Charles Acland, *Screen Traffic: Movies, Multiplexes and Global Culture* (2003); for the UK, see Phil Hubbard, "Fear and Loathing at the Multiplex: Everyday Anxiety in the Post-industrial City" (2003a) and "A Good Night Out? Multiplex Cinemas as Sites of Embodied Leisure" (2003 b). Further, Juan Llamas-Rodriguez (2019) has studied the Mexican multiplex chain Cinepolis across the United States and India—where it is the only foreign exhibitor—as an example of a global exhibition strategy of "modular cosmopolitanism" (49). He demonstrates that luxury theaters are involved in the work of engendering in their consumers feelings of belonging in a location that, agnostic to "elite experience," can be replicated across national contexts (69).

9 Govil (2015) writes that the multiplex in India marks "both a portal into the west and a gateway into the globalization of Indian life" (133–134). He reminds us that consumption and commercialization are the twin logics of the multiplex, which seeks to create a cordoned-off zone merging three spatial utopias: the urban exterior, the theatrical interior, and on-screen space. Govil's case studies cover other thwarted instances of industrial mergers between Hollywood and Bombay along the long arc of history that began in the 1920s and ended with the failed acquisition of a multiplex chain in Maharashtra in the mid-1990s.

10 Rai expounds that the multiplex has not only reformulated moviegoing in India by unleashing a new spatiotemporal regime but has also opened transnational avenues for commerce. He uses the popular Indian-English term "time pass," which is specifically associated with moviegoing in India (but also with any activity that results in an unproductive use of time), to elaborate on the unique relationship between time and embodied spectatorship in the subcontinent. The multiplex has indeed repackaged "time pass" in various ways. For instance, it produces new formats for cinema: shorter durations, shrinking of the average shot, and even the omission of intermission in some places.

11 See also Thomas Lamarre, "Regional TV: Affective Media Geographies" (2015) and "Platformativity: Media Studies, Area Studies" (2017); Sriram Mohan and

Aswin Punathambekar, "Localizing YouTube: Language, Cultural Regions, and Digital Platforms" (2018).

12 In the South Asian context, several scholars (Appadurai 1996; Fernandes 2006; Brosius 2010; Rai 2009) have discussed how the post-1990s moment of cultural globalization in the subcontinent was fueled largely by the rise of a "new middle class" that was distinct from the "old middle class," which symbolized the Indian State's transformation to privatization. Leela Fernandes (2006), for instance, has written that the new middle class—almost 300 million strong by the mid-2000s—became a powerfully visible category (xv). The rise of this class was also symptomatic of a shift in political culture: from a state-managed economy to a middle-class-based culture of consumption. India's move toward capitalism also necessitated a reframing of patriotism: "members of the new middle classes now consider themselves as motors of a new national revitalization, both in terms of economy and moral values" (Fernandes 2006, xv). Pleasure as individual and collective progress, pleasure-driven consumption, and displays of wealth are the bastions of this class performativity.

13 Christiane Brosius (2010, 327) has examined the urbanization of Delhi through gated communities and malls, religious sites like the Akshardham Cultural Complex, the health and wellness industry, and destination weddings, all of which provide important insights into the desires of the new middle classes. Brosius writes that these new aspirational practices often fall back on retranslating older traditions, practices, and ideas of cultural heritage based on caste and class.

14 See, for instance, Lila Abu Lughod, *Dramas of Nationhood: The Politics of Television in Egypt* (2005); Krisztina Fehérváry, *Politics in Color and Concrete: Socialist Materialities and the Middle Class in Hungary* (2013); and Lisa Rofel, *Desiring China: Experiments in Neoliberalism, Sexuality, and Public Culture* (2007).

15 The "new middle class" that emerged along the privatization of the Indian economy in the last three decades does espouse a politics of neoliberalism, globally understood as a class-based politics concerned with making economic elites more powerful, and associated with the deregulation of markets, liberalization of trade and industry, and privatization of state-owned enterprises (Harvey 2005; Steger and Roy 2010; Ganti 2014, 91). My use of the term "neoliberalism" in this book is tied to the reconfiguration of media industries and the media forms that generate the images associated with "the valorization of consumer capital and ideologies of individual empowerment, self-interest, and the conflation of consumer choice with political choice" (Ganti 2014, 98).

16 Gender, as several scholars have argued, is the "central ideological site" of conflict in the story of India's globalization (Fernandes 2001, 157). The Indian middle-class woman on the cusp of a rapidly globalizing nation was the arbiter of rampant anxieties about the loss of India's "cultural values" (Mankekar 2015; Fernandes 2001; Uberoi 1998; Phadke 2007). Specifically, these concerns regarded the loosening of sexual and moral codes of behavior that Indian women were expected to follow. This is important for understanding why the sexual safety of upper-caste

and middle-class women is so strongly engraved in the newly built environments for public leisure. However, in the last decade, the English-language press has framed the migrant, working-class male as the main threat to the sexual safety of the middle-class woman (more in chapter 3).

17 The liberalization of the Indian economy saw the Bollywoodization of popular Hindi Cinema. The state granted industry status to Bollywood in 1998. Through a combination of box-office successes overseas and steady corporatization of the industry at home, popular Hindi Cinema was able to alleviate its associations with poor taste (Ganti 2012).

18 Two important films that defined Bollywood were Sooraj Barjatiya's *Hum Aapke Hain Koun..!* (Who Am I to You?, 1994; henceforth *HAHK*) and Aditya Chopra's *Dilwale Dulhania Le Jayenge* (The Braveheart will Take the Bride, 1995; henceforth *DDLJ*). Both were narratives about young couples falling in love and negotiating their relationship among the established mores of the patriarchal family. The "youngsters" staunchly believed in and upheld the values of this system. In her study of audience reactions to *HAHK*, Patricia Uberoi (1998) finds that the primary reasons for its popularity were its lack of vulgarity (none of the raunchy, suggestive songs that had become the staple of the 1980s); its display of affluence in sets, costumes, props (even Tuffy, the dog, signified middle-class Indian aspirations to own a dog); and its spirit of sacrifice, especially by the heroine, reminiscent of the golden bygone era of Hindi cinema. It was a family film—that is, a film about a good Hindu family that could be watched with all members of one's family.

19 The name PVR is an acronym for Priya Village Roadshow. The Bijli brothers owned a single-screen theater called Priya Cinema in the South Delhi neighborhood of Vasant Kunj. In their initial years, they partnered with a company called Village Roadshow that was building multiplexes in Australia and elsewhere in the world. In 2002, Village Roadshow divested its investments and sold everything to Priya Exhibitors, who retained the name PVR.

20 The remarkable PPHP project (from SARAI, a research lab based in New Delhi) is one of the first archives of micro-histories and ethnographies of media and urban space in Delhi. It chronicles the early years of globalization and the transformations of cinemas, video and audio markets like Palika Bazaar, satellite television, and cable operators, along with government regulation of media practices in the capital (see Ravikant, Vasudevan, and Sundaram 2003). For more, see https://sarai.net/projects/publics-and-practices-in-the-history-of-the-present/.

21 In the Indian numbering system, 1 lakh denotes 1,00,00 (i.e., 10,000) rupees and 1 crore is 10 million rupees.

22 Several scholars (Mankekar 1999, 2015; Rajagopal 1999; Mazzarella 2003; Kumar 2010) have argued that after the privatization of the Indian economy, television shifted from capital goods to heavy promotion of consumer goods, turning viewers into consumers. Television also played a key role in positioning India as an emerging market for commodities and accelerated its integration into

global circuits of capital. It was also clear that cable television programming and advertising had begun to slowly erase images of those who could not afford to consume, in the process establishing a politics of exclusion that was also emphasized by spaces like the mall and the multiplex.

23 See, for example, *Dev.D* (2009), *Wake Up Sid* (2009), *Band Baaja Baaraat* (2010), *Vicky Donor* (2012), *Hasee toh Phasee* (2014), *Manmarziyaan* (2019), *October* (2019), *Dil Dhadakne Do* (2015).
24 Whereas the courtesan is an old-worldly tragic figure, the vamp is the modern urban prostitute. For more on the iconography of the vamp, see Mazumdar 2007.
25 In *The Dirty Picture* (Milan Luthria, 2011), for instance, prominent female star Vidya Balan plays a fictionalized version of Silk Smitha, an erotic actress from the B-circuit in the 1980s in South India. This choice was met with enormous positive press and Balan went on to win the National Award for Best Actress for the role. Anushka Sharma, a young mainstream A-lister, produced *NH10* along with the gritty police procedural *Paatal Lok* (Netherworld, 2020) for Amazon Prime Video and feminist gothic-horror *Bulbbul* (2020) for Netflix. Recent films continue to chart new terrain for the Hindi film heroine: *Thappad* (Slap, 2020), for instance, offers a revised and understated feminist take on the ubiquity of the casual slap that has long been a quick narrative trope through which the hero expresses frustration or tames his wife/girlfriend. In *Chhapaak* (Splash, 2020), Bollywood's reigning diva Deepika Padukone takes on the biographical role of acid-attack survivor Laxmi Agarwal. It was also Padukone's first foray into production.
26 Examples include *Chhapaak* (2020), *Thappad* (2020), *Raazi* (2018), *Veere Di Wedding* (2018), *Neerja* (2016), *Piku* (2015), *Kahaani* (2012), and *The Dirty Picture* (2011).
27 In a recent edited volume, *Bollywood's New Woman: Liberalization, Liberation, and Contested Bodies* (2021), Megha Anwar and Anupama Arora discuss the cinematic representation of the "new woman," a didactic figure/trope that they deploy to read neoliberal articulations of gender after 1991. Their theorization of this figure is expansive, ranging from Global Bollywood films like *DDLJ* and *Dil Toh Pagal Hai* (This Heart is Mad, 1997) to contemporary multiplex films like *Piku* (2015) and *Dear Zindagi* (Dear Life, 2016). Whereas the essays in this volume are concerned with the representation of women in Bollywood films after liberalization, I am interested in locating gender in the material conditions of exhibition and the spectatorial imaginations they produce, which in turn engender changes in production practices and narratives.
28 Scholars have also argued (for instance, Gopal 2021) that contemporary womanhood on screen is steeped in a politics of neoliberalism in which each woman, although ready to "take action," looks out only for herself—making solidarity across socioeconomic subjectivities impossible.
29 See, for example, *Manmarziyaan* (2019), *Bareilly ki Barfi* (2017), *Tanu Weds Manu* (2011), and *Gangs of Wasseypur* (2012).

30 Amit Rai (2009) writes about how the proliferation of transnational media created a new sensorium dominated by "feedback loops of capital, affect, pleasure and time" (71).

1. A MATERIAL HISTORY OF THE CINEMA HALL

1 Cinema arrived in July 1896: the first Lumiere Brothers film was shown at the elite Watson Hotel in Bombay. The first measure of spatial organization was through gender segregation (Srinivas 2000). This was not unique to India and parallels can be found in Damascus, Russia, and Kenya (see Larkin 1998). There was a significant time lapse between the arrival of cinema and its proliferation as a form of entertainment open to all classes (Hughes 1996; Srinivas 2000).

2 Scholars like Kaushik Bhaumik (2011, 44) have written about the first phase (1896–1919) of theater construction in Bombay. Bhaumik notes that the emergence of a new work regime in the city blurred boundaries of class, caste, and religion. This helped the formation of an anonymized mass public, which was an essential prerequisite for a twentieth-century modern metropolis. He also discusses how newspapers often emphasized the links between public transport and the location of a particular cinema along with descriptions of facilities like lights and electrical fans. The cinema theater was increasingly naturalized into the greater infrastructures of a bustling city.

3 For instance, Sudipta Kaviraj (1997) states that colonial modernity was premised upon a duality between the city and the country, where the former "was seen as orderly, hygienic, scientific, technologically superior and civilized" (84).

4 In Colonial India, there were two kinds of cinemas: Western and Indian. The Western cinemas were in the elite European sections of the principal metros (Bombay, Calcutta, Madras, Delhi) and were also known as "first-class" theaters. These catered to the Europeans, Anglo-Indians, and "educated Indians." They exclusively screened Western films. The Indian theaters were in the less fashionable areas of towns, catering to "wholly Indian audiences," mostly the "rougher sections of society." They screened a mixture of Indian and Western films (ICC Evidence vol. 1, 376; cited in Dass 2009, 86). The *Report of the Indian Cinematograph Committee 1927–1928* (henceforth *ICC*) states that there were 309 permanent cinemas in British India in 1927–28. The ICC gathered reports on 271, out of which around 100 were classified as "Western" cinemas (more than 60 were in the cantonments), and 200 catered to "wholly Indian audiences" (*ICC*, 20; cited in Dass 2009, 86).

5 Dipesh Chakrabarty (1991), for instance, discusses the *bazaar* (marketplace), a literal and imaginative site that firmly belonged to the public and the outside: an ideal space for transgressions, border crossing, dirt, disorder, and contamination.

6 Dass argues that spectatorship, from its inception, was a site "not just of imagining community but also of asserting class difference and social hierarchies" (2009, 79). The ICC report, despite its limitations, offers some key insights into how the mass audience was imagined and monitored in the subcontinent (83–84).

Anxieties around health, hygiene, and safety featured prominently. The British Social Hygiene Council visited India in 1926–27 and claimed that cinema was a major contributor to lowering the standards of sexual conduct and leading to an increase in diseases (*ICC*, 188). Fears of miscegenation existed at two levels: between the colonizer and the native, and between the upper-class Indian and the subaltern mass.

7 For instance, Rustomji Dorabji, proprietor of several upmarket theaters in Bombay, vehemently opposed any government decree that would require him to screen Indian films at his high-end theaters catering to the European elite and Westernized Indian middle classes. According to him (*ICC*, 362–364; cited in Dass 2009, 79), "If a theater is asked to show even once a week one Indian picture, even that will ruin that particular theater altogether, because Indian habits and the educated man's habits are so wide apart that with the betel leaves and other things which make them equally dirty and stinking, it will take another 3 weeks by the time you have cleaned it well and put it in order for the better class Indians." Dorabji's comments remain valuable to understanding the relationships between class, taste, and public leisure in the subcontinent.

8 Szczepaniak-Gillece notes that by the late 1920s modernism was prevalent in American art, literature, and architecture. In 1928, George Schutz, editor of *Motion Picture Herald*'s *Better Theatres Supplement*, explained that "immoderate embellishment—ornate figures, scrolls, floral excrescences, what is popularly referred to as 'lovely,' what we have been used to associating with the feminine—are ruled out." Art Moderne was all about "design based on simple line" (July 7, 1928; quoted in Szczepaniak-Gillece 2018, 7).

2. DESIGNING THE MALLTIPLEX

1 This can be compared to the popular "clean" family film espoused by postliberalization Bollywood in the first decade that began in 1995: the creation of a filmic environment that the entire "Indian family" can enjoy without any discomfort (i.e., no sex or overt intimacy, no class or caste issues, no extreme violence, no rape, no questioning of a pan-Indian [Hindu] identity).

2 See for instance, Lotte Hoek *Cut-Pieces: Celluloid Obscenity and Popular Cinema in Bangladesh* (2013) and Manishita Dass, *Outside the Lettered City: Cinema, Modernity, and the Public Sphere in Late Colonial India* (2015).

3 On September 18, 2016, militants attacked an army base in Indian-administered Kashmir, killing 17 soldiers. On September 29, 2016, India announced that it had conducted "surgical strikes" on Pakistani terrorist base camps along the LoC (Line of Control). Pakistan's and India's versions of what transpired differ significantly.

4 Vikas Sabharwal, Vice President, Architecture and Design, at PVR Cinemas further explained that the demography of a particular place is studied to answer the primary question, "are the people culturally ready for a multiplex?" (Sabharwal 2016).

3. THE MULTIPLEX FILM

1. Besides Delhi films Banerjee has also directed two landmark multiplex films: *Love, Sex aur Dhokha* (Love, Sex, and Betrayal, 2010)—three intersecting stories about honor killings, sexual exploitation, and media voyeurism told through handheld cameras and CCTV footage—and *Shanghai* (2012), a dark, stifling narrative about India's attempts to emulate the global city through an erasure of its poor and working classes.
2. Notably, that incidents of sexual/domestic violence and child abuse among middle and upper classes perpetrated by family members or others known to the victim are largely unreported. The same is true of the rapes of rural, lower-class, and lower-caste women. In fact, over 90 percent of Dalit women are the most vulnerable to sexual violence in the country, and several horrific cases of their rape and assault on them have been reported over the years, but not given much attention by the press or the public (Jolly 2016).
3. As outlined by Gopalan, a standard narrative unfolds in the following manner: films open with family settings that appear happy and normal according to Hindi film conventions, but with a difference—there is a marked absence of dominant paternal figures. The female protagonist is always a working woman with a strong presence on screen. These initial conditions are upset when the female protagonist is raped. The raped woman files charges against the perpetrator, who is easily identifiable. Courtrooms play a significant role in these films, if only to demonstrate the state's inability to convict the rapist and to precipitate a narrative crisis. This miscarriage of justice constitutes a turning point in the film—allowing for the passage of the protagonist from a sexual and judicial victim to an avenging woman (1997, 44).
4. Raj Kapoor's *Awaara* (The Vagabond, 1951) and *Shree 420* (Mr. 420, 1955) typify the former, while Mehboob Khan's iconic magnum opus *Mother India* (1957) became the blueprint for the latter.
5. "Honor killings" in India usually refers to the murder of women or couples by family members for marrying or engaging in romantic liaisons outside their social norms and code. It is usually associated with inter-caste marriage.
6. In a recent incisive reading of the film, Sangita Gopal (2021) finds the feminist politics of *NH10* to be distinctively neoliberal: no solidarity is possible between the three women in the film—each is always ready to "take action," but only for herself.
7. To recall, in the 1970s, Amitabh Bachchan gained superstardom and a cult status with Indian audiences for his portrayal of the "angry young man" in a series of films. Rising from the margins of society, this figure was an urban warrior fighting against injustice, poverty, and other social evils. He was deeply critical of the state, the police, law, and other institutions. This figure struck a chord with the filmgoing audience in the 1970s, especially working-class males, as the "angry young man" often mirrored the realities of their socioeconomic circumstances. Bachchan returned to the public consciousness in the late early 2000s as the

host of the Indian version of the British reality show *Who Wants to Be a Millionaire?* (*Kaun Banega Crorepati*), which became a sensational success. Since then, Bachchan has transitioned into mainstream globalized Bollywood films, mostly essaying roles of a super-rich, conservative, but benevolent patriarch.

8 The courtesan frequently appeared in the Muslim-Social, a genre that was most popular in the 1960s and 1970s. It featured films that portrayed an old-worldly Islamic culture that flourished predominantly in Lucknow, the seat of *nawabi* living and Urdu poetry. These films were set in an outdated, unreal world, removed from current realities. The courtesan was always a tragic figure who yearned for institutional domesticity and respect, and the narrative often concluded with her death. For more on the courtesan film, see Sumitha Chakravarty (1993).

4. NOSTALGIA AND FEAR IN THE SMART CITY

1 This was reported in *India Times* (Satija 2017), https://photogallery.indiatimes.com.

2 On November 8, 2016, the Government of India decided to demonetize two currency notes, INR 500 (US$7.5) and INR 1000 (US$15), in a sudden television address delivered by Prime Minister Narendra Modi. In the subsequent weeks, the country faced severe cash shortages, and rampant disruptions throughout the economy. Daily wage-earning laborers and other working-class populations were the worst hit by the government's decision.

3 *Ek Chhotisi Love Story* (A Small Love Story, Shashikal A. Nair, 2002) was controversial upon its release because the narrative revolved around a fifteen-year-old boy's voyeuristic obsession with his older female neighbor. This was an aberration in Global Bollywood's "clean" cinematic universe at the time and would now be classified as a multiplex film.

4 Bollywood superstar Salman Khan—and the peculiar brand of stardom associated with him—is significant here. More than any of the other male stars, Khan remains emblematic of the tactility of the single-screen culture, both in terms of film content and the types of fans and viewing activities associated with that space. His solid fan base is composed largely of lower- and working-class Muslim males—bodies that are firmly outside the multiplex imagination. Unlike Shah Rukh Khan, whose stardom is based on his big-budget romantic melodramas and popularity among diasporic audiences, Salman Khan's genre is action and stunts, often lacking entirely in plot and narrative.

5 See, for instance, popular reportage on this phenomenon: Petkauskas 2022 and Marsden 2020.

6 The complete Supreme Court judgement is available at https://rememberuphaar.com.

7 While the multiplexes continue to command 60 percent of the country's box-office revenue, the rise of digital platforms in the last five years has been staggering. The prestigious players have an extraordinary number of paid subscribers: Disney Hotstar at 300 million monthly subscribers, Amazon Prime Video at 13 million,

and Netflix at 11 million. These numbers increased substantially during the pandemic. Along with building massive libraries of film and television content, these platforms are also investing in producing "original" content at a rapid pace. Several prominent players from India's mainstream film industries—producers, actors, directors, technicians, writers—now simultaneously work for both digital platforms and films meant for theatrical release. This has been aided by a significant rise in the number of smartphone users in the country—estimated to reach over 1 billion by 2023 and 1.44 billion by 2040 (Sun 2023). Further, the rise of local-language Internet users in the Indian context—from 42 million in 2011 to 234 million by 2016—signals the arrival of vernacular practices that forcefully challenge Anglo-centric versions of digital cultures (Punathembekar and Mohan 2019). The Indian State is now one of the strongest champions of digital and has actively supported several private players who are buying internet infrastructures (also see Rahul Mukherjee 2019).

EPILOGUE

1 See, for instance, Samanth Subramanium, "When the Hindu Right came for Bollywood" (2022); Bhavya Dore, "The Player: Akshay Kumar's Role as Hindutva's Poster Boy" (2021); Sonia Felario, "Netflix v Modi and the battle for Indian Cinema's Soul" (2021).
2 For a full account of these incidents see Jafri and Raj 2022.
3 See Jafri 2022: "This is call for extermination. Theatres used to be a safe space for everyone: for couples, for minorities, for friends. Muslims have been robbed of one more comfortable public space today. Muslims going to theatres now stand the risk of mob violence."
4 See Sakshi Dayal and Deepti Nagpaul, "Padmavaat Protests: There's Freedom to Stone School Bus with Children" (2018).
5 The Hindu Right term "Love Jihad" is used to describe an alleged "organized conspiracy" by Muslim men to trap women belonging to non-Muslim communities by feigning romantic love. See, for instance, Rahul Bhatia, "The Year of Love Jihad in India" (2017).
6 Pinjra Tod (Break the Cage) is an autonomous collective of women in several student hostels in Delhi to protest the regressive and restrictive rules that govern women's hostels. The collective's key focus is on women's reclamation of public space. It has been protesting the peculiar norms around women's safety as defined by the state and educational institutions via which these hostels are regulated.
7 *Beti Bachao Bahu Lao* (Save the Daughter, Bring Home the Daughter-in-Law) is a counter "movement" by the Hindu Right Wing to curb the effects of the so-called Love Jihad. Here, Hindu men will convince educated Muslim women to marry them and "bring back" the women who have been led astray through Love Jihad. See for instance HT Correspondent, Agra, "Hindu Outfit Plans 'Beti Bachao, Bahu Lao' Campaign to Counter Love Jihad" (2017).

8 See for instance BBC News, "Why a Disabled Person Was Assaulted in an Indian Cinema" (2016).
9 In 2021, an Amazon Prime Show show, *Tandav* (Chaos, 2021), came under fire for "hurting Hindu sentiments" after a minister from the ruling government raised a complaint to the Ministry of Broadcasting and Information. Aparna Purohit, head of India Originals at Amazon, found herself legally and politically embroiled in this situation. She had to apply for anticipatory bail from Allahabad High Court, where another offended person had registered an FIR against her for daring to greenlight the show; the anticipatory bail was rejected (Allahabad High Court Judgement, 2021). Purohit made her Twitter handle private after incessant trolling and online abuse. The directors and producers of *Tandav* subsequently issued multiple apologies on Twitter and Instagram (Shivani 2021). All scenes found "objectionable" by the offended parties were removed and show was re-edited. A year later, Purohit had to seek special permission from a High Court to travel abroad to see her ailing parents (Tiwari 2022). Despite the lack of definitive digital censorship laws in the country, "political content"—and by extension any sociopolitical commentary—began to be quickly scrubbed out of any material under development for a streaming platform. Platforms and producers hired lawyers to fine comb through scripts before they went into production. Most shows with political themes that challenged the Hindu Right, or spoke of minority plights, or had interfaith romances were cancelled and put in cold storage (see also Subramanium 2022).

BIBLIOGRAPHY

Abassi, Asim, dir. 2020. *Churails*. Glasshouse Productions. 60 min. www.zee5.com.
Abbas, Ackbar. 2002. *Hong Kong: Culture and the Politics of Disappearance*. Minneapolis: University of Minnesota Press.
Acland, Charles. 2003. *Screen Traffic: Movies, Multiplexes and Global Culture*. Durham, NC: Duke University Press.
Agnihotri, Vivek, dir. 2022. *The Kashmir Files*. Zee Studios. 2 hr., 50 min. www.zee5.com.
Ahuja, Aashna. 2016. "PVR Cinemas Goes Gourmet: Introduces Sushi and Japanese Hot Dogs." *NDTV*, June 29.
Akhtar, Farhan, dir. 2001. *Dil Chahta Hai*. Excel Entertainment. 2 hr., 57 min. Blu-ray Disc, 1080p HD.
Akhtar, Zoya, dir. 2009. *Luck by Chance*. Excel Entertainment. 2 hr., 36 min. www.netflix.com.
Akhtar, Zoya, dir. 2011. *Zindagi Na Milegi Dobara*. Excel Entertainment. 2 hr., 55 min. Blu-ray Disc, 1080p HD.
Akhtar, Zoya, dir. 2015. *Dil Dhadakne Do*. Junglee Pictures and Excel Entertainment. 2 hr., 53 min. www.primevideo.com.
Akhtar, Zoya, dir. 2019. *Gully Boy*. Excel Entertainment and Tiger Baby Films. 2 hr., 55 min. Blu-ray Disc, 1080p HD.
Allen, Stan. 2009. *Practice: Architecture Technique + Representation*. Oxford: Routledge.
Anand, Vijay, dir. 1963. *Tere Ghar Ke Samne*. Nav Ketan. 2 hr., 21 min. www.youtube.com/watch?v=TduKMt6N964.
ANI. 2017. "PVR Chanakya Revamped as PVR ECX Multiplex, Reaches 600 Screens Mark." *Business Standard*, September 22, 2017. www.business-standard.com.
Anwer, Megha, and Anupama Arora, eds. 2021. *Bollywood's New Woman: Liberalization, Liberation, and Contested Bodies*. New Brunswick, NJ: Rutgers University Press.
Appadurai, Arjun. 1996. *Modernity at Large: Cultural Dimensions of Globalization*. Minneapolis: University of Minnesota Press.
Architect and Interiors India. 2023. "India's Tallest Shopping Mall Will Soon Take Over Noida's Skyline." *Architect and Interiors India*, April 11, 2023. www.architectandinteriorsindia.com.
Arora, Poonam. 1995. "Imperiling the Prestige of the White Woman: Colonial Anxiety and Film Censorship in British India." *Visual Anthropology Review* 11 (2): 35–50.

Arun, Avinash, and Prosit Roy, dirs. 2020. *Paatal Lok*. Clean Slate Films, 2020. 43–53 mins. www.primevideo.com.

Athique, Adrian, and Douglas Hill. 2010. *The Multiplex in India: A Cultural Economy of Urban Leisure*, Routledge Contemporary South Asia. New York: Routledge.

Ayyub, Rana. 2022. "I Tried Watching 'The Kashmir Files.' I Left the Theater to Screams of 'Go to Pakistan.'" *Washington Post*, March 29, 2022.

Bahl, Ajay, dir. 2012. *B.A Pass*. Filmybox n Tonga Talkies. 1 hr., 35 min. www.netflix.com.

Bahl, Vikas, dir. 2013. *Queen*. Viacom 18 Motion Pictures. 2 hr., 26 min. DVD.

Banaji, Shakuntala. 2018. "Vigilante Publics: Orientalism, Modernity and Hindutva Fascism in India." *Javnost—The Public* 25 (4): 333–350.

Banerjee, Dibakar, dir. 2006. *Khosla Ka Ghosla!* UTV Motion Pictures. 2 hr., 15 min. Blu-ray Disc, 1080p HD.

Banerjee, Dibakar, dir. 2009. *Oye Lucky! Lucky Oye!* UTV Motion Pictures. 2 hr., 10 min. Blu-ray Disc, 1080p HD.

Banerjee, Dibakar, dir. 2010. *Love, Sex aur Dhokha*. Alt Entertainment. 1 hr., 52 min. DVD.

Banerjee, Dibakar, dir. 2012. *Shanghai*. PVR Pictures. 2 hr. DVD.

Barjatya, Sooraj, dir. 1994. *Hum Aapke Hai Koun..!* Rajshri Productions. 3 hr., 19 min. Blu-ray Disc, 1080p HD.

Basu, Indrani. 2017. "I Watched the Last Day, Last Show at Delhi's Regal Cinema. It Was Like Stepping Back in Time." *Huffington Post*, March 31, 2017. www.huffpost.com.

Batra, Shakun, dir. 2016. *Kapoor and Sons*. Dharma Productions. 2 hr., 27 min. Blu-ray Disc, 1080p HD.

BBC News. 2016. "Why a Disabled Person Was Assaulted in an Indian Cinema." *BBC*, October 25, 2016. www.bbc.com.

Beck, Ulrich. 2003. "Politics of Risk Society." In *Environmentalism: Critical Concepts*, edited by David Pepper, Frank Webster and George Revill, 256–267. London: Routledge.

Behl, Kanu, dir. 2014. *Titli*. Yash Raj Films and Dibakar Banerjee Productions. 2 hr., 4 min. Blu-ray Disc, 1080p HD.

Benson-Allott, Caetlin. 2021. *The Stuff of Spectatorship: Material Cultures of Film and Television*. Oakland: University of California Press.

Berry, Chris, Soyoung Kim, and Lynn Spigel, eds. 2010. *Electronic Elsewheres: Media, Technology, and the Experience of Social Space*. Minneapolis: University of Minnesota Press.

Bhabha, Homi. 1992. "The Home and the World." *Social Text* 31/32: 141–153.

Bhansali, Sanjay Leela, dir. 2002. *Devdas*. Eros International. 2 hr., 54 min. Blu-ray Disc, 1080p HD.

Bhansali, Sanjay Leela, dir. 2018. *Padmaavat*. Bhansali Productions. 2 hr., 43 min. www.primevideo.com.

Bhaumik, Khaushik. 2011. "Cinematograph to Cinema: Bombay 1896-1928" *BioScope: South Asian Screen Studies* 2 (1): 41–67.

Bhardwaj, Vishal, dir. 2006. *Omkara*. Eros International. 2 hr., 35 min. DVD.

Bhardwaj, Vishal, dir. 2014. *Haider*. UTV Motion Pictures. 2 hr., 40min. Blu-ray Disc, 1080p HD.
Bhatia, Rahul. 2017. "The Year of Love Jihad in India." *New Yorker*, December 31, 2017. www.newyorker.com.
Bhatia, Sidharth. 2016. "Shah Rukh Khan Meeting Raj Thackeray Is Understandable, But Shameful on Many Levels." *The Wire*, December 13, 2016.
Bigelow, Kathryn, dir. 2012. *Zero Dark Thirty*. Columbia Pictures. 2 hr., 37 min. Blu-ray Disc, 1080p HD.
Bijli, Ajay. 2021a. "Has the Pandemic Changed Cinema? Ajay Bijli on Stars & Storytelling | Shoma Chaudhury." *Shoma Chaudhury*, March 20, 2021. Video, 42:36. www.youtube.com/watch?v=8hXsvcC8Ems.
Bijli, Ajay. 2021b. "India's Insatiable Appetite for Watching Movies in Theaters Will Help Recovery: PVR." *CNBC International TV*, January 20, 2021. Video, 2:48. www.youtube.com/watch?v=Lk_Dpk3graA.
Bijli, Ajay. 2021c. "On Biz Buzz: PVR Chief Ajay Bijli Reveals Exclusive Details of Revival and Rebooting Cinema Biz." Interview by Vikram Chandra & Saurav Majumdar, *Fortune India*, June 15, 2021. Video, 25:52. www.editorji.com.
Boym, Svetlana. 2001. *The Future of Nostalgia*. New York: Basic Books.
Bromley, Constance. 1926. "Films That Lower Our Prestige in India: Imperilling the Safety of the White Woman." *Leeds Mercury*, August 26, 1926.
Brosius, Christiane. 2010. *India's Middle Class: New Forms of Urban Leisure, Consumption and Prosperity, Cities and the Urban Imperative*. New Delhi: Routledge.
Bruno, Giuliana. 2002. *Atlas of Emotion: Journeys in Art, Architecture and Film*. London: Verso.
Burte, Himanshu. 2009. "How Sustainable Is Your Style?" *Live Mint*, October 14, 2009. www.livemint.com.
Bushan, Nyay. 2019. "Immersive 4DX and Butler Service: How India's Cinemas Are Changing the Moviegoing Experience." *Hollywood Reporter*, October 18, 2019. www.hollywoodreporter.com.
Butalia, Urvashi. 1998. *The Other Side of Silence: Voices from the Partition of India*. Delhi: Viking.
Chakrabarty, Dipesh. 1991. "Open Space/Public Space: Garbage, Modernity and India." *South Asia: Journal of South Asian Studies* 14 (1): 15–31.
Chakravarty, Sumita. 1993. *National Identity in Indian Popular Cinema*. Austin: University of Texas Press.
Chandra, Kanwar Krishna. 1954. *Delite Theater: Magnificent-Aristocratic Air-Conditioned Theatre in the North*. New Delhi.
Chatterjee, Partha. 1993. *The Nation and its Fragments: Colonial and Postcolonial Histories*, vol. 11. Princeton, NJ: Princeton University Press.
Chatterjee, Ranita. 2011. "Journeys in and Beyond the City: Cinema in Calcutta, 1897–1939." PhD Diss., University of Westminster.
Chattopadhyay, Swati. 2014. "Metro Pattern: Art Deco Residences and Modern Visuality in Calcutta." In *New Cultural Histories of India: Materiality and Practices*,

edited by Partha Chatterjee, Tapati Guha-Thakurta, and Bodhisattva Kar, 373–408. Oxford: Oxford University Press.

Chattopadhyay, Swati, and Jeremy White, eds. 2020. *The Routledge Companion to Critical Approaches to Contemporary Architecture*. New York: Routledge.

Choi, JungBong. 2010. "Of the East Asian Cultural Sphere: Theorizing Cultural Regionalization." *China Review* 10 (2): 109–136.

Chopra, Aditya, dir. 1995. *Dilwale Dulhania Le Jayenge*. Yash Raj Films. 3 hr., 15 min. Blu-ray Disc, 1080p HD.

Chopra, Anupama. 2015. "Team Dil Dhadakne Do | FC ADDA | Anupama Chopra | Film Companion." *Film Companion*, June 1, 2015. Video, 23:55. www.youtube.com/watch?v=LwIEw_yI7tk.

Chopra, Yash, dir. 1975. *Deewaar*. Trimurti Films. 2 hr., 56 min. DVD.

Chopra, Yash, dir. 1979. *Kaala Patthar*. Yash Raj Films. 2 hr., 50 min. DVD.

Chowdhury, Aniruddha Roy, dir. 2016. *Pink*. Rising Sun Films. 2 hr., 16 min. www.netflix.com.

Chowdhry, Seema. 2016. "Lounge Review: PVR Superplex, Noida." *Live Mint*, April 2, 2016. www.livemint.com.

Clover, Carol J. 1992. *Men, Women, and Chain Saws: Gender in the Modern Horror Film*. Princeton, NJ: Princeton University Press.

Colomina, Beatriz. 1996. *Privacy and Publicity: Modern Architecture as Mass Media*. Cambridge, MA: MIT Press.

Colomina, Beatriz. 2007. *Domesticity at War*. Cambridge, MA: MIT Press.

Couldry, Nick, and Anna McCarthy, eds. 2004. *Mediaspace: Place, Scale and Culture in a Media Age*. New York: Routledge.

Dasgupta, Rana. 2014. *Capital: The Eruption of Delhi*. New York: Penguin.

Dass, Manishita. 2009. "The Crowd Outside the Lettered City: Imagining the Mass Audience in 1920s India." *Cinema Journal* 48 (4): 77–98.

Dass, Manishita. 2015. *Outside the Lettered City: Cinema, Modernity, and the Public Sphere in Late Colonial India*. New York: Oxford University Press.

Dass, Manishita. 2021. "Modernity." *BioScope: South Asian Screen Studies* 12 (1–2): 129–133.

Dattatreyan, Ethiraj Gabriel. 2020. *The Globally Familiar: Digital Hip Hop, Masculinity, and Urban Space in Delhi*. Durham, NC: Duke University Press.

Dayal, Sakshi, and Dipti Nagpaul. 2018. "Padmaavat Protests: There's Freedom to Stone School Bus with Children." *Indian Express*, January 23, 2018.

Dedhia, Anish, dir. 2019. "Iss Andhere Mein Bahut Roshni Hai | Ft. Aamir Khan." *DM Media Solutions*, August 29. Video, 2:00. www.youtube.com/watch?v=UODV_txZSaE.

Dewey, Susan. 2008. *Making Miss India Miss World: Constructing Gender, Power, and the Nation in Post Liberalization India*. Syracuse, NY: Syracuse University Press.

Dhar, Aditya, dir. 2019. *Uri: The Surgical Strike*. RSVP Movies. 2 hr., 18 min. www.zee5.com.

Dholakia, Rahul, dir. 2017. *Raees*. Red Chilies Entertainment. 2 hr., 23 min. DVD.

Dickey, Sara. 2000. "Permeable Homes: Domestic Service, Household Space, and the Vulnerability of Class Boundaries in Urban India." *American Ethnologist* 27 (2): 462–489.
Doel, Marcus A., and David B. Clarke. 1997. "Transpolitical Urbanism: Suburban Anomaly and Ambient Fear." *Space and Culture* 1(2): 13–36.
Dolby Atmos. 2018. "Baahubali 2—Behind the Mix | Interview | Dolby Atmos | Dolby." *Dolby*, June 6, 2018. Video, 6:04. www.youtube.com/watch?v=YteD-9DJeA8.
Dolby Atmos. 2019. "Dolby Atmos Presents Behind the Mix Episode of Uri | Dolby Atmos | Dolby." *Dolby*, February 18, 2019. Video, 3:09. www.youtube.com/watch?v=OzzPPdoiN_U.
Dore, Bhavya. 2021. "The Player: Akshay Kumar's role as Hindutva's Poster Boy." *The Caravan*, February 1, 2021. https://caravanmagazine.in.
Dupont, Veronique D. N. 2011. "The Dream of Delhi as a Global City." *International Journal of Urban and Regional Research* 35 (3): 533–554.
Dutt, Anvita, dir. 2020. *Bulbbul*. Clean Slate Filmz. 1 hr., 34 min. www.netflix.com.
Dutta, Gautam. 2007. Interview by Brighupati Singh. *SARAI Archives*, July 31, 2007.
Dutta, Gautam. 2020. "Talking point with PVR CEO Gautam Dutta." Interview by Menaka Doshi. *NDTV Profit*, October 6, 2020. Video, 36:05. www.youtube.com/watch?v=VLnw1O2-k7M&ab_.
Dwyer, Rachel. 2006. *Filming the Gods: Religion and Indian Cinema*. London: Routledge.
Fehérváry, Krisztina. 2013. *Politics in Color and Concrete: Socialist Materialities and the Middle Class in Hungary*. Bloomington: Indiana University Press.
Felario, Sonia. 2021. "Netflix v Modi and the Battle for Indian Cinema's Soul." *MIT Technology Review*, March 24, 2021. www.technologyreview.com.
Fernandes, Leela. 2001. "Rethinking Globalization: Gender and the Nation in India." In *Feminist Locations: Global and Local, Theory and Practice*, edited by Marianne de Koven, 147–167. New Brunswick, NJ: Rutgers University Press.
Fernandes, Leela. 2006. *India's New Middle Class: Democratic Politics in an Era of Economic Reform*. Minneapolis: University of Minnesota Press.
Friedberg, Anne. 1993. *Window Shopping: Cinema and the Postmodern*. Berkeley: University of California Press.
Ganapathy, Priya, and Anurag Mallick. 2015. "Delhi Is Two Enemies Forced into a Friendship." *Conde Nast Traveller*, November 13, 2015. www.cntraveller.in.
Ganti, Tejaswini. 2012. *Producing Bollywood: Inside the Contemporary Hindi Film Industry*. Durham, NC: Duke University Press.
Ganti, Tejaswini. 2014. "Neoliberalism." *Annual Review of Anthropology* 43: 89–104.
Gattuso, Reina. 2016. "Pink's Right: Sometimes You Just Want to Clock a Man with a Beer Bottle." *The Ladies Finger*, September 24, 2016. http://theladiesfinger.com.
Ghaywan, Neeraj, dir. 2015. *Masaan*. Drishyam Films. 1 hr., 30 min. DVD.
Ghosh, Shashanka, dir. 2018. *Veere di Wedding*. Balaji Motion Pictures. 2 hr., 10 min. DVD.
Ghosh, Sujoy, dir. 2012. *Kahaani*. Viacom 18 Motion Pictures. 2 hr., 2 min. DVD.

Gopal, Sangita. 2011. *Conjugations: Marriage and Form in New Bollywood Cinema*. Chicago: University of Chicago Press.
Gopal, Sangita. 2019. "Media Meddlers: Feminism, Television and Gendered Media Work in India." *Feminist Media Histories* 5 (1): 39–62.
Gopal, Sangita. 2021. "Lethal Acts: Bollywood's New Woman and the Nirbhaya Effect." In *Bollywood's New Woman: Liberalization, Liberation, and Contested Bodies*, edited by Megha Anwer and Anupama Arora. New Brunswick, NJ: Rutgers University Press.
Gopalan, Lalitha. 1997. "Avenging Women in Indian Cinema." *Screen* 38 (1): 42–59.
Gopalan, Lalitha. 2002. *Cinema of Interruptions: Action Genres in Contemporary Indian Cinema*. London: British Film Institute.
Govil, Nitin. 2015. "The Theater of Influence: Reimaging Indian Film Exhibition." In *Orienting Hollywood: A Century of Film Exhibition Between Los Angeles and Bombay*. New York: New York University Press.
Graham, Stephen and Simon Marvin. 1996. *Telecommunications and the City: Electronic Spaces, Urban Places*. London: Routledge.
Graham, Stephen, and Simon Marvin. 2001. *Splintering Urbanism, Networked Infrastructures, Technological Mobilities and the Urban Condition*. London: Routledge.
Gray, Jonathan. 2010. *Show Sold Separately: Promos, Spoilers, and Other Media Paratexts*. New York: New York University Press.
Grewal, Keerat, and Amit Bhatia. 2023. "Getting Younger." *Ormax Media*, March 3, 2023. www.ormaxmedia.com/insights/stories/getting-younger.html.
Gulzar, Meghna, dir. 2018. *Raazi*. Junglee Pictures. 2 hr., 20 min. www.primevideo.com.
Gulzar, Meghna, dir. 2020. *Chhapaak*. Fox Star Studios. 2 hr. DVD.
Gupta, Rajan. 2016. Interview by author. April 17, 2016.
Gupta, Raj Kumar, dir. 2008. *Aamir*. UTV Spotboy. 1 hr., 36 min. DVD.
Gupta, Trisha. 2017. "The Sense of an Ending." *Mumbai Mirror*, April 2, 2017. https://mumbaimirror.indiatimes.com.
Haider, Faizan. 2022. "Cinemas Witness Soaring Crowds for The Kashmir Files." *Economic Times*, March 15, 2022.
Hall, Tim. 1998. *Urban Geography*. London: Routledge.
Harvey, David. 2005. *A Brief History of Neoliberalism*. Oxford: Oxford University Press.
Hebert, Daniel, Amanda Lotz, and Aswin Punathambekar. 2021. *A Short Introduction to Media Industry Studies*. Cambridge: Polity.
Hoek, Lotte. 2013. *Cut-Pieces: Celluloid Obscenity and Popular Cinema in Bangladesh*. New York: Columbia University Press.
HT Correspondent, Agra. 2017. "Hindu Outfit Plans 'Beti Bachao, Bahu Lao' Campaign to Counter Love Jihad." *Hindustan Times*, December 1, 2017.
Hubbard, Phil. 2003a. "Fear and Loathing at the Multiplex: Everyday Anxiety in the Post-Industrial City." *Capital & Class* 27 (2): 51–75.
Hubbard, Phil. 2003b. "A Good Night Out? Multiplex Cinemas as Sites of Embodied Leisure." *Leisure Studies* 23 (3): 255–272.

Hughes, Stephen. 2003. "Pride of Place." *Seminar* 525: 28–32.

Hughes, Stephen. 2006. "House Full: Silent Film Genre, Exhibition and Audiences in South India." *Indian Economic & Social History Review* 43 (1): 31–62.

IANS. 2017. "Never Put On So Much Weight Before: Ranbir Kapoor." *Indian Express*, March 20, 2017.

India Blooms News Service. 2021. "PVR Cinemas Announces Reopening of Its First Multiplex Saket." *India Blooms*, October 1, 2021. www.indiablooms.com.

Indian Cinematograph Committee. 1928. *Report of the Indian Cinematograph Committee 1927–1928*. Calcutta: Government of India Central Publication Branch. Available at https://archive.org.

Iyer Tiwari, Ashwini, dir. 2017. *Bareilly ki Barfi*. Junglee Pictures. 1 hr., 56 min. www.netflix.com.

Jafri, Alishan (@alishan_jafri). 2022. "This is call for extermination. Theatres used to be a safe space for everyone: for couples, for minorities, for friends. Muslims have been robbed of one more comfortable public space today. Muslims going to theatres now stand the risk of mob violence." Twitter, March 16, 2022, 8:23 a.m. https://twitter.com/alishan_jafri/status/1504070962110554112?t=rb-Gaft2DSxAyWTNo5Cdiw&s=19.

Jafri, Alishan, and Kaushik Raj. 2022. "We ID'd Anti-Muslim Sloganeers at the Kashmir Files Screenings. What We Found Won't Surprise You." *The Wire*, March 22, 2022. https://thewire.in.

Johar, Karan, dir. 2016. *Ae Dil Hai Mushkil*. Dharma Productions. 2 hr., 37 min. www.primevideo.com.

Johar, Karan, dir. 2023. *Rocky aur Rani kii Prem Kahaani*. Dharma Productions. 2 hr., 48 min. www.primevideo.com.

John, Mary E. 1998. "Globalisation, Sexuality and the Visual Field: Issues and Non-issues for Cultural Critique." In *A Question of Silence? The Sexual Economies of Modern India*, edited by Mary E. John and Janaki Nair. New Delhi: Kali.

Jolly, Joanna. 2016. "Rape Culture in India: The Role of the English-Language Press." The Shorenstein Center on Media, Politics and Public Policy, July 20, 2016. https://shorensteincenter.org.

Kalia, Ravi. 2006. "Modernism, Modernization and Post-Colonial India: A Reflective Essay." *Planning Perspectives* 21 (2): 133–156.

Kalil, Shahzad, dir. 1985. *Tanhaiyaan*. Shalimar Recording Company, 43 min. www.youtube.com/watch?v=qcP7rtNHuWo.

Kalyan, Rohan. 2011. "Fragmentation by Design: Architecture, Finance, and Identity." *Grey Room* 44: 26–53.

Kapoor, Abhishek, dir. 2021. *Chandigarh Kare Aashiqui*. T-Series. 1 hr., 56 min. www.netflix.com.

Kapoor, Raj, dir. 1951. *Awaara*. R.K Films. 2 hr., 44 min. www.youtube.com/watch?v=V88h_NvPIKU.

Kapoor, Raj, dir. 1955. *Shree 420*. R.K Films. 2 hr., 48 min. www.youtube.com/watch?v=qu8ShpSlFXo.

Kapoor, Raj, dir. 1964. *Sangam*. R.K Films. 3 hr., 58 min. DVD.
Kapoor, Raj, dir. 1973. *Bobby*. R.K Films. 2 hr., 49 min. DVD.
Kapoor, Vijay. 2016. Interview by author. July 6, 2016.
Kapur, Jyotsna. 2009. "There Once Was a Maiden and a Middle Class: The Making of a Neoliberal Thriller." *Visual Anthropology* 22 (2–3): 155–166.
Karim, Farhan. 2019. *Of Greater Dignity than Riches: Austerity and Housing Design in India*. Pittsburg: University of Pittsburgh Press.
Kashyap, Anurag, dir. 2007. *Black Friday*. Mid Day Multimedia. 2 hr., 42 min. www.netflix.com.
Kashyap, Anurag. 2008. "Dev.D—Genesis." *Passion for Cinema*, December 20. https://passionforcinema-archive.blogspot.com/.
Kashyap, Anurag. 2009a. "Anurag Kashyap Speaks About Dev D." *Eros Now Music*, February 2. Video, 3:18. www.youtube.com/watch?v=L5Fch4rLeV8.
Kashyap, Anurag, dir. 2009b. *Dev.D*. UTV Motion Pictures. 2 hr., 24 min. Blu-ray Disc, 1080p HD.
Kashyap, Anurag. 2009c. "Dev.D— The Look and the Style." *Passion for Cinema*, January 2, 2009. https://passionforcinema-archive.blogspot.com.
Kashyap, Anurag, dir. 2009d. *Gulaal*. Zee Limelight. 2 hr., 20 min. Blu-ray Disc, 1080p HD.
Kashyap, Anurag, dir. 2012. *Gangs of Wasseypur*. Viacom 18 Motion Pictures. 2 hr., 40 min. Blu-ray Disc, 1080p HD.
Kashyap, Anurag, dir. 2014. *Ugly*. Phantom Films. 2 hr., 6 min. DVD.
Kashyap, Anurag, dir. 2016. *Raman Raghav 2.0*. Reliance Entertainment. 2 hr., 7 min. www.netflix.com.
Kaur, Karanjeet. 2014. "Opening a Channel." *The Caravan*, November 1, 2014. Available at www.karanjeetkaur.com.
Kaushik, Amar, dir. 2019. *Bala*. Maddock Films. 2 hr., 13 min. DVD.
Kaushish, D. C. 1971. *Sheila Cinema: Ten Years of Progressive Showmanship*. New Delhi.
Kaushish, Uday. 2015. Interview by author. October 15, 2015.
Kaviraj, Sudipta. 1997. "Filth and the Public Sphere: Concepts and Practices about Space in Calcutta." *Public Culture* 10 (1): 83–113.
Kazmi, Sahira, dir. 1987. *Dhoop Kinare*. Pakistan Television Corporation. 50 min. www.youtube.com.
Kejriwal, Shailaja. 2015. Interview by Ritika Pant. October 25, 2015.
King, Anthony. 2004. *Spaces of Global Culture: Architecture, Urbanism, Identity*. London: Routledge.
Koolhaas, Rem. "Junkspace." *October* (2002): 175–190.
Krishna, Anubhuti. "Reconnecting with Pakistan Through Stories and Songs." *Huffington Post India*, January 26, 2016.
Kumar, Agneet. 2016. Interview by author. June 20, 2016.
Kumar, Akshaya. 2016. "Bhojpuri Cinema and the 'Rearguard': Gendered Leisure, Gendered Promises." *Quarterly Review of Film and Video* 33 (2): 151–175.
Kumar, Shanti. 2010. *Gandhi Meets Primetime: Globalization and Nationalism in Indian Television*. Champaign: University of Illinois Press.

Kumar, Shanti, and Aswin Punathambekar. 2014. "Introduction." In *Television at Large in South Asia*, edited by and Shanti Kumar and Aswin Punathambekar. London: Routledge.

Lakhani, Somya. 2017. "Lights Out: Single Screens in Delhi Face the Inevitable as Demonetization Pushes Them off the Edge." *Indian Express*, January 4, 2017.

Lal, Niharika. 2017a. "Bidding Adieu to Regal—Memories, Tickets in Black and Wohi Coffee." *Times of India*, April 1, 2017.

Lal, Niharika. 2017b. "PVR Superplex is Noida's New Cinema Hub." *Times of India*, January 28, 2017.

Lamarre, Thomas. 2015. "Regional TV: Affective Media Geographies." *Asiascape: Digital Asia* 2 (1–2): 93–126.

Lamarre, Thomas. 2017. "Platformativity: Media Studies, Area Studies." *Asiascape: Digital Asia* 4 (3): 285–305.

Larkin, Brian. 1998. "Theaters of the Profane: Cinema and Colonial Urbanism." *Visual Anthropology Review* 14 (2): 46–62.

Larkin, Brain. 2008. *Signal and Noise: Media, Infrastructure, and Urban Culture in Nigeria*. Durham, NC: Duke University Press.

Lee, Rachel, and Kathleen James-Chakraborty. 2012. "Marg Magazine: A Tryst with Architectural Modernity: Modern Architecture as Seen from an Independent India." *ABE Journal: Architecture Beyond Europe* 1.

Liberty Cinema. 1949. Opening Souvenir. Bombay.

Liechty, Mark. 2003. *Suitably Modern: Making Middle-Class Culture in a New Consumer Society*. Princeton, NJ: Princeton University Press.

Llamas-Rodriguez, Juan. 2019. "A Global Cinematic Experience: Cinépolis, Film Exhibition, and Luxury Branding." *JCMS: Journal of Cinema and Media Studies* 58: 49–71.

Lughod, Lila Abu. 2005. *Dramas of Nationhood: The Politics of Television in Egypt*. Chicago: University of Chicago Press.

Luthria, Milan, dir. 2011. *The Dirty Picture*. Balaji Motion Pictures. 2 hr., 24 min. Blu-ray Disc, 1080p HD.

Madhvani, Ram, dir. 2016. *Neerja*. Fox Star Studios. 2 hr., 1 min. DVD.

Magnier, Mark. 2011. "In New Delhi, Anger Rising Violently to the Surface." *Los Angeles Times*, January 13, 2011.

Mahendroo, Anand, dir. 1985. *Idhar Udhar*. DD National. 22 min. www.youtube.com.

Malik, Ektaa. 2021. "Reopens after Close to Two Years: PVR Anupam, India's First Multiplex, Gets a New Name, Features." *Indian Express*, October 1, 2021.

Mankekar, Purnima. 1999. *Screening Culture, Viewing Politics: An Ethnography of Television, Womanhood, and Nation in Postcolonial India*. Durham, NC: Duke University Press.

Mankekar, Purnima. 2015. *Unsettling India: Affect, Temporality, Transnationality*. Durham, NC: Duke University Press.

Marks, Laura U. 2000. *The Skin of the Film: Intercultural Cinema, Embodiment, and the Senses*. Durham, NC: Duke University Press.

Marks, Laura U. 2002. *Touch: Sensuous Theory and Multisensory Media*. Minneapolis: University of Minnesota Press.
Marsden, Rhodri. 2020. "Nostalgia Tech: Why Are We So Obsessed with Technology that Is Old and Clunky?" *National News*, February 8, 2020. www.thenationalnews.com.
Martin, Reinhold, and Kadambari Baxi. 2007. *Multi-National City: Architectural Itineraries* New York: Actar.
Massey, Doreen. 1994. *Space, Place, and Gender*. Minneapolis: University of Minnesota Press.
Mazumdar, Ranjani. 2007. *Bombay Cinema: An Archive of the City*. Ranikhet: Permanent Black.
Mazumdar, Ranjani. 2010. "Friction, Collision and the Grotesque: Dystopic fragments of Bombay Cinema." In *Noir Urbanisms: Dystopic Images of the Modern City*, edited by Gyan Prakash, 150–187. Princeton, NJ: Princeton University Press.
Mazzarella, William. 2003. *Shoveling Smoke: Advertising and Globalization in Contemporary India*. Durham, NC: Duke University Press.
McCahill, Mike. 2016. "Pink Review—Subtle Drama that Grapples with India's Rape Culture." *The Guardian*, September 15, 2016.
McCarthy, Anna. 2001. *Ambient Television: Visual Culture and Public Space*. Durham, NC: Duke University Press.
McGowan, Abigail. 2016. "Domestic Modern: Redecorating Homes in Bombay in the 1930s." *Journal of the Society of Architectural Historians* 75 (4): 424–446.
McQuire, Scott. 2003. "From Glass Architecture to Big Brother: Scenes from a Cultural History of Transparency." *Cultural Studies Review* 9 (1): 103–123.
McQuire, Scott. 2008. *The Media City: Media, Architecture and Urban Space*. London: Sage.
Mehra, Nitya, Zoya Akhtar, and Reema Kagti, dirs. 2019. *Made in Heaven*. Excel Entertainment and Tiger Baby Films. 45–74 min. www.primevideo.com.
Mehra, Prakash, dir. 1973. *Zanjeer*. Prakash Mehra Productions. 2 hr., 27 min. DVD.
Mehra, Rakyesh Omprakash, dir. 2009. *Delhi-6*. UTV Motion Pictures. 2 hr., 20 min. Blu-ray Disc, 1080p HD.
Mehta, Monika. 2005. "Globalizing Bombay Cinema: Reproducing the Indian State and Family." *Cultural Dynamics* 17 (2): 135–154.
Mehta, Monika. 2011. *Censorship and Sexuality in Bombay Cinema*. Austin: University of Texas Press.
Mehta, Riche, and Tanuj Chopra, dirs. 2019. *Delhi Crime*. Golden Caravan and Ivanhoe Productions. 36–64 min. www.netflix.com.
Meneley, Anne. 2008. "Oleo-signs and Quali-signs: The Qualities of Olive Oil." *Ethnos* 73 (3): 70–88.
Menon, Ritu, and Kamla Bhasin. 1998. *Borders and Boundaries: Women in India's Partition*. New Brunswick, NJ: Rutgers University Press.
Metcalf, Thomas. 2002. *An Imperial Vision: Indian Architecture and British Raj*. New York: Oxford University Press.

Mishra, Vijay. 2009. "Specters of Sentimentality: the Bollywood Film." *Textual Practice* 23 (3): 439–462.
Mitra, Shreya. 2012. "Screening the Nation: Producing the Bollywood Star in Contemporary India." PhD Diss., University of Wisconsin-Madison.
Mohan, Sriram, and Aswin Punathambekar. 2018. "Localizing YouTube: Language, Cultural Regions, and Digital Platforms." *International Journal of Cultural Studies* 22 (3): 317–333.
Morley, David. 2000. *Home Territories: Media, Mobility, and Identity*. London: Routledge.
Mukherjee, Debashree. 2020. *Bombay Hustle: Making Movies in a Colonial City*. New York: Columbia University Press.
Mukherjee, Rahul. 2019. "Jio Sparks Disruption 2.0: Infrastructural Imaginaries and Platform Ecosystems in 'Digital India.'" *Media, Culture & Society* 41 (2): 175–195.
Munshi, Shoma. 2004. "Representations of the Body in Beauty Pageants and the Visual Media in Contemporary India." In *Confronting the Body: The Politics of Physicality in Colonial and Post-Colonial India*, edited by James H. Mill and Satadru Sen, 162–182. London: Anthem Press.
Nair, Mira, dir. 2001. *Monsoon Wedding*. IFC Productions. 1 hr., 53 min. DVD.
Nehru, Jawaharlal. 1959. "Inaugural Address," Seminar on Architecture. New Delhi: Lalit Kala Academi, March 17, 1959. Available at https://archive.org.
Neves, Joshua. 2014. "The Long Commute: Mobile Television and the Seamless Social." In *Chinese Television in the Twenty-First Century: Entertaining the Nation*, edited by Ruoyn Bai and Geng Song, 51–66. New York: Routledge.
Neves, Joshua. 2020. "Watching the City: A Genealogy of Media Urbanism." In *The Routledge Companion to Critical Approaches to Contemporary Architecture*, edited by Swati Chattopadhyay and Jeremy White, 311–322. New York: Routledge.
Neves, Joshua, and Bhaskar Sarkar, eds. 2017. *Asian Video Cultures*. Durham, NC: Duke University Press.
Pandey, Neeraj, dir. 2008. *A Wednesday!* UTV Motion Pictures. 1 hr., 39 min. DVD.
Pandey, Prashasti. 2014. "A Day at Mistral and PVR Director's Cut, Part Two: 180-Degree Reclining Leather Sofas And Gourmet Food Make Movie Viewing Extravagant." *Luxury Launches*, accessed August 1, 2022. https://luxurylaunches.com.
Pant, Ritika. 2019. "Televisual Tales from Across the Border: Mapping Neo-Global Flows in Media Peripheries." *BioScope: South Asian Screen Studies* 10 (2): 164–182.
Parameswaran, Radhika. 2004. "Global Queens, National Celebrities: Tales of Feminine Triumph in Post-Liberalization India." *Critical Studies in Media Communication* 21 (4): 346–370.
Paranjpye, Sai, dir. 1981. *Chashme Buddoor*. PLA Entertainment. 2 hr., 25 min. DVD.
Pathak, Ankur. 2021. "Friends." *Fifty-Two*, 11 June 2021. https://fiftytwo.in.
Phadke, Shilpa. 2007. "Dangerous Liaisons: Women and Men: Risk and Reputation in Mumbai." *Economic and Political Weekly* 42 (17): 1510–1518.
Peirce, Charles Sanders. 1955. *Philosophical Writings of Peirce*. New York: Dover Publications.

Petkausaskas, Vilius. 2022. "Playing in Style: 9 Most Audacious Retro Gaming Set-Ups." *Cybernews*, March 14, 2022. www.cybernews.com.

Prasad, Madhav M. 1998. *Ideology of the Hindi Film: A Historical Construction*. New Delhi: Oxford University Press.

Prasanna, R. S., dir. 2017. *Shubh Mangal Saavdhan*. Eros International. 1 hr., 59 min. DVD.

Punathambekar, Aswin. 2013. *From Bombay to Bollywood: The Making of a Global Media Industry*. New York: New York University Press.

Punathambekar, Aswin, and Sriram Mohan. 2019. "Introduction: Mapping Global Digital Cultures." In *Global Digital Cultures: Perspectives from South Asia*, edited by Aswin Punathambekar and Sriram Mohan. Ann Abor: University of Michigan Press.

Punathambekar, Aswin, and Pavitra Sundar. 2017. "The Time of Television: Broadcasting, Daily Life, and the New Indian Middle Class." *Communication, Culture & Critique* 10 (3): 401–421.

PVR Cinemas. 2015. Brand Book. New Delhi: PVR Cinemas Ltd.

PVR Cinemas. 2019. "PVR Playhouse Kids Day Out Event." *PVR*, November 28, 2019. Video, 1:25. www.youtube.com/watch?v=gqJ99zFLnxk.

PVR Cinemas. 2020a. "PVR Cares | Your Safety is our Priority." *PVR*, June 22, 2020. Video, 4:21. www.youtube.com/watch?v=QDpkrha8btE.

PVR Cinemas. 2020b. "Ready to Welcome You, Safely | #PVRCares." *PVR*, October 14, 2020. Video, 2:12. www.youtube.com/watch?v=NulC_JU4MSM.

PVR Cinemas. 2021a. "The All New PVR Anupam Is Coming Back Soon." *PVR*, September 15, 2021. Video, 2:58. www.youtube.com/watch?v=cWBTV_VnE1o.

PVR Cinemas. 2021b. "PVR Priya is Back." *PVR*, September 1, 2021. Video, 1:15. www.youtube.com/watch?v=L8j4OZYVCY8.

Rai, Aanand, dir. 2011. *Tanu Weds Manu*. Viacom 18 Motion Pictures. 1 hr., 59 min. DVD.

Rai, Amit. 2009. *Untimely Bollywood: Globalization and India's New Media Assemblage*. Durham, NC: Duke University Press.

Raizada, Shashank. 2016. Interview by author. October 14, 2016.

Rajadhyaksha, Ashish. 2003. "The 'Bollywoodization' of Indian Cinema: Cultural Nationalism in a Global Arena." *Inter-Asia Cultural Studies* 4 (1): 25–29.

Rajagopal, Arvind. 1993. "The Rise of National Programming: The Case of Indian Television." *Media, Culture & Society* 15: 91–111.

Rajagopal, Arvind. 1999. "Thinking Through Emerging Markets: Brand Logics and the Cultural Forms of Political Society in India." *Social Text* 60: 131–149.

Rajamouli, S. S, dir. 2017. *Baahubali 2: The Conclusion*. Arka Media Works. 2 hr., 51 min. DVD.

Ramnath, Nandini. 2016. "What Should the New Bollywood Film Be Called? 'Underdog,' 'Balcony' or 'New-Age Mainstream'?" *Scroll.in*, May 12, 2016. https://thereel.scroll.in.

Rao, Nikhil. 2013. *House, but No Garden: Apartment Living in Bombay's Suburbs, 1898–1964*. Minneapolis: University of Minnesota Press.

Ravikant, Ravi S. Vasudevan, and Ravi Sundaram, eds. 2003. "PPHP Broadsheet #02: The Media Fabric of the Contemporary City." *Sarai Archive*. http://archive.sarai.net.
Ray, Satyajit, dir. 1965a. *Kapurush*. R.D. Bansal & Co. 1 hr., 14 min. DVD.
Ray, Satyajit, dir. 1965b. *Mahapurush*. R.D. Bansal & Co. 1 hr., 5 min. DVD.
Rofel, Lisa. 2007. *Desiring China: Experiments in Neoliberalism, Sexuality, and Public Culture*. Durham, NC: Duke University Press.
Routray, Om. 2014. "Cinema Excelsior, Old Delhi." *The Young Bigmouth*, February 18, 2014. https://theyoungbigmouth.com.
Roy, Abhijit. 2008. "Bringing Up TV: Popular Culture and the Developmental Modern in India." *South Asian Popular Culture* 6: 29–43.
Roy, Akshay, dir. 2017. *Meri Pyaari Bindu*. Yash Raj Films. 1 hr., 56 min. DVD.
Sabharwal, Vikas. 2016. Interview by author. July 6, 2016.
Sadana, Rashmi. 2022. *The Moving City: Scenes from the Delhi Metro and the Social Life of Infrastructure*. Oakland: University of California Press.
Sahu, Ipsita. 2018. "From the Ruins of Chanakya: Exhibition History and Urban Memory." *BioScope: South Asian Screen Studies* 9 (1): 73–96.
Samanta, Shakti, dir. 1967. *An Evening in Paris*. Shakti Films. 2 hr., 56 min. DVD.
Sarkar, Bhaskar. 2008. "The Melodramas of Globalization." *Cultural Dynamics* 20 (1): 31–51.
Sarkar, Bhaskar. 2022. "Teaching the Global as Emergence." *JCMS: Journal of Cinema and Media Studies* 7 (1).
Satija, Garima. "Regal Cinema Is Pulling the Curtains Down with Raj Kapoor's Classics to Get Multiplex Makeover." *India Times*, March 30, 2017. www.indiatimes.com.
Schlanger, Benjamin. 1931. "Motion Picture Theatres of Tomorrow." *Motion Picture Herald, Better Theatres Supplement*, February 14, 1931, 12–13.
Sen, Raja. 2009. "Devdas Learns to Rock." *Rediff.com*, February 6, 2009.
Sen, Raja. 2014. "Review: *Haider* May Be Vishal Bhardwaj's Best Film." *Rediff.com*, October 1, 2014. www.rediff.com.
Sen, Raja. 2015. "Review: NH10 Is a Strikingly Believable Horror Film." *Rediff.com*, March 13, 2015. www.rediff.com.
Sen, Raja. 2016. "Review: *Pink*, a Film that Must Be Championed." *Rediff.com*, September 16, 2016. www.rediff.com.
Shahjahanabad Redevelopment Corporation. 2024. "1900–2000." Shahjahanabad Redevelopment Corporation. https://srdc.delhi.gov.in.
Sharma, Maneesh, dir. 2010. *Band Baaja Baaraat*. Yash Raj Films. 2 hr., 20 min. Blu-ray Disc, 1080p HD.
Sharma, Sampada. 2016. "PINK Was Supposed to Have a Different Climax. Taapsee Pannu Reveals the Movie's Original Ending." *ScoopWhoop*, September 26, 2016. www.scoopwhoop.com.
Shashidhar, Ajita. 2019. "Consumers' Movie Habits Haven't Changed At All: PVR Chairman Ajay Bijli." *Business Today*, June 13, 2019. www.businesstoday.in.
Sherab, Jamphel. 2017. "The Last Picture Shows: The Slow Death of Single-Screen Cinemas in Delhi." *Scroll*, January 30, 2017. https://thereel.scroll.in.

Shetty, Rohit, dir. 2022. *Sooryavanshi*. Reliance Entertainment and PVR Pictures. 2 hr., 25 min. Blu-ray Disc, 1080p HD.

Shivani. 2021. "SC Stays Amazon Prime Video's Aparna Purohit's Arrest, Directs Her to Cooperate in the Ongoing Investigation." *Hindustan Times*, March 5, 2021.

Shivkumar, Rohan, and Avijit Mukul Kishore, dirs. 2017. *Nostalgia for the Future*. Films Division India, 2017. 55 min. www.vimeo.com.

Shopping Centre New Bureau. 2018. "A Lot of Tech Goes into Building PVR & Getting It Mall Ready: Gautam Dutta, CEO PVR Cinemas." *India Retailing*, August 2, 2018. www.indiaretailing.com.

Siddharth, Hon. J. 2021. "Aparna Purohit vs State of U.P. on 25 February, 2021." Allahabad High Court. https://indiankanoon.org/doc/194293303/.

Siddique, Salma. 2017. "The Futility of Dreaming of the Padmavati-Khilji Dream Sequence." *The Wire*, December 14, 2017. https://thewire.in.

Siddique, Salma. 2022. *Evacuee Cinema: Bombay and Lahore in Partition Transit, 1940–1960*. Cambridge: Cambridge University Press.

Sircar, Shoojit, dir. 2015. *Piku*. MSM Motion Pictures. 2 hr., 2 min. DVD.

Singh, Bhrigupati. 2008. "Aadamkhor Haseena (The Man-Eating Beauty) and the Anthropology of a Moment." *Contributions to Indian Sociology* 42 (2): 249–279.

Singh, Harneet. 2014. "'Kashmir Is the Hamlet of My Film,' Says Vishal Bhardwaj on Haider." *Indian Express*, October 5, 2014.

Singh, Jai Arjun. 2005. "Madhuban Fine Dining, and PVR Memories." *Jabberwock*, November 29, 2005. http://jaiarjun.blogspot.com.

Singh, Jai Arjun. 2016. "Unhappy in Other Ways: How Hindi-Film Families Changed (or Did They?)." *Jabberwock*, April 8, 2016. http://jaiarjun.blogspot.com.

Singh, Navdeep, dir. 2015. *NH10*. Phantom Films. 1 hr., 55 min. www.netflix.com.

Singh, Ranjan. 2014. Interview by author. July 14, 2014.

Sinha, Anubhav, dir. 2020. *Thappad*. AA Films. 2 hr., 22 min. www.primevideo.com.

Sinha, Pranay. 2015. Interview by author. June 15 and June 20, 2015.

Sobchack, Vivian Carol. 1992. *The Address of the Eye: A Phenomenology of Film Experience*. Princeton, NJ: Princeton University Press.

Sood, Ayesha, dir. 2022. *Indian Predator: The Butcher of Delhi*. Vice and India Today, 2022. 41–44 min. www.netflix.com.

Spigel, Lynn. 2022. *TV Snapshots: An Archive of Everyday Life*. Durham, NC: Duke University Press.

Srinivas, Lakshmi. 2016. *House Full: Indian Cinema and the Active Audience*. Chicago: University of Chicago Press.

Srinivas, S. V. 2000. "Is There a Public in the Cinema Hall?" *Framework* 42.

Srinivas, S. V. 2003. "Hong Kong Action Film in the Indian B Circuit." *Inter-Asia Cultural Studies* 4: 40–62.

Steger Manfred B and Ravi K. Roy. 2010. *Neoliberalism: A Very Short Introduction*. Oxford: Oxford University Press.

Steinberg, Marc, and Jinying Li. 2017. "Introduction: Regional Platforms." *Asiascape: Digital Asia* 4: 173–183.

Studio Gronda. 2017. "PVR Cinemas Chanakya." Studio Gronda, accessed March 27, 2024. www.studiogronda.com.

Subramanium, Samanth. 2022. "When the Hindu Right Came for Bollywood." *New Yorker*, October 10, 2022. www.newyorker.com.

Sun, Shangliao. 2023. "Smartphone Users in India 2010–2040." *Statistica*, September 18, 2023. www.statistica.com.

Sundaram, Ravi. 2007. "The Visceral City and the Theater of Fear." *Architectural Design* 77 (6): 30–33.

Sundaram, Ravi. 2010a. "Imaging Urban Breakdown: Delhi in the 1990s." In *Noir Urbanisms: Dystopic Images of the Modern City*, edited by Gyan Prakash. Princeton, NJ: Princeton University Press.

Sundaram, Ravi. 2010b. *Pirate Modernity: Delhi's Media Urbanism*. New York: Routledge.

Sunder Rajan, Rajeshwari. 1999. "Introduction." In *Signposts: Gender Issues in Post-Independence India*. New Delhi: Kali.

Szczepaniak-Gillece, Jocelyn. 2018. *The Optical Vacuum: Spectatorship and Modernized American Theater Architecture*. Oxford: Oxford University Press.

Szczepaniak-Gillece, Jocelyn, and Stephen Groening. 2016. "Afterword: Objects in the Theater." *Film History: An International Journal* 28 (3): 139–142.

Tan, Dewi. 2022. "Starting with Sarinah: Chasing Modernity through Indonesia's Iconic Shopping Mall." *Society + Space*, August 29, 2022. www.societyandspace.org.

Taneja, Anand Vivek. 2005. "Begum Samru and the Security Guard." In *Sarai Reader 05: Bare Acts*, edited by Monica Narula, Shuddhabrata Sengupta, Jeebesh Bagchi, and Geert Lovink, 287–296. Delhi: Centre for the Study of Developing Societies.

Theatre World. 2022. "PVR Cinemas: 25 Glorious Years of Success." *Theatre World*, September–November 2022.

Thomas, Rosie. 1985. "Indian Cinema: Pleasures and Popularity." *Screen* 26 (3–4): 116–131.

Times of India. 1919. "The Cinema in Bombay: A New 'Picture House.'" *Times of India*, September 10, 1919.

Times of India. 1938. "Building Bombay's Newest Cinema: Scheme Completed in Nine Months." *Times of India*, June 8, 1938.

Tiwari, Salil. 2022. "[Tandav Row] UP Court Allows Amazon Prime Head Aparna Purohit to Travel Abroad." *Lawbeat*, February 7, 2022. https://lawbeat.in.

Trice, Jasmine Nadua. 2021. *City of Screens: Imagining Audiences in Manila's Alternative Film Culture*. Durham, NC: Duke University Press.

Trigg, Dylan. 2006. *The Aesthetics of Decay: Nothingness, Nostalgia, and Absence of Reason*. New York: Peter Lang.

T-Series. 2021. "Sooryavanshi | #BackToCinemas This Diwali | 5th Nov | Akshay, Ajay, Ranveer, Katrina | Rohit Shetty." *T-Series*, October 15, 2021. Video, 0:58. www.youtube.com/watch?v=w6PpxQfl5TU.

Uberoi, Patricia. 1998. "The Diaspora Comes Home: Disciplining Desire in DDLJ." *Contributions to Indian Sociology* 32 (2): 305–336.

Udwin, Leslee, dir. 2015. *India's Daughter*. Assassin Films. 1 hr., 3 min. www.youtube.com.

Upton, Dell. 1997. *Holy Things and Profane: Anglican Parish Churches in Colonial Virginia*. New Haven: Yale University Press.

Vasudevan, Ravi. 2002. "The Exhilaration of Dread: Genre, Narrative Form and Film Style in Contemporary Urban Action Films." *Sarai Reader 2002: The Cities of Everyday Life*, edited by Ravi S. Vasudevan et al., 59–67. Delhi: Centre for the Study of Developing Societies.

Vasudevan, Ravi. 2003. "Cinema in Urban Space." *Seminar* 525: 21–27.

Verma, Rahul. 2011. "Beyond Bollywood: Indian Cinema's New Cutting Edge." *The Guardian*, June 23, 2011.

Viacom 18 Studios. 2017. "Sanjay Leela Bhansali Speaks | Padmavati | Ranveer Singh | Deepika Padukone | Shahid Kapoor." *Viacom 18 Studios*, November 8, 2017. Video, 1:16. www.youtube.com/watch?v=v3nuxG2Q6Ew.

Vidler, Anthony. 1992. *The Architectural Uncanny: Essays in the Modern Unhomely*. Cambridge, MA: MIT Press.

Virdi, Jyotika. 2003. *The Cinematic ImagiNation: Indian Popular Films as Social History*. New Brunswick, NJ: Rutgers University Press.

Virdi, Jyotika. 2008. "Deewar/Wall (1975)—Fact, Fiction, and the Making of a Superstar." In *Global Bollywood*, edited by Anandam P. Kavoori and Aswin Punathambekar. New York: New York University Press.

Visit Dubai. 2022. "Dubai Presents: Shah Rukh Khan." *Visit Dubai*, March 8, 2022. Video, 3:06. www.youtube.com/watch?v=fuSpjxrdhTw.

Vitali, Valentina. 2006. "Hong Kong—Hollywood—Bombay: On the Function of 'Martial Art' in the Hindi Action Cinema." In *Hong Kong Connections: Transnational Imagination in Action Cinema*, edited by Meaghan Morris, Siu Leung Li, and Stephen Chan Ching-kiu. Hong Kong: Hong Kong University Press.

Vohra, Paromita. 2014. "Heat and Lust." *LiveMint*, June 21, 2014. www.livemint.com.

Walia, Ramna. 2014. "Recycle Industry: The Visual Economy of Remakes in Contemporary Bombay Film Culture." *Synoptique: An Online Journal of Film and Moving Image Studies* 3 (1). www.synoptique.ca.

Wani, Ishitiaq. 2016. "Delhi's Single-Screen Cinemas Inch Closer to the Final Curtain Call." *Hindustan Times*, August 27, 2016.

Zhou, Chenshu. 2021. *Cinema Off Screen: Moviegoing in Socialist China*. Oakland: University of California Press.

INDEX

Page numbers in *italics* indicate figures

Aamir, 34
Abbas, Ackbar, 160
Abraham, John, 95
advertising, Dubai in, 21
Ae Dil Hai Mushkil (This Heart is Complicated), 180–81
Africa, cinema industry in, 41
Akhtar, Farhan, 1, 3–4
Akhtar, Javed, 3
Akhtar, Zoya: *Dil Dhadakne Do*, 1–2, 4; film casting by, 3; films of, 1–3; as multiplex director, 30; television series by, 3; *Zindagi Na Milegi Dobara*, 31
alcohol consumption, in multiplexes, 99–101
Allen, Stan, 12
analog nostalgia, 172; global epidemic of, 157; Internet as influence on, 157–58; for single screen theaters, 146–54
Anand, Dev, 39–41
Angarey (Flames), 50
Angrezi Medium, 56
"angry young man" archetype, in Indian films, 189n2
Anwar, Megha, 193n27
architecture: Art Moderne, 55; in Global South, 8; stylistic qualities of, 48; transitional, 75. *See also* Art Deco architecture; modernism
architecture, in India: in Delhi, 8, 50–51; as media industry, 12–18; media studies and, 12; modernist, 40; multiplex architecture as influence on, 4–5; Nehru's influence on, 8, 40; pre-colonial, 60; rational, 52–63; transitional, 75. *See also* Art Deco architecture; multiplex architecture
Arora, Anupama, 193n27
Arora, Poonam, 45–46
Arora, Shashank, 32
Art Deco architecture, in India, 47, 50–52; in colonial era, 8; cultural/social context for, 48; during decolonization, 40, 49; Delite Cinema, 8; Regal Cinema, 8, 147–48; in residential structures, 48–49; Rivoli Cinema, 8; urban migration as influence on, 48
Art Moderne, 55
Association of the Victims of Uphaar Tragedy (AVUT), 162
Athique, Adrian, 18, 75, 190n8
atmospheric sound, in multiplex cinemas, 93
atypical Hindi film *(hatke)*, 1
avenging woman genre, *NH10*, 123–24
AVUT. *See* Association of the Victims of Uphaar Tragedy
Ayyub, Rana, 176–77

Baahubali, 95
Bachchan, Amitabh, 3, 27, 128, 196n7
Bachchan, Jaya, 27
Baker, George, 50
Balan, Vidya, 193n25

217

Band Baaja Baaraat (Bands, Horns, and Revelry), 111
Banerjee, Dibakar, 30, 32, 112–13, 196n1
B. A. Pass, 111
Barjatiya, Sooraj, 192n18
Baswani, Ravi, 66
Bedi, Angad, 127
Behl, Kanu, 32
Benson-Allott, Caetlin, 15, 100–101, 175
Beti Bachao Bahu Lao (Save the Daughter, Bring Home the Daughter-in-Law) movement, 198n7
Bhabha, Homi, 142
Bhansali, Sanjay Leela, 132, 178, 184
Bharadwaj, Vishal, 30; *Haider,* 34
Bhasin, Arjun, 3
Bhatt, Alia, 124, 183
Bhaumik, Kaushik, 194n2
Bijli, Ajay, 24, 27–29, 99, 157, 166–68, 170. See also PVR Cinemas
Bijli, Sanjeev, 24. See also PVR Cinemas
bio-surveillance strategies, 167–71
Biswas, Moinak, 110
Black Friday, 34, 132
Bollywood, Indian film industry and: Bombay film industry and, 33–34; corporate involvement in, 190n8; economic restructuring of, 190n8; family film genre in, 23; globalization of, 70, 117, 133; inequality in, 33; masculinity as theme in, 33; media assemblages in, 19; sexism in, 33; Yash Raj Films, 31–32
Bombay (Mumbai), 189n1; Bollywoodization of film industry in, 33–34, 192n17; cinema theater construction in, 44; cinema theaters in, 44, 194n2; Empress Theater, 43–44; expansion of cinema in, 41–44, 194n2; female safety in, 10; Liberty Cinema, 49–50, 162–63; Metro Theater, 44–45; shopping malls in, 77
Bombay Hustle, 42
Bordwell, David, 140
Boym, Svetlana, 156–57

Bromley, Constance, 46
Brosius, Christiane, 75, 191n12, 191n13
Bruno, Giuliana, 16

Calcutta, shopping malls in, 77
caste structure, 47; in *NH10,* 121; in PVR Cinemas, 106. See also middle class; upper classes
Chakrabarty, Dipesh, 194n3
Chanakya Cinema, 158, 160–61
Chandigarh Kare Aashiqui (Chandigarh Falls in Love), 32
Chashme Buddoor (Far Be the Evil Eye), 111
Chatterjee, Biswadeep, 93
Chattopadhyay, Sarat Chandra, 133
Chattopadhyay, Swati, 48–49
Chenshu Zhou, 16, 18
China, television systems in, 12–13
Chopra, Aditya, 192n18
Chopra, Anupama, 1
Chopra, B. R., 58
Chopra, Priyanka, 1
Chopra, Yash, 184
Choudhary, Vishal, 147
Chowdhury, Aniruddha Roy, 110. See also *Pink*
Churails (Witches), 70
cine-ecology, 42, 182
cinema, film industry and: in Bombay, 41–44, 194n2; cine-ecology, 42; cine-workers in, 42; in colonial Africa, 41; in colonial India, 41–47; early days of, 194n1; economic class and, 4; methodological approach to, 4–8; as social/public activity, 41; streaming platforms as influence on, 182–83, 197n7; television's influence on, 62; theory of contact and, 16; transition to color, 40. See also Bollywood; multiplex; *specific films; specific genres; specific topics*
Cinema Excelsior, 150–52
Cinema Off Screen (Chenshu Zhou), 16

cinema theaters: absence of women from, 5; availability of white women through, 45; in Bombay, 44, 194n2; heritage, 25–26; indigenous, 46; neighborhoods altered by, 44; as public spaces, 45–46; single screen, 5, 146–54; transition to multiplexes, 25–26
cine-workers, 42
class, economic: cinema and, 4; as cultural capital, 46–47; exhibition industries and, 4; PVR Cinemas and, 98, 106; retail industry and, 4. *See also* middle class; upper classes
climate issues, in Delhi, 11
code-switching, in Hindi films, 2
colonial India: Art Deco architecture in, 8; expansion of cinema in, 41–47, 194n.4; movie-going in, 42–47. *See also* Partition of British India
color: in Hungary, 89–90; in PVR Cinemas, 88–92
commodity affect, 23, 80
Conjugations (Gopal), 140
conspiracy thriller genre, 110
contagion, disease and: containment strategies, 171–72; in public spaces, 46
COVID-19 pandemic: death toll from, 181; Delhi during, 11; hygiene protocols in cinemas, 167–71
cultural capital, class as, 46–47
Curfewed Nights (Peer), 34

Dasgupta, Rana, 139
Dass, Manishita, 44, 46–47, 194n6
DDA. *See* Delhi Development Authority
decolonization, in India, Art Deco architecture movement after, 40, 49
Delhi (New Delhi): architecture in, 8, 50–51; beautification programs in, 156; climate issues in, 11; during COVID-19 pandemic, 11; Delite Cinema, 8, 50–51, 177; globalization of, 143; as media-architecture complex, 13–14; as media city, 8–12; in multiplex films, 111–13; multiplex market in, 10–11, 109; in *NH10*, 117; Old, 50–51; after Partition of British India, 9; *Pink* and, 128–29; in post-colonial era, 9; Select Citywalk in, 21, 71; Sheila Cinema, 8, 41, 52–59; Sikh Massacres and, 112–13; urban planning in, 9; urban poor in, 51; violent history of, 10–11, 113–16
Delhi-6, 111, 113
Delhi Belly, 111
Delhi Crime, 111
Delhi Development Authority (DDA), 40, 71
Delite Cinema, in Delhi, 50, 177; Art Deco architecture of, 8; urban poor and, 51
Dev.D, 34, 110–11, 132, 138, *138*; female characters in, 136; genesis of, 133; location and setting for, 137, 139–40; reviews of, 135
Devdas, 184; classical version of, 136; remakes of, 133–34
Devgn, Ajay, 169, *170*
Dhar, Aditya, 93–94
Dhoop Kinare (The Edge of Sunshine), 65–70
Dickey, Sara, 98
Dil Chahta Hai (What the Heart Wants), 3–4
Dil Dhadakne Do (Let the Heart Beat), 1–2, 4
Dilwale Dulhania Le Jayenge (The Braveheart Will Take the Bride), 134, 192n18
The Dirty Picture, 193n25
disease. *See* contagion
Dixit, Madhuri, 132, 135, 184
Doctor, Shobha, 66
Do Dooni Chaar (Two Times Four), 111
Doordashan channel, 64–67
Dorabji, Rustomji, 194n7
Doval, Ajit, 93
Dream Girl, 32
Dubai, UAE: in advertising, 21; Indian urban spaces influenced by, 75
Dutta, Gautam, 91–92, 165, 170–71

ECX (Enhanced Cinema Experience), 25, 92–93
Ek Chhotisi Love Story (A Small Love Story), 197n3
elites. *See* upper classes
Empress Theater, in Bombay, 43–44
Enhanced Cinema Experience. *See* ECX
exhibition industries: corporatization of, 105–6; economic class and, 4; in film and media studies, 14; methodological approaches to, 34–38; multiplex as influence on, 4

family films, as genre, 195n1; in Bollywood films, 23; as multiplex film, 32–33; promotion by Indian state, 23; *Titli,* 31–32
Fehérváry, Krisztina, 61, 89–91
female urban stroller. See *flâneuse*
femininity, of Indian women, 82
feminism: media studies and, 5; in *NH10,* 196n6
Fernandes, Leela, 191n12
film and media studies. *See* media studies
film piracy, 25
flâneuse (female urban stroller), in shopping malls, 17–18
food and hospitality. *See* hospitality and food
4DX theater, 95, 165–66
Freud, Sigmund, 141
Friedberg, Anne, 17, 87
Fukrey (Wastrels), 111

Gandhi, Indira, 59, 112–13
Gangs of Wasseypur, 34
gender: cultural politics in shopping malls, 17; multiplex and, 5–6; in multiplex films, 32–33; paravisuality and, 13; representation and, 5; as site of conflict, 191n16; technology and, 63–70; televisuality and, 63–70; ticket prices and, 27. *See also* gender politics; males; women

gendered spaces: in multiplex films, 110; in PVR Cinemas, 98, *105*; in Select Citywalk, 78; television as influence on, 62–63; video as influence on, 62–63
gender politics: in Hindutva era, 178; in *Pink,* 117
gentrification, of Delhi neighborhoods, 157
geocultural traffic, 20–21
George, Walter Sykes, 147
Ghai, Subhash, 184
Giri, V. V., 59
Global Bollywood films, 70, 117; economic power of, 133
globalization: of Bollywood, 70, 117, 133; of Delhi, 143; of entertainment industry, 14; Indian middle class and, 23
global media studies, 5
Global North, 126
Global South: architectural styles in, 20; media cities in, 14. See also *specific countries*
Gopal, Sangita, 64, 140, 196n6
Gopalan, Lalitha, 116, 196n3
Goswami, Manoj, 95
Govil, Nitin, 18–19, 75, 103, 158–59, 190n9
The Guardian, 130
Gully Boy, 2–3, 34
Gupta, Rajan, 153, 162

Haider, 34
hatke (atypical Hindi film), 1
Hebert, Daniel, 15
heroine genre, 64; in multiplex films, 33
Hill, Douglas, 18, 75, 190n8
Hindi films: acting styles in, 2; code-switching in, 2; before multiplex era, 33. *See also* Bollywood
Hindu nationalism, 175
Hindu Right, 198n5, 198n7, 199n9
Hindutva era: Beti Bachao Bahu Lao (Save the Daughter, Bring Home the Daughter-in-Law) movement, 198n7;

campaigns for gender protections, 180; gender politics in, 178; Hindu nationalism, 175; Hindu Right, 198n5, 198n7, 199n9; *The Kashmir Files*, 176–78, 180, 184; "Love Jihad," 198n5, 198n7; moviegoing in, 175–81
Hoek, Lotte, 14
The Hollywood Reporter, 166
honor killing, in *NH10*, 121–24, 196n5
hospitality and food, in multiplexes: alcohol consumption, 99–101; political symbolism of, 99–100; in PVR Cinemas, 95–101
Huffington Post, 148
Hughes, Stephen, 14
Hum Aapke Hain Koun..! (Who Am I to You?), 104, 192n18
Hungary, 61–62; modernist theaters in, 8; symbolism of color in, 89–90
Hyderabad, shopping malls in, 77
hygiene, health and, in cinemas: biosurveillance and, 167–71; British Social Hygiene Council, 194n6; contagion strategies, 171–72; COVID-19 safety procedures, 167–71; in PVR Cinemas, 101–6, 167–71, *169–70*; touchless encounters, 167

"ideal woman" genre, 31
Idhar Udhar (Here and There), 65–67
IMAX (Image Maximum) screens, in PVR Cinemas, 25, 92–93
India: caste structure in, 47; Dubaisition of, 75; family films promoted by, 23; liberalization of economy in, 4; modernist architecture in, 52–63; national identity for, 59–60; privatization of economy in, 4. *See also* colonial India; *specific topics*
The Indian Express, 157
Indian film industry. *See* Bollywood
Indian Institute of Architects, 48
Indianness, definition of, 146

India's Daughter, 129
Indonesia, shopping malls in, 78
Internet: analog nostalgia influenced by, 157–58; digital cultures as result of, 197n7
"interval" narrative, in film, 11
Irani, Honey, 3

Jain, Siddharth, 166
Jayasi, Malik Muhammad, 178
Jinying Li, 20
Johar, Karan, 180, 183–84
Journal of the Indian Institute of Architects, 48
JungBong Choi, 20

Kalia, Ravi, 60
Kanoon (Law), 58
Kapoor, Anil, 1
Kapoor, Raj, 64, 147, 164, 196n4
Kapoor, Ranbir, 164
Kapoor, Vijay, 96, 101–2, 105
Kapur, Jyotsna, 110, 141
Kapurush (The Coward), 58
Karim, Farhan, 52
The Kashmir Files, 176–78, 180, 184
Kashyap, Anurag, 30, 110, 132, 137–39. *See also Dev.D*
Kaushal, Vicky, 93
Kaushish, D. C., 53–54, 58
Kaushish, Uday, 53, 58
Kaviraj, Sudipta, 194n3
Kazmi, Rahat, 67
Kejriwal, Shailaja, 69
Khan, Fawad, 180–81
Khan, Mahira, 181
Khan, Marina, 67
Khan, Mehboob, 196n4
Khan, Salim, 3
Khan, Salman, 153–54, 158, 197n4
Khan, Shah Rukh, 21, 132, 134, 158, 180–81, 197n4
Khattar, Sriram, 160–61

Khosla Ka Ghosla! (Mr. Khosla's House), 111–12
Khurrana, Ayushmann, 32–33
King, Anthony, 75
Kishore, Avijit Mukul, 61
Koechlin, Kalki, 134
Koenigsberger, Otto, 50
Koolhaas, Rem, 172
Korean Wave, in pop culture, 21
Kothari, Shri N., 51
Kulhari, Kirti, 127
Kumar, Agneet, 89, 97, 104
Kumar, Akshay, 169, *170*
Kumar, Darshan, 120

Lal, Ashok B., 60
Lal, Jessica, 120
Larkin, Brian, 19, 68–69
Le Corbusier, 50, 52
liberalism, of Indian economy, 4, 74; consumption as result of, 75. *See also* neoliberalism
Liberty Cinema, in Bombay, 49, 162–63; sound in, 50
Liechty, Mark, 22
The Life of Pi, 114
Llamas-Rodriguez, Juan, 190n8
Lotz, Amanda, 15
Love, Sex aur Dhokha (Love, Sex, and Betrayal), 111, 196n2
"Love Jihad," 198n5, 198n7
Luck by Chance, 2
Luyten, Edward, 50

Made in Heaven, 3, 111
Madhuban Fine Dining and PVR Memories (Singh, J. A.), 26
Mahapurush (The Holy Man), 58
males, multiplexes designed for, 6
Malik, Shilpa, 86
malls. *See* shopping malls
Mankekar, Purnima, 23, 80–81
Marks, Laura, 87, 153

Masaan, 34
masculinity, as theme, in Bollywood films, 33
Massey, Doreen, 182
materialism, middle class and, 22
Mazumdar, Ranjani, 33, 75, 117
McQuire, Scott, 13, 189n5
media, in India: architecture as, 12–18; feminist studies in, 5; global studies in, 5; multiplex as influence on, 4. *See also* cinema; television, in India
media-architecture complex, 13–14; networks for, 21
media cities: Delhi as, 8; in Global South, 14
media industry: components of, 15–16. *See also* media; media-architecture complex; *specific topics*
media studies, film and: architecture and, 12; convergence of, 16; exhibition in, 14
media urbanism, 14
Mera Naam Joker (My Name is Joker), 147
Metro Theater, in Bombay, 44–45
middle class, in India: commodity affect and, 23; as cultural process and practice, 22; development of, 191n12; globalization and, 23; materialism and, 22; neoliberalism and, 23–24; new, 191n15; place for, 22–24; space for, 22–24, 45; television and, 6–7, 23, 25, 41
Mishra, Piyush, 128
Mitra, Manoj, 114
modernism, in architecture, 142; as escape, 40; in India, 52–63; materiality in, 62; national identity through, 59–60; under Nehru, 40–41, 52–63. *See also* modernist theaters; Schlanger, Benjamin
modernist theaters: Chanakya Cinema, 158, 160–61; in Hungary, 8; under Nehru, 41; Sheila Cinema, 8, 41, 52–63; Szczepaniak-Gillece on, 54–55
Modi, Narendra, 93, 175
modular cosmopolitanism, 190n8
Moin, Haseena, 67
Monsoon Wedding, 3

Morley, David, 103
Motion Picture Association, 27
Motion Pictures Export Association of America, 53
Motion Pictures Theaters of Tomorrow, 55
Motwane, Vikramaditya, 30
Mukherjee, Debashree, 42–43, 182
multiplex, as cinema concept: architecture influenced by, 4–5; audiences for, 30; in Delhi, 10–11; design for male "masses," 6; exhibition industry and, 4; as exhibition space, 87; gender and, 5–6; historical development of, 4; hospitality and food in, 95–101; in media-architecture complex, 13–14; media landscape influenced by, 4; methodological approach to, 34–38; in moviegoing heritage, 155–61; "multiplex directors," 30; as novel media formation, 6; Return to Heritage Project, 155–56; sensory immersion, 164–67; single-screen cinemas transition to, 25–26; Sinha on, 86–87; as socio-symbolic double space, 24; sound in, 30, 93; spatial politics of, 7; as spatiotemporal formation, 11–12; sticky, 18; Superplex, 95, 165–66; vernacular of, 29–34; video and, 69. *See also* multiplex films; Select Citywalk; *specific multiplex chains*
multiplex architecture: global nature of, 7; Indian commercial/residential architecture influenced by, 4–5. *See also* Select Citywalk
multiplex culture, 6
"multiplex directors," 30. *See also specific directors*
multiplex films: conspiracy thriller genre, 110; Delhi in, 111–13; *Dev.D*, 34, 110–11, 132–40, *138*; directors of, 30; family film genre, 32–33; gendered space in, 110; gender in, 32–33; heroines in, 33; "ideal woman" genre in, 31; Muslim-Social genre, 140; panoramic exterior in, 117;

Pink, 110–11, 117, 127–31, *129*; psychogeography in, 109; rape scenes in, 115; "reality effect" in, 110; second generation of, 140; spatial vocabulary of, 109. *See also NH10*
The Multiplex in India (Athique and Hill), 18
multiplex studies, 19–20; cultural globalization in, 21; definition of, 18; global, 18
Muslims, violence against, 113
Muslim-Social genre, 140, 197n8

naagin (snake-woman) genre, 62
Nair, Mira, 3
Nanda, Sanjeev, 138–39
Nandy, Ashis, 120
Nargis, 50
national identity, for India, through architecture, 59–60
Naval, Deepti, 122
NDMC. *See* New Delhi Municipal Corporation
Nehru, Jawaharlal: Indian architecture influenced by, 8; modernist architecture under, 40–41, 52–53; modernist theater construction under, 41
neoliberalism, 191n15; middle class and, 23–24
Neves, Joshua, 12–14
new cinema, 16
New Delhi. *See* Delhi
New Delhi Municipal Corporation (NDMC), 155
New Indian Woman, 82, 193n27; Select Citywalk and, 83
new middle class, 191n15
NH10, 34, 110–11, *119*–20, *125*, *126*, 164, 193n25; avenging woman genre, 123–24; caste in, 121; city as metaphor in, 117; feminist politics of, 196n6; honor killing in, 121–24, 196n5; location and setting for, 116–17; rape scenes in, 124; road-trip-gone-wrong genre, 116; rural-urban divide in, 117; slasher genre as influence on, 126; violence in, 118–20

nostalgia. *See* analog nostalgia
Nostalgia for the Future, 60–61
Nutan, 39

Omkara, 34
Orienting Hollywood (Govil), 18–19
Oye Lucky! Lucky Oye!, 34, 111–12

Paatal Lok, 111
Padmaavat, 95, 178–80
Padukone, Deepika, 178, 193n25
Pannu, Taapsee, 127
panoramic exterior, 117
Pant, Ritika, 69
paravisuality, gender and, 13
Partition of British India: Delhi after, 9; displaced refugees after, 9, 60–61; violence against Muslims after, 113; violence against women after, 9
Passion for Cinema (blog), 137
Peer, Basharat, 34
Pierce, Charles S., 90
Pink, 110–11, *129*; as courtroom drama, 128, 130–31; Delhi setting in, 128–29; gender politics in, 117; privilege in, 127–31; rape culture in, 127–31; reviews of, 130
Pirate Modernity (Sundaram), 189n3
place, for Indian middle class, 22–24
post-colonial era: Delhi during, 9. *See also* Partition of British India
private spaces, 45
private television, 6–7
psychogeography, in multiplex films, 109
public spaces: absence of middle-class families in, 162–63; absence of women in, 162; cinema theaters as, 45–46; contagion and disease in, 46; for economic classes, 45; risks in, 161–64; safety threats in, 161–64
public television, 6–7
Punathambekar, Aswin, 15, 63
Purohit, Aparna, 199n9

PVR Cinemas, 20, 192n19; caste coding in, 106; classification of theaters, 89, 94–95; color design in, 88–92; conversion of older theaters, 155; demographics for, 25; economic class and, 98, 106; ECX screens, 25, 92–93; establishment of, 24; expansion outside of urban areas, 24–26; felt experience in, 92; 4DX theater, 95, 165–66; gendered spaces in, 98, *105*; gentrification of neighborhoods influenced by, 157; hospitality and food, 95–101; hygiene and safety programs in, 101–6, 167–71, *169–70*; IMAX screens, 25, 92–93; industrial strategy of, 160; infrastructure for, 29; legitimization of, 26–27; pilot theater program, 171; private investment in, 24; promotion and publicity campaigns for, *99, 105, 157, 159–60, 168, 169*; PVR Anupam, 24–26; PVR Complex, 26; PVR PHPP, 26; PVR Priya, 24; PVR Saket, 57–58; risk issues in, 101–6; Select Citywalk and, 77–78, 89, *102*; sensory experience technologies in, 164–67; sound design in, 92–95; spectator experience in, 161; staffing at, 97–98; Superplex, 95, 165–66; ticket prices at, 26; upgrading of facilities, 157; U.S. films in, 95; virtual reality lounges in, 164–65
PVR Playhouse Kids Day Out Event, 99

Radio Corporation of America (RCA), 50
Raees (Wealthy), 181
Rai, Aishwarya, 132, 184
Rai, Amit, 19, 152, 154, 156, 190n9, 194n30
Raizada, Shashank, 50
Rajnikanth, 105
Ramayana, 31
rape, 116; in multiplex films, 115; in *NH10*, 124; in *Pink,* 127–31. *See also* Singh, Jyoti
rape-revenge genre, in film, 62, 196n3

rational architecture, 52–63. *See also* Sheila Cinema
Ray, Satyajit, 58
RCA. *See* Radio Corporation of America
"reality effect," 110
Regal Cinema: Art Deco architecture of, 8; demise of, 147–48; as single screen theater, 147–48
regionalization, definition of, 20
representation, gender and, 5
retail industry, economic class and, 4
Return to Heritage Project, 155–56
risk, risk factors and: in public spaces, 161–64; in PVR Cinemas, 101–6
Rivoli Cinema, Art Deco architecture of, 8
road-trip-gone-wrong genre, 116
Rocky aur Rani kii Prem Kahaani (Rocky and Rani's Love Story), 183–84
Roy, Abhijit, 64
rural-urban divide, in *NH10*, 117

Sabharwal, Vikas, 96, 155, 195n4
safety issues: in public spaces, 161–64; in PVR Cinemas, 101–6. *See also* hygiene
Sangam, 147
Sarkar, Bhaskar, 19–20, 133
Satheesh, P. M., 95
Saxton, Aditi, 114
Schlanger, Benjamin, 41, 54–55, 72
Schutz, George, 195n8
Select Citywalk: classification of theaters in, 89; design templates for, 79–80, 86; development of, 76–77; gendered spaces in, 78; interiors, *80, 85, 90*; location of, 73; multiplexes in, 21, 71; New Indian Woman and, 83; open spaces, 84–85; public leisure as focus of, 76–88; public response to, 74; PVR Cinemas and, 77–78, 89, *102*; security for, 84; selected areas in, 79; shopper-spectators in, 84; Sinha on, 73–74, 76–79, 81–87; tenant mixing at, 83
Sen, Raja, 34

sexism, in Indian film industry, 33
sexual violence. *See* violence against women
Shanghai, 34, 196n2
Sharma, Anushka, 1, 118, *120, 125*, 193n25
Sharma, Manu, 120
Sheila Cinema, in Delhi, *56*; design of, 41; as first modernist theater, 8, 41, 52; indigenous projection system for, 58; infrastructural improvements for, 53; location of, 53, 59; publicity campaigns for, 56–57; screen placement in, 57; sound in, 53; space design in, 57; ticket prices at, 57–58; U.S. films at, 53
SHEILARAMA projection system, 58
shopping malls: in Bombay, 77; in Calcutta, 77; *flâneuse* in, 17–18; gendered cultural politics in, 17; in Hyderabad, 77; in Indonesia, 78; Sarinah Mall, 78; as space of global culture, 75. *See also* Select Citywalk; *specific malls*
A Short Introduction to Media Industry Studies (Hebert, Lotz, and Punathambekar), 15
Shubh Mangal Zyada Saavdhan, 32
Siddique, Salma, 179–80
Sikh Massacres, 112–13
Singapore Mall, 20
Singh, Jai Arjun, 26, 31
Singh, Jyoti: gang rape and murder of, 10, 109–10, 114–15, 189n4; "people like us" symbolism of, 114; in popular press, 109–10
Singh, Kuldip, 71
Singh, Navdeep, 110. *See also NH10*
Singh, Ranjan, 103
Singh, Ranveer, 1, 169, *170*, 178, 183
Singh, Smriti, 114
single screen theaters, 5; analog nostalgia for, 146–54; Cinema Excelsior, 150–52; demise of, 147–48; Liberty Cinema, 49–50, 162–63; Regal Cinema, 8, 147–48

Sinha, Pranay: on multiplexes, 86–87; on Select Citywalk, 73–74, 76–79, 81–87
Sircar, Shoojit, 30
slasher genre, 126
snake-woman *(naagin)* genre, 62
Sobchack, Vivian, 16
Solly, Allen, 84
Solomon and Sheba, 53
Sooryavanshi, 169
sound, sound technology and: atmospheric, 93; in Liberty Cinema, 50; in multiplexes, 30, 93; in PVR Cinemas, 92–95
space: of global culture, 75; for Indian middle class, 22–24, 45; multiplex as socio-symbolic double space, 24; private, 45; in Select Citywalk, 78, 84–85; in Sheila Cinema, 57; for upper classes, 45. *See also* gendered spaces; public spaces
space-sharing, for economic classes, 45
spatial segregation, 142
state-owned television: in China, 12–13; in India, 12, 65–67
Steinberg, Marc, 20
sticky multiplex, 18
streaming platforms, 142, 182–83, 197n7
The Stuff of Spectatorship (Benson-Allott), 15
Sukarno, 78
Sundar, Pavitra, 63
Sundaram, Ravi, 60, 112, 163–64, 189n3; on urban planning, 9
Superplex, 95, 165–66
Szczepaniak-Gillece, Jocelyn, 54–55, 190n7, 195n8

Tandav (Chaos), 199n9
Taneja, Anand Vivek, 154
Tanhaiyaan (Loneliness), 67
Tariang, Andrea, 127
technology: of biopolitical control, 156; gender and, 63–70; indigenous projection systems, 58. *See also* sound

television: in China, 12–13; state-owned, 12–13, 65–67
television, in India: cable, 70; in China, 12–13; *Churails* (Witches), 70; cinema popularity negatively influenced by, 62; commodities market development influenced by, 192n22; crime shows, 10; cultural significance of, 63–64; *Delhi Crime,* 111; *Dhoop Kinare* (The Edge of Sunshine), 65–70; Doordashan channel, 64–67; expansion of access to, 63–64, 70–71; gendered spaces influenced by, 62–63; Hinduization of, 70; *Idhar Udhar* (Here and There), 65–67; *Made in Heaven,* 111; middle class and, 6–7, 23, 25, 41; *Paatal Lok,* 111; private, 6–7; public, 6–7; relationship with video-recorders, 69; state-by-state media markets, 67; state-owned, 12, 65–67; *Tanhaiyaan* (Loneliness), 67; televisuality and, 13, 63–70; violence on, 10; women-centered shows, 64–65, 81–82; *Yeh Jo Hai Zindagi (YJHZ)* (Such Is Life), 65–67; Zee TV, 69–70; *Zindagi* (Life) channel, 69–70
televisuality, 13; gender and, 63–70
tenant mixing, at Select Citywalk, 83
Tere Ghar Ke Samne (In Front of Your House), 39–41
theaters. *See* cinema theaters
Theatre World, 27–28
ticket prices: gender and, 27; at PVR Cinemas, 26; at Sheila Cinema, 57–58
Times of India, 43–45, 114
Titli (Butterfly), 31–32, 111
Tiwari, Mayak, 100
Tod, Pinjra, 198n6
transitional architecture, 75
Trigg, Dylan, 172
Trivedi, Amit, 137

Uberoi, Patricia, 192n18
Udwin, Leslee, 129

Ugly, 34
the uncanny, 141–42
Untimely Bollywood (Rai), 19
Uphaar Cinema catastrophe, 161–62
upper classes, elites and: navigation of cinema by, 47; space for, 45
urban planning: in Delhi, 9; in India, 60; Sundaram on, 9. *See also* architecture; multiplex architecture
urban poor, in Delhi, 51
urban redevelopment projects, 107
Uri, 93–94
U.S. films: in PVR Cinemas, 95; in Sheila Cinema, 53

Varma, Vijay, 127
Vasudevan, Ravi, 14
Verma, J. S., 115
Vicki Donor, 111
video, video distribution and: expansion of, 64; gendered spaces influenced by, 62–63; multiplex relationship with, 69; television's relationship with, 69
violence, in India: in Delhi, 10–11, 113–16; against Muslims, 113; political assassinations, 112–13; Sikh Massacres, 112–13
violence against women: in Delhi, 113–16; in *NH10*, 118–20; after Partition of British India, 9; poor males migrants as primary threat, 115; rape, 115–16. *See also* Singh, Jyoti
virtual reality lounges, 164–65
Vohra, Paromita, 67–68

A Wednesday!, 34
white women, male gaze and, through cinema, 45
women, in India: in Bombay, 10; as cine-workers, 42; as consumer, 82; as *flâneuse*, 17; Hindu femininity ideals for, 82; Indian television shows featuring, 64–65, 81–82; New Indian Woman, 82–83, 193n27; after Partition of British India, 9; in single-screen cinemas, 5. *See also* feminism; gendered spaces; sexism; violence against women; white women

Yeh Jo Hai Zindagi (YJHZ) (Such Is Life), 65–67
Zee TV, 69–70
Zero Dark Thirty, 93
Zindagi (Life) channel, 69–70
Zindagi Na Milegi Dobara (You Only Live Once), 2, 31

ABOUT THE AUTHOR

TUPUR CHATTERJEE is an Assistant Professor of Global Film and Media in the School of English, Drama, and Film at University College Dublin.

www.ingramcontent.com/pod-product-compliance
Lightning Source LLC
Chambersburg PA
CBHW021812170526
45157CB00007B/2557